CW00821730

WIMBLEDON
- 2024 -

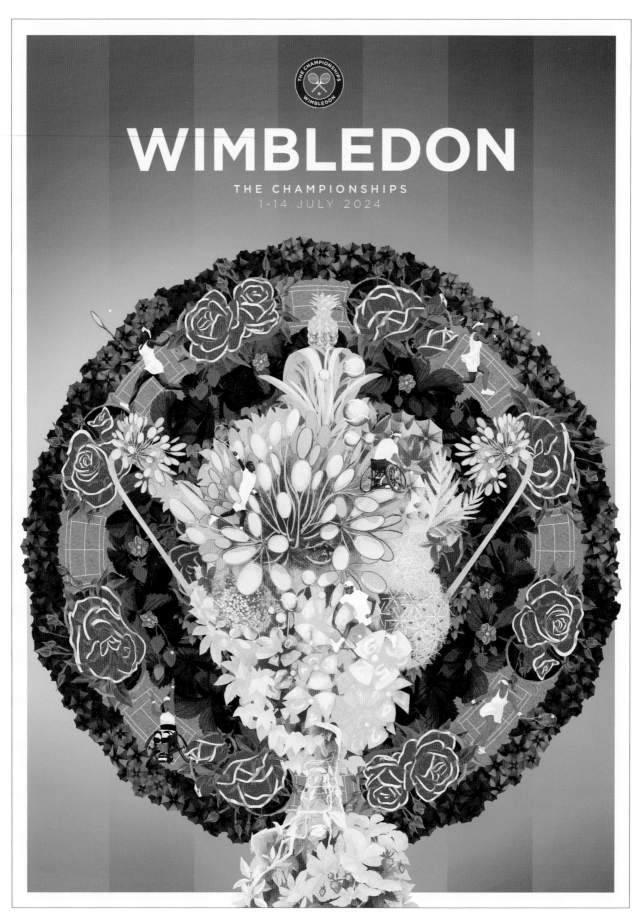

The Official Poster for The Championships 2024 was created by British illustrator Bella Grace. It includes 14 hidden elements to find, one for each day of the event

WIMBLEDON
- 2024 -

By Paul Newman
& Alix Ramsay

Published in 2024 for The All England Lawn Tennis Club by Vision Sports Publishing

Vision Sports Publishing Ltd
19-23 High Street
Kingston upon Thames
Surrey
KT1 1LL
www.visionsp.co.uk

ISBN: 978-1913412-64-7

© The All England Lawn Tennis Club (Championships) Limited ('AELTC')

Written by: Paul Newman and Alix Ramsay
Edited by: Jim Drewett, William Giles and Eloise Tyson
Photographic manager: Bob Martin
Production editor: Ed Davis
Photographic support: Sarah Frandsen
Club Historian: Robert McNicol
Photographic reproduction: Bill Greenwood
Proofreading: Lee Goodall

All photographs © AELTC unless otherwise stated

Photo Team 2024
Bob Martin, Thomas Lovelock, Andrew Baker, Simon Bruty, Dillon Bryden, Kieran Cleeves, Felix Diemer, Florian Eisele, Tom Flathers, Chloe Knott, Mike Lawrence, Mark Lewis, Jason Ludlow, Joel Marklund, Paul Marriott, Jeff Moore, Jonathan Nackstrand, Pete Nicholls, Tony O'Brien, Andrew Parsons, Ben Queenborough, Chris Raphael, Jon Super, Joe Toth, Ian Walton, Edward Whitaker

Editors 2024
Sammie Thompson, Lucy Bull, Ryan Jenkinson, Dan Law, Jamie McPhilimey, Sean Ryan, James Smith, Neil Turner, Richard Ward

Photo Liaison 2024
Chris Davey, Paul Gregory, Stephanie Morel-Lidgerwood, Trisha Webbe

Results and tables are reproduced courtesy of the AELTC

All rights reserved. No part of this publication may be reproduced, stored in a retrieval system, or transmitted in any form or by any means, electronic, mechanical, photocopying, recording or otherwise, without the prior permission of the publishers. This book is sold subject to the condition that it shall not, by way of trade or otherwise, be lent, re-sold, hired out, or otherwise, without the publishers' prior consent in any form of binding or cover other than that in which it is published and without a similar condition including this condition being imposed on the subsequent purchaser.

The views expressed in this book do not necessarily reflect the views, opinions or policies of the AELTC, nor those of any persons, players or tennis federations connected with the same.

The All England Lawn Tennis Club (Championships) Limited
Church Road
Wimbledon
London
SW19 5AE
England
Tel: +44 (0)20 8944 1066
www.wimbledon.com

Printed in Italy by Printer Trento

This book is published with the assistance of Rolex

CONTENTS

—

6	Chair's Foreword
10	Introduction
20	The Seeds
22	Day 1
36	Day 2
50	Day 3
64	Day 4
78	Murray Farewell
86	Day 5
100	Day 6
116	Day 7
130	Day 8
144	Day 9
156	Day 10
168	Day 11
182	Day 12
192	Day 13
214	Day 14
238	The Champions 2024
240	The Draws 2024
253	The Rolls of Honour

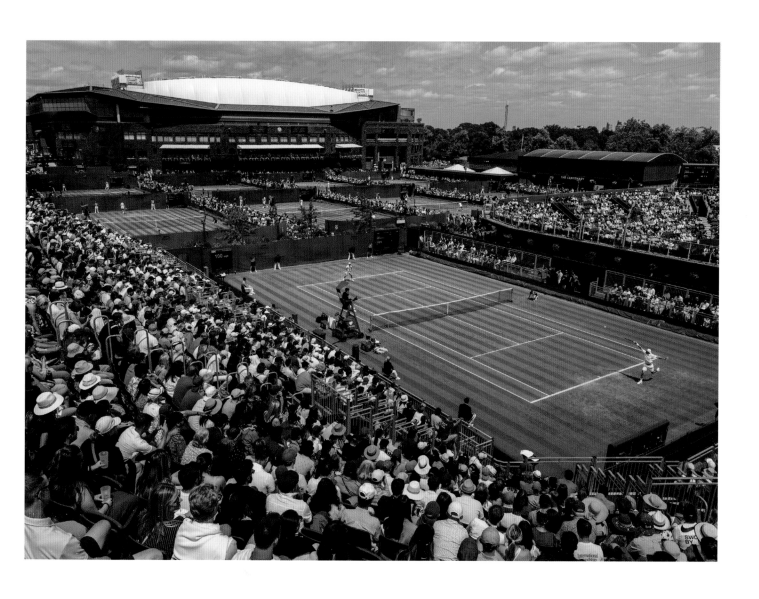

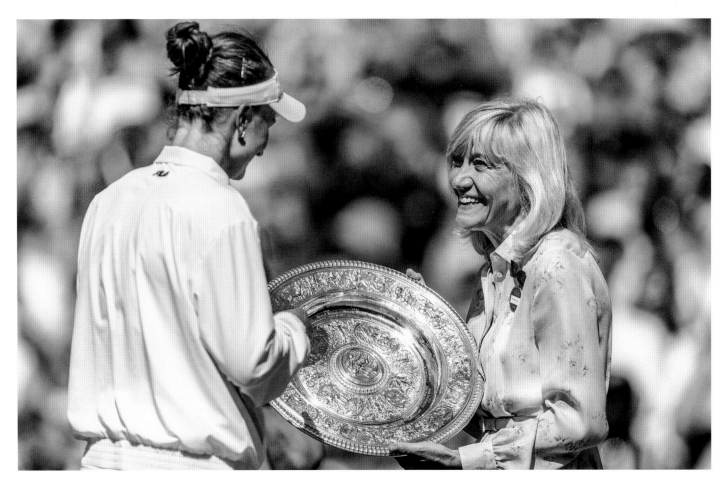

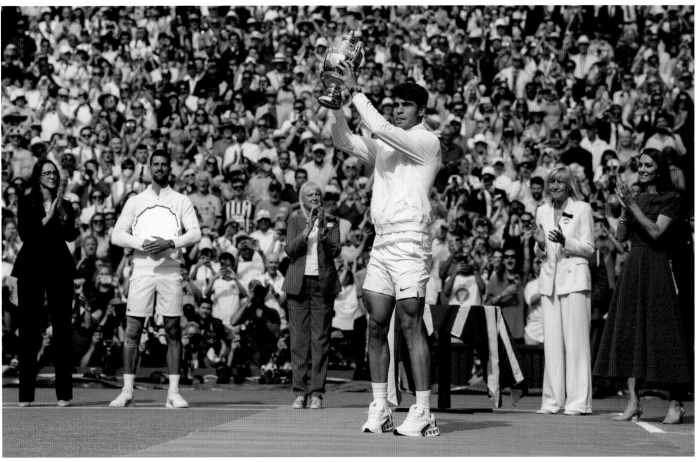

Top: *Deborah Jevans, Chair of the All England Club, presents Barbora Krejcikova with the Venus Rosewater Dish*

Above: *Carlos Alcaraz lifts the Gentlemen's Singles Trophy for the second time, having been presented with it by HRH The Princess of Wales*

FOREWORD

—

By Chair Deborah Jevans CBE

Welcome to the Official Annual of The Championships 2024, a celebration of the 137th staging of this treasured event. It gives me great pleasure to reflect upon my first Championships as Chair of the All England Club, and what a Fortnight it was, comprising thrilling matches, dramatic moments and heartfelt tributes.

I would like to first offer my congratulations to all our 2024 champions on their outstanding achievements. Carlos Alcaraz defended his gentlemen's singles title in spectacular fashion, while Barbora Krejcikova emerged from a thrilling battle to become our Ladies' Singles Champion and newest Honorary Member.

Whilst we are a truly international event, there is no doubt we take pride in British success too: Alfie Hewett, who completed his career Grand Slam by winning the Gentlemen's Wheelchair Singles title; Gordon Reid, who with Alfie, won a sixth Gentlemen's Wheelchair Doubles title; and Henry Patten, on an incredible victory in the Gentlemen's Doubles Championship, alongside Harri Heliovaara. Every one of our remarkable champions has their own inspiring story of success detailed beautifully in the pages that follow.

During week one we celebrated the extraordinary career and accomplishments of our two-time Gentlemen's Singles Champion, Andy Murray. It was a truly special moment to watch Andy play doubles with brother Jamie on Centre Court, and to welcome Sue Barker back to speak with Andy after the match in front of his family and friends. We thank Andy for all the amazing memories he has given us during his career.

We were deeply honoured by the presence of our Patron, HRH The Princess of Wales, who was joined by her daughter, HRH Princess Charlotte, on the last day of The Championships. We also thank Her Majesty The Queen for her continued support of Wimbledon and we were delighted to welcome her and her sister on the second Tuesday.

The Chair's Special Guests for this year were Conchita Martinez, on the 30th anniversary of her becoming the first Spaniard to win the ladies' singles title; Andre Agassi, who won the first of his eight Grand Slam singles titles at The Championships in 1992; Chris Evert, who marked the 50th anniversary of her first ladies' singles title; and Ken Rosewall, who finished runner-up in singles at Wimbledon on four occasions between 1954 and 1974 and was twice a doubles champion.

During the Fortnight, we celebrated the 10-year anniversary of the Wimbledon Foundation, the official charity of the All England Club and The Championships. To mark the occasion, four inspirational young people representing charities chosen by the Wimbledon Foundation performed the pre-match coin toss at the gentlemen's and ladies' singles finals and, for the first time, the Wheelchair singles finals which were staged on No.1 Court.

Despite the challenging weather conditions, interest in The Championships remains extremely high and we achieved our second-highest attendance on record, with 526,455 guests coming through the gates. To everyone who played a part in welcoming them, as well as providing the best possible facilities for our players, and supporting the staging and delivery of this iconic event, I would like to offer my sincere thanks.

I hope you enjoy this account of all the key moments from The Championships 2024.

CARLOS

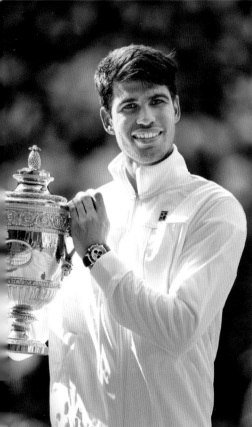

OFFICIAL TIMEKEEPER

BACK-TO-BACK
WIMBLEDON VICTORIES

And there it is. Another exceptional achievement. On hallowed
ground. A second consecutive Wimbledon victory. Congratulations
Carlos Alcaraz on your fourth Grand Slam® title.

#Perpetual

OYSTER PERPETUAL
COSMOGRAPH DAYTONA

ROLEX

INTRODUCTION

—

By Paul Newman

Speak to any professional player and they will tell you how physically demanding tennis is. The sport is played around the world for 11 months of the year, with tournaments held every week. Players are fitter than they have ever been, but – given the sport's gruelling schedule and the increasingly physical nature of the game – it is no wonder that injuries are frequent. As the 137th edition of The Championships approached, it felt like more players than ever were struggling with their fitness.

Rafael Nadal, who had fought with injuries throughout his career, had managed to play only 12 matches in the previous 17 months and had announced in the wake of Roland-Garros that he would not play at the All England Club. With Andy Murray and Novak Djokovic also suffering recent physical setbacks and with Roger Federer already retired, we had to contemplate the very real prospect of The Championships going ahead without any of the so-called 'Big Four' who had dominated men's tennis for the previous 20 years.

No player had fought harder in the latter part of his career to recover from serious injury than Murray, who had been hinting since early in the year that he was unlikely to play beyond the end of 2024. His latest problem was a spinal cyst, on which he had had surgery just a week before The Championships. Everyone had been hoping that the 37-year-old Scot would be fit enough to make one last appearance on his favourite stage, but with one day to go he said he was still not sure whether he would make the start line.

Djokovic had seemed even less likely to be fit in time when he had surgery to repair the torn medial meniscus in his right knee less than four weeks before the start of The Championships. However, the seven-time Gentlemen's Singles Champion had shown remarkable powers of recovery in the past and as The Championships approached he had sounded increasingly confident that he would be fit to play.

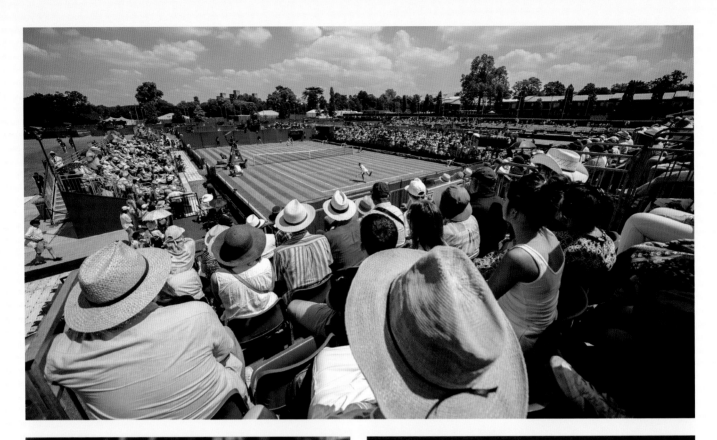

IT ALL BEGINS HERE

The Wimbledon Qualifying and Community Sports Centre at Roehampton plays host to the Qualifying Competition – unsurprisingly given the name – and can accommodate 3,500 spectators on each of the four days of play. *This page, clockwise from top:* There was not a spare seat on Show Court 1 on the opening day; Britain's Sonay Kartal earns her place in the main draw; Amarni Banks celebrates her second round win. *Opposite page:* Spectators pass a poster of last year's champions; Hugo Gaston is down but not out on his way to qualifying; Lucas Pouille celebrates; Mark Lajal and his trademark dreadlocks are on their way to the main draw.

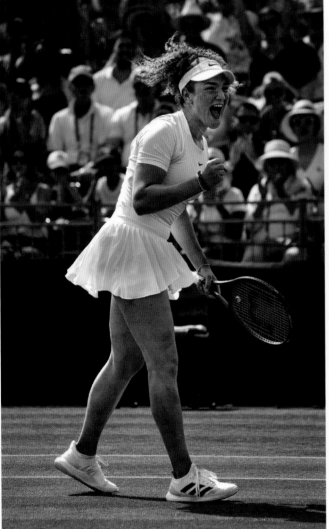

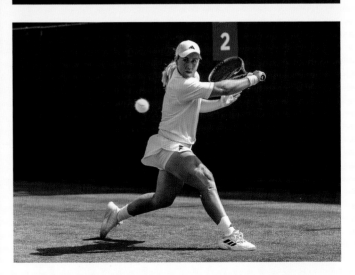

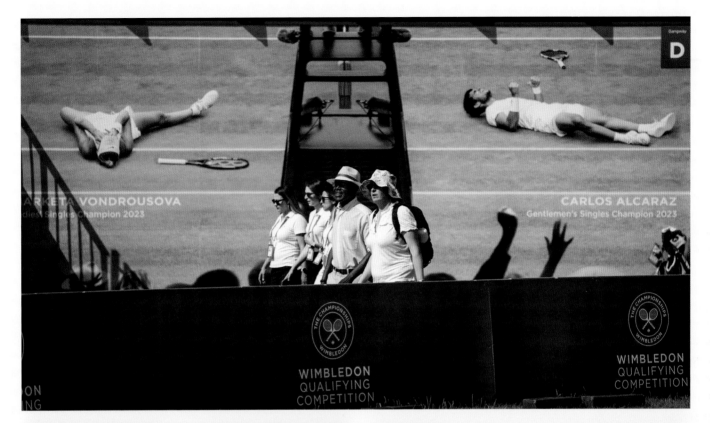

MARKETA VONDROUSOVA
Ladies' Singles Champion 2023

CARLOS ALCARAZ
Gentlemen's Singles Champion 2023

WIMBLEDON
QUALIFYING
COMPETITION

WIMBLEDON
QUALIFYING
COMPETITION

Murray and Djokovic were not the only players focusing as much on their fitness as on their tennis during the final week of practice at Aorangi Park and elsewhere. Aryna Sabalenka, the Australian Open champion and world No.3, and Victoria Azarenka, a former world No.1, were both dealing with shoulder problems, while Marketa Vondrousova and Caroline Wozniacki had both retired because of injury from their final matches before Wimbledon. At least there was better news about Emma Raducanu, who had missed Roland-Garros but proved her fitness with some promising performances on grass at Nottingham and Eastbourne.

Most of the fitness concerns heading into The Championships 2024 involved the more senior players, which underlined the sense that a changing of the guard was well under way at the top of the game. Carlos Alcaraz had highlighted that trend 12 months earlier with his stunning victory over Djokovic in the 2023 gentlemen's singles final and now arrived at the All England Club as the new champion of Roland-Garros. Jannik Sinner, aged 22, was the world No.1 and reigning Australian Open champion. The 'Next Gen' group, headed by Daniil Medvedev and Alexander Zverev, whose takeover at the top had been anticipated for so long, were finding themselves outflanked by a younger wave of players.

In the women's game Iga Swiatek, who had just won Roland-Garros for the fourth time at the age of 23, was the undisputed world No.1, ahead of 20-year-old Coco Gauff, 26-year-old Sabalenka and 25-year-old Elena Rybakina. However time never stands still in sport, especially in women's tennis. Mirra Andreeva, aged 17, had just made the semi-finals at Roland-Garros, while other teenagers like the Czech trio of Linda Noskova and the Fruhvirtova sisters were snapping at the heels of the leading players. There had been six different Ladies' Singles Champions at Wimbledon since Serena Williams won the last of her titles in 2016 and once again the field looked wide open. Two popular champions of recent times would be missing, with Petra Kvitova expecting her first child and Garbiñe Muguruza

Andy Murray pushes himself to the limit in a desperate attempt to be ready to play his opening singles match

having announced her retirement, but three former world No.1s – Wozniacki, Angelique Kerber and Naomi Osaka – would be back following maternity breaks.

Players come and go, but the appeal of The Championships to the sporting public grows with every passing year. More people than ever had entered the annual Public Ballot for tickets, while Keith Prowse, Wimbledon's exclusive Official Hospitality Partner, announced in March that its hospitality packages had sold out earlier than ever before. Meanwhile an issue of Centre Court debentures for the period from 2026 to 2030 had been significantly oversubscribed. The debentures were priced at £116,000 each, an increase of 45 per cent compared with the 2021-2025 issue. The £238m raised will be used to help finance the continuing development and refurbishment of facilities and to repay borrowings. One of the most significant improvements to facilities since The Championships 2023 had been the completion of the final redevelopment phase of the AELTC Community Tennis Centre at nearby Raynes Park. The facility has 16 grass courts, and for the first time would be an official practice venue for The Championships.

An expansion of the Wheelchair events, reflecting their increasing popularity, would mean that more matches than ever would be played at this year's Championships. With the ladies' and gentlemen's draws in both singles and doubles doubling in size, the Wheelchair events were scheduled to start one day earlier, on the second Tuesday. Meanwhile everyone would be playing for increased prize money, the total pot for The Championships having increased by 11.9 per cent from 2023 to £50m. Only 20 years earlier the prize fund had totalled less than £10m.

There were also changes behind the scenes. Deborah Jevans, a former professional player who had held several other high-profile leadership positions in sport, was the new Chair of the All England Club, having succeeded Ian Hewitt, while Denise Parnell had taken over from

Could Novak Djokovic recover from knee surgery in time to launch a challenge for the title?

IT'S GREAT TO BE BACK!

They may be the fiercest of rivals, but as they arrived at Wimbledon the best players in the world were having some fun on the practice courts. *This page, clockwise from top left:* Coco Gauff has a laugh in her pre-Championships press conference; Andy Murray is delighted to be back after his recent back operation; Tommy Paul in his fishing hat (fishing is his passion); Marketa Vondrousova in playful mood; Naomi Osaka enjoys a giggle and Carlos Alcaraz can't wait to get back on the famous grass. *Opposite page:* A smiling Novak Djokovic; Stefanos Tsitsipas happily heads into work; Ons Jabeur and Aryna Sabalenka dance on No.1 Court; Frances Tiafoe brings style and a smile to SW19; Heather Watson arrives in great spirits.

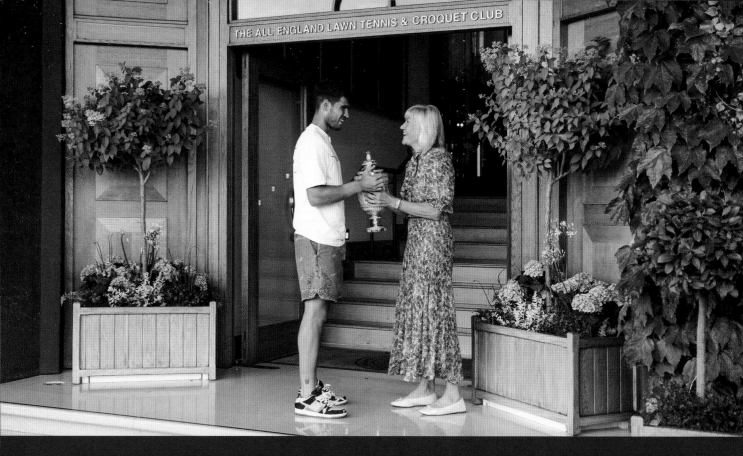

THE CHAMPIONS RETURN

—

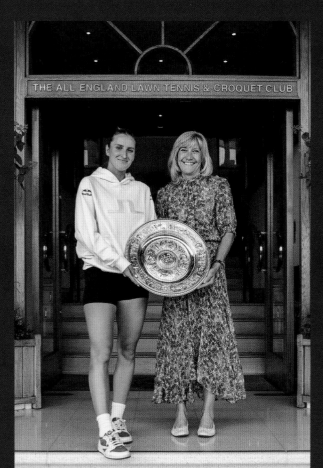

Wimbledon is the home of tennis history and tradition, so when a change to the norm comes about it tends to raise a few eyebrows.

In the past, the champions did not touch the trophy again once the presentation ceremonies and the last photocalls were over. That which had taken a lifetime of hard work and dedication to win was theirs to hold for only a matter of minutes, simply because the trophies very rarely leave the Club.

You may have noticed this in the television coverage of the champions as they leave Centre Court. They hold their trophy lovingly and as if they will never let it go; they show it to the massed throng below the Clubhouse balcony... and then, as they head back towards the Millennium Building to cross the bridge over St Mary's Walk, the trophy is taken back by Sally Bolton, the Chief Executive of the Club. The precious silverware is then returned to its rightful place in the Club's trophy cabinet (fear not, the champions are presented with a replica trophy within hours). And that used to be that.

This year, however, a new tradition was unveiled: the two returning singles champions came to the Clubhouse to be greeted by Deborah Jevans, the Club's Chair, who reunited them with their trophies. They could hold them again, albeit briefly, before they returned them. Those priceless pieces of tennis history were now seven matches away again, just as they were last year.

And for those of you with eagle eyes, you may spot a strawberry tattoo on Carlos Alcaraz's right ankle: he could not take the real trophy home with him but he carries that inked memory everywhere.

Gerry Armstrong as Championships Referee. Although the Referee's task has been made significantly less stressful by the installation of retractable roofs over Centre Court and No.1 Court, the weather forecast promised a challenging Fortnight. After a cool and damp spring a brief spell of fine weather in June had suggested that summer had finally arrived, but as The Championships loomed on the horizon so did more rain clouds.

In the coming days the tennis would have to fight for space in the media with European Championship football, England having reached the quarter-finals by beating Slovakia on the eve of The Championships, and the General Election, which would take place on the first Thursday.

It would be the first time that a General Election had been held during The Championships since 1895. For anyone looking for historical parallels, the 1895 election was when Keir Hardie's Independent Labour Party went to the polls for the first time. Now, 129 years later, Sir Keir Starmer, who had been named after Hardie, would be leading the Labour Party into the election. As for any tennis connections between 1895 and 2024, consider this. Wilfred Baddeley won the gentlemen's singles in 1895, coming back from two sets down in the final, and also claimed the doubles title, in partnership with his twin brother, Herbert. Might that be a good omen for another pair of British brothers, Andy and Jamie Murray, who were set to play together in the gentlemen's doubles?

Thanks to the tireless efforts of the groundstaff, the courts were once again immaculate for the start of The Championships

GENTLEMEN'S SINGLES SEEDS

—

1

Jannik SINNER
(Italy)
Age: 22
Wimbledon titles: 0
Grand Slam titles: 1

2

Novak DJOKOVIC
(Serbia)
Age: 37
Wimbledon titles: 7
Grand Slam titles: 24

3

Carlos ALCARAZ
(Spain)
Age: 21
Wimbledon titles: 1
Grand Slam titles: 3

4

Alexander ZVEREV
(Germany)
Age: 27
Wimbledon titles: 0
Grand Slam titles: 0

5

Daniil MEDVEDEV
Age: 28
Wimbledon titles: 0
Grand Slam titles: 1

6

Andrey RUBLEV
Age: 26
Wimbledon titles: 0
Grand Slam titles: 0

7

Hubert HURKACZ
(Poland)
Age: 27
Wimbledon titles: 0
Grand Slam titles: 0

8

Casper RUUD
(Norway)
Age: 25
Wimbledon titles: 0
Grand Slam titles: 0

9

Alex DE MINAUR
(Australia)
Age: 25
Wimbledon titles: 0
Grand Slam titles: 0

10

Grigor DIMITROV
(Bulgaria)
Age: 33
Wimbledon titles: 0
Grand Slam titles: 0

11
Stefanos
TSITSIPAS
(Greece)

12
Tommy
PAUL
(USA)

13
Taylor
FRITZ
(USA)

14
Ben
SHELTON
(USA)

15
Holger
RUNE
(Denmark)

16
Ugo
HUMBERT
(France)

17
Felix
AUGER-ALIASSIME
(Canada)

18
Sebastian
BAEZ
(Argentina)

19
Nicolas
JARRY
(Chile)

20
Sebastian
KORDA
(USA)

21
Karen
KHACHANOV

22
Adrian
MANNARINO
(France)

23
Alexander
BUBLIK
(Kazakhstan)

24
Alejandro
TABILO
(Chile)

25
Lorenzo
MUSETTI
(Italy)

26
Francisco
CERUNDOLO
(Argentina)

27
Tallon
GRIEKSPOOR
(Netherlands)

28
Jack
DRAPER
(Great Britain)

29
Frances
TIAFOE
(USA)

30
Tomas Martin
ETCHEVERRY
(Argentina)

31
Mariano
NAVONE
(Argentina)

32
ZHANG
Zhizhen
(China)

All 'titles' statistics refer
only to singles events

LADIES' SINGLES SEEDS
—

1
Iga SWIATEK
(Poland)
Age: 23
Wimbledon titles: 0
Grand Slam titles: 5

2
Coco GAUFF
(USA)
Age: 20
Wimbledon titles: 0
Grand Slam titles: 1

3
Aryna SABALENKA

Age: 26
Wimbledon titles: 0
Grand Slam titles: 2

4
Elena RYBAKINA
(Kazakhstan)
Age: 25
Wimbledon titles: 1
Grand Slam titles: 1

5
Jessica PEGULA
(USA)
Age: 30
Wimbledon titles: 0
Grand Slam titles: 0

6
Marketa
VONDROUSOVA
(Czech Republic)
Age: 25
Wimbledon titles: 1
Grand Slam titles: 1

7
Jasmine PAOLINI
(Italy)
Age: 28
Wimbledon titles: 0
Grand Slam titles: 0

8
ZHENG Qinwen
(China)
Age: 21
Wimbledon titles: 0
Grand Slam titles: 0

9
Maria SAKKARI
(Greece)
Age: 28
Wimbledon titles: 0
Grand Slam titles: 0

10
Ons JABEUR
(Tunisia)
Age: 29
Wimbledon titles: 0
Grand Slam titles: 0

11
Danielle
COLLINS
(USA)

12
Madison
KEYS
(USA)

13
Jelena
OSTAPENKO
(Latvia)

14
Daria
KASATKINA

15
Liudmila
SAMSONOVA

16
Victoria
AZARENKA

17
Anna
KALINSKAYA

18
Marta
KOSTYUK
(Ukraine)

19
Emma
NAVARRO
(USA)

20
Beatriz
HADDAD MAIA
(Brazil)

21
Elina
SVITOLINA
(Ukraine)

22
Ekaterina
ALEXANDROVA

23
Caroline
GARCIA
(France)

24
Mirra
ANDREEVA

25
Anastasia
PAVLYUCHENKOVA

26
Linda
NOSKOVA
(Czech Republic)

27
Katerina
SINIAKOVA
(Czech Republic)

28
Dayana
YASTREMSKA
(Ukraine)

29
Sorana
CIRSTEA
(Romania)

30
Leylah
FERNANDEZ
(Canada)

31
Barbora
KREJCIKOVA
(Czech Republic)

32
Katie
BOULTER
(Great Britain)

All 'titles' statistics refer
only to singles events

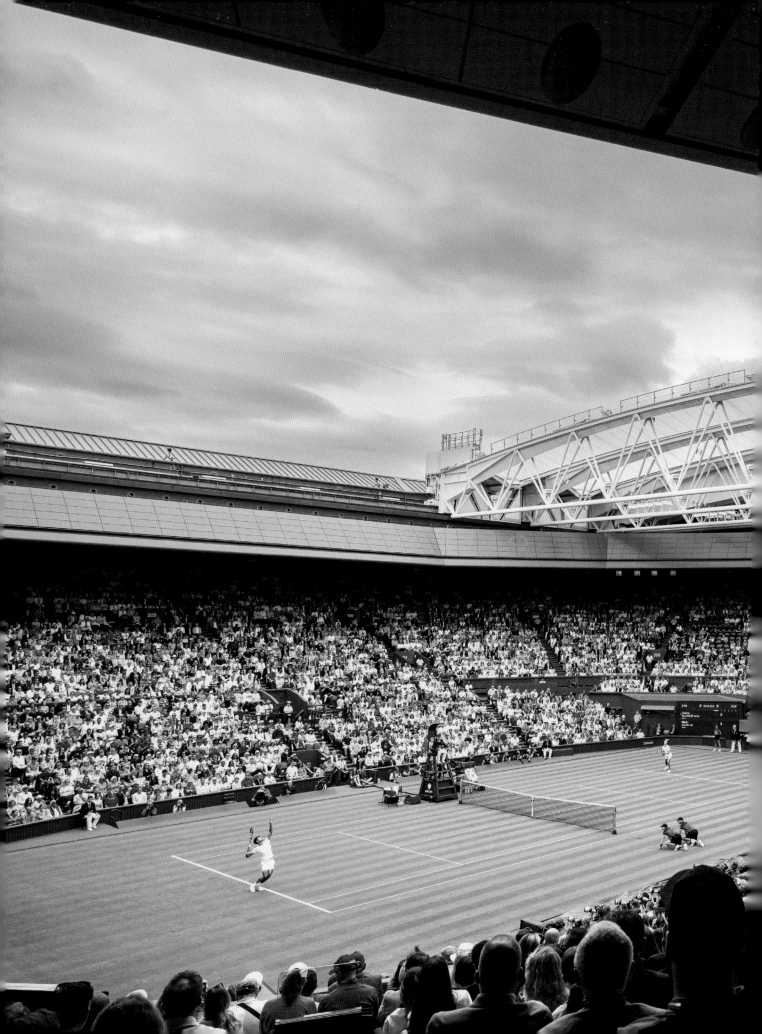

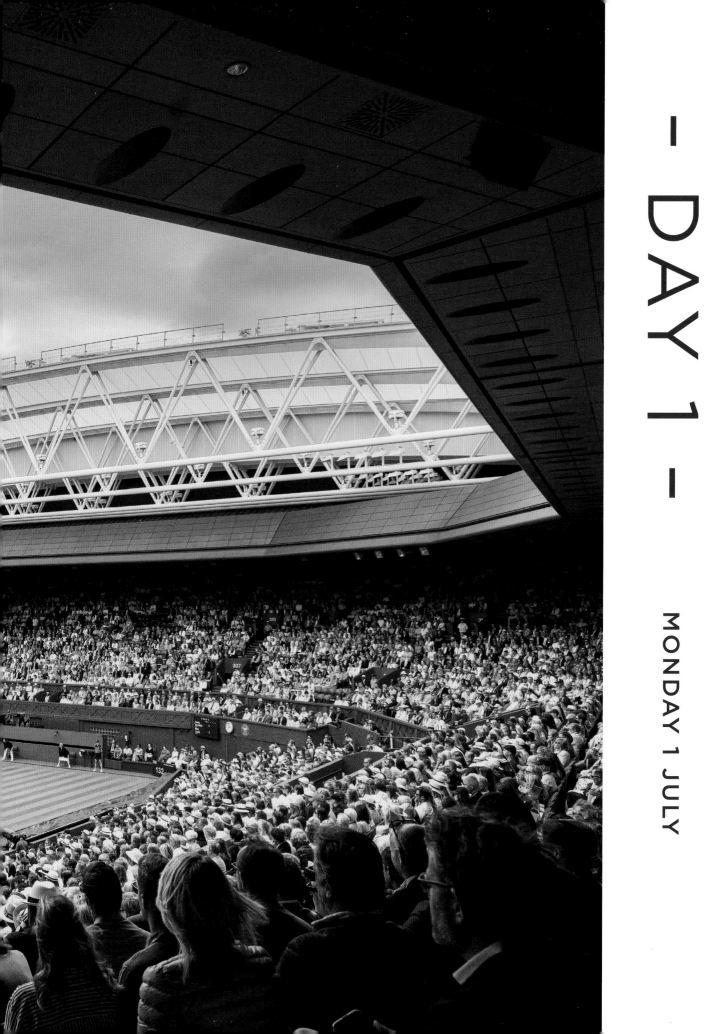

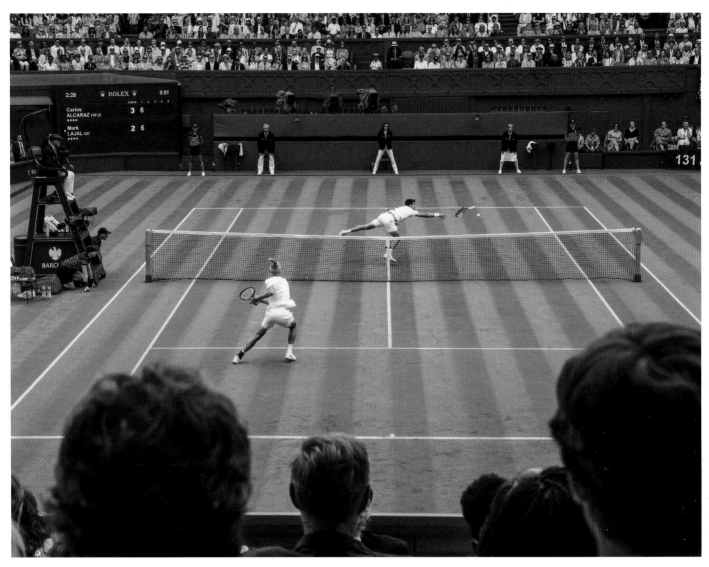

O ne of the perks of being Wimbledon champion is that you know in advance when you will be playing your first match in defence of your title. Wimbledon is the only Grand Slam event that follows this tradition, which brings a welcome sense of continuity, connecting each Championships with the previous year's edition.

Previous pages: A portent of things to come? Carlos Alcaraz begins the defence of his title under leaden skies

Above: The champion flings himself (and his racket) after another potent forehand from Mark Lajal

Twelve months after Carlos Alcaraz had brought the curtain down on the gentlemen's singles competition in 2023 with his thrilling victory over Novak Djokovic, the 21-year-old Spaniard walked back on to the Centre Court stage as the 137th edition of The Championships got under way on an overcast but thankfully rain-free day.

Mark Lajal, Alcaraz's opponent, was one week younger than him, but there could hardly have been a greater contrast between the two men in terms of their achievements and experience. Lajal, ranked No.269 in the world, was making his Grand Slam debut and had only ever won two tour-level matches, neither of them on grass. Nevertheless, his three wins in Qualifying at Roehampton had demonstrated that he could not be taken lightly. The Estonian had actually won more matches on the surface in 2024 than his Centre Court opponent, though Alcaraz's second round defeat at The Queen's Club in his only build-up tournament had been understandable given his recent exertions, the Spaniard having just won his third Grand Slam title at Roland-Garros.

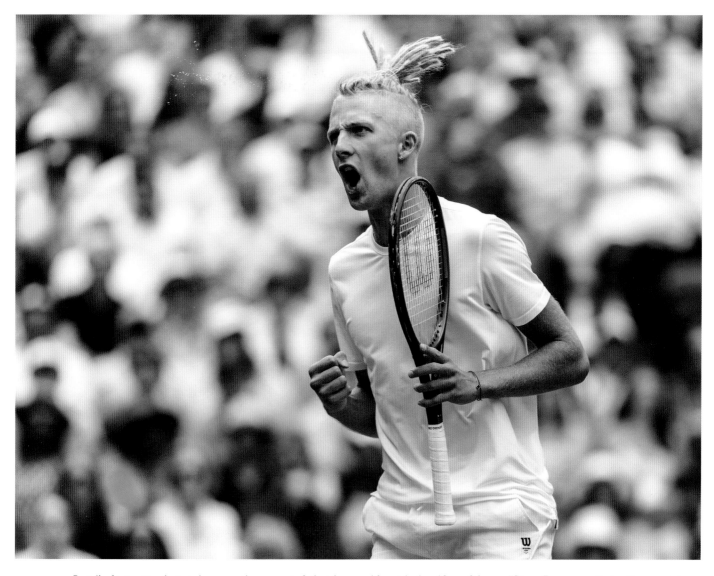

Lajal's distinctive hairstyle correctly suggested that he would not lack self-confidence. "Since I was little I've always been the white guy with the dreadlocks," he said after a match in which his flamboyant shot-making often had Alcaraz on the back foot. Lajal went a break up in both of the first two sets, but Alcaraz held firm to win 7-6(3), 7-5, 6-2 in two hours and 22 minutes. Alcaraz, who made as many unforced errors (28) as his opponent, admitted afterwards that he had been surprised at how well Lajal had played. "I still get nerves when I'm playing here," Alcaraz added. "I played for 45 minutes here on Thursday and it's the first time I've got nervous practising. I'm a privileged guy to play on this court. When I walk around here, I get goosebumps."

While Alcaraz safely negotiated his opening match, four other gentlemen's seeds fell at the first hurdle. Nicolas Jarry, the No.19 seed, had the misfortune to be pitted against Denis Shapovalov, whose position at No.121 in the world was a reflection of his recent injury issues rather than his talent. The 2021 Wimbledon semi-finalist won 6-1, 7-5, 6-4. Adrian Mannarino, the No.22 seed, might have had a similar sense of foreboding when he saw his own first round draw, having lost his previous four meetings with Gael Monfils. At the age of 37 (which was only one year older than Mannarino), Monfils beat his fellow Frenchman 6-4, 3-6, 7-5, 6-4. For the Argentinian clay court specialists Sebastian Baez (No.18 seed) and Mariano Navone (No.31), straight-sets defeats to Brandon Nakashima and Lorenzo Sonego respectively barely registered as surprises. Bigger upsets appeared on the cards when Frances Tiafoe and Alexander Bublik both went two sets down, but the former recovered to defeat Matteo Arnaldi 6-7(5), 2-6, 6-1, 6-3, 6-3, while the latter went on to beat Jakub Mensik 4-6, 6-7(2), 6-4, 6-4, 6-2.

Carlos Alcaraz and the Centre Court crowd would remember Lajal for much more than his hairstyle after the Estonian's spirited performance

Jannik Sinner, the top seed, survived a nasty tumble against Yannick Hanfmann but came through safely enough in four sets

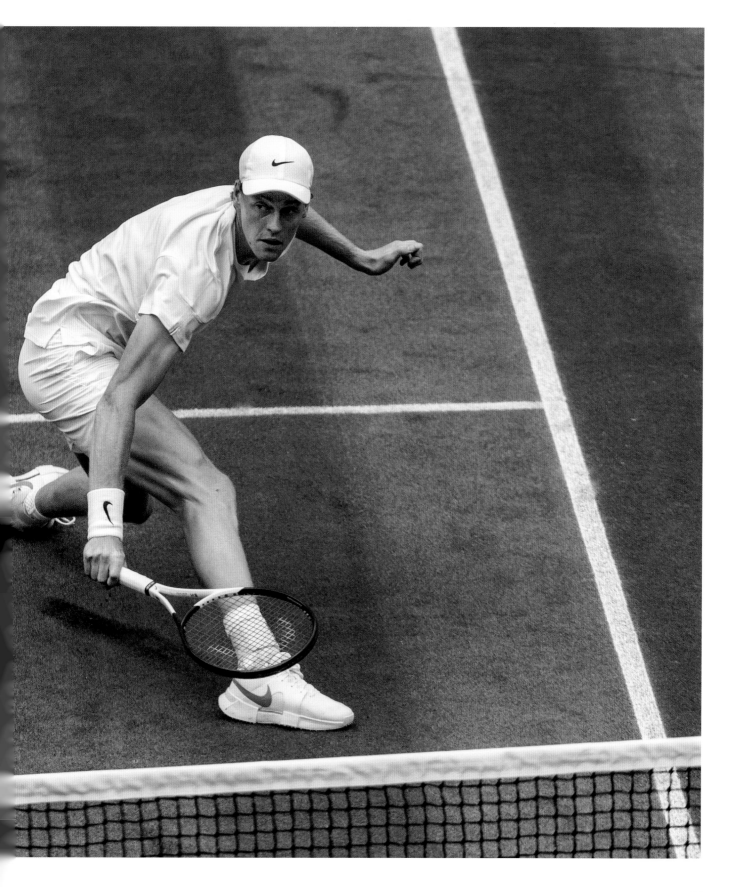

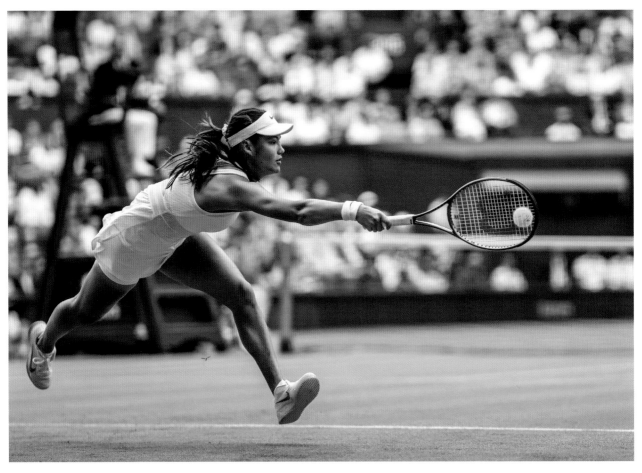

Clockwise from top: Emma Raducanu had to work hard for her win over Renata Zarazua; Naomi Osaka, at Wimbledon for the first time in five years, dropped a set against Diane Parry; Britain's Lily Miyazaki was delighted with her straight-sets win over Tamara Korpatsch

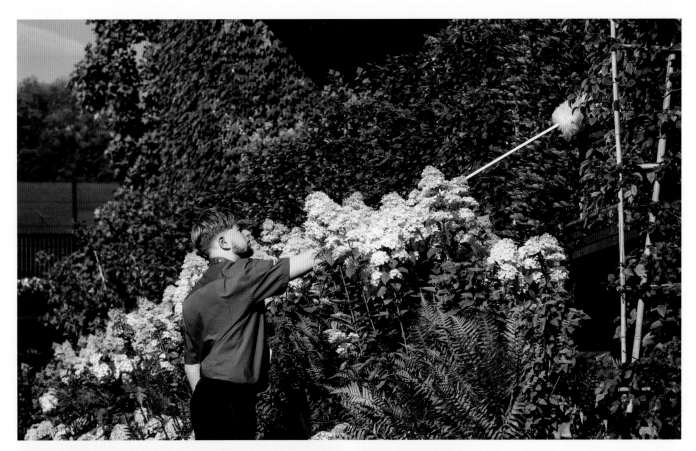

IT'S ALL IN THE DETAIL

It's the morning of Day 1 and the gates are yet to open. Within the Grounds, the last-minute preparations are in full swing. Nothing is left to chance: no blade of grass is left unattended (even if it means a final trim with scissors to make the sprinkler covers look perfect) and the courts are given their final wash and brush up. The statues are polished and the petunias are perfectly aligned. Even the fencing gets dusted. Everything must be perfect; only then can The Championships begin.

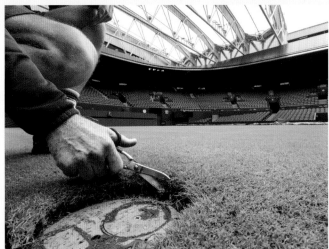

Daniil Medvedev was happy to open proceedings on No.1 Court, where he needed only an hour and 46 minutes to beat Aleksandar Kovacevic 6-3, 6-4, 6-2. "I've still never lost on No.1 Court, so hopefully I can play a lot more matches here," he said afterwards. Jannik Sinner wound up the day's play on No.1 Court but was less convincing. The Australian Open champion took the first two sets off Yannick Hanfmann with something to spare but lost the third after going 4-0 down, the legacy perhaps of a heavy fall. Sinner nevertheless recovered his poise and went on to win 6-3, 6-4, 3-6, 6-3.

Andy Murray, who was due to play his opening singles match on the second day, had said on the eve of The Championships that he expected to make a decision on whether he would be fit to take the court by the end of the opening day. However, the Scot deferred his decision until the following morning in order to give himself every chance of playing. Meanwhile four other players withdrew without striking a ball. Pablo Carreno Busta pulled out with his latest injury issue, having endured a difficult 18 months following elbow problems, while three seeds in the ladies' singles withdrew.

Aryna Sabalenka, the world No.3, would have been one of the favourites after reaching the semi-finals on her two most recent appearances at The Championships, but failed to recover from a shoulder injury sustained in the Berlin tournament a fortnight earlier. Victoria Azarenka, the No.16 seed, also withdrew because of a shoulder problem, while Ekaterina Alexandrova, the No.22 seed, pulled out because of illness.

Alexandrova had been due to face Britain's Emma Raducanu that afternoon on Centre Court, but her withdrawal gave a chance to Mexico's Renata Zarazua, who stepped in as a 'lucky loser' following her defeat in the final round of Qualifying. Zarazua, making her Championships debut, quickly impressed with her creativity and resilience in fighting back from an early break of serve. Raducanu, playing her first match at The Championships for two years after missing last summer following wrist and ankle surgery, was below her best, but gritted her teeth to win 7-6(0), 6-3. Afterwards Raducanu said she had taken inspiration from England's footballers and their uninspiring victory over Slovakia in the European Championship the previous evening. "For sure I sympathise with the players who are being told they need to play a lot better, need to play perfect," she said. "At the end of the day it's about getting over the line. Today I used it as motivation. It doesn't need to be beautiful, it doesn't need to be perfect. As long as you get through the opening rounds, you give yourself another chance to play better."

Four other British players – Liam Broady, Arthur Fery, Charles Broom and Heather Watson – were knocked out by higher-ranked opponents, but Sonay Kartal and Lily Miyazaki progressed with highly creditable victories. Kartal, who was the only home player to reach the main draw via Qualifying, knocked out the No.29 seed, Sorana Cirstea, winning the last 10 games to secure a 3-6, 6-2, 6-0 victory. It was the 22-year-old Briton's first win at Grand Slam level and rewarded her perseverance after health issues had contributed to her fall to No.298 in the world rankings. "I felt good this year coming through

RIGHT ON QUEUE

The Queue is unique to Wimbledon and this year it was given a makeover. Guests entered the welcome area, moved through to the 'purchase phase' to buy their tickets and then moved into the Queue Village. Here, the Official Partners of The Championships offered all kinds of activities and comestibles to make the queuing experience as much fun as possible. Emirates cabin crew handed out hot towels, the Stella Artois bar and evian stand kept guests fully refreshed and the Barclays big screen kept everyone up to date with the action.

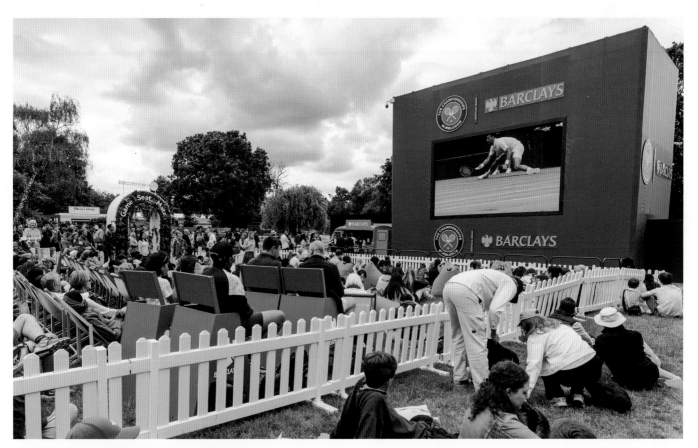

I ACED THE QUEUE AT WIMBLEDON

Far right: Brenda Fruhvirtova of the Czech Republic won a thrilling battle of the teenagers, beating Mirra Andreeva in a high-quality match

Right: Erika Andreeva, Mirra's older sister, was clearly giving it her all as she beat Emina Bektas in three hard-fought sets

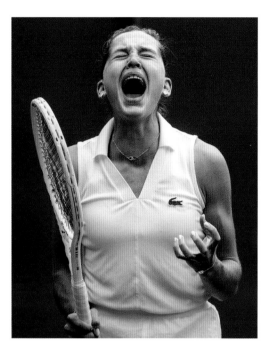

Qualifying," she said afterwards. "It really helped with my performance. It gave me extra confidence, having played the matches not that long ago. I think that really played a part in the win. It was my greatest and definitely my proudest day."

Miyazaki, aged 28, was born in Tokyo but moved to Britain as a child. She went on to play college tennis at the University of Oklahoma and has made steady progress since. Miyazaki won her first Grand Slam match at last year's US Open after coming through Qualifying and claimed her second here with a 6-2, 6-1 victory over Germany's Tamara Korpatsch, who as the world No.73 was ranked 75 places higher than her opponent. Miyazaki dropped only seven points on her serve and did not have to defend any break points. The win guaranteed that she would leave The Championships with a cheque for at least £93,000, which would double her total earnings for 2024.

Naomi Osaka marked her first match at The Championships for five years by beating France's Diane Parry on No.2 Court. Osaka, who returned to the tour earlier this year after a 15-month maternity break, has won four Grand Slam titles but has never gone beyond the third round at The Championships. The 26-year-old lost her way in the second set before completing a 6-1, 1-6, 6-4 victory. "I feel like these are the type of matches that you have to play just in order to ease into the tournament," she said afterwards.

The highest-ranked player to lose on the opening day was China's Zheng Qinwen, the No.8 seed, who had beaten Osaka in Berlin a fortnight earlier. Zheng, a quarter-finalist at the 2023 US Open and runner-up at this year's Australian Open, appeared to run out of steam against Lulu Sun, who won 4-6, 6-2, 6-4. Sun, a 23-year-old New Zealander who had come through Qualifying, looked the more comfortable player on the surface. Meanwhile Coco Gauff eased past her fellow American, Caroline Dolehide, winning 6-1, 6-2 in just 65 minutes on Centre Court.

Spectators who stayed late on Court 12 enjoyed a vision of the future as two 17-year-olds, Mirra Andreeva and Brenda Fruhvirtova, went toe-to-toe. Andreeva, who had reached the fourth round as a qualifier 12 months earlier and had just made the semi-finals at Roland-Garros, went a set and 3-0 up before Fruhvirtova launched a stunning comeback, despite having trouble with her breathing and having to leave the court for treatment. Combining resolute defence with astute variations of spin and pace, the Czech won 1-6, 6-3, 6-2. Asked how she had turned the contest around, Fruhvirtova said: "It's Wimbledon. I think everyone tries their best until the very end of the match. I just didn't want to give up."

DAILY DIARY **DAY 1**

Preparation is everything. After Iga Swiatek *(above)* won Roland-Garros she had not lost in 19 matches and three tournaments. She had had plenty of match play; now it was time to practice on the Wimbledon grass and hone her game on the surface. And after all that winning she also felt that she deserved a treat, so off to Liverpool she went to see Taylor Swift. But the plan almost backfired. Taylor gave her a handwritten note congratulating her on her French success. "I'm dead," Swiatek posted on social media, clutching the prized missive. However, any plans to go to a second gig were squashed by her team. "Basically, after this concert, [for] like three days after, I was so excited I couldn't sleep," she said. "We decided it's better to focus on the tournament."

• The first day. The excitement mounts. Wimbledon is in full swing. But while most of the attention was focused elsewhere – a certain C. Alcaraz was beginning the defence of his title – Lloyd Harris was having his moment in the sun. The 27-year-old South African qualifier came back from two sets down to beat America's Alex Michelsen 11-9 in the first match tie-break of The Championships. Match point was a rip-roaring 18-stroke rally which saw Harris fall twice at the back of the court before clinching victory with a forehand volley. He fell face first to the floor (intentionally this time) before doing a lap of honour and high-fiving everyone he could reach on Court 9. Wimbledon had begun.

• Emma Raducanu marched purposefully past Renata Zarazua and into the second round, although her progress was halted briefly – and not by the world No.98 from Mexico. A bird landed on Centre Court during the second set and stayed for a bit of sightseeing. Strolling around and seemingly revelling in the attention, it showed no sign of flapping off anytime soon. In the commentary box, Johanna Konta and Nick Mullins discussed what sort of bird it could be (with not a clue between them). The cameras immediately panned to Sir David Attenborough *(below)* sitting in the Royal Box. "Ah, he'd know," our intrepid commentators chirped. Sir David just gave a wry smile – he knows all about the pitfalls of working with animals on live TV.

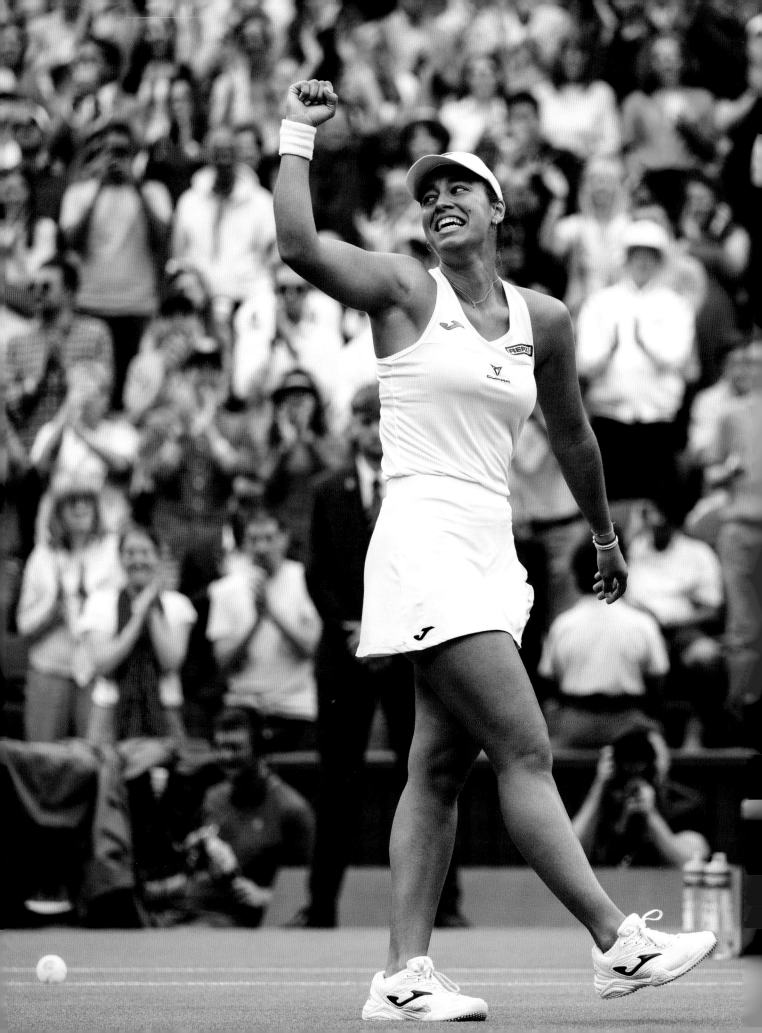

Choosing when to retire is often the most difficult decision players ever have to take, particularly when they have reached the pinnacle of their sport. Many choose to bring down the curtain on home territory at their favourite tournament; and if you can do so on a winning note, what better way to bid farewell?

Above: Andy Murray had run out of time. He had not recovered sufficiently from back surgery and he was withdrawing from the gentlemen's singles

Previous pages: She's done it: Jessica Bouzas Maneiro celebrates her victory over defending Ladies' Singles Champion Marketa Vondrousova

Most would surely love to bow out like Pete Sampras, who never played again after winning his 14th Grand Slam title at the US Open in 2002, or Ashleigh Barty, who played the final match of her competitive career when she won the Australian Open in 2022.

Given all his injury troubles, Andy Murray surely knew that he was never going to win a third gentlemen's singles title at The Championships 2024. However, he had still been aiming to end his Grand Slam singles career on the courts where he had enjoyed his greatest moments. For the previous six months the 37-year-old Scot had been asked at almost every press conference whether this would be his last year. In the build-up to The Championships he had finally revealed that he was aiming to make his final appearances at Wimbledon and the Olympics.

You would have thought that in the previous seven years Murray had endured enough pain – both physical and emotional – to last a professional lifetime, but fate had one last wicked hand to deal him. Competing at The Queen's Club a fortnight before Wimbledon, he had to retire five games into his second round match with a painful back problem that had been troubling him for a while. Nine days before the start of The Championships he underwent surgery on a spinal cyst.

Murray, whose recovery from hip resurfacing surgery had been one of the most remarkable comebacks in the history of tennis, did all he could to be fit in time for his opening singles match at Wimbledon, but on the morning of his scheduled encounter with Tomas Machac on Centre Court he finally admitted defeat, though he still aimed to play doubles with his brother, Jamie.

"I'm disappointed," Murray said on a day when the rain clouds over Wimbledon reflected his mood. "I wanted to have a chance to go out there and walk out on my own on the Centre Court again and give it another go. But I also was only going to do that if I felt like I could be competitive and I didn't feel like that today. I'm sorry for everyone that came and wanted to support and watch again. I wanted that moment as well, as much for me as the people who have supported me over the years: the fans but also my closest friends, family, my team. It was important for me to do that with them as well. It's one of those things. The timing was horrible. The surgery was a complex one and it wasn't to be."

Murray's withdrawal forced a symbolic change in the schedule. The match that replaced Murray's as the last of the day on Centre Court featured Jack Draper, Britain's best young male player at The Championships, who took on Elias Ymer, a Swedish qualifier. As if to underline the passing of the baton, 22-year-old Draper treated the crowd to the sort of five-set roller-coaster ride that had been Murray's trademark over the years. Draper's form hit peaks and troughs before he finally closed out a 3-6, 6-3, 6-3, 4-6, 6-3 victory. "You probably wanted to see Andy out here but you were stuck with me instead," Draper told the crowd in his post-match on-court interview. "I wouldn't be here without Andy. He's an incredible guy off the court, so funny, so genuine. One of a kind. What a competitor and what a champion."

Draper's next match would be against Cameron Norrie, his predecessor as British No.1, who put recent disappointments behind him to beat Argentina's Facundo Diaz Acosta 7-5, 7-5, 6-3. Another

Andy Murray's incredible singles career at Wimbledon is finally over as his name is removed from the draw

Briton, Jacob Fearnley, had an even more daunting challenge ahead after a 7-5, 6-4, 7-6(12) victory over Alejandro Moro Canas on Court 8 earned the 22-year-old wild card a second round meeting with Novak Djokovic. The seven-time Gentlemen's Singles Champion, looking in good shape in his first match since knee surgery just a month earlier, beat Czech qualifier Vit Kopriva 6-1, 6-2, 6-2 in under two hours on Centre Court. "I'd be lying if I said I wasn't watching the scores on Centre Court," Fearnley admitted afterwards. "It was getting in my head a little bit that I was going to have to play him. It's going to be a little bit intimidating, but it's a match that I'm super excited for. It's the biggest match of my career so far. Just to be able to share the court with a player like that will be really special."

Paul Jubb and Jan Choinski went close to providing further cheer for British supporters, but both lost in five sets. Jubb had a match point in the tie-break at the end of the third set against Thiago Seyboth Wild but lost 6-1, 6-3, 6-7(6), 4-6, 5-7, while Choinski was beaten 5-7, 6-4, 6-2, 5-7, 2-6 by Luciano Darderi. Two more Britons, Henry Searle and Billy Harris, lost in four sets to Marcos Giron and Jaume Munar respectively.

In the ladies' singles there were home wins for Katie Boulter and Harriet Dart, who beat Tatjana Maria and Bai Zhuoxuan respectively in straight sets, but Fran Jones struggled physically in losing to Petra Martic. Boulter's match was a fascinating clash of styles as the British No.1 countered Maria's spin with her impressive power. Maria led 4-1 in the first set after winning 10 points in a row, but Boulter held firm to win 7-6(6), 7-5. Dart won eight games in succession from 4-4 in the opening set to beat Bai 6-4, 6-0.

Opposite: Jack Draper took Andy Murray's teatime slot on Centre Court and filled the former champion's shoes in style with a five-set marathon win over Elias Ymer

Below: It wasn't just the weather making Paul Jubb look glum: he was on his way to a five-set defeat to Brazil's Thiago Seyboth Wild

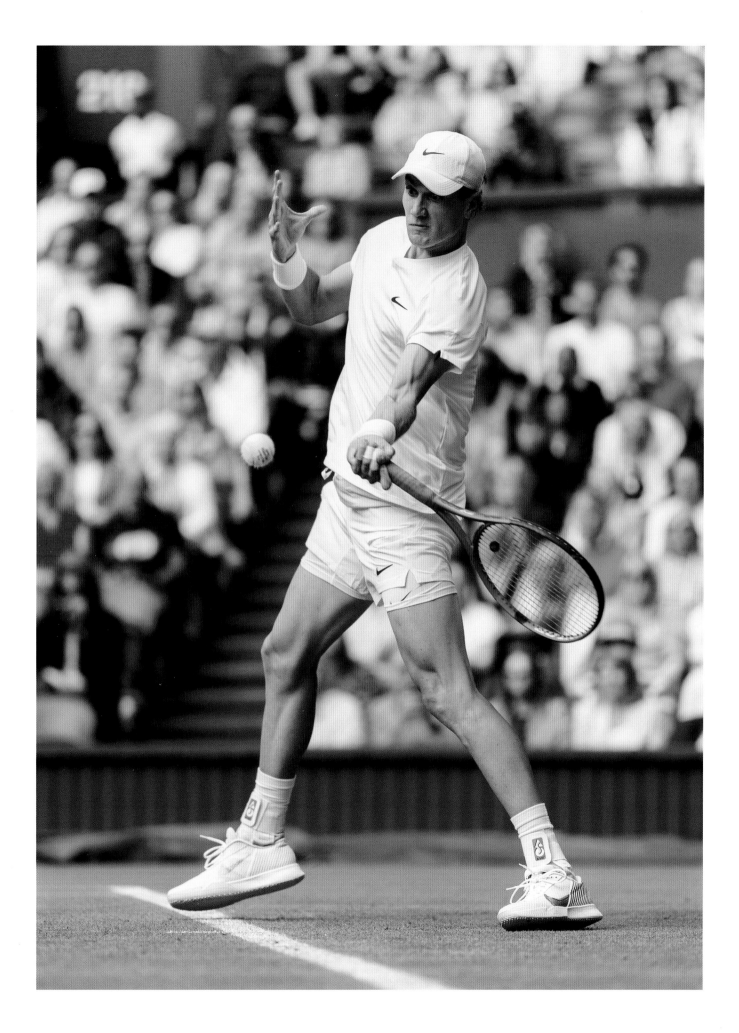

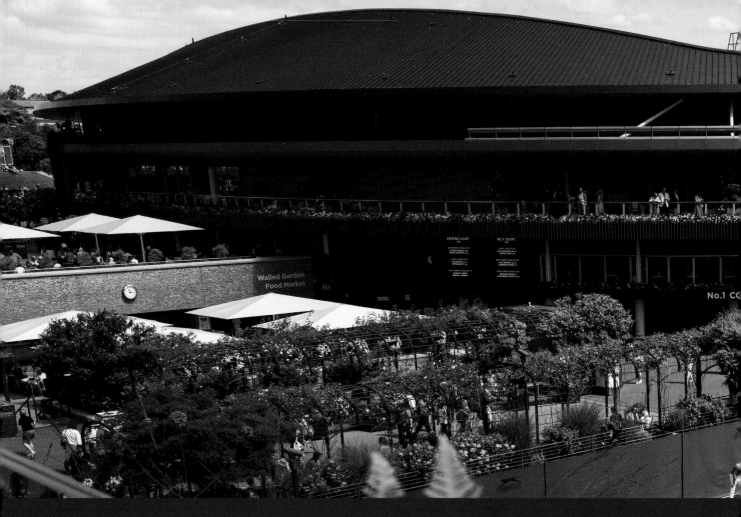

100 YEARS AT NUMBER ONE

—

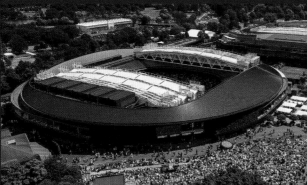

This year marks the centenary of No.1 Court, although looking at today's impressive, modern, high-tech structure, it is hard to imagine that it began life tucked under the west wing of Centre Court. Back in 1924, it was built to be the central focus of the National Hardcourt Championships. Then the plans were changed: the hardcourt event was moved elsewhere and No.1 Court was swiftly converted to grass in time for the start of that summer's Championships. French superstar Suzanne Lenglen played the first-ever ladies' match on the new court and won without dropping a game.

Over the decades, No.1 Court hosted the good and the great – it was the scene of John McEnroe's famous "You cannot be serious" moment – and it grew in size from its original 3,250 capacity (2,500 sitting) to just under 7,500. Much smaller than Centre Court, it had its own unique atmosphere and the eyeline from the seats in the lower tier of the east stand was only inches above the court surface – offering a real worm's-eye view of the action.

By the end of the 20th century, however, the old court was simply too small and – as part of the Club's Long Term Plan – work on the new No.1 Court began in 1994. Opened in 1997, the retractable roof and a further 1,000 seats were added by 2019, and nowadays No.1 Court holds 12,345 lucky ticket holders.

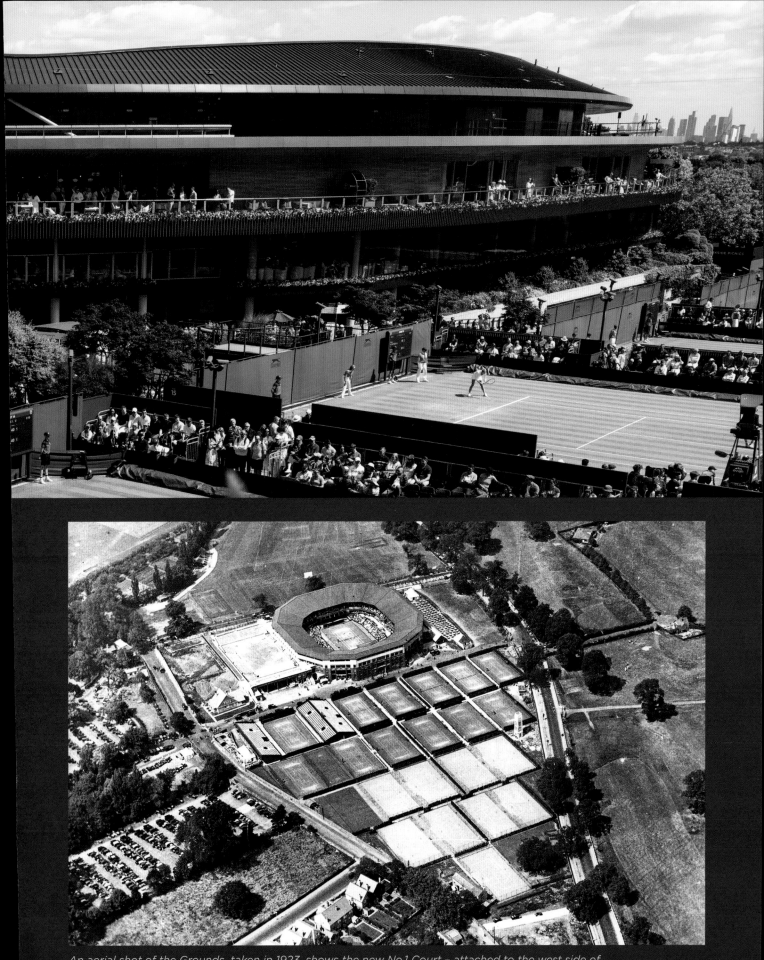

An aerial shot of the Grounds, taken in 1923, shows the new No.1 Court - attached to the west side of

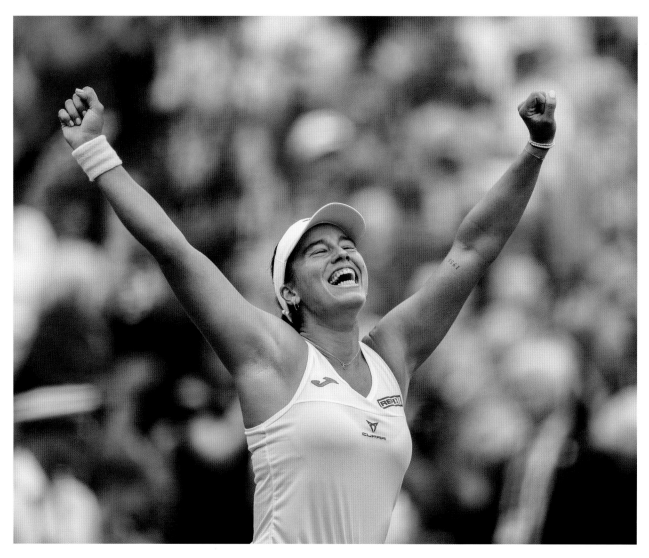

Above: Sheer delight radiates from the face of Jessica Bouzas Maneiro as she celebrates her victory over Marketa Vondrousova

Opposite: Vondrousova is clearly devastated in the post-match press conference. The defence of her ladies' singles title lasted just 67 minutes

As is the custom on the second day of The Championships, the opening match on Centre Court featured the defending Ladies' Singles Champion. Twelve months earlier Marketa Vondrousova had become the first unseeded player to win the title. The Czech looked to have been handed a reasonable draw against Spain's Jessica Bouzas Maneiro, but the 21-year-old Spaniard, who had never previously won a Grand Slam match and had only one tour-level win to her name in 2024, sprang a major surprise, winning 6-4, 6-2 in just 67 minutes. Steffi Graf, who lost to Lori McNeil in 1994, is the only other defending Ladies' Singles Champion to have lost in the first round.

Vondrousova, who had retired with a hip injury in the second round of her only warm-up grass court tournament a fortnight earlier, never recovered after hitting three double faults in the opening game. "I was really nervous," she admitted afterwards. "I was a bit scared because of my leg, too, but I don't think that was the reason. I felt nervous from the start. She also played a good match. Overall it was very tough. It's tough feelings to go back. I feel like everybody just expects you to win." Bouzas Maneiro said she had felt no pressure and had been able to play freely. "This is one of the most important moments of my life, in my career, here on this court," she said. "This is the most beautiful tournament I ever played."

On a day when the bad weather limited play on the outside courts, Jessica Pegula was the only early starter to finish her work before the rain came. The No.5 seed needed just 49 minutes to beat Ashlyn Krueger 6-2, 6-0. Caroline Wozniacki, playing her first match at The Championships for five years,

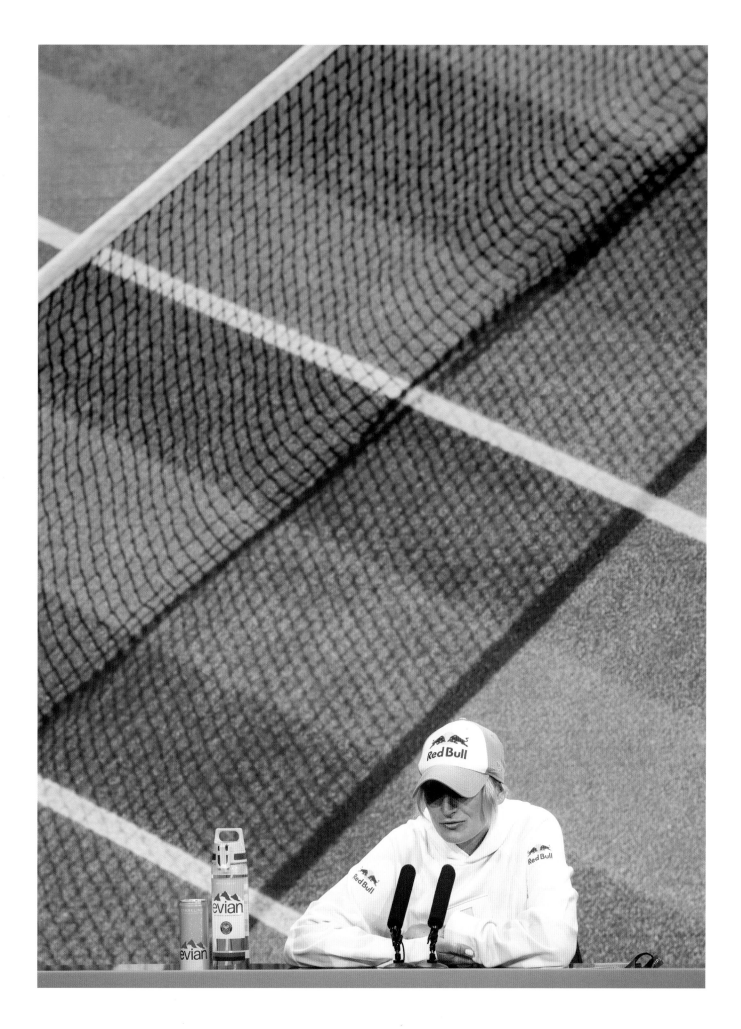

Here comes the rain again. Brollies, cagoules and covered courts are the order of the day

crushed Alycia Parks by the same margin in only 53 minutes, but Angelique Kerber, another returning mother, was beaten 5-7, 3-6 by Yulia Putintseva. Elena Rybakina, the 2022 Ladies' Singles Champion, needed just 71 minutes to beat Elena-Gabriela Ruse 6-3, 6-1, while Iga Swiatek, fresh from her latest triumph at Roland-Garros, beat Sofia Kenin, the 2020 Australian Open champion, 6-3, 6-4.

As if the rain was not enough, Sebastian Korda, the No.20 seed, had to contend with a whirlwind on Court 16 in the shape of Giovanni Mpetshi Perricard, a 6ft 8in Frenchman with a huge serve. The world No.58, who came through Qualifying, cracked 51 aces in his 7-6(5), 6-7(4), 7-6(6), 6-7(4), 6-3 victory to become only the seventh man in history to hit 50 or more aces in a match. Korda failed to convert any of his 11 break points, while Mpetshi Perricard made the only break of serve in the second game of the decider.

The frustrations of those who had their matches delayed or did not even get on court were understandable, but the unhappiest player of the day was surely Andrey Rublev. He was beaten 4-6, 7-5, 2-6, 6-7(5) by the world No.122, Francisco Comesana, who was playing his first match at Grand Slam level. Rublev lost his temper on several occasions and berated his courtside coaching team, but the No.6 seed reserved his greatest admonishments for himself. In the third set he hit his knee repeatedly with his racket, drawing blood. Rublev said later that he had done so because he was aware of the need not to hurl his racket to the ground because it might damage the grass. "I couldn't take it any more," he said. "I needed to let my emotions out." However, he admitted: "I could do much better. This is not the way."

Why me? Why this? Why now? Andrey Rublev, the No.6 seed, loses in four frustrating and furious sets to Francisco Comesana of Argentina

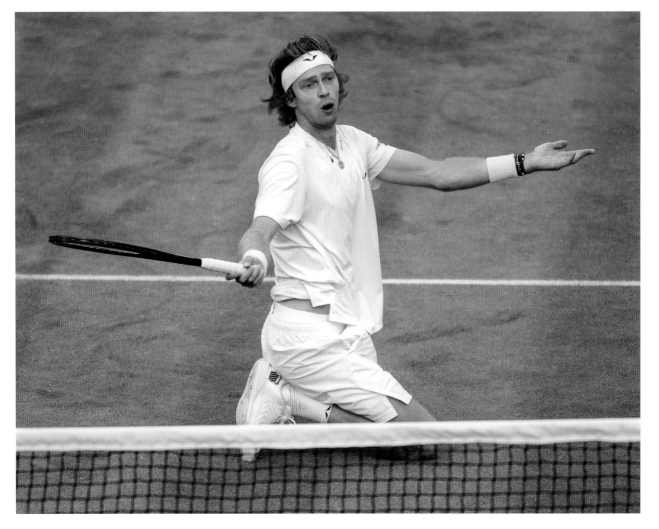

DAILY DIARY **DAY 2**

There was no need for *Singing in the Rain* on Centre Court despite the weather because of the ever-handy roof. This was a bit of a shame, really, because Dave Grohl *(above, right)* of the Foo Fighters and Nirvana and Simon Le Bon of Duran Duran were two of the invited guests in the Royal Box. A brief remix of some of their hits would have made a great accompaniment to action on court: *Wild Boys* as Messrs Draper, Ymer, Djokovic and Kopriva flung themselves around the court; *This is a Call* (out, fault or let...) as someone fluffed a shot; or perhaps *The Reflex* as a volley was punched away. For Marketa Vondrousova, it was very much a case of *Lonely in Your Nightmare* as the pressure of being the defending champion undermined her and she went out in straight sets.

• Jessica Pegula had enjoyed an impressive escape. No, not in her first round win over Ashlyn Kruger but, rather, in her warm-up for The Championships. At a loose end one day, she and her team tried their hands at an escape room in nearby Kingston. "We actually crushed it," she said. "Maybe I'll go do another one tonight to keep the momentum." Well, with the weather forecast predicting yet more rain, she might have some time to kill...

• Could it be? No, surely not? Crikey, it is. Yes, it really was Ronnie O'Sullivan – alongside his daughter, Lily – sitting by Novak Djokovic's team in the players' box as the Serb opened his campaign against Vit Kopriva. The seven-time world champion has long been an admirer of Djokovic and the respect is clearly reciprocated. "I watch snooker just because of him," Djokovic said, before admitting to a rare sporting weakness. "Hopefully we're able to play some snooker because I'm really bad." He was not alone in revealing his sporting Achilles' heel: Carlos Alcaraz *(right, putting in unorthodox fashion with golf pro Paul McGinley)* tried to relax between matches by playing golf at the Royal Wimbledon Club. "This is a sport that I love to play," he revealed, "but the ball never goes straight."

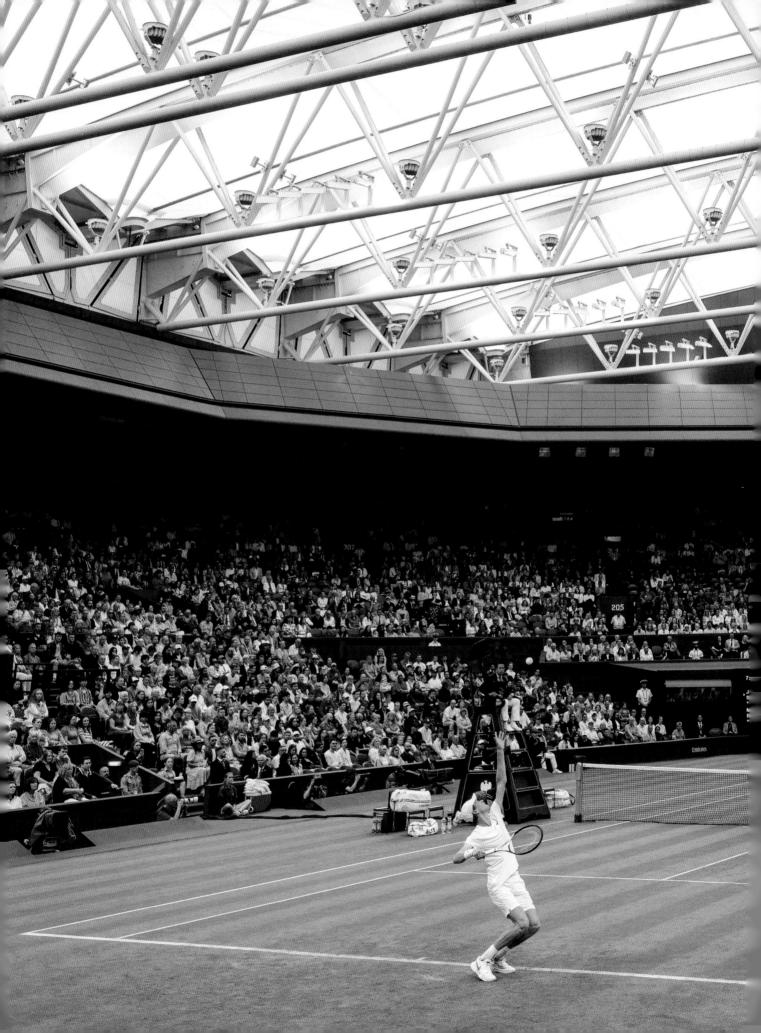

DAY 3 –

WEDNESDAY 3 JULY

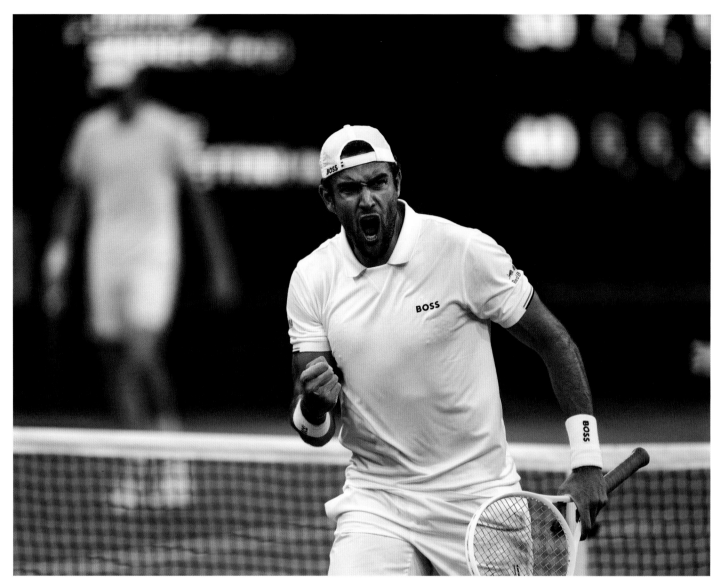

W hen he arrived at the All England Club last summer Jannik Sinner was ranked No.8 in the world, had never gone beyond the quarter-finals of a Grand Slam tournament and had yet to win a Masters 1000 title. Everyone had talked about his great potential, but when would it be realised?

Above: Matteo Berrettini, the 2021 finalist, had been in excellent form in recent months. Could he oust the top seed on Centre Court?

Previous pages: Italy takes centre stage as Berrettini and Sinner go toe-to-toe in an epic match

Looking back, it was The Championships 2023 that put the Italian on a path that would transform his fortunes over the next 12 months. After reaching the Wimbledon semi-finals, he won the Toronto Masters 1000 in August, led Italy to Davis Cup glory in December and won the Australian Open in January. Between November 2023 and January 2024 he also beat Novak Djokovic, the world No.1, three times. Having also reached the semi-finals at Roland-Garros in June, Sinner stood at the top of the world order, one place above Carlos Alcaraz, with whom he was building a formidable rivalry.

Alcaraz had gone 5-4 up in their head-to-head record following his five-set victory over Sinner in the semi-finals in Paris, but the Spaniard could not be certain that he would have the edge if they met on grass, despite his Wimbledon title triumph in 2023. Sinner had won their only previous meeting on the surface at The Championships 2022 and had just underlined his grass court prowess by winning the title at Halle.

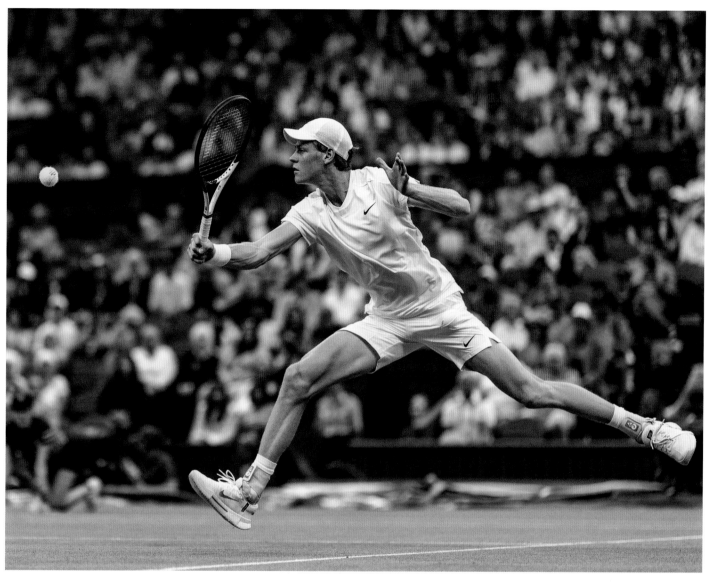

Now, in the second round here, Sinner faced a major challenge in the shape of his compatriot Matteo Berrettini, who had been runner-up to Djokovic at The Championships 2021 and had twice won the title at The Queen's Club. The former world No.6 had slipped down the world rankings because of injury issues, but a recent run to the grass court final in Stuttgart suggested that he was back on an upward curve.

On another day of rain interruptions, the match was played under the Centre Court roof, which amplified the firecracker sound of the ball-striking by the two men. It was not a match for the faint-hearted. Berrettini hit more aces (28 to his opponent's 10) and more winners (65 to 32) but also made more unforced errors (48 to 25) as Sinner closed out a 7-6(3), 7-6(4), 2-6, 7-6(4) victory after three hours and 42 minutes. With the 11pm curfew rapidly approaching, the match would have gone into a second day if Berrettini had won the tie-break at the end of the fourth set. "It was very tough to face Matteo in the second round in such an important tournament," Sinner said afterwards. "We both played well and in the three tie-breaks I got a bit lucky."

There was already talk of a potential semi-final showdown between Sinner and Alcaraz, though both men knew it was much too early to consider such a prospect. Alcaraz won in straight sets for the second round in a row, but the defending champion again struggled to find his best form in the early stages of his 7-6(5), 6-2, 6-2 victory over Australia's Aleksandar Vukic. The world No.69 served for the opening set at 6-5, only for Alcaraz to break back and then win the tie-break, after which he played with growing confidence. "I'm really happy about my performance," he said afterwards. "In the second set and third set I played at a really high level."

Jannik Sinner finally got his way in the three tie-breaks as the clocked ticked towards the 11pm curfew

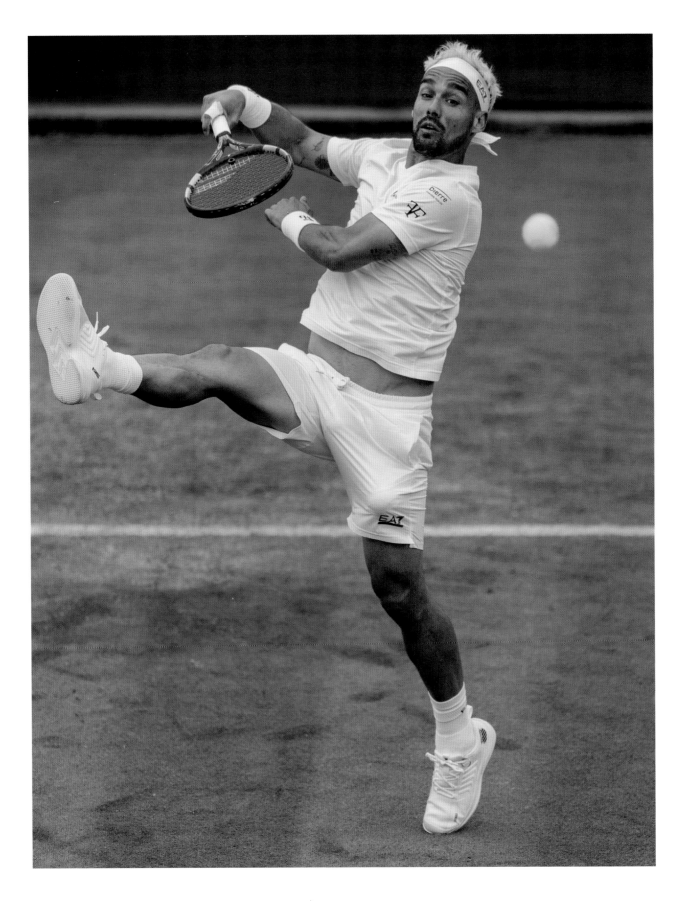

Daniil Medvedev recovered from the loss of the first set against Alexandre Muller to win the next three, but Casper Ruud's grass court woes continued. The No.8 seed, who had played in three Grand Slam finals but had never gone beyond the second round at The Championships, was beaten 4-6, 5-7, 7-6(1), 3-6 by 37-year-old Fabio Fognini, who would have won even more comfortably but for a remarkable turnaround in the third set, which he lost after leading 5-2 and going 0-30 up on the Norwegian's serve.

Felix Auger-Aliassime, the No.17 seed, also went out after a swashbuckling comeback by Thanasi Kokkinakis, who recovered from two sets down and saved four match points before winning 4-6, 5-7, 7-6(9), 6-4, 6-4. All three of the Australian's matches at Roland-Garros had also gone to five sets. Tomas Machac completed an even more stunning fightback when he beat David Goffin 3-6, 3-6, 6-4, 6-1, 7-6(5) in a match spread over two days. Goffin led 3-1 in the third set and was 5-0 up in the fifth but tired in the closing stages. "Sometimes tennis is very tough," the Belgian said afterwards. Dan Evans might have echoed that sentiment after the 34-year-old Briton, his right knee heavily strapped, went down in straight sets to Alejandro Tabilo.

The day had begun with the headline-grabbing news that Andy Murray and Emma Raducanu would be playing together in the mixed doubles. Murray – who was also entered in the gentlemen's doubles with his brother, Jamie, but had pulled out of the singles – had decided the previous evening to play in the mixed and put Raducanu at the top of his wish list for a partner. Raducanu said it had taken her "literally like 10 seconds" to accept his invitation. "I think some things are a once-in-a-lifetime memory that you're going to have for the rest of your life," she said.

Raducanu has had limited experience in doubles. If she wanted to learn more about doubles play she might have looked no further than her next opponent in singles, Elise Mertens, who topped the world doubles rankings. The 28-year-old Belgian is a good singles player too, with eight titles to her name. At No.33 in the singles rankings, she sat 102 places above Raducanu, who was still rebuilding her

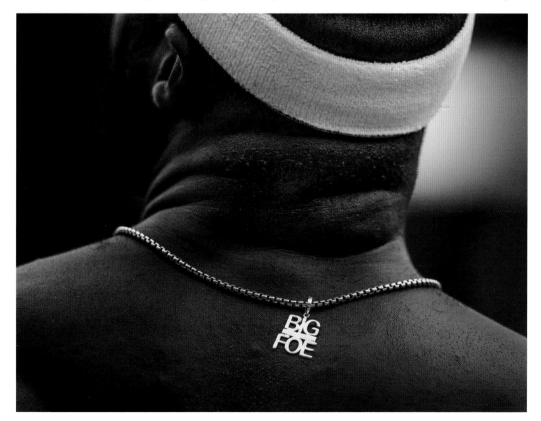

Left: Frances Tiafoe, known as 'Big Foe' to his friends, moved past Borna Coric in straight sets

Opposite: They say that blondes have more fun – Fabio Fognini was certainly having a great time as he rolled back the years on No.2 Court

MUM'S THE WORD

—

Motherhood is a demanding job at the best of times – and the best of times is usually not during a Grand Slam championship when the mother in question is trying to beat the finest players in the world. Yet more and more players are finding a way to combine family life with top level sport.

It helps enormously that Wimbledon, like the other three Grand Slam events, offers creche facilities but, even so, there are many times during the day when only Mum will do for the little ones.

Tatjana Maria *(pictured above)* knows all of this only too well. She and her husband Charles travel the world with their two daughters Charlotte, 10 *(above, right)*, and Cecilia, two. Charles is a busy man: he coaches both Tatjana and Charlotte. And it is Charlotte's budding tennis career that is keeping the 36-year-old mum on tour. "My goal would be to play doubles with Charlotte," Maria said. "She practises every day and I practise with her. I'm her sparring partner. It's her dream to play at Wimbledon one day."

Caroline Wozniacki retired in January 2020 and started a family *(left)*, but the lure of competition pulled her back. Now three-year-old Olivia and 21-month-old James are getting used to life on the road. Naomi Osaka *(right, top)* had her daughter Shai last July and Angelique Kerber *(right, below)* had her daughter, Liana, last February. Both former Grand Slam champions have been back on tour since the start of the year. While they are still fit enough to compete all these mothers want to pursue their goals. And now their children come with them as they do it.

Right: Britain's Sonay Kartal had come through Qualifying and was now in the third round, having beaten Clara Burel (and the rain) to set up an appointment with Coco Gauff

Opposite: Emma Raducanu dropped a miserly three games as she raced past Elise Mertens

career after missing the last eight months of 2023 following ankle and wrist surgery. The 21-year-old Briton had decided to skip Roland-Garros in order to focus on her grass court game, which was looking in decent shape after she made the semi-finals in Nottingham and the quarter-finals in Eastbourne, where she had beaten a top 10 player, Jessica Pegula, for the first time in her career.

It says everything about Raducanu's struggles in the wake of her extraordinary US Open triumph in 2021 that she had not gone beyond the second round in any of the six Grand Slam tournaments she had played subsequently. That might have explained her exuberant displays of emotion as she swept Mertens aside under the No.1 Court roof, winning 6-1, 6-2 with a formidable display of ball-striking. Fist-pumping after almost every winner, Raducanu won five games before Mertens could get on the board and completed her victory in just 75 minutes. "I'm super pleased with that performance," Raducanu said at her post-match press conference, where her focus on her tennis became apparent when she was asked when she would be casting her vote in the following day's General Election. "I didn't even know it was tomorrow, to be honest," she smiled. "Thanks for letting me know."

Raducanu would be joined in the third round by her childhood friend and rival, Sonay Kartal, who became the first British female qualifier to reach the last 32 since Karen Cross in 1997. Kartal, the world No.298, beat France's Clara Burel 6-3, 5-7, 6-3 in a rain-disrupted match on No.3 Court. The 22-year-old Briton went a set and 3-0 up before Burel won seven of the next nine games to level the

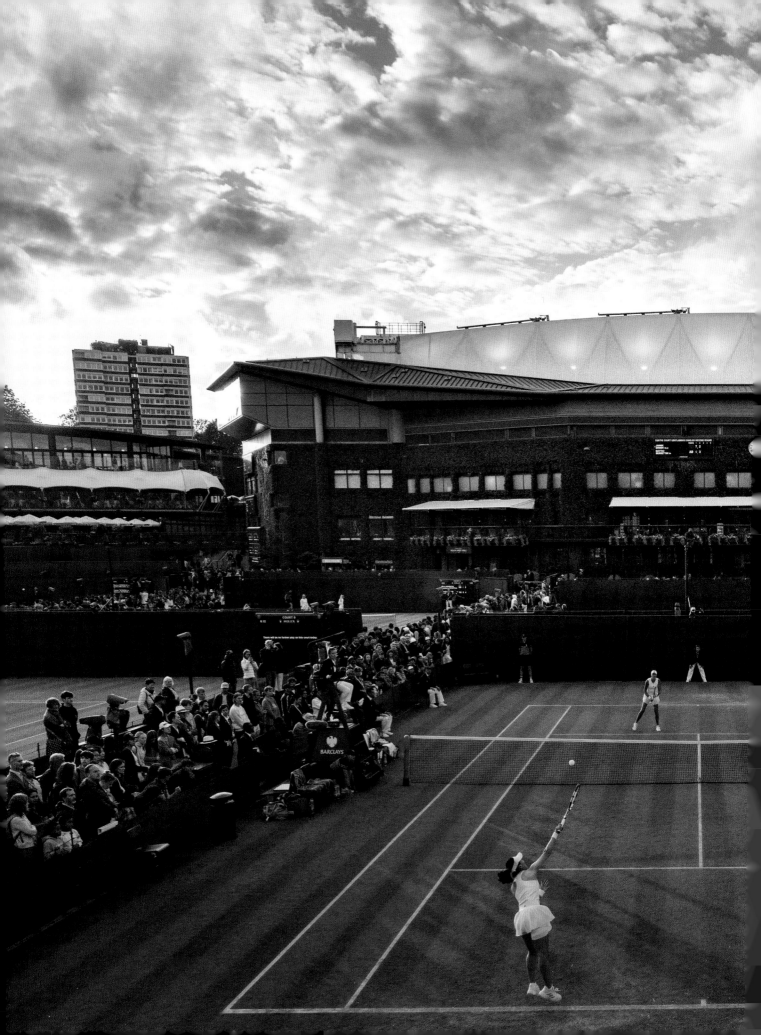

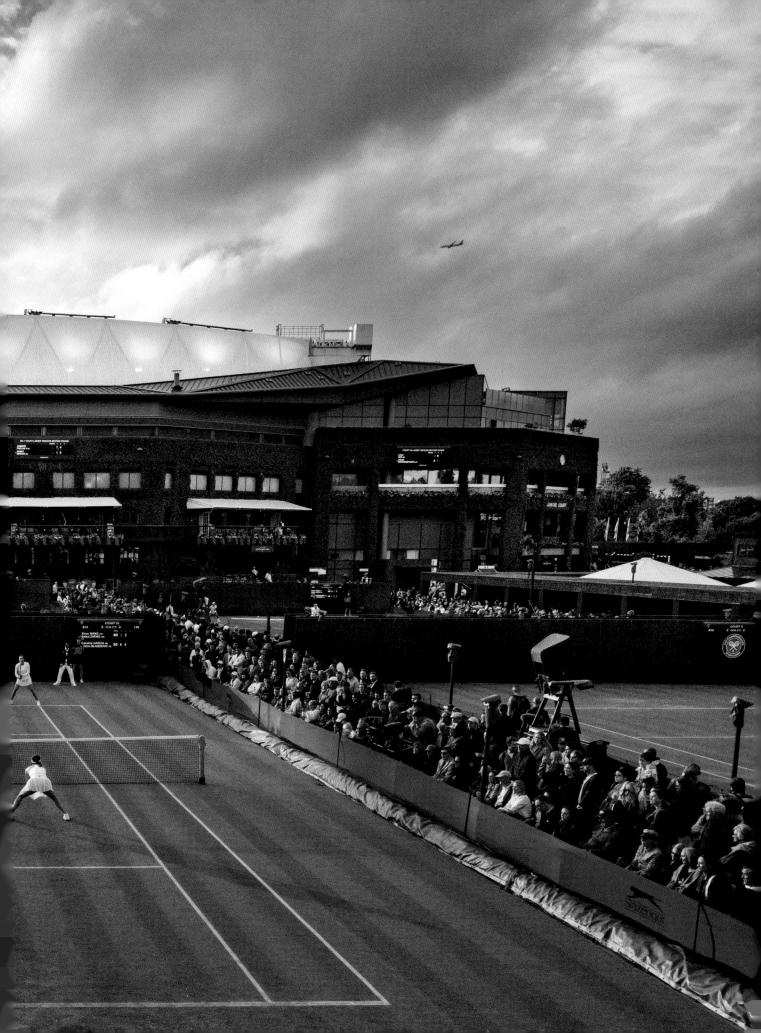

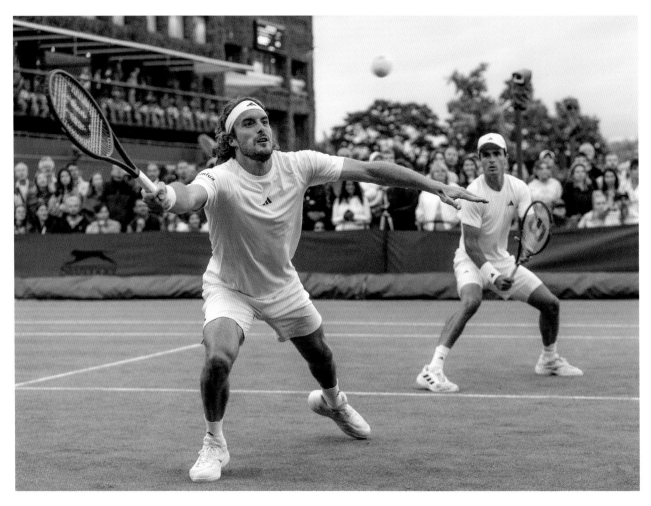

Above Brothers in arms: Stefanos and Petros Tsitsipas were a set down and 3-3 in the second set when play was called for the day

Previous pages: The French team of Caroline Garcia and Kristina Mladenovic on their way to victory against China's Wang Xinyu and Zheng Saisai

match, but Kartal made the decisive move in the decider by breaking serve in the fifth game. Kartal's next opponent would be Coco Gauff, who needed only 66 minutes to beat Anca Todoni, a Romanian qualifier, 6-2, 6-1 on No.1 Court.

Naomi Osaka's Wimbledon return ended in a sobering 4-6, 1-6 defeat on Centre Court to Emma Navarro, a 23-year-old American with a rapidly growing reputation. After finding her feet on clay at Roland-Garros, where she had gone within one point of ending Iga Swiatek's quest for a fourth Paris title, Osaka had been hoping to make similar progress on another surface she has found challenging, but Navarro was too hot to handle. "I didn't feel fully confident in myself," Osaka admitted afterwards. "Those doubts started trickling into my game a lot. I don't know why those thoughts were so prevalent." The 26-year-old Japanese added with a smile: "I do know that my last clay court match was really good, so I might end up liking that surface a lot more than grass now."

Jasmine Paolini had proved her own love of clay by reaching the final at Roland-Garros less than four weeks earlier, but the 28-year-old Italian showed that she was also developing a liking for grass when she beat Greet Minnen 7-6(5), 6-2.

Because of the rain disruptions, some players reached the third round before others had completed their opening matches. Barbora Krejcikova and Elina Svitolina were among those who were kept waiting and both struggled to make it over the first hurdle. Krejcikova eventually beat Veronika Kudermetova 7-6(4), 6-7(1), 7-5 in a desperately tight encounter on Court 15 that lasted three and a quarter hours, while Svitolina toiled for two hours and 38 minutes on Court 17 before beating Magda Linette 7-5, 6-7(9), 6-3.

DAILY DIARY DAY 3

I t is 20 years since Maria Sharapova *(above)* beat Serena Williams to lift the Venus Rosewater Dish. Much has changed in those two decades (she now has a 23-month-old son, Theodore) but to her, it still feels like yesterday. Invited to sit in the Royal Box, she reminisced before play started. "There's a sense of royalty about this entire place, so I was completely surprised by the way I handled the moment," she said. "It was the jump start of my career and a moment that I will forever remember. I felt fearless that day."

• Romeo Beckham is following in his father's footsteps – and not just because he is a professional footballer. David Beckham's second son was there on No.1 Court to cheer on Emma Raducanu's every winner (just as his father had done – admittedly from the Royal Box on Centre Court – on the opening day) as she dispatched Elise Mertens on Day 3. David brought his mother, Sandra, on Monday; the Beckham family clearly love their tennis. But they were not the only family settling in for a day of drama and excitement: Robert and Lynette Federer had brought their twin grandsons, Leo and Lenny, to watch Coco Gauff beat Anca Todoni. And, being a proud grandmother, Lynette took a couple of snaps of the boys on the famous court during the change of ends, as any grandma would.

• Just because you are one of the best players on the planet, it doesn't necessarily mean you can count. Daniil Medvedev *(left)* was being given a thorough workout by Alexandre Muller on Centre Court and was trailing 6-3 in the first set tie-break when he walked to his chair and sat down. "I went a little crazy," Medvedev explained. "I thought the set was gone. I heard the referee talking to me. At one moment I start hearing, 'Daniil, it's 6-3, 6-3.' I'm like, 'What are you talking about?' Then I see the score. Don't know if it ever happened to me before. I thought in my head, 'OK, maybe that's my second chance to win it.' Then I lost the point." All was well in the end – Medvedev won in four sets.

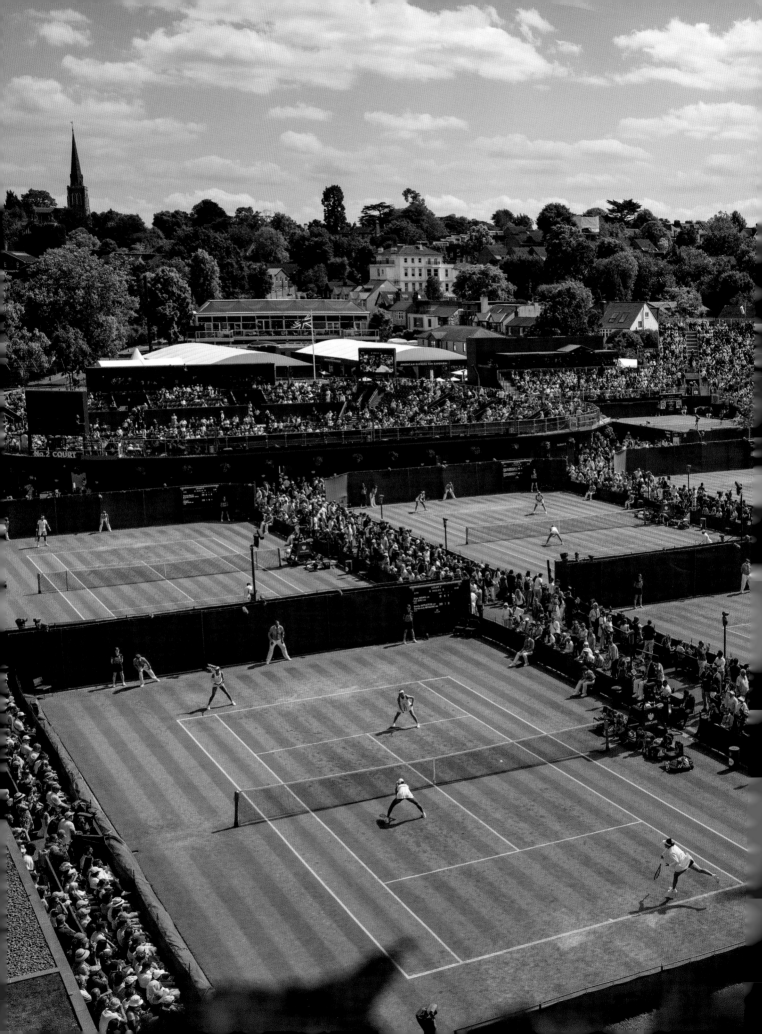

D ecision day had arrived and it was time for the British public to choose who they were going to support. Rishi Sunak or Sir Keir Starmer? Jack Draper or Cameron Norrie? Katie Boulter or Harriet Dart? It seemed appropriate that the General Election fell on a day when home players would be the focus of significant attention at The Championships.

Above: Katie Boulter described it as "a tough day at the office" after she lost her early lead to compatriot Harriet Dart

Previous pages: Sunshine at last. All the outside courts were in action and there was not an umbrella to be seen

By a neat quirk of fate, the British No.1 and No.2 were meeting in the second round of both the gentlemen's and ladies' singles, with Draper taking on Norrie and Boulter facing Dart. Meanwhile another Briton, 22-year-old Jacob Fearnley, playing in his first Grand Slam tournament, would be taking on Novak Djokovic, the seven-time Gentlemen's Singles Champion, in the opening match on Centre Court, where the day would end with Andy and Jamie Murray playing doubles. By the end of that match we might also know how the Sunak-Starmer head-to-head was shaping up.

With the sun shining at last, it would certainly be a day for Britons to remember, though it did not get off to the best of starts as Lily Miyazaki was beaten 0-6, 0-6 in just 50 minutes by Daria Kasatkina in the opening match on Court 18. Focus quickly shifted to the first all-British clash on No.1 Court, where Boulter was hoping to build on the best spell of her career, which had seen her climb into the world's top 30. Having finally overcome the physical issues which had dogged her early years on the tour, the 27-year-old from Leicester had won three WTA titles in the previous 13 months. She had also come out on top in her last three matches against 27-year-old Dart, who had just dropped out of the world's top 100.

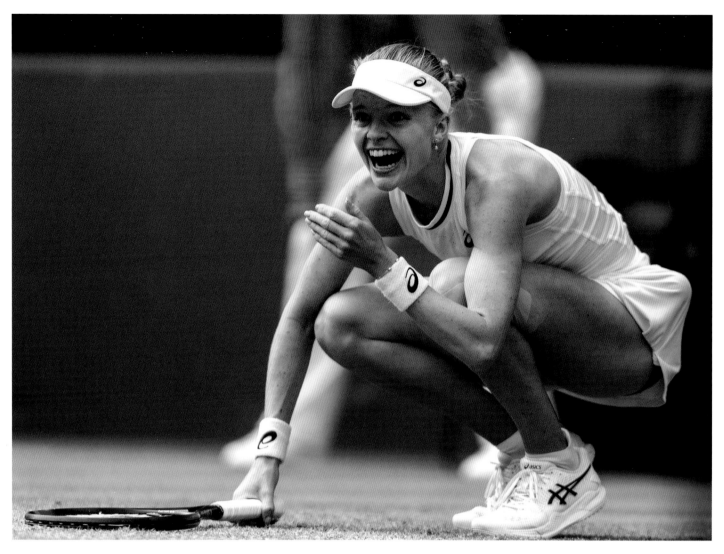

With so much at stake, it was no surprise that it was a tense and emotional match littered with mistakes as both women struggled to find consistency. Boulter set the early pace, but Dart fought back doggedly, particularly in the deciding tie-break, and eventually won 4-6, 6-1, 7-6(8) in just under three hours. The match featured 110 unforced errors, including 75 by Boulter, who admitted afterwards: "I just had a tough day at the office. Not my best tennis today unfortunately, but it's what happens sometimes. I've just got to take it on the chin."

Dart looked the better player for most of the second and third sets but let slip a 4-2 lead in the decider and was in tears when she went 6-2 down in the deciding first-to-10-points tie-break. Boulter, however, was unable to drive home her advantage and eventually lost the match with two successive unforced forehand errors. "I always knew it was going to be tough," Dart said afterwards. "I wear my emotions on my sleeve, so you see everything how I'm thinking unfortunately. This is massive for me, surreal." The win took the Londoner into the third round for the second time in her career. With Emma Raducanu and Sonay Kartal already through, it meant the home nation would have three players in the last 32 of the ladies' singles for the first time in 40 years.

For the second leg in the battle of Britain, played on the same court, it was again the current No.1 who started as the clear favourite. Draper, the world No.28, had long been regarded as the country's best male prospect. Now that he had put a number of physical issues behind him, the 22-year-old was starting to realise his great potential. He arrived at The Championships having just won his first ATP title in the Stuttgart grass court event and beaten Carlos Alcaraz, no less, at The Queen's Club. Norrie, in contrast, had been having a difficult time. The 28-year-old former world No.8 had dropped to No.42 in the rankings, having failed to win two matches in a row since April.

Above: Harriet Dart's emotions were plain for all to see – tears, smiles, grimaces – but finally she had found a way to win. That was all that mattered

Following pages: At last Dart could relax and enjoy her success as the No.1 Court crowd gave her a standing ovation

Above: Jack Draper, Britain's top male player, had his chances but could not find a way through the brick wall of Cameron Norrie's defence

Opposite: Norrie shows just what winning the Battle of Britain meant to him. The home country's No.2 had just edged the No.1

It was another tense affair, but after a tight opening set in which neither player had a break point it was Norrie who made the decisive move, winning five points in a row as he went on to take the tie-break 7-3. Norrie took the second set after racing into a 4-0 lead and held his nerve when Draper went 5-2 up in the third. After winning 10 points in a row to level the score at 5-5, Norrie went on to close out a 7-6(3), 6-4, 7-6(6) victory.

"It was not easy coming out here today to play Jack," Norrie said afterwards. "He's been playing so well and we're such good friends off the court. We had to put that aside today. I felt like I was a little bit of the underdog, so I was pretty relaxed coming in today." Draper thought that practising regularly with Norrie might have given his opponent an advantage. "We know each other so well that sometimes he can almost take away what I'm good at," Draper said. "I feel like when we were playing, he knew all my patterns of play."

There had been no doubting who the underdog was in the day's opening match on Centre Court as Fearnley took on Djokovic. The Briton had just played his first match at a Grand Slam tournament, while the Serb had just played his 371st singles match, more than any other man or woman in history. Fearnley, who had beaten both Carlos Alcaraz and Jannik Sinner in his junior career, spent five years playing college tennis at Texas Christian University and had never appeared on the main tour until the week before The Championships. The Edinburgh-born Scot had earned his Wimbledon wild card by winning a Challenger grass court tournament at Nottingham in mid-June, a result that had taken him from No.525 in the world rankings to No.274.

Fearnley, nevertheless, showed few signs of nerves. He hit more winners than Djokovic (42 to 34) and showed his all-round qualities both from the back of the court and at the net. He won his opening service game to love with a 121mph ace and got to 3-3 in both of the first two sets before Djokovic put his foot on the accelerator. Growing in confidence, Fearnley broke serve twice to take the third set and led 5-4 in the fourth before the world No.2 took control to complete a 6-3, 6-4, 5-7, 7-5 victory. "I was playing the greatest tennis player of all time on Centre Court, Wimbledon, so it's very difficult to be too disappointed," Fearnley said afterwards. Djokovic said that his opponent had "put in a great effort and played very good tennis".

Elsewhere, Stefanos Tsitsipas' Wimbledon struggles continued as the No.11 seed was beaten 6-7(6), 6-7(10), 6-3, 3-6 by Emil Ruusuvuori. In his seven appearances in the main draw here Tsitsipas had never gone beyond the fourth round. Hubert Hurkacz, the No.7 seed, retired in the fourth set against Arthur Fils with a knee injury, while 37-year-old Gael Monfils beat 39-year-old Stan Wawrinka 7-6(5), 6-4, 7-6(3).

On a day when eight gentlemen's matches went to five sets, 33-year-old Grigor Dimitrov came back from two sets down to beat China's Shang Juncheng, 14 years his junior, 5-7, 6-7(4), 6-4, 6-2, 6-4. "I just had to stay in the moment and keep on building and keep on believing and keep on playing," Dimitrov said afterwards. "I had to almost strip down my game to a complete basic with serve and first shot after and make sure I was putting enough returns in and putting him in uncomfortable positions."

Ben Shelton rarely finds himself outserved but Lloyd Harris hit 31 aces to the American's 14 in a heavyweight contest on Court 18. Shelton, nevertheless, won 4-6, 7-6(5), 6-7(5), 6-3, 7-6(7) in a match

Opposite: As the training manual says: keep your eye on the ball. Jacob Fearnley was doing just that against Novak Djokovic

Below: Old friends – Gael Monfils, aged 37, hugs Stan Wawrinka, aged 39, after beating the Swiss in straight sets

Previous pages: Iga Swiatek, the top seed and Roland-Garros champion, extended her winning run to 21 matches with a win over Petra Martic on Centre Court

Below: They are presented as reusable cups when you buy your drinks at the All England Club – but is this the reuse the designer had in mind? They certainly helped one spectator get a better view

that lasted 11 minutes short of four hours. With Americans celebrating Independence Day, Bernarda Pera marked the occasion by beating Caroline Garcia, the No.23 seed, 3-6, 6-3, 6-4. However, Jessica Pegula had little reason to smile. The No.5 seed, who enjoyed her best run at The Championships when she reached the quarter-finals in 2023, was beaten 4-6, 7-6(7), 1-6 by China's Wang Xinyu.

Barbora Krejcikova won a match of tight margins for the second round in a row, beating Katie Volynets 7-6(6), 7-6(5) despite winning fewer points in the match (83 to 86) and making more unforced errors (35 to 16). Caroline Wozniacki and Leylah Fernandez started their match on Court 12 in the early evening before it was moved to No.1 Court to enable it to be completed under the lights. Wozniacki won 6-3, 2-6, 7-5. Back on Centre Court, Iga Swiatek took her unbeaten run to 21 matches when she beat Petra Martic 6-4, 6-3. The world No.1 won successive titles on clay in Madrid, Rome and Paris before arriving at The Championships without any grass court matches under her belt. She said she was now "doing everything step by step".

Swiatek's win was the last singles match on Centre Court, but for many spectators the highlight of the day was yet to come. The evening was to conclude with the first gentlemen's doubles opening round match to be scheduled on Centre Court since Todd Woodbridge and Mark Woodforde had taken on Ken Flach and Robert Seguso in 1995. It was time to welcome Andy Murray back on to his favourite stage.

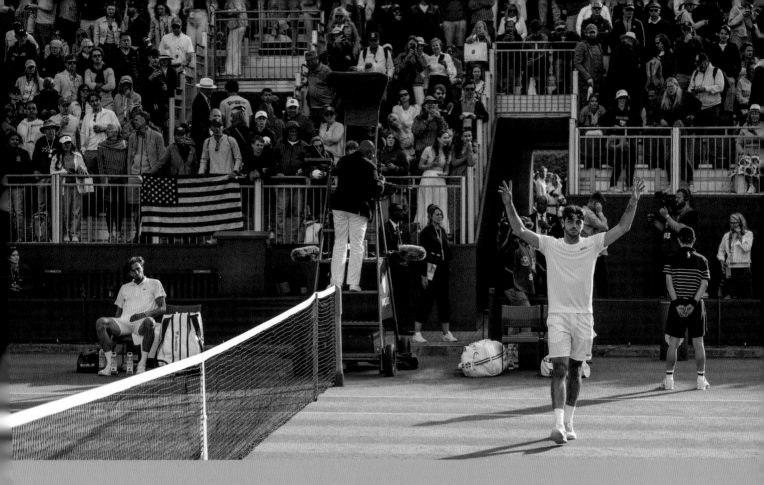

DAILY DIARY DAY 4

It was handbags at dawn – the first player spat of The Championships: Taylor Fritz vs France's Arthur Rinderknech. This was a rematch of their meeting at Roland-Garros last year, when the American beat the local hero and then had the temerity to shush the very vocal Paris crowd. Before Fritz beat him this summer on Court 12 (*above*), Rinderknech was asked about their previous encounter: "I hold no grudge against him, but he was wrong if he thought the crowd would send him kisses in between points." This did not go down well with Fritz, who shook hands with his opponent after the match and said, with a hint of sangfroid: "Have a nice flight home." Rinderknech was having none of that. "I'm still in the doubles," he said, pointedly. "Oh, congrats," Fritz replied. "Good for you." After some childish back and forth, the American headed for the third round. "It gave me the extra fire to win," Fritz explained.

• Ons Jabeur was busy out on No.2 Court, the scene of more medical dramas than *Casualty, ER* and *Grey's Anatomy* all rolled into one. First she was the patient, then the nurse, then – finally – the winner. Playing Robin Montgomery, she twisted her ankle in the first set. After treatment, she was able to continue but the match was then delayed due to a spectator fainting in the stands. Cue Ons rushing to her bag to get bottles of water to help the stricken fan. Then she won. All of this came

after Hubert Hurkacz was forced to retire against Arthur Fils. Diving for a ball in the fourth set tie-break, he injured his knee. After a medical timeout and much strapping, he resumed and dived again. This time the knee was beyond repair, forcing him to throw in the towel.

• Jacob Fearnley (*below*) was disappointed to have lost to Novak Djokovic, but was definitely still buzzing. At home in Edinburgh, he had watched on TV as Andy Murray beat Djokovic to win his first Wimbledon title in 2013; now here he was facing the same Djokovic on the same court. And Andy had helped by offering a few pointers to coach Mark Hilton, who works with both

players. "The stuff he said actually helped a lot," Fearnley said. "Unsurprisingly because he's played him so many times. That was really nice of him. It was awesome that he was even thinking about the match."

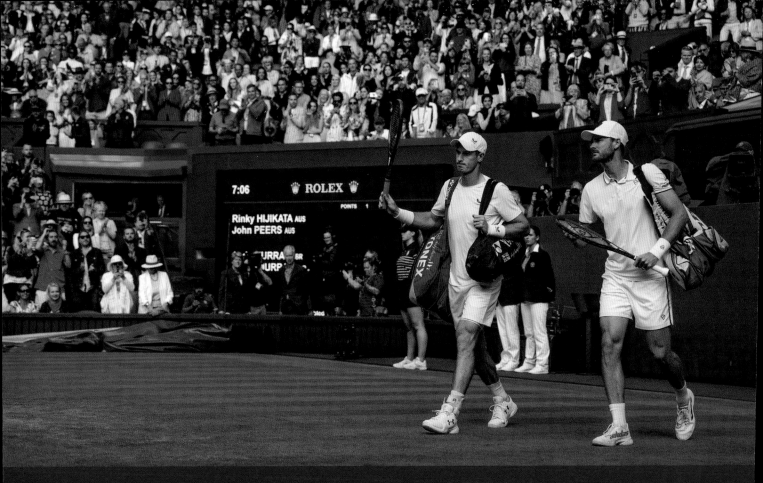

FAREWELL TO A LEGEND

—

Andy Murray would have loved one more run in the gentlemen's singles, but when that became impossible because of his latest physical setback, bidding farewell to Wimbledon alongside his brother, Jamie, in the doubles felt like a good back-up plan. Whether they had been winning their own Grand Slam titles or joining forces to bring the country Davis Cup glory, the Murrays had represented the best of British tennis for some 20 years.

This, nevertheless, would be the first time the brothers had played together at The Championships and their draw could have been kinder. Their first round opponents were the Australians John Peers, who used to partner Jamie and had 27 career doubles titles to his name, and Rinky Hijikata, who had won the Australian Open men's doubles in 2023.

There were times in the match when Andy rekindled memories of past glories with his creative shot-making, but it soon became evident that his movement had been impaired by the surgery he had undergone less than two weeks earlier on a spinal cyst. Peers and Hijikata completed their 7-6(6), 6-4 victory in less than an hour and a half.

Spectators had wondered how Wimbledon would mark the farewell to Britain's greatest player in more than three-quarters of a century. Surely there would be some sort of celebration of his career in the stadium where he had enjoyed so many of his finest moments?»

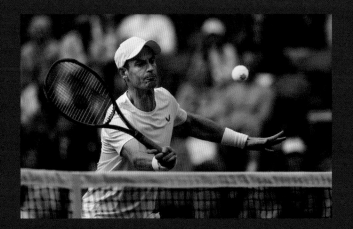

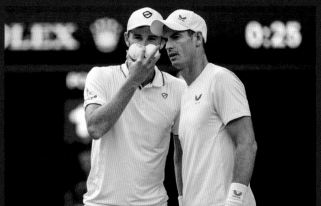

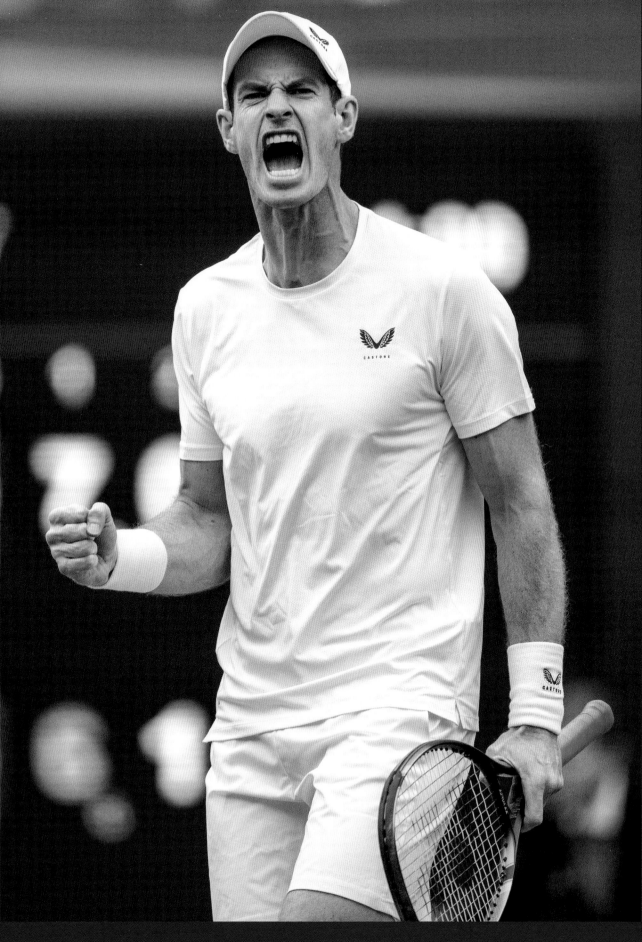

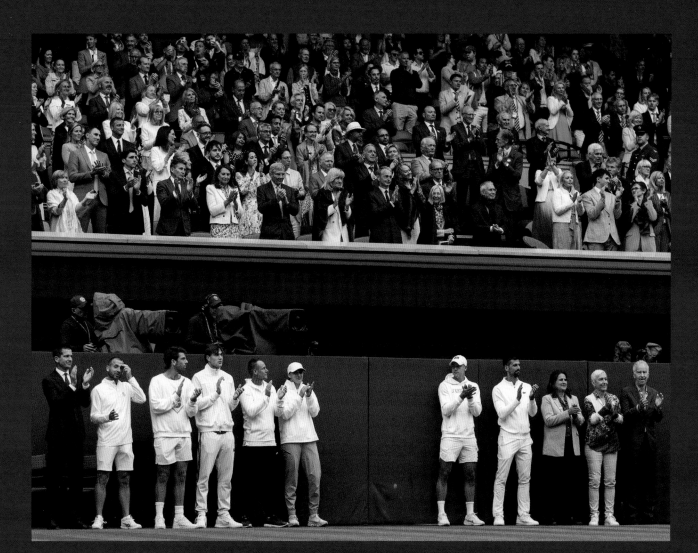

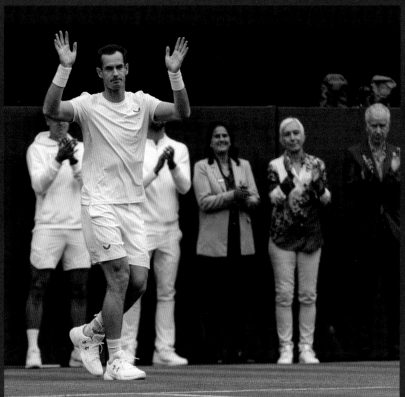

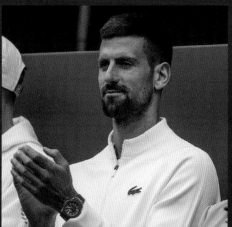

"I couldn't miss this," Sue Barker (**opposite, top**) said as she walked out onto Centre Court to host Andy Murray's farewell to Wimbledon. Champions, both past and present, together with his international peers came to applaud, as did many of his fellow British players. Novak Djokovic (**above**), just one week younger than Murray and one of his greatest and most respected rivals, was a particularly special part of the celebration

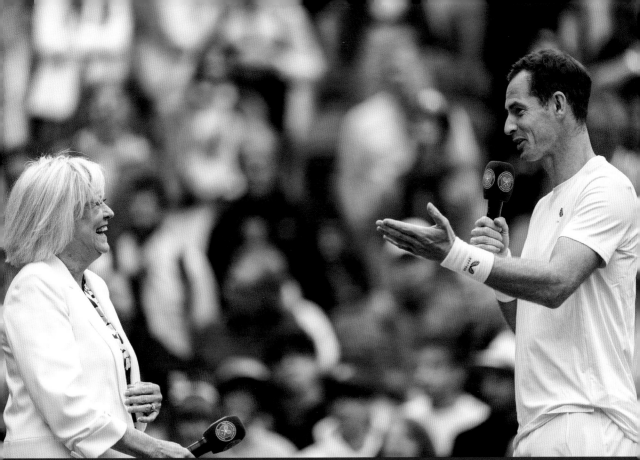

After Peers and Hijikata had completed their post-match interview, leaving the Murrays centre stage, the crowd quickly realised that something special was in store when a familiar figure walked out onto Centre Court. Sue Barker, for so long the face of the BBC's coverage of The Championships, was back to interview Murray on court one last time.

However, before she could start, Barker had to wait for several minutes for the crowd's cheers and applause to die down. "I can't stop them, Andy, they love you," she told Murray, who was already wiping tears from his eyes. He said he would "try and keep it quick" as two of his children, Sophia and Edie, were present "and it's well past their bedtime".

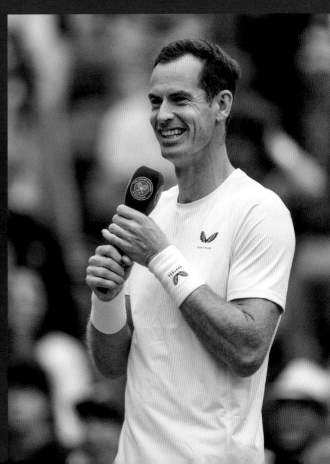

A video of the Scot's career highlights – along with personal tributes from Roger Federer, Rafael Nadal, Novak Djokovic and Venus Williams – was played on the big screens, while former and current players gathered on the court. John McEnroe, Martina Navratilova, Lleyton Hewitt, Conchita Martinez, Tim Henman, Laura Robson, Djokovic, Iga Swiatek, Dan Evans, Jack Draper, Cameron Norrie and Holger Rune were all there, while members of Murray's family were in the crowd: his parents, Judy and William, his wife, Kim, and the two children.

Barker asked Murray about some of the most significant moments in his Wimbledon career, including the tearful interview he gave to her »

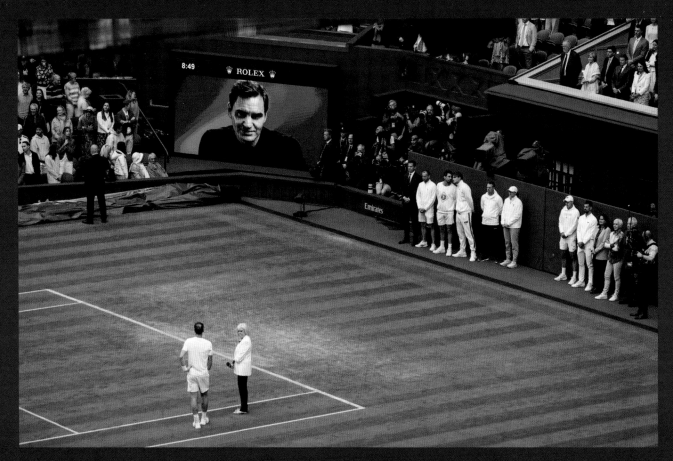

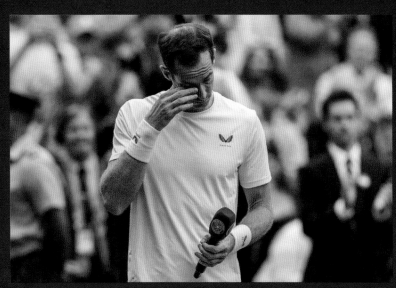

There were always going to be tears as Murray said farewell, particularly when Sue Barker asked him about his family while his wife Kim, daughters Sophia and Edie, mother Judy, father William and brother Jamie watched on. The heartstrings were tugged still further when the video of Federer, Nadal, Djokovic and Williams was played. After hugging everyone, Andy left the arena for a few moments on his own (**opposite**). A legend had left the court forever

on court after losing to Federer in the 2012 final. "It was quite an important moment in my career," he recalled. "I think maybe people saw for the first time how much I cared about the sport."

Murray said the 2012 Olympic final, when he finally beat Federer on Centre Court, was "one of my favourite days I've ever had as an athlete". As for the 2013 Wimbledon final, when he finally ended Britain's 77-year wait for a Gentlemen's Singles Champion, Murray admitted: "I didn't enjoy it as much as I should have done. I found the whole thing very, very stressful. When I got off the court I didn't remember any of what happened."

He said that his 2016 Wimbledon triumph had been much more enjoyable. "I had an amazing evening that night with all my friends and family," he recalled. "I went out and enjoyed it properly with the people closest to me. Of my Slams, 2016 was my favourite one." To roars of laughter from the crowd he added: "I don't remember much of that night. I'd had a few drinks and unfortunately I did vomit in the cab on the way home."

On a similar theme, Murray recalled his first meeting with his future wife in New York when they were 18. "We went out for dinner at the US Open," he said. "I walked Kim back to her hotel and then asked her for her email address. I don't think that's a normal thing to do. The first match she came to see me live was at the US Open. I vomited twice in that match: once right in front of where she was sitting and then I stood up and vomited over my opponent's racket bag.»

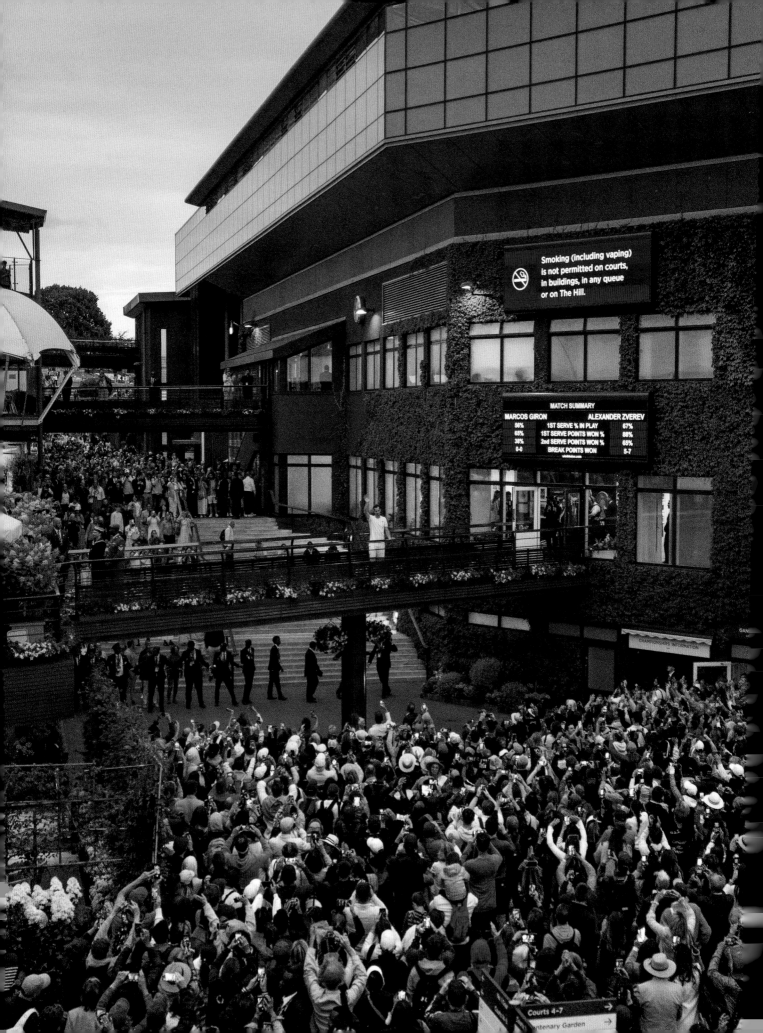

Smoking (including vaping)
is not permitted on courts,
in buildings, in any queue
or on The Hill.

MATCH SUMMARY		
MARCOS GIRON		ALEXANDER ZVEREV
56%	1ST SERVE % IN PLAY	67%
65%	1ST SERVE POINTS WON %	88%
38%	2nd SERVE POINTS WON %	65%
0-0	BREAK POINTS WON	5-7

Courts 4-7

Centenary Garden

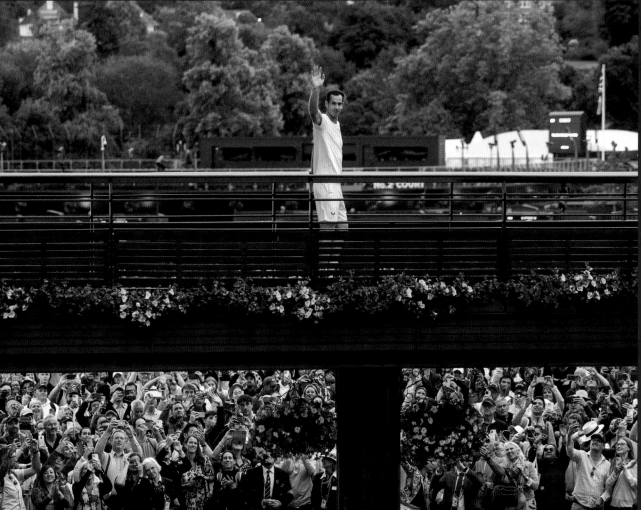

And she still seemed to like me. So I knew she was a keeper after that."

Murray thanked his parents for the "amazing support" they had given their sons. "Jamie left home to go to train when he was 12 and then moved over to Paris," he recalled. "I left to go over to Spain. I know now, having children, that I don't like them being away for a day. So allowing us to go and train abroad and pursue our dreams, we couldn't have done that without their support."

Tears welled up in Murray's eyes again when he paid tribute to his team. "The last few years have been hard for me but also hard for them," he said, his voice wavering. Asked how difficult it had been to make his retirement decision, Murray admitted: "It's hard. I would love to keep playing, but I can't. Physically it's too tough now. All of the injuries have added up. They haven't been insignificant. I want to play for ever. I love the sport. It's given me so much. It's taught me loads of lessons over the years that I can use for the rest of my life."

Murray went over to greet all the current and former players who had been on court before sharing a lengthy embrace with his brother. It was a fitting way to end an evening that would be treasured in the memories of all those who had been part of it.

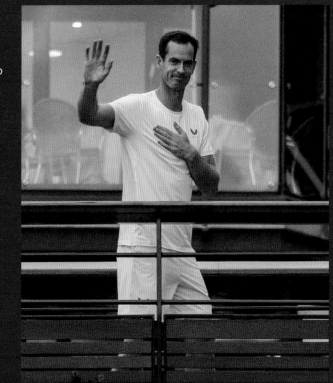

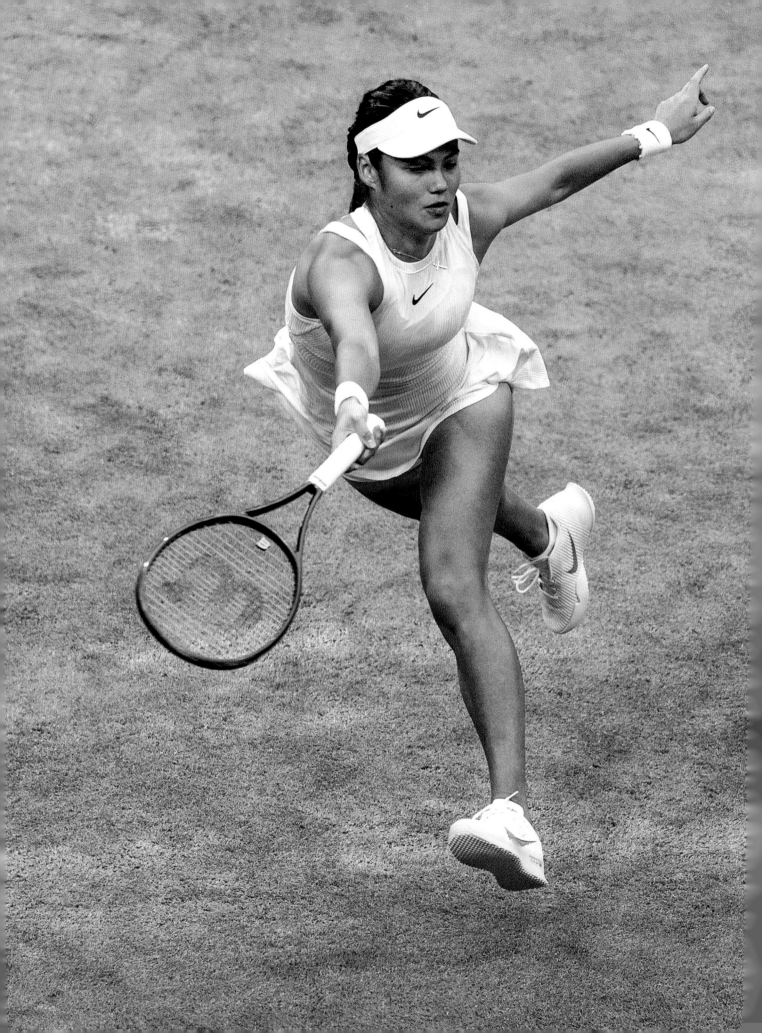

– DAY 5 –

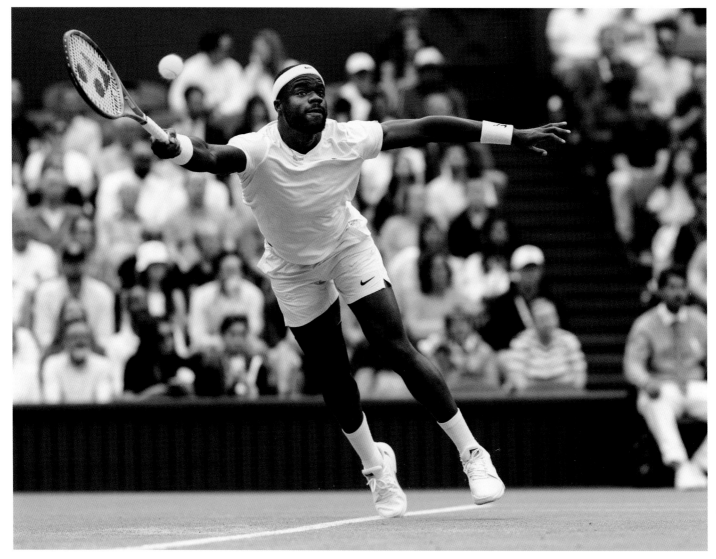

B ritain had awoken to news of major political change, with Sir Keir Starmer's Labour Party sweeping to a landslide victory in the General Election after 14 years in opposition. At one stage on the fifth day at The Championships we wondered whether a new order might also be on the horizon at Wimbledon as Carlos Alcaraz, the defending Gentlemen's Singles Champion, went two sets to one down against Frances Tiafoe on Centre Court.

Above: An inspired Frances Tiafoe seemed to be on his way to causing a huge upset against Carlos Alcaraz

Previous pages: Emma Raducanu put in a superb performance against Maria Sakkari

However, the 21-year-old Spaniard has mental strength to match his brilliant shot-making and stunning athleticism and after nearly four hours he completed a memorable 5-7, 6-2, 4-6, 7-6(2), 6-2 victory to secure his place in the fourth round.

It was the 13th time in his career that Alcaraz had been taken to a fifth set; on all but one of those occasions he has emerged the winner. "I know that good players push 100 per cent physically and mentally in the fifth set and play their tennis at 100 per cent too," he said afterwards. "For other players it can sometimes be difficult to keep this kind of intensity and level during a fifth set. In my head I think: 'I'm good at it and my opponent has to believe that I'm going to win, that I'm going to play my best tennis.' In every match I've played fifth sets I've played my best tennis, or really close to it."

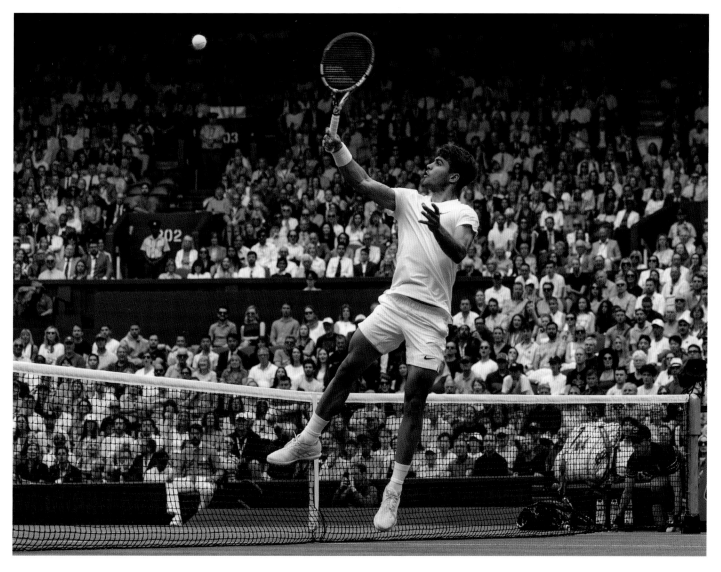

Tiafoe, who also lost to Alcaraz in five sets in the semi-finals of the US Open in 2022, had played some outstanding tennis in the first three sets. Hitting thunderous winners from all corners of the court, the 26-year-old American appeared untroubled by the knee support he was wearing after a heavy fall at The Queen's Club which had forced him to retire during his first round match and had threatened his participation at Wimbledon. At the end of the fourth set the world No.29 was a tie-break away from creating the biggest upset of the Fortnight so far, but that was the moment when Alcaraz took control. "I was a little tentative in the breaker," Tiafoe said afterwards. "I let him dictate a little too much."

The match was played with the Centre Court roof closed, the previous day's sunshine having proved an all too brief interlude. On a day of lengthy spells of rain, only four gentlemen's singles matches were completed. The other three were all decided in straight sets as Jannik Sinner, Tommy Paul and Grigor Dimitrov brushed aside Miomir Kecmanovic, Alexander Bublik and Gael Monfils respectively.

In the second match on Centre Court Emma Raducanu took on Maria Sakkari, the world No.9, in their first meeting since the semi-finals of the 2021 US Open. Raducanu had won in straight sets on that occasion and gone on to win the title, but this was the first time since then that the 21-year-old Briton had made the third round of any Grand Slam tournament. If anyone looked nervous, however, it was Sakkari, whose form in the Grand Slam events had been equally modest since 2021, a year when she had also made the semi-finals at Roland-Garros. The 28-year-old Greek was broken here in the opening game, which ended with a double fault and an unforced error on her forehand, and she continued to falter as Raducanu won 6-2, 6-3 in 92 minutes.

The champion fights back: if the match goes to five sets, Carlos Alcaraz usually wins. It did, and so did he...

Raducanu struck the ball sweetly from the start and played the big points particularly well. Sakkari failed to convert any of her seven break points, while Raducanu took four of her nine. The Briton broke again to lead 5-2, sealing the game with a superbly judged backhand lob which landed on the baseline. With further breaks of serve in the third and ninth games of the second set, she completed her second notable victory in the space of a fortnight. Until her win over Jessica Pegula, the world No.5, in Eastbourne the previous month, Raducanu had never beaten an opponent ranked in the world's top 10.

"I think today is up there with the most fun I've had on a tennis court," Raducanu said afterwards. "I really enjoyed every single moment. I was just telling myself: 'How many times are you going to get to play in front of a full Centre Court?' I'm most proud of the fact that I was so focused, so determined in every single point, every single moment. Maria's a top 10 opponent, so in a way I came in with a free swing, but she's so tough. She has amazing weapons and I knew I had to battle and fight hard. I tried not to let the scoreline affect me. You have to play every point like it's your last."

In reaching the fourth round Raducanu matched her previous best run at The Championships in 2021. So did Coco Gauff. Five years after first making the last 16 on her Championships debut at the age of 15, the American eased past Sonay Kartal, winning 6-4, 6-0 under the No.1 Court roof. The first set was tight as Kartal retrieved an early break of serve and matched the world No.2 blow for blow, but from 4-4 Gauff won eight games in a row. "She was playing a high level, especially in the first set," Gauff said afterwards. "She wasn't giving me much to work with and not letting me settle. I felt like I was going for the right shots but was just missing. But eventually I found it."

In reaching the third round via Qualifying, Kartal had beaten five higher-ranked opponents in succession. The 22-year-old Briton's performances secured a rise of 105 places in the world rankings, to No.193, while her prize money of £143,000 was easily the biggest pay cheque of her career. "I'm proud

"Thank you very much, madam!" One of the Chelsea Pensioners makes a pretend grab for a laughing spectator's glass of Pimm's

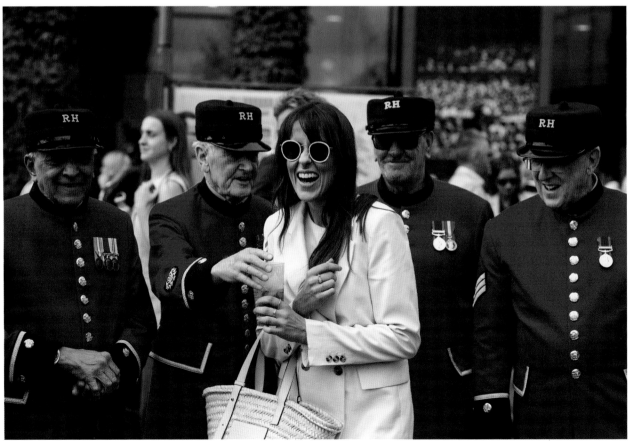

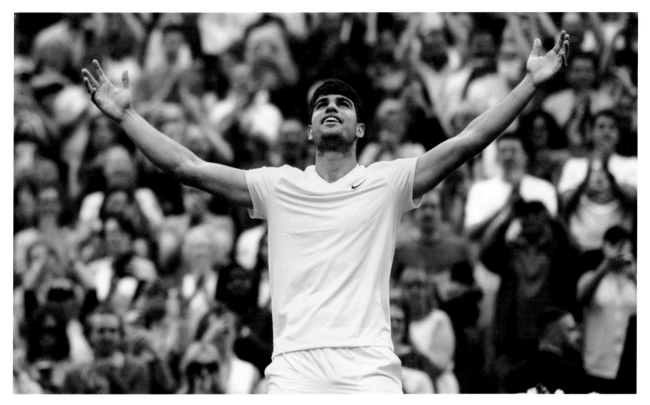

Above: To mark his hard-fought victory over Frances Tiafoe, Carlos Alcaraz mimics England football superstar Jude Bellingham's goal celebration

Left: Alcaraz helped Tiafoe to his feet – but was determined not to let him into the fourth round

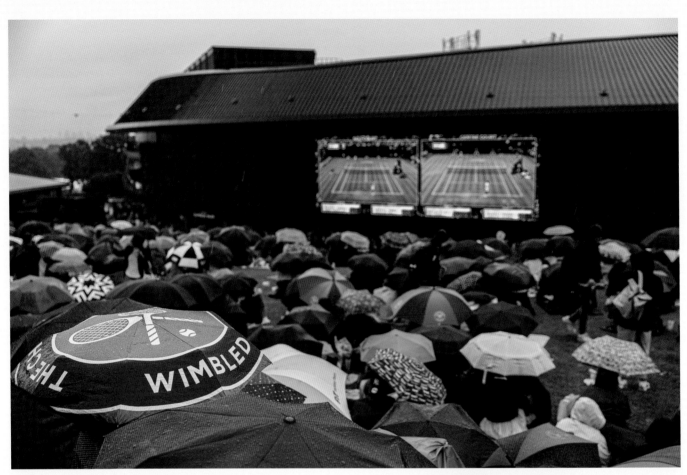
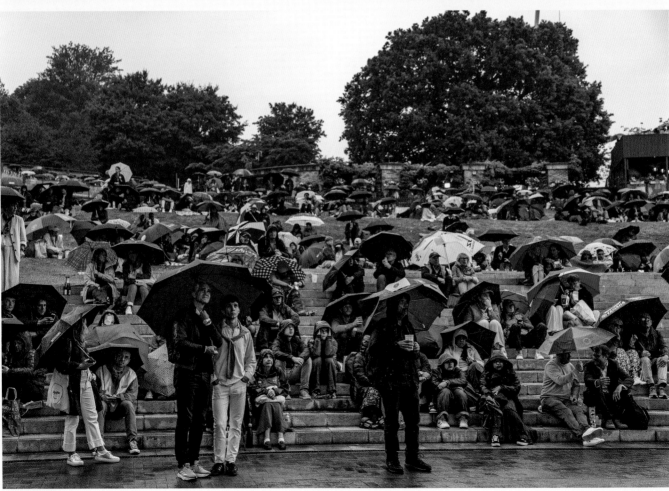

RAINING CHAMPIONS

Those blissful few hours of sunshine on Day 4 had been and gone. The skies were now heavy and dripped endlessly over the All England Club, allowing only 23 of the scheduled 46 matches to be completed. For those on Centre and No.1 Court life was definitely easier: they had a roof, they were dry; those outside had a different story to tell. Yet the Wimbledon faithful are a hardy crew: patient, resourceful (with a bit of imagination, wet-weather gear can be crafted from almost anything) and determined to see any tennis available. Many huddled on The Hill to watch the action on the big screen; others claimed a seat on an outside court and just hoped.

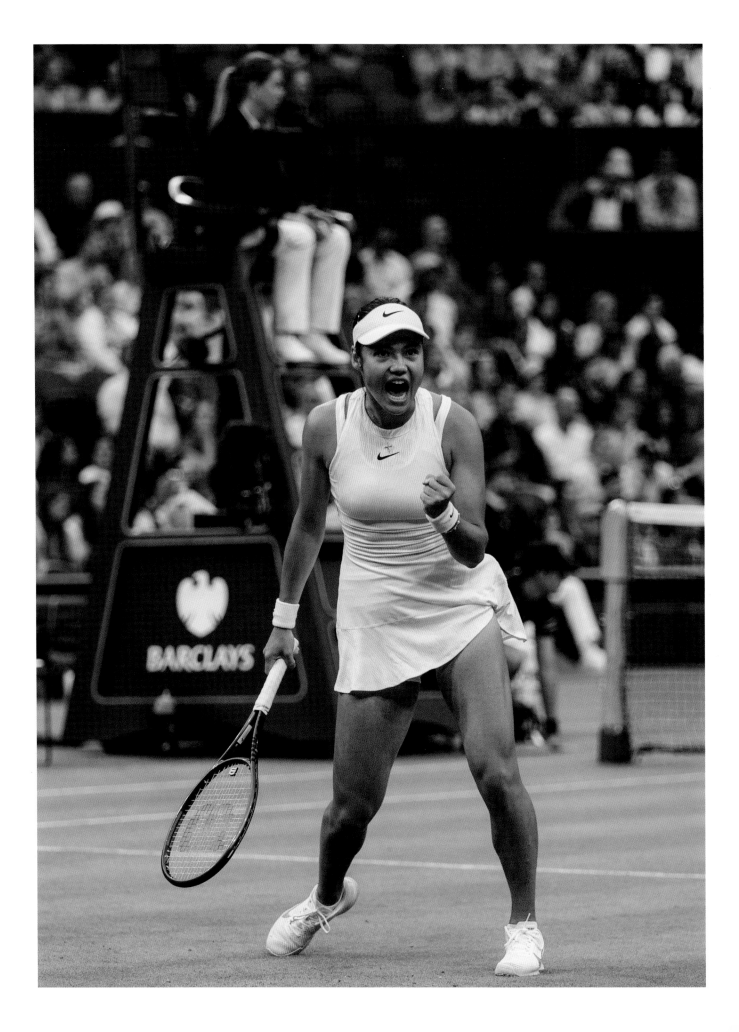

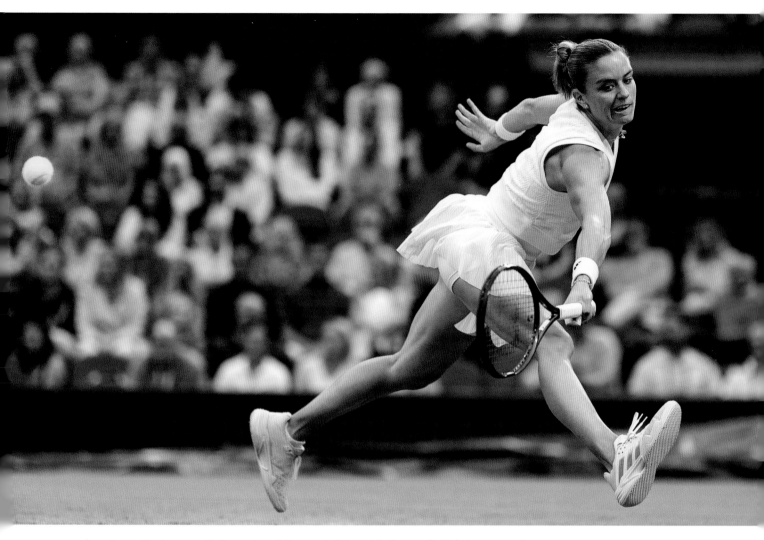

of not just today but my whole week and last week," she said afterwards. "It's important for me now to play the bigger WTA tournaments and mix in with that level. Before this week I wasn't sure if I was going to make US Open qualies or not, whereas now after this week I'll be in there. For me, the best way for me to develop is to put myself out there against the higher-level players."

Someone who could sympathise with Raducanu's struggles in recent years was Bianca Andreescu. The 24-year-old Canadian had made the second week of a Grand Slam tournament only once since her own US Open triumph in 2019, having taken three lengthy breaks from the sport in the ensuing five years. She was out for 15 months with a knee injury, took what she describes as "a mental break" in 2021 and returned to competition in May 2024 after 10 months out with a stress fracture in her back. The former world No.4 reached the final of her second tournament in her latest comeback, on grass at 's-Hertogenbosch, and had started The Championships with two straight-sets victories. Now, however, she faced Jasmine Paolini, who had just beaten her at the same stage at Roland-Garros en route to the final.

Paolini had not gone beyond the first round in her three previous visits to the All England Club and had never won a main draw match on grass until the week before The Championships, but the 28-year-old Italian, enjoying the best year of her career, was learning fast. Andreescu broke in the opening game and the momentum shifted from one player to the other in a tight opening set. It went to a tie-break, which Paolini won 7-4 after coming back from 4-3 down. Andreescu held serve at the

Above: The nerves brought the errors and the errors brought defeat for Maria Sakkari on Centre Court

Opposite: "Play every point like it's your last" was Emma Raducanu's mantra as she strode into the last 16

Following pages: Diana Shnaider was on the back foot against Emma Navarro, the No.19 seed, on Court 18

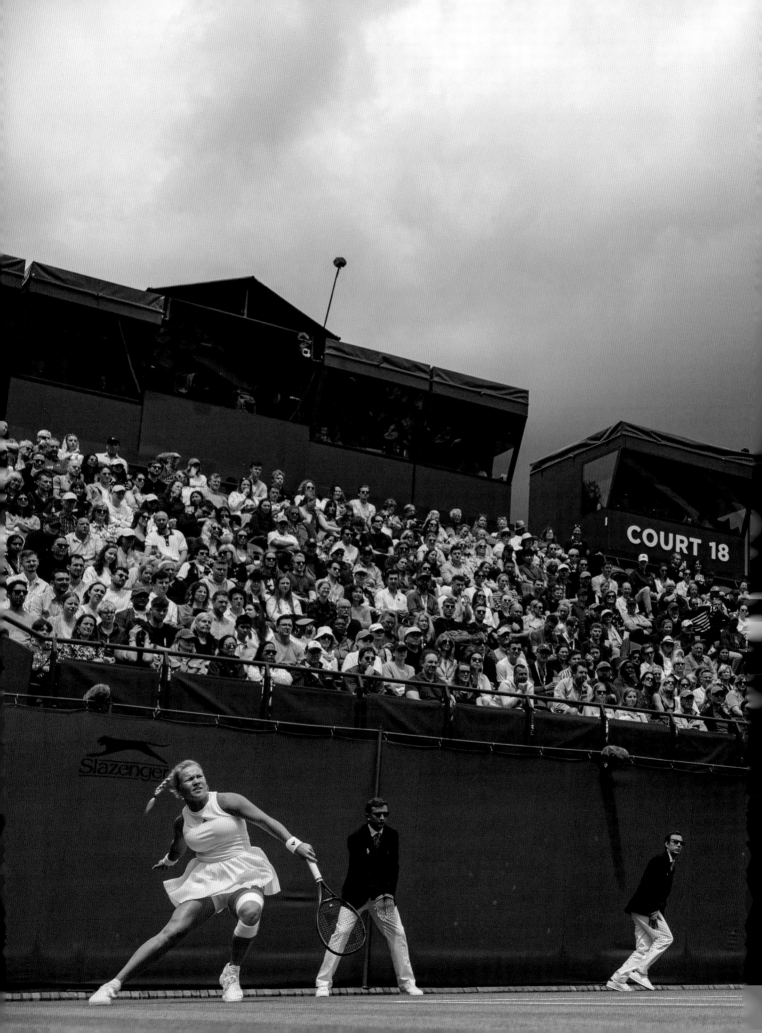

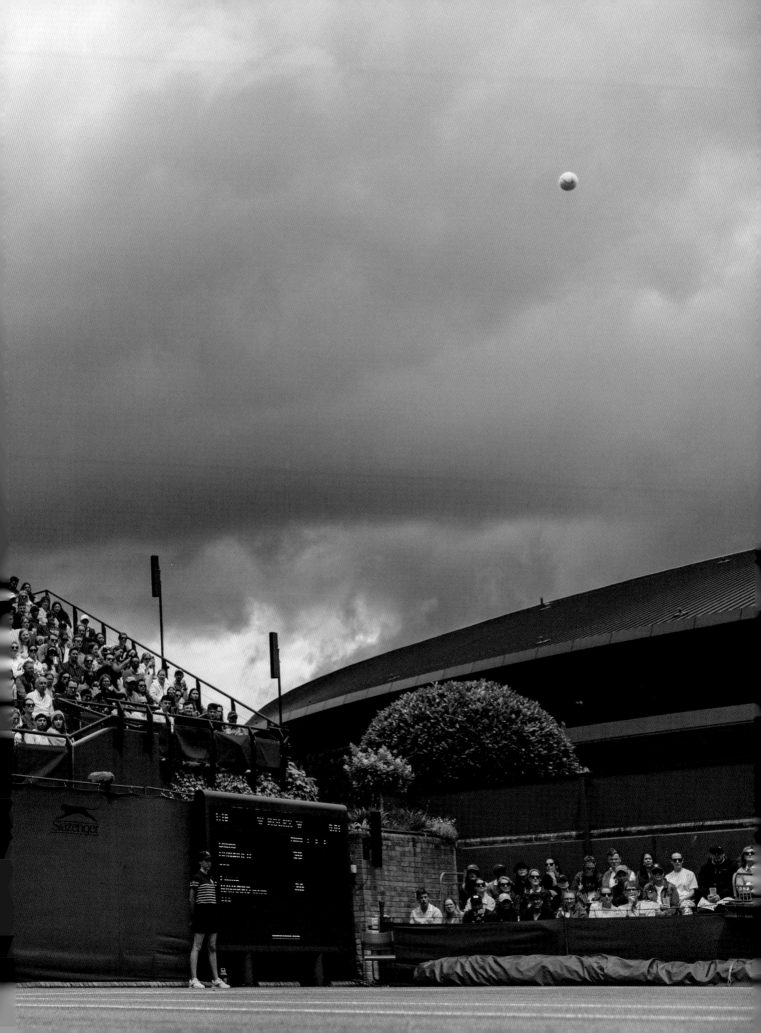

Back at Wimbledon for the first time in seven years, Dustin Brown thought that being on the grass was "like coming home" as he and Sebastian Baez won their opening doubles match

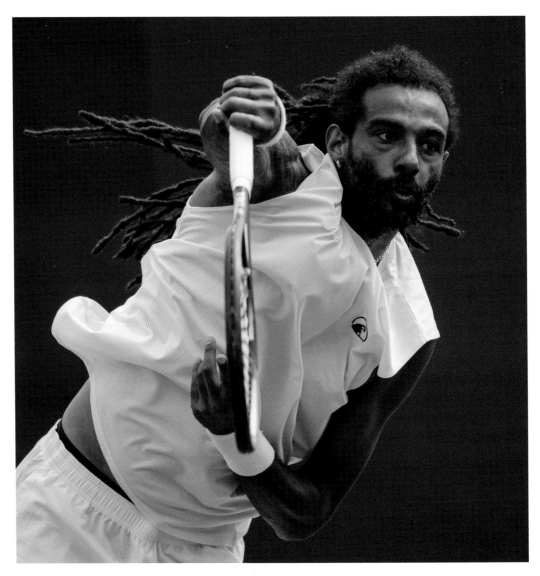

start of the second set but Paolini did not lose another game and went on to win 7-6(4), 6-1. "It's really fun to play here," Paolini said afterwards. "I like to volley. Of course I played many doubles matches this year, so I think that helped me. But it's really fun to play on grass."

Daria Kasatkina had been enjoying the surface too, having just won the title at Eastbourne and dropped only three games in her first two matches at The Championships. However, the world No.12's seven-match winning run ended with a 6-7(6), 6-4, 4-6 defeat to Paula Badosa on No.3 Court in a match that lasted two hours and 51 minutes. That was three minutes shorter than another marathon on No.1 Court, where Donna Vekic beat Dayana Yastremska 7-6(4), 6-7(3), 6-1.

Spectators on Court 5 might have enjoyed watching one of the most unlikely pairings in the gentlemen's doubles. Sebastian Baez, who has short-cropped hair and stands 5ft 7in tall, and Dustin Brown, who has dreadlocks down to his waist and is 6ft 5in tall, beat Hugo Nys and Jan Zielinski 3-6, 6-3, 7-6(5). Brown, who famously beat Rafael Nadal in the second round of the singles in 2015, was playing at The Championships for the first time in seven years. Having been out of the game for 11 months with back trouble, the 39-year-old was now on a mission to make farewell appearances in doubles at the four Grand Slam tournaments before retiring. "Playing on the grass is like coming home," he said. "Six months ago it didn't look like I was ever going to play tennis again."

DAILY DIARY DAY 5

When he wasn't practising with Novak Djokovic – or playing doubles with Novak's children – Nick Kyrgios was earning his crust in the BBC commentary booth, squeezed in beside the likes of Tim Henman and John McEnroe (those booths are not big and Nick is 6ft 4in). As the days flew by he increasingly felt a part of the team and wanted to know if there was a team-bonding, end-of-Championships BBC drinks do. Deadpan and without missing a beat, Henman replied: "Didn't you get the invite?" Fair enough, he would have to make do with half a shandy at the Dog & Fox up in Wimbledon village, one of his regular haunts during The Championships whether he is playing or not.

• Victory in five sets over Frances Tiafoe; a place in the fourth round – Carlos Alcaraz turned to the Centre Court crowd with both arms aloft to celebrate, à la Jude Bellingham. This was a big moment. But why would Spain's No.1 be copying the England star, particularly when England and Spain were both still vying for the European Championship? Because Carlos is a football fan and his team is Real Madrid. And Real Madrid's latest star is Bellingham. "I have huge respect for him," Carlos said. "We're in London. He is England. So that's why. I told him that the big win deserves a big celebration." Well, he said

it eventually, having watched Spain beat Germany from the ice bath and delayed his press conference until after extra time was over.

• Two years ago, Paula Badosa *(left)* was the world No.2 and life was good. But then she developed a back problem, had to retire in the second round at last year's Championships and did not play again until the start of this season. The problem was diagnosed as a stress fracture and the doctors told her that she might not play again. She would not listen, even if it meant playing through pain, and this summer she was back in SW19 again, beating the No.14 seed, Daria Kasatkina, in a tight, tense three-setter on No.3 Court to reach the fourth round. She then promptly burst into floods of tears. "I was, like, I'm going to continue no matter what," she said. "I think that's also what made me the player I am, that I always want more, and I'm always going to fight even how difficult is that moment."

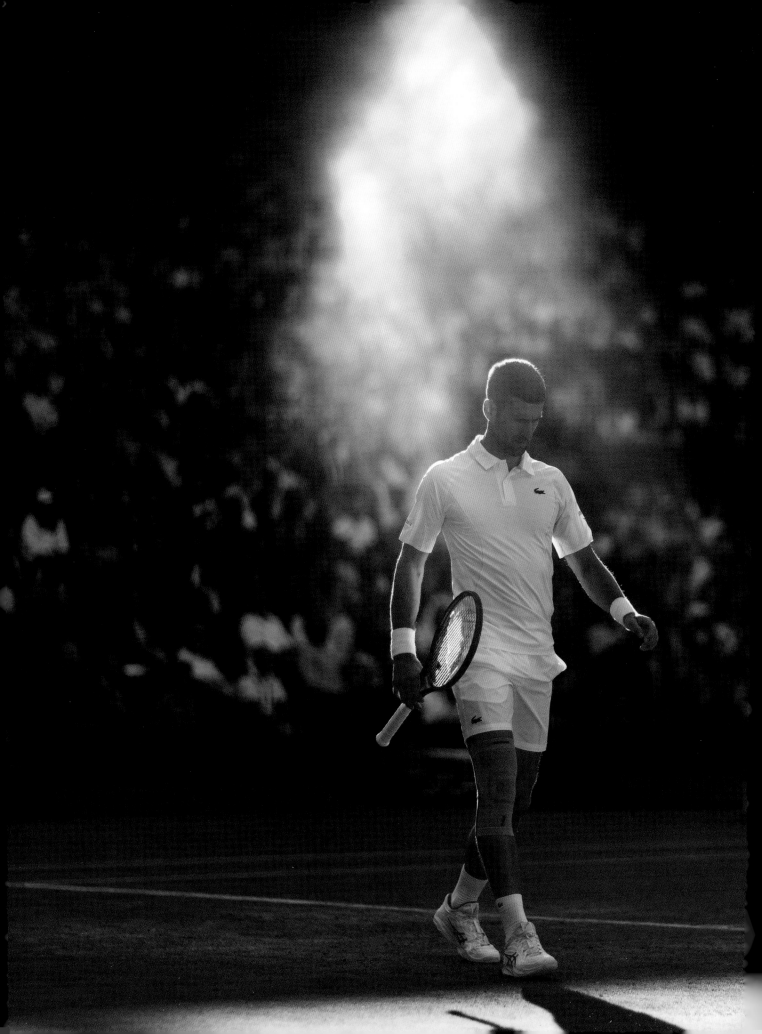

DAY 6 –

SATURDAY 6 JULY

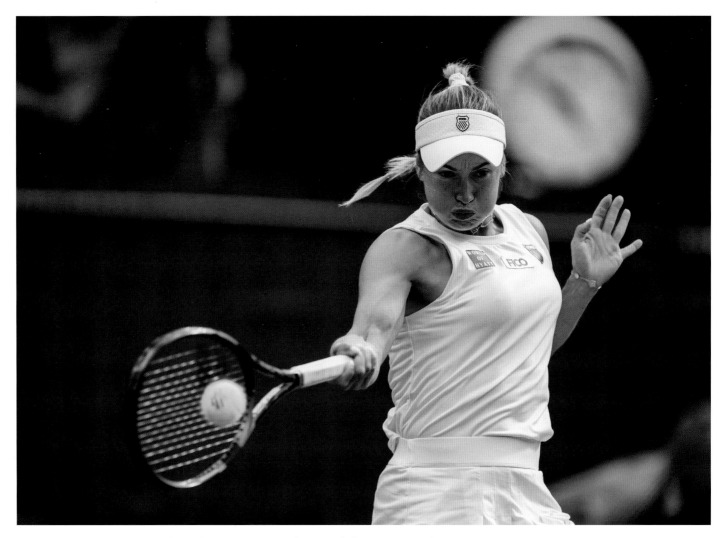

Winning Roland-Garros and Wimbledon in the same year remains one of the biggest challenges in tennis. It is by no means impossible, as Serena Williams, Rafael Nadal, Roger Federer and Novak Djokovic had all proved since the turn of the century, but switching from clay to grass demands an instant change of strategy, mindset and physical approach.

Above: Yulia Putintseva put relentless pressure on Iga Swiatek, the top seed, and finally got her reward

Previous pages: For Novak Djokovic the sun was finally shining – his knee was improving daily and he had safely negotiated the first week

The proximity of the two Grand Slam events also demands an immediate recharge of batteries drained by a gruelling clay court campaign. Increasing the gap between the two events from two weeks to three in recent years has helped, but many players still struggle to solve the conundrum.

Iga Swiatek, the modern game's outstanding female player on clay, has yet to find the answer. The world No.1 arrived at The Championships having just won Roland-Garros for the fourth time in five years at the end of a clay court season in which she had also claimed the titles in Madrid and Rome. However, at Wimbledon the 23-year-old Pole ran out of steam at the very moment when it seemed she might at last have found her way in the only Grand Slam played on grass.

Swiatek, who is also a former US Open champion, had won her first two matches at The Championships comfortably enough to take her unbeaten run to 21 matches, but in the third round she ground to a halt. Swiatek took the first set against Yulia Putintseva, but then wilted under a barrage of attacking shots from the world No.35, who won 3-6, 6-1, 6-2 to take her own winning sequence to eight matches following her title triumph at Birmingham. For Swiatek, meanwhile, a run to the quarter-finals in 2023 remained her best effort to date at The Championships.

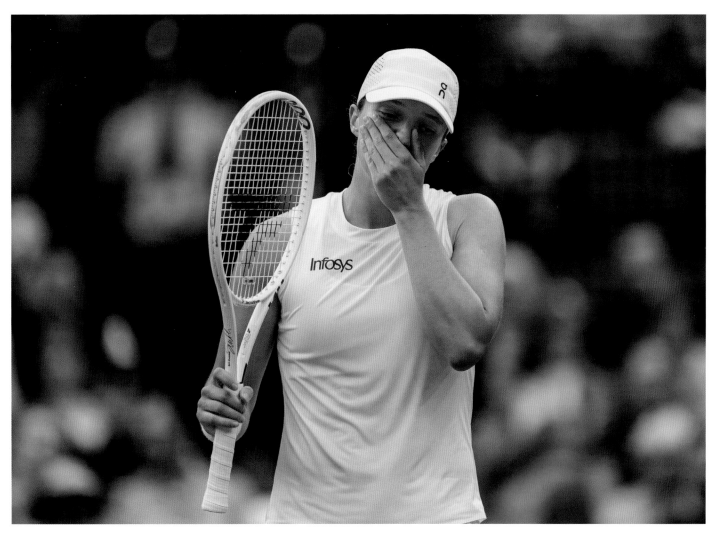

"My tank of really pushing myself to the limits suddenly became empty," Swiatek said afterwards. "I was kind of surprised, but I know what I did wrong after Roland-Garros. I didn't really rest properly. I'm not going to make this mistake again. After such a tough clay court season, I really must have my recovery. Maybe that's also the reason. But I thought that I was going to be able to play at the same level. I feel like on grass I need a little bit more of that energy to keep being patient and accept some mistakes. Mentally I didn't really do that well at this tournament. I need to recover better after the clay court season, both physically and mentally. Going from playing what I felt like was the best tennis of my life to another surface where I struggle a little bit more, it's not easy."

Putintseva had previous experience of upsetting a world No.1 on grass, having beaten Naomi Osaka at Birmingham five years ago. A feisty competitor who can get under the skin of opponents and spectators alike, the 29-year-old had on this occasion the support of several people in the No.1 Court crowd who did not approve of the lengthy bathroom break Swiatek took at the end of the first set. "It was great energy from all of you," Putintseva told the crowd in her post-match interview. "I was trying to entertain you more and more with my shots."

Ons Jabeur loves playing on grass, but the 29-year-old Tunisian's hopes of reaching a third successive Wimbledon final were dashed by Elina Svitolina, who beat her 6-1, 7-6(4) to reach the second week of a Grand Slam tournament for the 18th time. Jabeur, who had been dealing with knee pain, admitted that losing on Centre Court again had brought back "sad memories" of her defeat to Marketa Vondrousova in the 2023 final.

Danielle Collins has sometimes struggled to find her best form at The Championships, but in her final year on the tour the 30-year-old American made the second week for the first time by beating Beatriz Haddad Maia 6-4, 6-4. Collins announced her decision to make this her farewell

The tank was empty. Swiatek, the Roland-Garros champion, simply ran out of fuel as her Wimbledon challenge ground to a halt

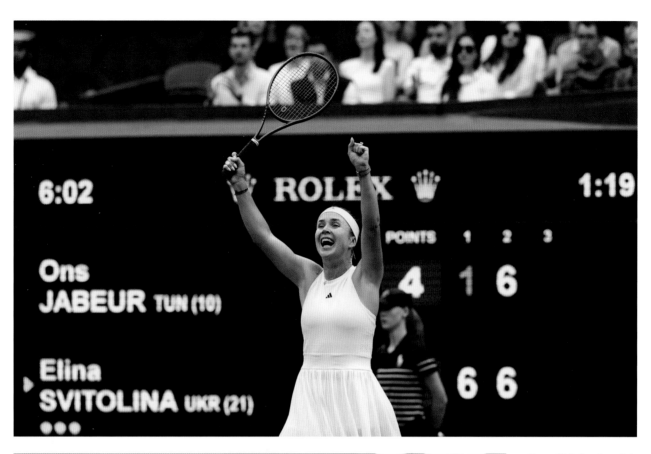

Above: She's done it again! By beating Ons Jabeur, Elina Svitolina was heading for the second week of a Grand Slam for the 18th time in her career

Left: In her final appearance at Wimbledon, Danielle Collins – who will retire at the end of 2024 – had reached the fourth round for the first time. Clearly, it meant the world to her

Opposite: The victory roar! Yulia Putintseva had never advanced beyond the second round before and now she had dispatched the world No.1 to reach the second week

PEP IS THE TALK OF WIMBLEDON
—

Super Saturday is the day when the Club invites stars from an array of sports to celebrate their achievements. But while these champions drank in the tennis, football was also in the forefront of many minds – England were playing Switzerland at Euro 2024 later in the day. Manchester City manager Pep Guardiola *(above and left)* was given a rousing reception, as was Leah Williamson *(opposite, bottom row, middle)*, who captained the Lionesses to European Championship glory on home soil in 2022, and former England manager Roy Hodgson. Conchita Martinez, the 1994 Ladies' Singles Champion, was a special guest of Club Chair Deborah Jevans *(middle row, left)* to mark the 30th anniversary of her victory. India's Sachin Tendulkar *(top)* led a cricket contingent that included England's Ben Stokes, Jos Buttler and Joe Root, and they were joined by rugby's Alun Wyn Jones and Gareth Edwards. Three weeks away from this year's Games, some of Britain's greatest Olympians were also in attendance. Sir Jason and Dame Laura Kenny *(middle row, right)* and Dames Denise Lewis *(bottom row, right)* and Jessica Ennis-Hill *(bottom row, left)* were given heroes' welcomes, as was swimmer Adam Peaty, who would soon be competing in Paris. Cycling's Sir Chris Hoy, sailors Sir Ben Ainslie and Hannah Mills, multi-discipline Paralympian Kadeena Cox, ice-skating's Jayne Torvill and Christopher Dean, and hockey's Kate and Helen Richardson-Walsh all brought further gold medals to a truly star-studded Royal Box.

season at the start of the year, saying she wanted to start a family. She suffers with two chronic health conditions, rheumatoid arthritis and endometriosis, which can affect fertility. The 2022 Australian Open runner-up, who was a late starter on the professional tour after playing college tennis, nevertheless rejected the idea that knowing this was her last season had enabled her to play more freely. Nevertheless, her Wimbledon results followed an excellent run in the spring, highlighted by her triumph at the Miami Open. "I don't feel like I've had that much pressure on me throughout my career," she insisted. "When I first came on tour I felt like nobody was expecting me to have any success."

After hard-fought wins in her first two matches Barbora Krejcikova was no doubt happy to be kept on Court 14 for less than an hour as Jessica Bouzas Maneiro, who had knocked out the defending champion Marketa Vondrousova in the first round, retired with a back problem when trailing 0-6, 3-4. Elena Rybakina, the 2022 Ladies' Singles Champion, made a similarly fleeting visit to No.1 Court, where she hit 36 winners to Caroline Wozniacki's four in beating the Dane 6-0, 6-1 in just 57 minutes.

Harriet Dart won the first set against China's Wang Xinyu and led 5-4 in the second and 3-0 in the third but was unable to drive home her advantage and lost 6-2, 5-7, 3-6. "I don't think I'm going to sleep very well tonight, that's for sure," the British No.2 said afterwards. "It was really tough. To be up in two sets and come away with a loss is pretty heartbreaking."

Emma Raducanu, who was now the only Briton left in the ladies' singles, had announced earlier in the day that she was withdrawing from the mixed doubles, in which she had been due to partner

Opposite: Ben Shelton was the marathon man – his win over Denis Shapovalov was his third consecutive five-set victory

Below: Could it be? Were those courts being uncovered? Was that a patch of blue sky overhead…?

Following pages: … It was indeed! At last the rain had gone, the sun was out and Wimbledon was back in full swing

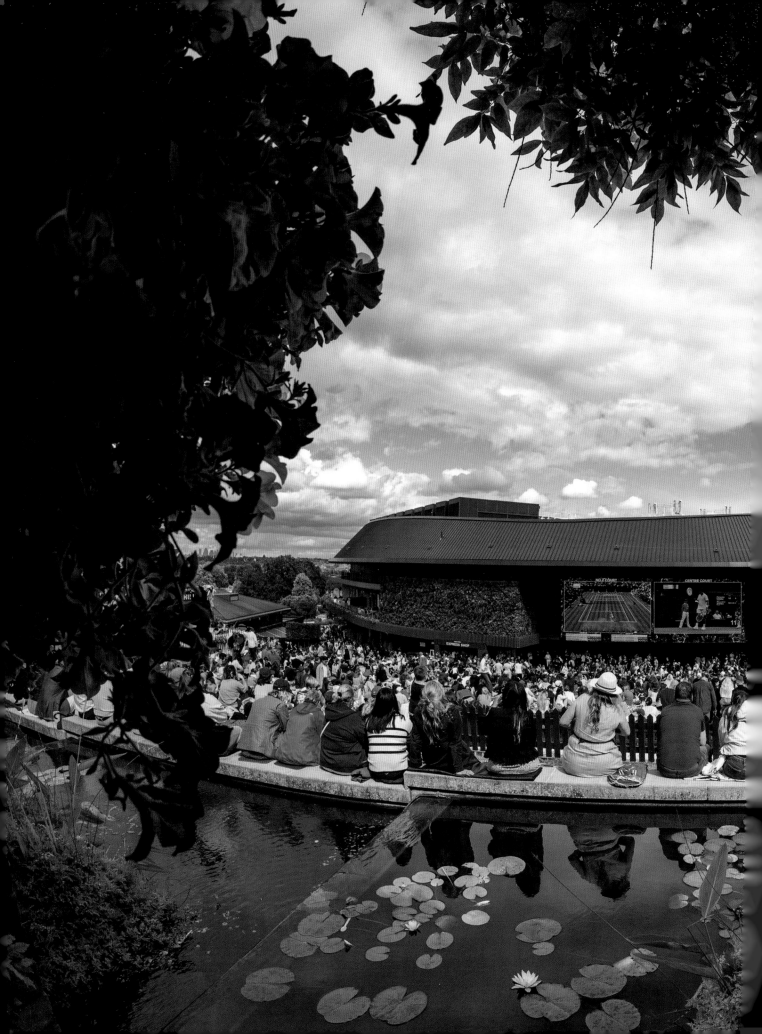

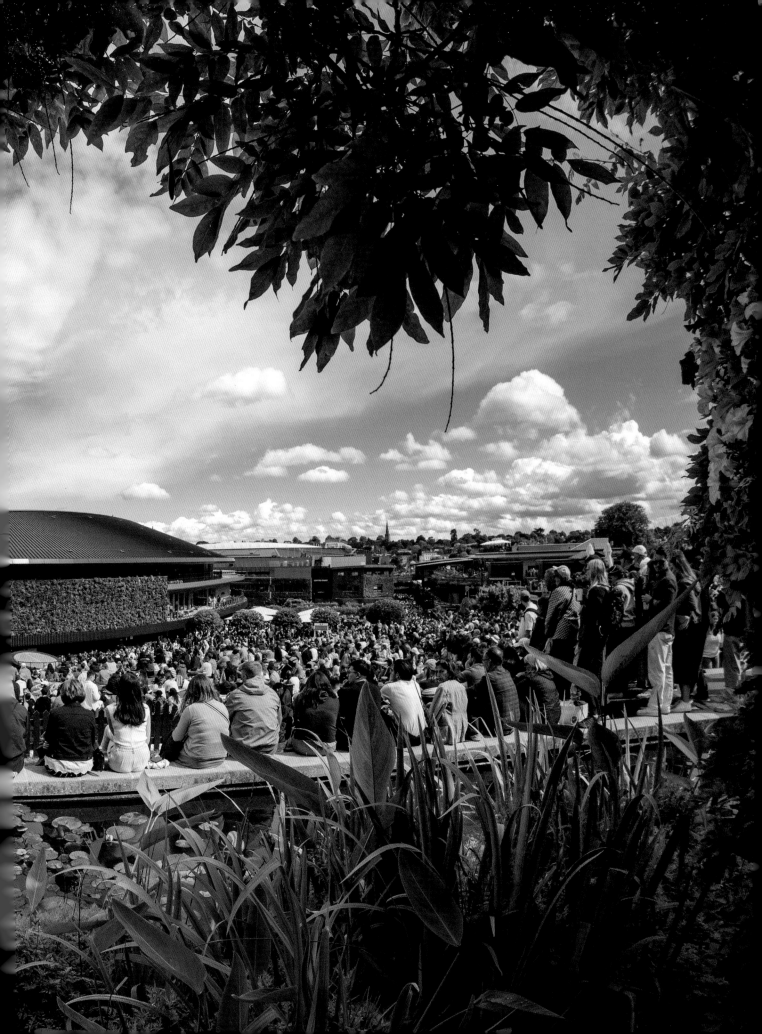

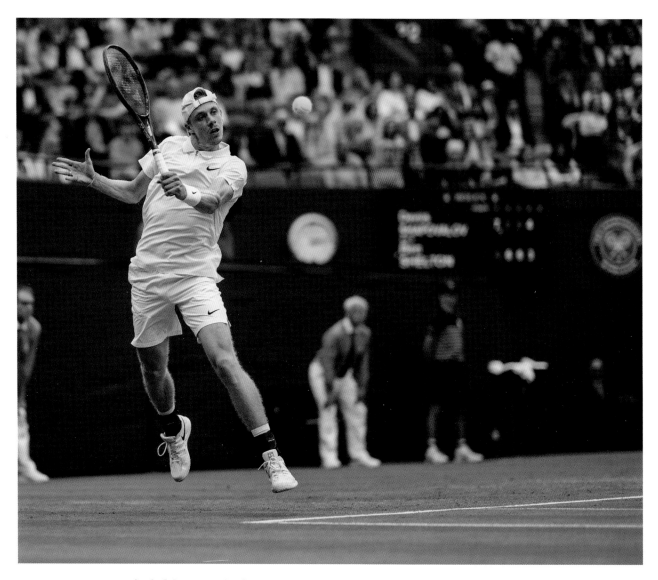

Denis Shapovalov's trademark flying backhand was in good order against Ben Shelton. After two years struggling with a knee injury, it was great to see the young Canadian flying high once again

Andy Murray in the final match of the day on No.1 Court. The scheduling meant she would have had only a limited amount of time to recover before her next singles match the following day. "Unfortunately I woke up with some stiffness in my right wrist this morning," Raducanu said in a statement. "Therefore I have decided to make the very tough decision to withdraw from the mixed doubles tonight. I'm disappointed as I was really looking forward to playing with Andy, but I've got to take care."

Cameron Norrie, the last Briton in the gentlemen's singles, opened the day's programme on Centre Court, where he was beaten 4-6, 4-6, 6-7(15) by Alexander Zverev. It was a tight contest throughout, but Zverev's big ground strokes and booming serve proved decisive. The No.4 seed hit 52 winners and won 66 out of 73 points played when his first serve found the court. Norrie, who saved five match points in an epic tie-break at the end of the third set, said afterwards that he had been very happy with his level of play and felt "really pumped for the rest of the season". Zverev's only concern was a knee injury which he suffered early in the second set after falling awkwardly.

Novak Djokovic recovered from a slow start to record a 4-6, 6-3, 6-4, 7-6(3) victory over Alexei Popyrin, who had also taken a set off the Serb at the Australian Open earlier in the year. Djokovic said he was pleased with his progress given that he had recently had surgery on his right knee.

I LIVE AT
WIMBLEDON
—
REDEEM YOUR DEPOSIT
By returning me to a designated point

DONATE TO CHARITY
By placing me in a charity return point

FOOTBALL STOPS PLAY

England's footballers seem to love putting their fans through the emotional wringer. For 120 minutes (plus penalties) the tennis had to share the limelight as desperate supporters tried to keep up – via phones and tablets – with the Three Lions' progress against Switzerland at Euro 2024. In anticipation of the match, Emma Raducanu *(left)* had worn her England shirt to practice, while Novak Djokovic could only join in with the mood. He was beating Alexei Popyrin on Centre Court when a huge cheer went up: Trent Alexander-Arnold had scored the winning spot kick in Germany – England were through to the semi-finals. Djokovic, realising what had happened, smiled and promptly mimed taking a penalty of his own *(below)*.

Holger Rune celebrates fighting back from two sets down to beat Quentin Halys, the tenth such comeback at this year's Championships – an Open-era record

"I definitely got better today than in my second match in terms of my feeling of movement, my confidence, particularly on extreme balls, reaching, sliding," he said.

Rain was continuing to make life difficult for all those not scheduled to play on Centre Court or No.1 Court. Daniil Medvedev's third round meeting with Jan-Lennard Struff, which had been halted the previous day with the Russian leading by two sets to one, was delayed again by rain before the No.5 seed completed a 6-1, 6-3, 4-6, 7-6(3) victory. "I knew it was going to be a long day," Medvedev said afterwards. "It definitely wasn't easy, but I'm happy to win. I feel good physically, which is important."

Ben Shelton and Denis Shapovalov were also back on court for a second day. After rain had curtailed the action on No.3 Court the previous evening, the two men were no doubt grateful to see the match switched to No.1 Court on the resumption. With Roger Federer watching from the stands, Shelton won 6-7(4), 6-2, 6-4, 4-6, 6-2 to reach the fourth round 30 years after his father, Bryan, achieved the same feat. "We're back, Big Dog!" Shelton told his father, who is also his coach, after securing a fourth round meeting with Jannik Sinner.

Quentin Halys, a 6ft 3in Frenchman with a huge serve, was leading Holger Rune by two sets to one on Court 18 when their match was also switched to No.1 Court. Halys, who had come through Qualifying, appeared to catch Rune off guard with his big game in the early stages, but the No.15 seed fought back to win 1-6, 6-7(4), 6-4, 7-6(4), 6-1. "I managed to raise my level, raise my tennis, when it mattered," Rune said afterwards. "I told myself that today had to be the first time for me to come back from two sets to love down and win – and I managed to do it. I'm extremely proud."

DAILY DIARY DAY 6

Unfazed by any of the excitement on court or, indeed, at the football in Germany, Tara Djokovic was sitting quietly with her mother, Jelena, and brother, Stefan. Daddy was playing and she had come to cheer him on. But four sets and more than three hours of watching is a lot when you are only six. Tara, clearly having been through this before, had thought ahead and brought a book – *Unicorn Academy* – and had her head buried in it for much of Dad's victory. When Dad finally beat Pop, he turned to Tara, put his racket under his chin and mimed playing the violin (Tara is learning to play). What a father has to do to get his daughter to notice him...

• Alexander Zverev was star-struck. Only for a few minutes, mind you, but star-struck nonetheless. As he went through his warm-up with Cameron Norrie, his eye strayed to the Royal Box. He spotted Pep Guardiola. Gulp. Sascha is a football fan; Pep, the Manchester City boss, is one of the best managers in the world. Sascha is a Bayern Munich fan; Pep is a former Bayern manager. Gulp again. Right: try to get the pulse rate down and stop the palms from sweating. After a couple of games, Sascha did just that and secured his place in the fourth round. Afterwards, chatting to the BBC's Rishi Persad on court, he did admit to some early jitters and then he turned to Pep

and offered him a couple of job opportunities should he tire of life in Manchester (a bit of a long shot, mind you). "Bayern Munich needs a coach, man," he said. "And if you're tired of football, you can coach me on a tennis court anytime."

• Pep was a very busy man on the Middle Saturday. After Zverev's match he had a long chat in the Clubhouse with the German star, but Sascha was not the only player seeking an audience with the great man. Liam Broady, who does not so much support Man City as bleed sky blue, was desperate to meet Pep *(above)*. On a huge day for England at the European Championship in Germany, finally he got his chance to talk football with the master tactician. Alas, history does not record their conversation, but Liam was definitely a very happy Man City man.

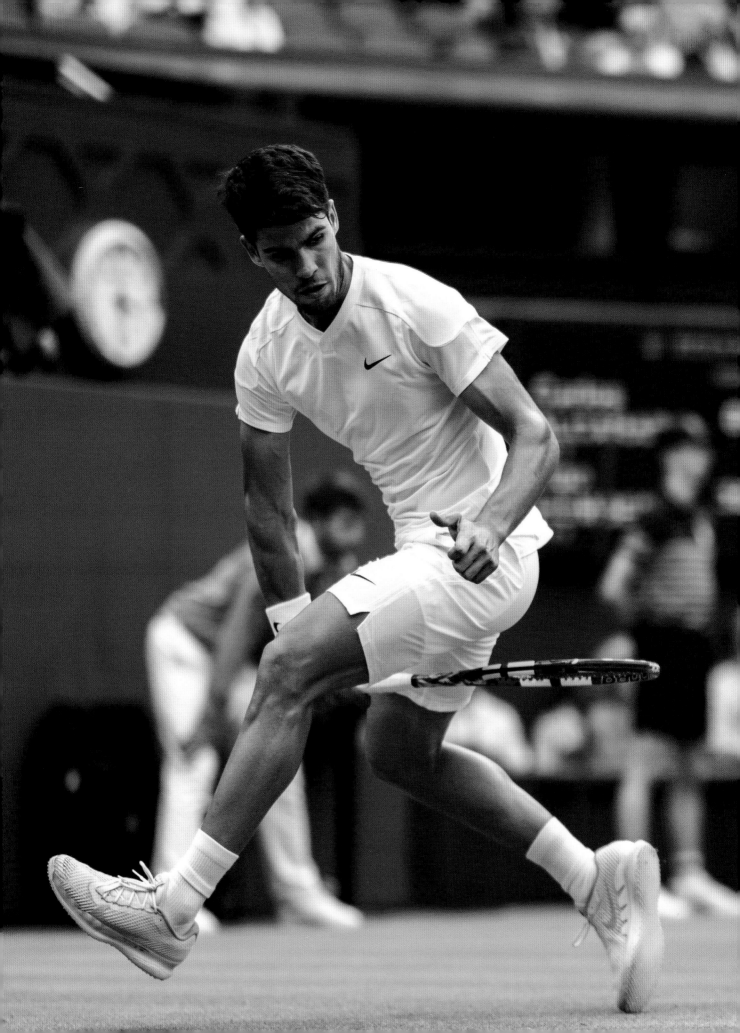

— DAY 7 —

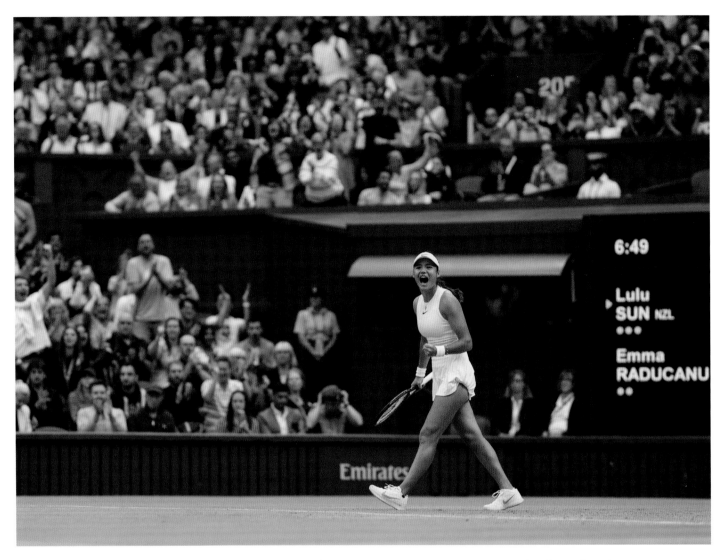

It was raining elsewhere, but Sun shone on Centre Court. Lulu Sun had already made her mark at The Championships by winning three matches in Qualifying and her first three in the main draw, but the world No.123 saved her best for the biggest stage of all.

Above: Emma Raducanu tries to fight back against Lulu Sun but the New Zealander would not be denied

Previous pages: You won't take this from me! The defending champion fought tooth and nail – and tweener – to beat Ugo Humbert of France

Emma Raducanu, who was enjoying her best run at a Grand Slam tournament since her US Open triumph in 2021, had been expected to put Sun in the shade, but the 23-year-old New Zealander kept her cool in the heat of battle to win 6-2, 5-7, 6-2 after two hours and 50 minutes. She was the first qualifier to reach the quarter-finals since Kaia Kanepi in 2010.

Sun, who had lost in the first round on her Grand Slam debut at the Australian Open in January, had never won a main draw match on grass when she arrived at Roehampton to play in Qualifying the week before The Championships. She saved a match point before beating Gabriela Knutson in the second round of Qualifying, survived another tight encounter with Alexandra Eala to secure her place at the All England Club and then claimed an unlikely victory over Zheng Qinwen, the world No.8, on her debut in the main draw. Further wins over Yuliia Starodubtseva and Zhu Lin had earned her the chance to take on Raducanu, whose victories over Elise Mertens and Maria Sakkari had raised hopes that the last Briton left in singles could make further progress.

Sun, who said she had learned some useful lessons about grass court tennis by watching matches involving Steffi Graf, Martina Navratilova and Roger Federer on YouTube, played like a seasoned

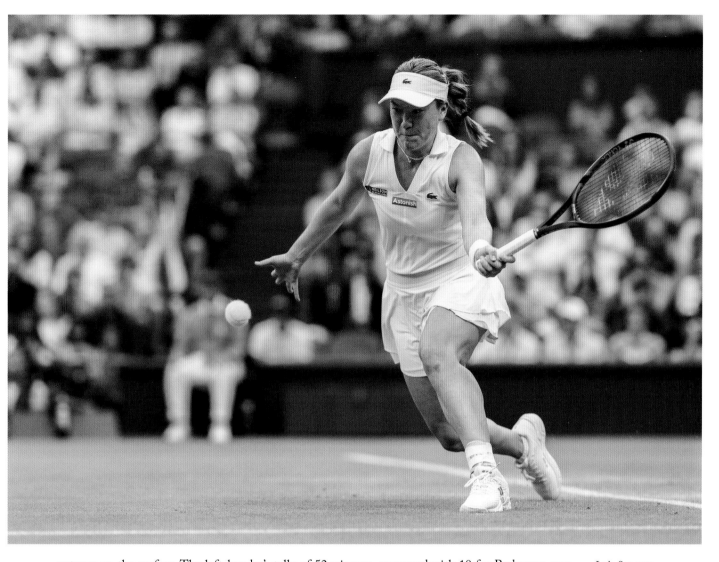

Lulu Sun was in her element – illuminating Centre Court to become the first qualifier to reach the quarter-finals since 2010

veteran on the surface. The left-hander's tally of 52 winners, compared with 19 for Raducanu, was evidence of her determination to take the game to her opponent, who looked nervous from the start and did not strike the ball with her usual conviction. Sun, in contrast, hit her ground strokes with venom, attacked the net when the opportunity arose and constructed her points with intelligence and purpose. She also remained unflappable, even in the face of Raducanu's comeback in the second set.

"Staying aggressive was definitely a key point to the match," Sun said afterwards. "Getting her to move and make her defend was what I wanted, because as soon as she gets aggressive on her side my chances get smaller." Raducanu said that when she had set out on her comeback at the start of the year following wrist and ankle surgery she would have happily settled for a run to the fourth round at The Championships. "I gave my best," she added. "Her tennis was better and she deserved the win."

Sun became the first player representing New Zealand to reach the ladies' singles quarter-finals. Born on the country's South Island to a Croatian father and Chinese mother, she moved to Switzerland at the age of five and competed for several years under the Swiss flag. After playing college tennis for the University of Texas she eventually switched her allegiance back to New Zealand. "I was born in New Zealand and my family is still there," she said. "I grew up in Switzerland as well. Both countries are dear to me."

One Emma had fallen before the quarter-finals, but in the following match on Centre Court another made it to the last eight in highly impressive fashion. Emma Navarro had taken only four games off Coco Gauff, her fellow American, in their only previous meeting in Auckland at the start of the year, but turned the tables on her as the Centre Court crowd looked on, winning 6-4, 6-3 to secure a place in the last eight of a Grand Slam tournament for the first time. Gauff, the No.2 seed –

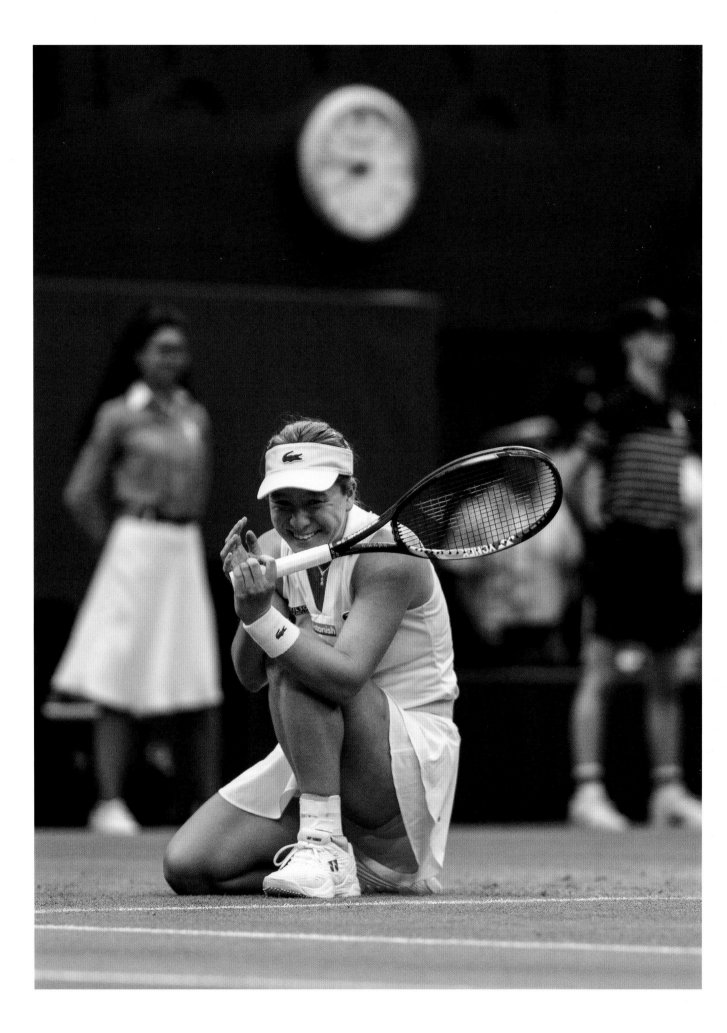

who was the only man or woman to reach the semi-finals or better of the previous three Grand Slam events – was outplayed in all departments. The US Open champion's forehand repeatedly misfired, while the No.19 seed was a model of consistency.

Gauff's frustration was evident as she repeatedly looked helplessly towards the players' box and her coach, Brad Gilbert. "Tell me something," she shouted to her team at one point. "You guys aren't saying anything." Gauff explained later: "We had a gameplan going in. I felt that it wasn't working. I don't always ask for advice from the box. Today was one of those rare moments where I felt I didn't have solutions. I definitely have to learn from today because it's not going to be the first or last time that a player plays a great match against me. When those moments happen I have to figure out how to raise my level."

Navarro, who is known in her family as 'Ice Girl', remained focused and looked much less nervous than her father, Ben, who is a billionaire businessman. His anxiety was evident throughout the match as he watched his daughter knock out another Grand Slam champion on Centre Court following her victory over Naomi Osaka in the second round. "I've been way more comfortable playing on that stage than I would have thought I would have felt," Navarro said. "Maybe the accumulation of a lot more experiences on stages and in stadiums like that have allowed me to be more comfortable playing in that type of environment."

Another American looked poised to secure her place in the quarter-finals when Madison Keys served at 5-2 and 40-40 in the deciding set against Jasmine Paolini on No.1 Court. However, the

Opposite: The moment of victory – after three sets and 52 clean winners, Lulu Sun celebrates her win over Emma Raducanu

Below: At home they call her 'Ice Girl', and Emma Navarro was certainly as cool as ice as she outplayed Coco Gauff in two sets

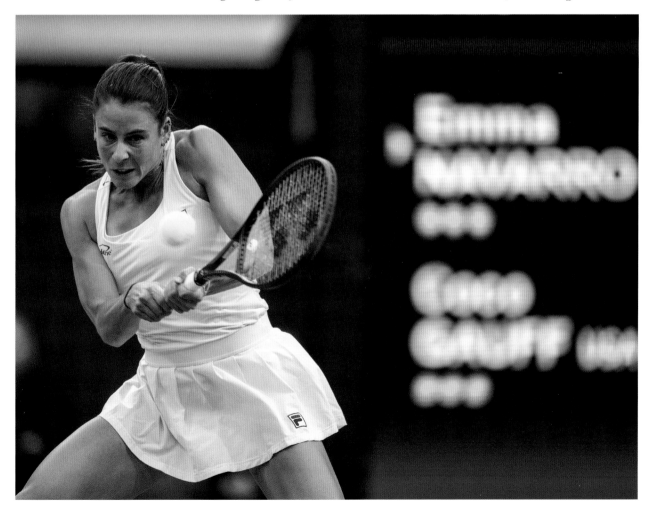

ANYONE WHO IS ANYONE

During the Fortnight, the guest list for Centre Court read like a veritable who's who of entertainment and sport. *This page, clockwise from top left:* Singer Beverley Knight; Duran Duran frontman Simon Le Bon; actress Hannah Waddingham; Stephen Fry; TV chef Andi Oliver; Tony Adams; Joanna Lumley; the ever-youthful Sir Cliff Richard; Novak Djokovic takes a selfie with actress Rebel Wilson. *Opposite page, from left to right and row by row:* Baroness Benjamin of Beckenham alongside David Beckham and his mother, Sandra; Julia Roberts; Michael McIntyre; HRH Princess Beatrice; Hugh Grant; Sienna Miller, Tom Cruise; Grace Jones; Will Ferrell; Lisa and Dustin Hoffman.

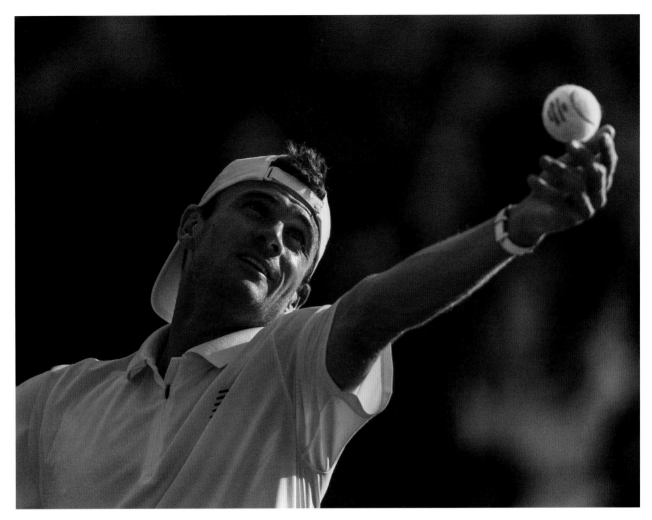

No.12 seed suffered a hamstring injury in losing that game and thereafter struggled even to walk between points. After taking a medical time-out off the court, Keys looked in distress as Paolini levelled the score at 5-5. Two points into the next game Keys retired and left the court with tears streaming down her face. "I'm so sorry for her," Paolini said afterwards. "We played a really good match. It was really tough, with lots of ups and downs."

While play had progressed smoothly under the two roofs, it was a stop-start day elsewhere. Donna Vekic was scheduled to begin her fourth round match on No.2 Court at 11am, but it was not until after 6pm that Paula Badosa missed a forehand to give the Croatian a 6-2, 1-6, 6-4 victory and a place in the quarter-finals for the first time. There was still another match to play on No.2 Court, so Tommy Paul and Roberto Bautista Agut were grateful to see the weather improve in late afternoon. Paul clearly had no intention of hanging around any longer and won 6-2, 7-6(3), 6-2 in just over two hours.

With the tournament behind schedule, the Referee's Office announced that a first-to-10-points match tie-break would replace any third sets in the mixed doubles. A succession of lengthy five-set matches in the gentlemen's singles had not helped with the schedule. Ben Shelton had been responsible for three of them and went into his fourth round encounter with Jannik Sinner knowing that another could see him become the first player in Grand Slam history to win four five-set matches in succession. However, the American's latest marathon, against Denis Shapovalov, had finished only 24 hours earlier and Sinner was just the man to take advantage of any weariness in

Above: Tommy Paul made the most of a break in the weather to speed past Roberto Bautista Agut in straight sets

Opposite: This wasn't just rain; this was a deluge. People sheltered from the torrent as best they could, and when it was over the groundstaff swiftly got to work

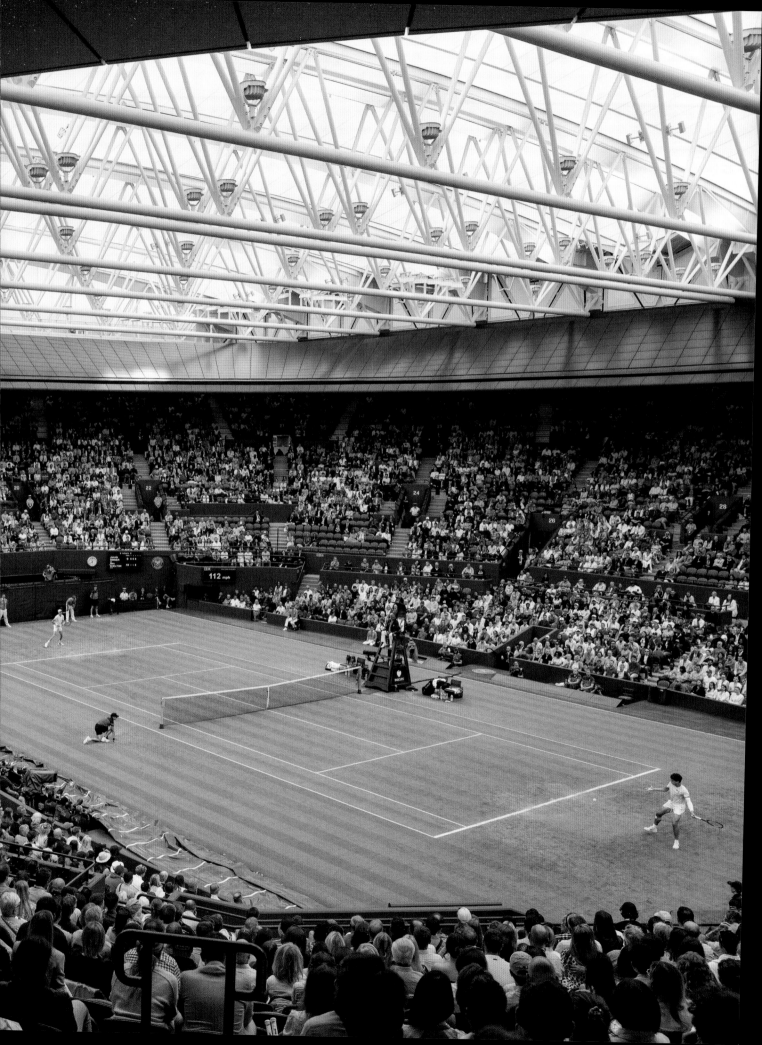

the 21-year-old's legs. The world No.1 won 6-2, 6-4, 7-6(9), with Shelton coming to life only in the third set. He went 3-0 up and then forced a tie-break before Sinner completed his victory in two hours and nine minutes. It meant that the Italian had made the quarter-finals or better of every tournament he had played so far in 2024.

Previous pages:
Protected from the elements, Jannik Sinner moved past Ben Shelton in three sets

Below: It was not the way Daniil Medvedev (right) wished to progress as, after only eight games, Grigor Dimitrov (left) was forced to withdraw from their fourth round match due to injury

Carlos Alcaraz was pushed hard again, this time by France's Ugo Humbert, who broke the defending champion's serve five times and hit more winners than his opponent (47 to 45) before going down 3-6, 4-6, 6-1, 5-7 in an entertaining three-hour encounter on Centre Court. Alcaraz dropped his serve three times in a row in the third set and twice more in the fourth as Humbert went on the attack. Serving at 3-4 in the fourth set, Alcaraz held serve from 0-40 down and went on to take the match by winning the last three games. Despite his wobbles on serve, Alcaraz was happy with his progress. "I'm feeling great on the court," he said. "I think I'm getting better and better every match that I'm playing."

Daniil Medvedev was happy to be back on his favourite No.1 Court, but the No.5 seed did not progress to the quarter-finals in the way he would have wanted after Grigor Dimitrov retired hurt when 5-3 behind in the first set. Dimitrov had gone 3-0 up, only to suffer a groin injury when he slipped on the playing surface. At 3-2 the Bulgarian called for the trainer and subsequently left the court for treatment, but when he returned it soon became clear that he would be unable to continue. "I feel sorry for Grigor," Medvedev said afterwards. "I told him at the net. We've had so many great matches, great points, great three-setters. Sometimes he wins, sometimes I win. I was looking forward to playing him on grass."

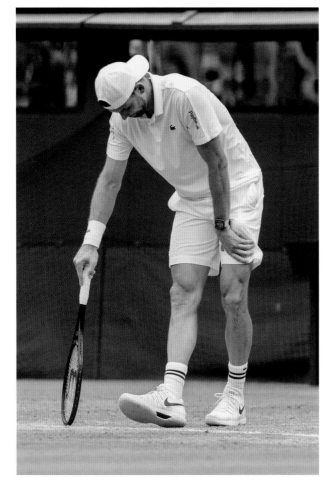

DAILY DIARY DAY 7

Mums are the same the world over and Lulu Sun's is no exception. No matter that her daughter had reached her first Wimbledon quarter-final; no matter that by beating Emma Raducanu on Centre Court she was now the talk of Wimbledon and no matter that by reaching the last eight she had more than doubled her career earnings – Mum had issued her instructions. What were the first words she said to Lulu *(above)* after her victory? Apart from a couple of emojis messaged to her phone, the new superstar was told: "OK, you need to come back home quickly and we need to recover," Lulu said. "I was like, 'OK, thanks, Mum.'"

• Ben Shelton was dog tired. He had lost to Jannik Sinner in straight sets. Thanks to the rain-disrupted schedule, he had been on court for six of the last seven days and had played 17 sets of tennis in singles and doubles, six and a half of them the previous day. But why? As his schedule began to back up, why did he not make his excuses and simply pull out of the doubles to conserve his energies for the singles? Because Ben is not made that way. He had made a commitment to play with Mackenzie McDonald and he would honour it, no matter what. "I signed up to play doubles," he said. "That's my decision. I think a lot of people probably would have pulled out of doubles in that situation, but I didn't want to do that to my partner. I'm not just going to pull out on the guy. Just

kind of wasn't raised that way." And then he went back out to play another set of doubles.

• With 37 years on the clock and a knee that has endured more than its share of wear and tear, you would think that the seven-time Gentlemen's Singles Champion would relish a day off. Not a bit of it. Novak Djokovic volunteered for some overtime with the groundstaff as they rolled back the covers on the practice courts *(below)* – and that task is a lot harder than it looks. The world No.2, one of the fittest men on tour, joined a dozen or so members of staff as they got the courts ready for play and, it has to be said, he did look like he had been through a proper workout.

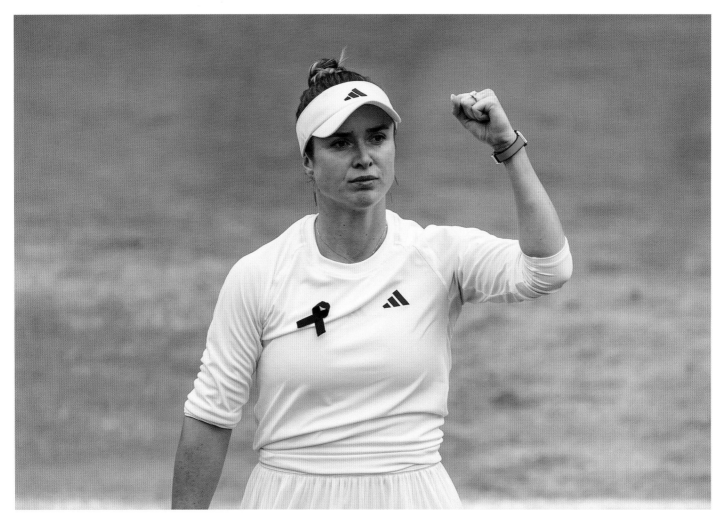

Sport can be a glorious escape from the harsh realities of life, but there are times when events in the wider world weigh heavily on us all. Nobody knows that better than Ukrainians following the invasion of their country by Russia in 2022. Although most Ukrainian professional tennis players had continued to compete around the world, the fate of their compatriots back in their homeland was never far from their minds.

Above: Ukraine's Elina Svitolina wears a black ribbon in remembrance for those lost in the Russian missile attacks on her homeland that morning

Previous pages: Jelena Ostapenko launches into another backhand on her way to victory over Yulia Putintseva

On the morning of Day 8 at The Championships news had broken of Russian missile attacks on targets across Ukraine. One had hit the Ohmatdyt children's hospital in Kyiv. There had been a number of casualties and footage from the scene had shown children being evacuated, some of them still connected to IV drips.

Quite how anyone can focus on a tennis match after hearing news like that is difficult to comprehend, but Elina Svitolina had grown accustomed to competing in such circumstances. The 29-year-old Ukrainian wore a black ribbon on her top when she went on to No.2 Court to face China's Wang Xinyu. She put aside her sadness long enough to complete a 6-2, 6-1 victory over the world No.42. However, during her on-court interview after the match Svitolina burst into tears. "Today is a difficult day for Ukrainian people," she said. "It wasn't easy to focus on the match. Since the morning it was difficult to read the news. To go on the court is extremely tough."

Later, Svitolina told reporters that using her platform to highlight her country's plight was one of her motivations. "I have to put my head down and show up and do my best, my very best," she said.

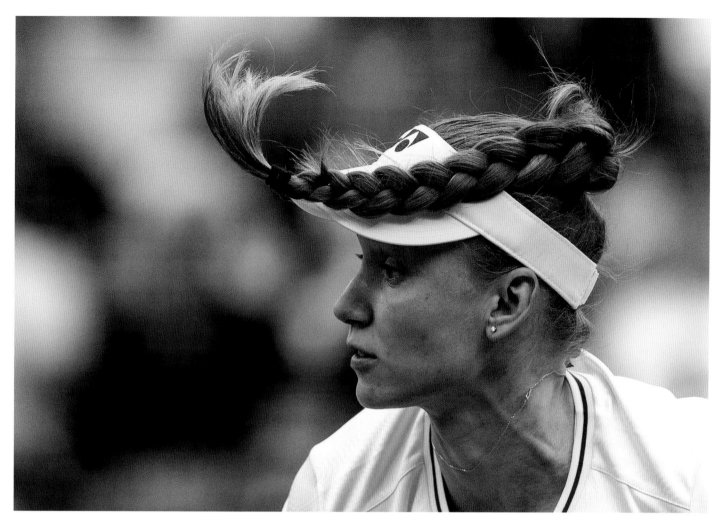

"Every Ukrainian is using their own way to raise awareness, to raise money, to help in every possible way they can. My way is through tennis."

Although Svitolina has never played in a Grand Slam final, she has remained one of the most consistently successful players of recent years, even after taking a maternity break. Following her return to competition in 2023 after giving birth to Skai, the daughter she had with her husband Gael Monfils, Svitolina had reached the quarter-finals or better in three of the last six Grand Slam tournaments.

If Svitolina was to match her previous best runs at The Championships, having reached the semi-finals in both 2019 and 2023, she would now have to beat Elena Rybakina. The 2022 Ladies' Singles Champion became the latest player to benefit from a retirement when Anna Kalinskaya quit with a wrist problem when trailing 3-6, 0-3. The No.17 seed had broken Rybakina in the opening game and taken a 3-1 lead but lost the next eight games.

Yulia Putintseva, Iga Swiatek's conqueror in the third round, lasted just 68 minutes against Jelena Ostapenko, who won 6-2, 6-3 under the No.1 Court roof on another day disrupted by rain. The defeat could have been even heavier, with Putintseva winning just seven points as Ostapenko raced into a 5-0 lead. "I feel like my level is really good," the 2017 Roland-Garros champion said, having dropped only 15 games in her first four matches. "I'm just trying to play my game and be aggressive in the deciding moments especially. I think that's the key."

Another former Roland-Garros champion, Barbora Krejcikova, had also run into good form. The 28-year-old Czech moved into the quarter-finals for the first time with a 7-5, 6-3 victory on No.1 Court over Danielle Collins in what was the last match the American would play at The Championships before retiring. Collins, who had been hampered by a leg problem in the second set, said afterwards that it had been "an honour" to play at Wimbledon. "I think this is a lot of players' favourite Slam," she added. "It's certainly up there for me. I will miss coming here."

Former champion Elena Rybakina's place in the quarter-finals was assured when Anna Kalinskaya retired with a wrist injury in the second set

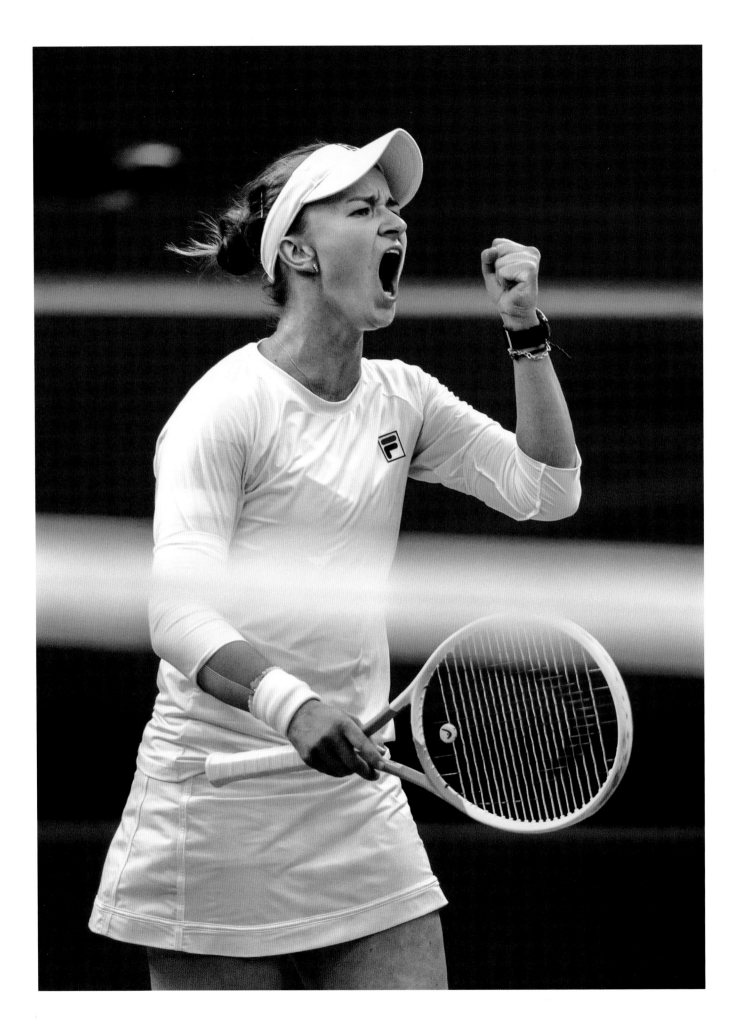

Collins was not the only player to suffer with a physical issue. Alexander Zverev said after losing in five sets to Taylor Fritz that he had been playing "on one leg", while Alex de Minaur suffered a hip injury on the very last point of his victory over Arthur Fils.

Zverev had hurt his knee two days earlier during his fourth round victory over Cameron Norrie and was wearing a protective support, though there did not seem much wrong with the No.4 seed as he took the first two sets on Centre Court in a heavyweight contest dominated by huge serves and potent ground strokes. The German had been serving superbly, but at 4-4 in the third set he made two double faults and was broken for the first time at these Championships. Fritz took the fourth set on a tie-break and won the match after breaking serve in the fourth game of the decider. It was quite a contrast to the American's last match on Centre Court two years earlier, when he had lost to Rafael Nadal in a marathon quarter-final.

Zverev told reporters that he had been unable to walk the previous day but had decided to play because he was feeling better on the day of the match. However, he added: "I wasn't moving really the entire match. If I was running for a dropshot, I was limping there more than running. There weren't really any long rallies because I couldn't play long rallies. Credit to him that he came back, but it wasn't a great tennis match."

That all seemed to be news to Fritz, who thought the match had been "extremely normal" until he broke Zverev in the deciding set. The No.13 seed added: "Even though I lost the first two sets, I really

Opposite: Barbora Krejcikova celebrates her place in the last eight after beating Danielle Collins in straight sets

Below: Alexander Zverev, hampered by a knee injury, was slowly reeled in by Taylor Fritz over five sets

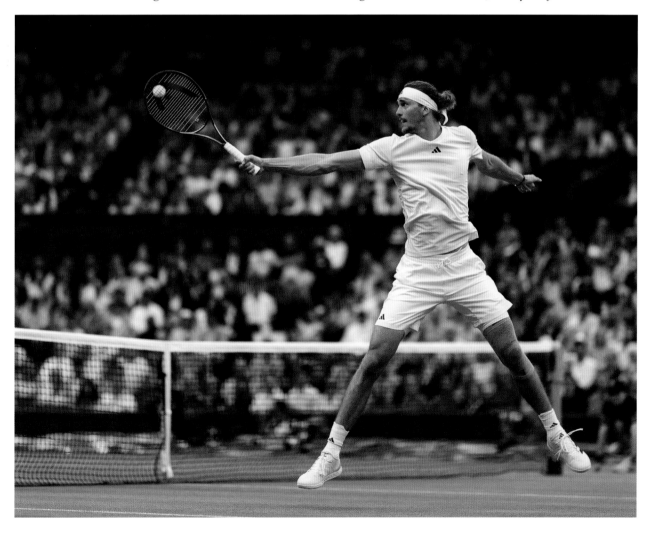

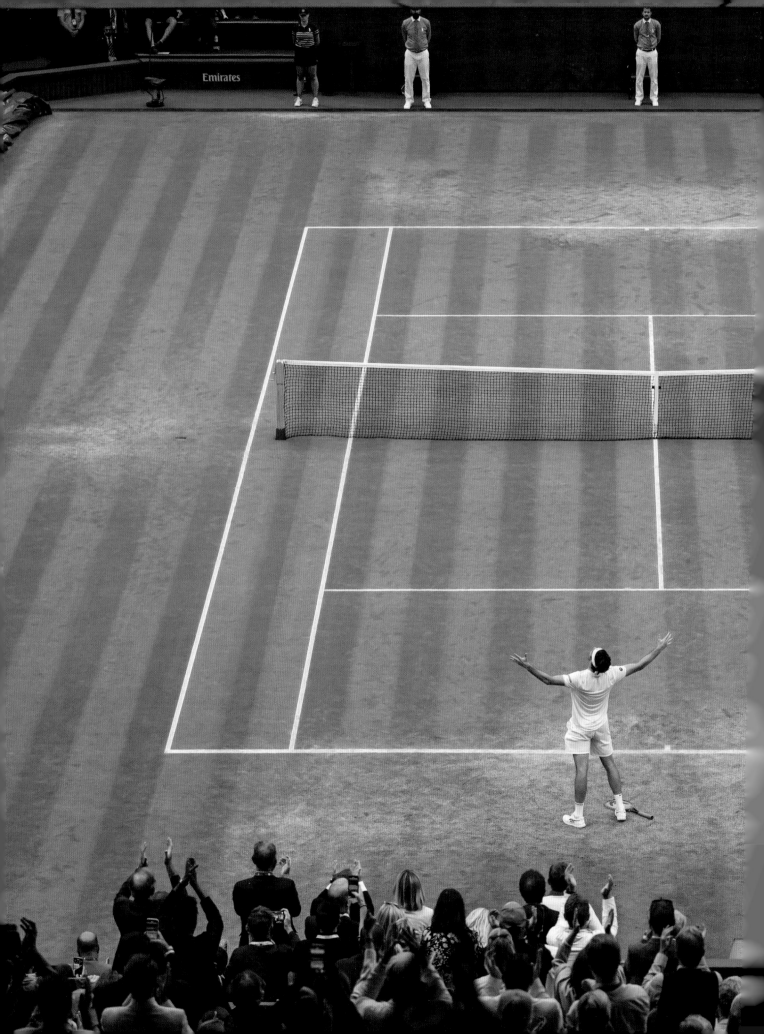

114 mph

*Taylor triumphs –
it had taken Taylor
Fritz nearly three
and a half hours but
he had finally got the
better of Alexander
Zverev*

VILLAGE IN FULL BLOOM

The competition is always fierce; the contestants know each other's games only too well. But this is not Centre Court; this is the Wimbledon Village Tennis Windows Competition. An annual test of artistic flair and ingenuity, the tennis-themed displays of the village's shops, restaurants and bars are judged on their impact, creativity, effort and more. From the giant strawberries outside The Ivy *(above, left)* to the painted window fronts at Hemingways *(opposite, top)* – who would win? All would be revealed tomorrow *(see Day 9 Diary)*.

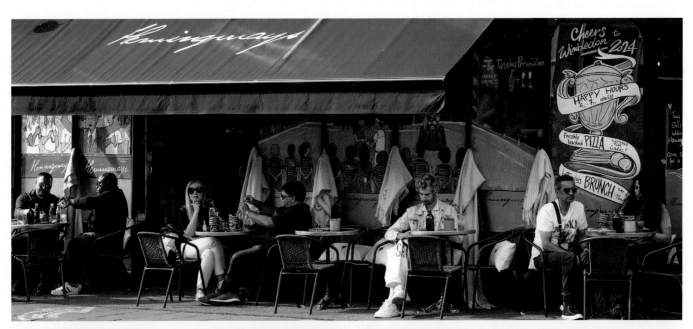

Above: Despite a late rally from Arthur Fils (left), Alex de Minaur (right) was always in control as he reached his second consecutive Grand Slam quarter-final and his first at Wimbledon

Opposite: Resistance is futile – Holger Rune tried to make a fight of it but Novak Djokovic simply would not let him, the Serb eventually triumphing in straight sets

believed I was playing good tennis. I felt it was just a couple of points here and there and that I could take it one step at a time and turn it around."

De Minaur dropped his first set at this year's Championships but still beat Arthur Fils with something to spare. The No.9 seed, who won 6-2, 6-4, 4-6, 6-3 in just under three hours on No.1 Court, appeared to be heading for another straight-sets victory when he led 4-2 in the third set, but Fils refused to capitulate. The 20-year-old Frenchman, making his first appearance in the second week of a Grand Slam event, won four games in a row to take the set. Even when de Minaur served for the match at 5-2 in the third set Fils hung on, breaking for the fifth time in the match, but the 25-year-old Australian responded admirably in the next game to secure a place in the quarter-finals for the first time.

However, the match ended on a concerning note for de Minaur when he hurt his hip during the very last point. At the time the look of concern on his face suggested that the problem might be serious, though he downplayed the injury at his post-match press conference. "I'm sure I'll be feeling great tomorrow," he said.

Giovanni Mpetshi Perricard, who was celebrating his 21st birthday, threatened to extend his barnstorming run when he took the first set off Lorenzo Musetti, but the big-serving 6ft 8in Frenchman was unable to maintain the pace and was beaten 6-4, 3-6, 3-6, 2-6. Mpetshi Perricard ended The Championships with 115 aces from his four matches but was broken five times by Musetti, who was through to his first Grand Slam quarter-final.

The 22-year-old Italian now had to reach only 59 more quarter-finals to catch up with Novak Djokovic, who secured a place in the last eight of The Championships for the 15th time when he beat

Holger Rune 6-3, 6-4, 6-2 in just over two hours on Centre Court. Rune had been expected to give the seven-time Gentlemen's Singles Champion his biggest test yet, but the 21-year-old Dane never recovered after losing the first 12 points.

During the match Djokovic became irritated by some of his opponent's fans, who supported their man with drawn-out chants of "Ruuuune!" The chants, which Djokovic seemed to interpret as boos directed at himself, grew louder and louder as Rune saved six set points at the end of the second set. After taking the set at the seventh time of asking Djokovic appeared to mimic the fans' chanting and in the third set he covered his ears to indicate that he was blocking out their noise. When he mimicked playing a violin with his racket at the end of the match – something he had done after his previous match in recognition of his daughter's violin lessons – some spectators thought the Serb was mocking the Rune fans' sorrow in defeat.

Djokovic's irritation boiled over in his on-court interview. "To all the fans that had respect and stayed here tonight, thank you very much from the bottom of my heart, I appreciate it," he said. "And to all those people that have chosen to disrespect the player, in this case me, have a gooood night. Gooood night. Gooood night."

And it's gooooood night from him – Novak Djokovic makes his point to those in the crowd he thought had booed him

When it was put to Djokovic that the fans had simply been chanting his opponent's name and were not booing him, the Serb insisted that was not the case. "I know they were cheering for Rune, but that's an excuse to also boo," he said. "I have been on the tour for more than 20 years. Trust me, I know all the tricks. I know how it works." He added: "I have played in much more hostile environments, trust me. You guys can't touch me."

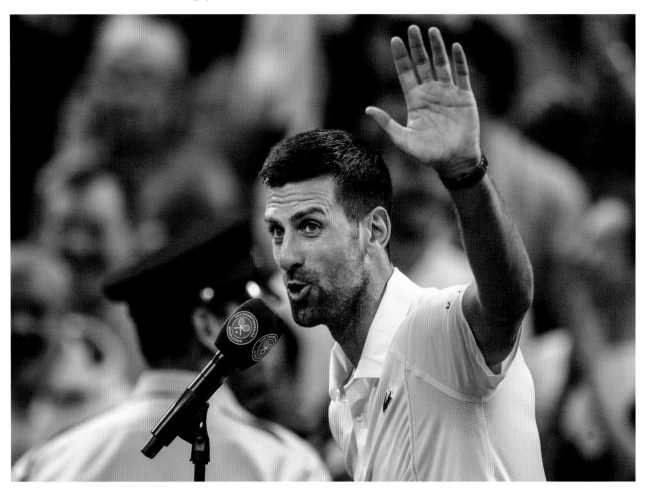

DAILY DIARY DAY 8

At home, more than 3,500 miles away, a tall American heaved a sigh of relief. John Isner, all 6ft 10in of him, was still the King of the Aces. At The Championships 2018 he served a record 214 aces, a number few thought could ever be beaten. But then along came Giovanni Mpetshi Perricard (above, right). The 6ft 8in Frenchman, who had earned his spot in the main draw as a lucky loser in the Qualifying event, seemed determined to make his mark at SW19. By the time he faced Lorenzo Musetti, he had delivered 105 clean aces (51 of them in the first round) and 189 unreturned serves. It was not enough to beat Musetti, though, and as Giovanni began to tire, he could only manage another 10 thunderbolts before his Wimbledon was over. Big John's record was safe – for another year.

• Luke Donald, sitting in the Royal Box, must have wondered what all the fuss was about. Novak Djokovic was upset as he powered past Holger Rune; he thought the crowd was booing him. In fact, they were just chanting "Ruuuuuune! Ruuuuuune!", as the Dane's fans are wont to do. The Ryder Cup captain knew all about this: he has spent his playing days being followed by a loyal band of supporters who greet his every chip and putt with long cries of "Luuuuuuke! Luuuuuuke!" which,

to the uninitiated, sounds very much like booing but isn't. If only Novak had asked Luke...

• Jelena Ostapenko (below) was enjoying herself. The 27-year-old Latvian was back to her best, playing as she had when she won Roland-Garros in 2017, the first title of her career. The following summer she reached the semi-finals here but, since then, it has been slim pickings. Now, though, she was through to the quarter-finals with a straight-sets romp past Yulia Putintseva. And she was smiling. "I feel like they kind of like me here," she said. She thought the crowd's affection for her stemmed from when she won the junior title 10

years ago; the pundits thought it had more to do with her high-octane, high-risk, go-for-the-winner approach. She chuckled and explained her tactics: "I have the ability to hit the ball hard, so why shouldn't I use it?" Tennis is a very simple game when put like that.

– DAY 9 –

TUESDAY 9 JULY

T
hank goodness for the retractable roofs over Centre Court and No.1 Court. After eight days during which the busiest people at The Championships had probably been the groundstaff responsible for pulling the court covers on and off, the weather on Day 9 actually took a turn for the worse.

Previous pages: No matter which way you looked – and this aerial view takes in almost all of the Grounds – it was wet and miserable

With rain falling from morning through to late afternoon, the only matches completed away from the two main Show Courts were three in the first round of the mixed doubles. The first day of Wheelchair events was washed out completely. It was a frustrating time for many spectators, but at least those who had bought tickets for No.2 Court or a Grounds Pass before 5pm were entitled to a full refund.

By now there was no way that the mixed doubles final could be played on its scheduled day on the second Thursday, so plans were put in place to move it to the final Sunday, with the gentlemen's and ladies' doubles finals to be played the previous day. In the circumstances it was quite an achievement that the gentlemen's and ladies' singles remained firmly on schedule. Imagine what those two competitions would have been looking like without the two roofs.

Another factor in the backlog was the number of five-set matches in the gentlemen's singles. When the first match of the day on Centre Court went the distance, Daniil Medvedev beating Jannik Sinner 6-7(7), 6-4, 7-6(4), 2-6, 6-3, it was the 36th gentlemen's singles match at The Championships to go to five sets, which broke the record for a Grand Slam tournament in the professional era. There had

As the rain continued to pelt down, the lights under the Centre Court roof glowed in the gloom. Everywhere else, the courts remained covered all day

also been no 6-0 sets in the gentlemen's singles, which remained the case through to the end of the Fortnight – another first in the history of Grand Slam tournaments.

Medvedev's victory was a notable upset given he had lost his five most recent matches against Sinner, but the surprise was that the world No.1 lasted as long as he did. Sinner had fallen ill in the morning and felt tired and dizzy during the match. He sent for the doctor early in the third set and then left the court to take a medical time-out. Although his health seemed to improve as the match progressed, it was clear that he was still well below his best.

"Already this morning I didn't feel great," Sinner said afterwards. "Then, with the fatigue, it was tough, but I don't want to take anything away from Daniil. I think he played very smart. He played good tennis. I didn't want to go off the court, but the physio told me it would be better to take some time because he could see that I didn't seem in shape to play. I was struggling physically. It was not an easy moment, but I tried to fight with that what I had. I never thought about retiring. For sure the crowd helped me a lot, trying to push me. You don't want to retire in the quarter-final of a Grand Slam."

The result might even have been different if Medvedev had not saved two set points towards the end of the third set, which he eventually won on a tie-break. Although Sinner won the fourth set, Medvedev quickly took a 4-1 lead in the decider and went on to complete his victory after exactly four hours.

The No.5 seed said afterwards that it had been important to win given his recent record against Sinner, who had come back from two sets down to beat him in the Australian Open final at the start of the year. "It was important to show that I'm always going to be there, I'm always going to fight, I'm always going to try to make your life difficult," he said.

Above and opposite, bottom: Jannik Sinner had beaten Daniil Medvedev five times in a row but it was not to be in this year's quarter-finals. Feeling unwell when he woke up, he became dizzy during the match and needed medical attention

Opposite, top: Medvedev said he knew how to make Sinner suffer – "in a good way" – and he did just that as the No.5 seed reached his second consecutive Wimbledon semi-final

Having beaten one of the two younger men who had been dominating world tennis of late, Medvedev would now take on the other in the semi-finals in three days' time after Carlos Alcaraz came from behind to beat Tommy Paul 5-7, 6-4, 6-2, 6-2 in a highly entertaining contest on No.1 Court.

With Spain's footballers taking on France that evening in the European Championship semi-finals, Alcaraz had probably hoped to finish in plenty of time to watch his compatriots on television, but if so he had reckoned without Paul's flying start. The 27-year-old American, who had just succeeded Alcaraz as Queen's Club champion, dominated the early stages by coming forward at every opportunity and attacking the Spaniard's serve. Paul went a set and a break up before Alcaraz started to turn the contest around, largely by making big inroads into his opponent's service games. By the end of the match Alcaraz had forced 27 break points, converting eight of them.

"At the beginning of the first set and the beginning of the second, it was like I was playing on clay, with big rallies, over 10 or 15 shots on every point," Alcaraz said later. "I had to stay strong mentally when I lost the first set. It was a little bit difficult for me, but I knew this was a long journey, a really long match, so I just had to stay in there."

Despite Paul's defeat, it had been a good fortnight so far for Americans. Seven men and women had made it to the fourth round in singles, which was the most in 20 years, and three had gone on to the quarter-finals. There were high hopes in particular for Emma Navarro, who had already beaten Naomi Osaka and Coco Gauff and was now facing Jasmine Paolini with a semi-final place at stake.

Navarro, who had never gone this far at a Grand Slam tournament before, had beaten Paolini in all three of their previous meetings, but the 28-year-old Italian was on a sharply upward curve. She had

Raindrops on roses may have been one of Maria's favourite things in 'The Sound of Music', but everyone had had enough of raindrops on anything at The Championships

just reached the final at Roland-Garros and was rapidly finding her feet on grass, having never won a tour-level match on the surface before this year. Navarro made the first break of serve, in the third game, but from that moment everything went downhill for the world No.17. The American has a big game, but Paolini's crunching forehand quickly became the most telling shot in the match. In less than an hour Paolini completed a 6-2, 6-1 victory that was every bit as convincing as the scoreline suggested.

"She was a totally different player today than when I played her in the past," Navarro said. "I felt like in our previous meetings I was the aggressor, I was the one controlling points, getting ahead at the beginning of points, then controlling the rallies too. I felt just the opposite of that today. I felt like she was just on top of me from the very first point. I struggled to push back against that. I feel like she served really well too."

Paolini, who became the first Italian to reach the last four of the ladies' singles, said she had told herself before the start that this match would be different to the three recent defeats she had suffered against Navarro. "My forehand was working really well today," she added. "I was trying to hit the ball hard because if I didn't she was going to control the point."

Following page: Jasmine Paolini celebrates after beating Emma Navarro for the loss of only three games

Below: Carlos Alcaraz begins to find a way back after dropping the first set to Tommy Paul

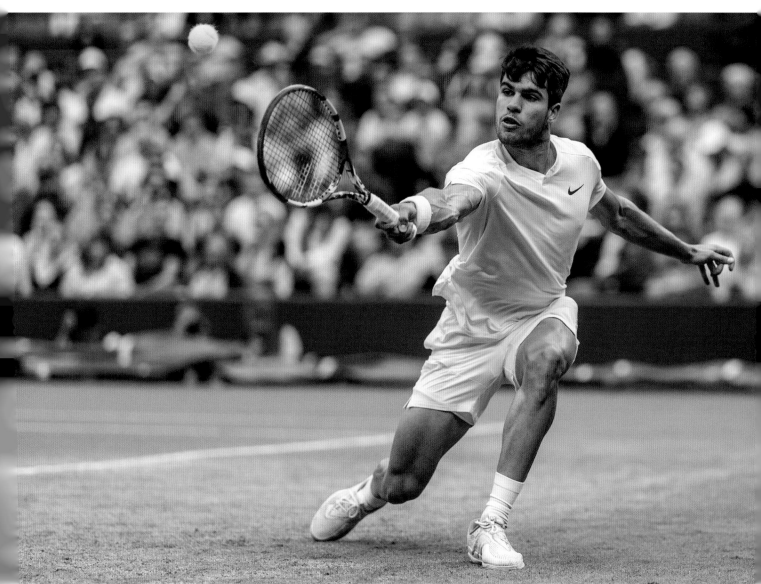

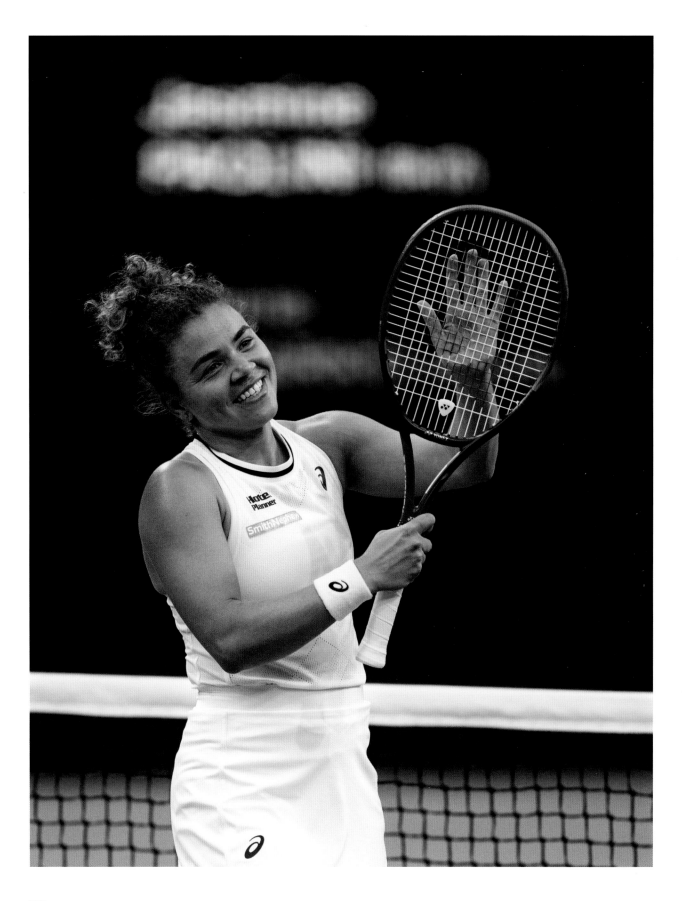

IN AT THE DEEP END!

—

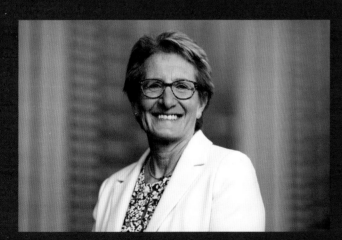

"I love a challenge and, honestly, being British, if I'm not used to rain on tennis courts by now, there's something wrong with me," Denise Parnell said cheerily. Such a positive outlook was vital in her first year as Championships Referee – the weather was atrocious from Day 2 until the middle of the second week.

Parnell *(pictured, left)* has been working with the Championships Referee's Office since 2006 and is one of the few female Gold Badge referees in the sport. Moving gradually up to the top position, she admitted to a little twinge of apprehension before The Championships began. "I was thinking, I know that this year the buck stops with me," she said. "But I got back at the end of the first day and I thought, actually, this is fine." And then the rain clouds moved in and refused to budge.

Day 9 was when everything came to a head, with only 45 minutes of play possible on the outside courts. The event schedule was now 80 matches behind. No matter, Parnell's philosophy is to push as hard as possible for as long as possible to deal with the problem immediately ahead, so on Day 10 109 matches were scheduled and 107 of them were completed – a new record. On Day 11, 98 matches were completed.

"We were behind from the first Tuesday and we only caught up on the final Sunday," she said. "But I never came home thinking, 'How are we ever going to get this through?'"

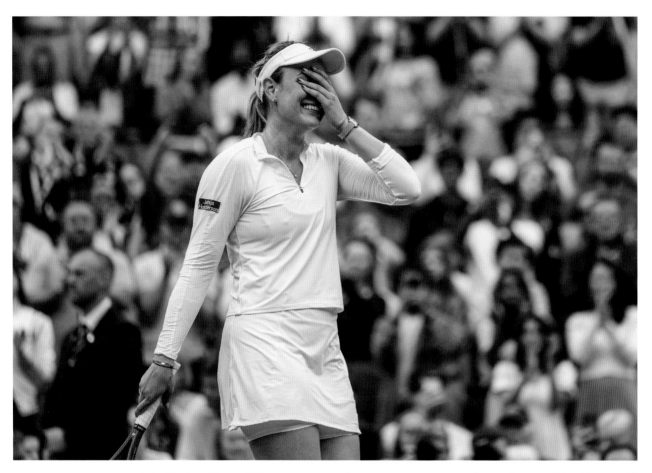

Donna Vekic overcame a misfiring serve to beat qualifier Lulu Sun and become only the second Croatian woman ever to reach the semi-finals in the ladies' singles

Like Paolini, Donna Vekic was proving that success can come to those who wait. The 28-year-old Croatian, who is five months younger than Paolini, had won her first title in 2014 and been considered an outstanding prospect as a teenager but had never quite realised that potential. She reached a career-high position at No.19 in the world rankings in 2019, but her progress then stalled. She contemplated retirement after struggling to rediscover her best form after knee surgery in 2021. However, reaching the quarter-finals at last year's Australian Open and going on to win the biggest title of her career in Monterrey had helped restore her confidence.

Three of Vekic's four wins at The Championships 2024 had gone to three sets and her quarter-final against Lulu Sun, the qualifier from New Zealand who had already knocked out Zheng Qinwen and Emma Raducanu, went the same way. As torrential rain pounded the No.1 Court roof, Sun won a tight opening set before an edgy Vekic took the second. Serving for the set at 5-3, Vekic dropped her serve after making five double faults in the game, only to break back immediately and level the match. Vekic ran away with the deciding set to win 5-7, 6-4, 6-1 and become only the second Croatian woman to reach the semi-finals, emulating Mirjana Lucic's run in 1999.

Vekic was through to the last four of a Grand Slam tournament for the first time at the 43rd attempt. Since tennis went Open in 1968, only four women had needed more Grand Slam appearances to reach their first semi-final: Barbora Strycova (53), Anastasia Pavlyuchenkova (52), Elena Likhovtseva (46) and Roberta Vinci (44).

Reflecting on her struggle to recover from knee surgery three years earlier, Vekic admitted: "I didn't think I was ever going to come back even to the level that I had last year. So this now, achieving my best result ever at a Slam, I'm really proud of myself, of the work that I've done, of the work that my team has done. I'm very thankful to them for believing in me when I didn't."

DAILY DIARY DAY 9

The Last 8 Club is an exclusive society: only those who have reached the quarter-finals of the singles, semi-finals of the doubles or the final of the mixed doubles at The Championships can gain membership. This is an elite group of grass court specialists. So what did they do as the rain hosed down outside? Discuss the differences between the western and the continental grip and form a focus group on the hybrids of both? Dissect Elena Rybakina's fearsome serve and its effect on grass? Er, no. They had a party. They kicked their heels up and had some fun. Billie Jean King *(above, front row, centre)* was, of course, leading the jollifications, although the gathered throng did not look as if they needed much encouragement at all.

• The party spirit was in full flow in the village, too. It was awards night for the annual Wimbledon Village Tennis Windows Competition and the Rose & Crown was packed for the presentations (Hemingways was the eventual winner). Among the nervous hopefuls waiting to see if they had scooped the honours stood one unexpected guest: a small Shetland pony from Wimbledon Village Stables clad fetchingly in a white hat and a purple and green rug. His tipple? A wee half, natch.

• Love was in the air. Daniil Medvedev *(right)* was falling for Centre Court. This came as something of a surprise. During his Wimbledon career he has played on No.1

Court nine times and never lost. Playing four of his first five matches there last year, he reached the semi-finals for the first time and said that he wanted to play every match there. Sadly for him, the penultimate round in both the gentlemen's and ladies' singles competitions are played on Centre Court so he had to move. And then he lost. He was not looking forward to going back there. This year, though, he won twice on Centre and reached his second semi-final by ousting Jannik Sinner, the top seed, in five sets. "It's my first time winning two matches on Centre Court at Wimbledon," he said to rapturous applause. "Usually I would win one or zero so this is a record already." The crowd cheered; Daniil grinned. He was getting to like Centre Court and, in turn, the famous old court was beginning to love him.

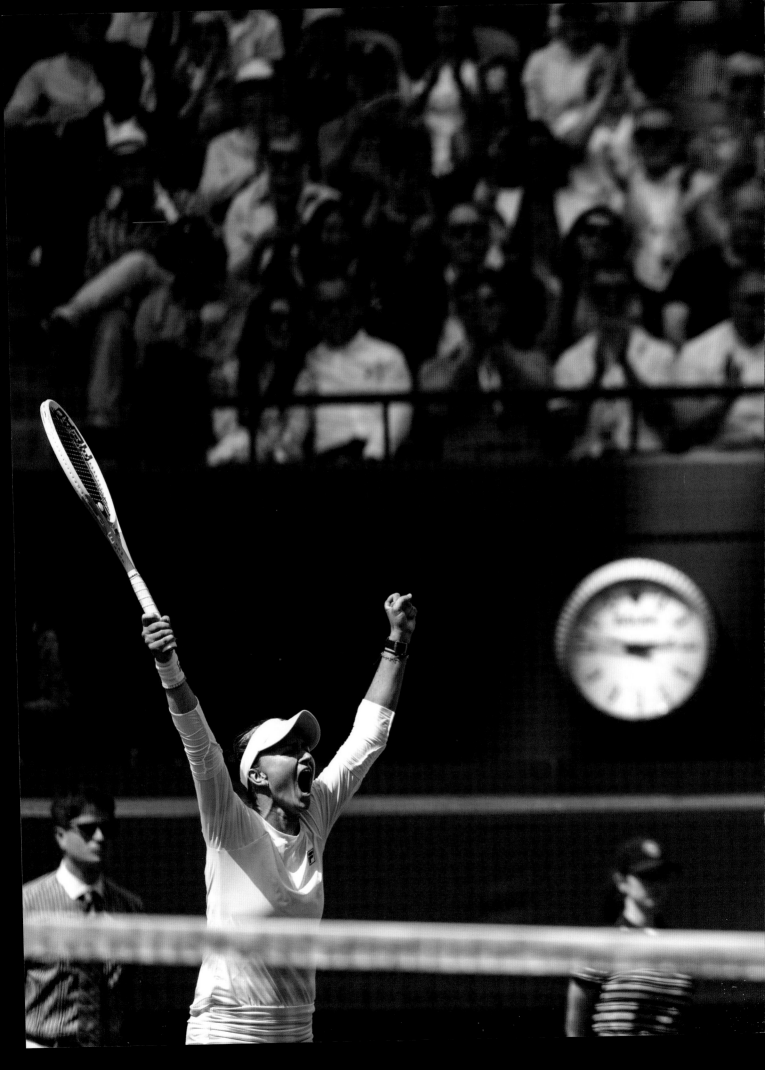

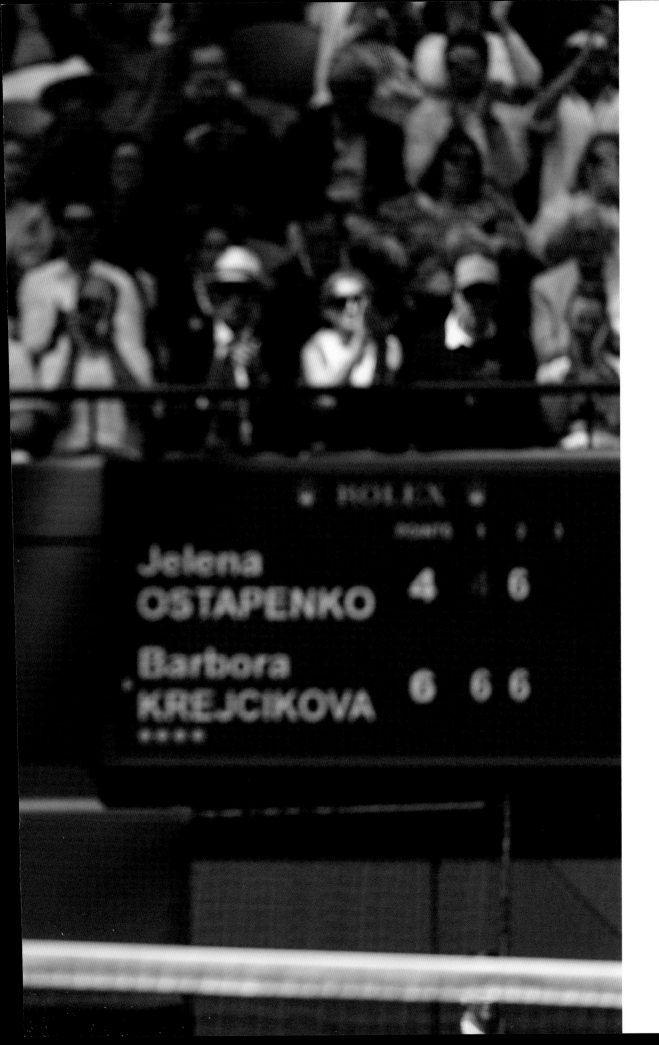

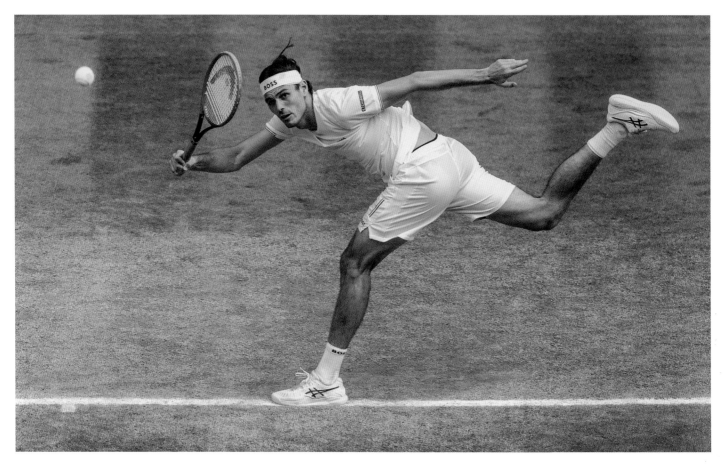

Another day, another epic contest. Twenty-four hours after The Championships 2024 became the Grand Slam tournament with the most five-set gentlemen's singles matches in the Open era, Lorenzo Musetti and Taylor Fritz treated the No.1 Court crowd to another highly entertaining marathon.

Above: Taylor Fritz, three-time Eastbourne champion, puts everything into a ground stroke

Opposite: However, Fritz could find no way past an inspired Lorenzo Musetti

Previous pages: Barbora Krejcikova lets out a roar of delight after beating Jelena Ostapenko

Musetti's 3-6, 7-6(5), 6-2, 3-6, 6-1 quarter-final victory over Fritz was the 37th gentlemen's singles match of the Fortnight to go the distance. Plenty of pundits had expected a 22-year-old Italian to reach the latter stages here, but few would have picked Musetti ahead of the world No.1, Jannik Sinner.

With blue skies finally replacing the rain clouds, it was a day to enjoy both the warmth of the sunshine and the dashing style of a tennis entertainer. Musetti had yet to find the consistency he would need to win tournaments on a regular basis – he had not won a tour-level title for two years – but his flamboyant shot-making marked him out as a player who could beat anybody when everything in his game fell into place. The world No.25 was also building a reputation as a fine grass court player. Heading into The Championships, he had made the semi-finals in Stuttgart and the final at The Queen's Club.

Fritz, however, had an even better record on grass. The 26-year-old American had just won his third Eastbourne title and was now through to his second Wimbledon quarter-final, though he would probably have preferred not to hear mention of his first. Two years earlier he had suffered what he described as the toughest defeat of his career when an ailing Rafael Nadal, playing with a torn abdominal muscle, beat him in five sets. As if to rub salt into Fritz's own wounds, the injury forced the Spaniard to withdraw before his scheduled semi-final against Nick Kyrgios two days later.

Fritz, who had faced either Nadal or Novak Djokovic in all three of his previous Grand Slam quarter-finals, had beaten Musetti in straight sets in their only previous meeting on grass at The Championships two years earlier. When he took the first set here and broke Musetti in the first game of the second

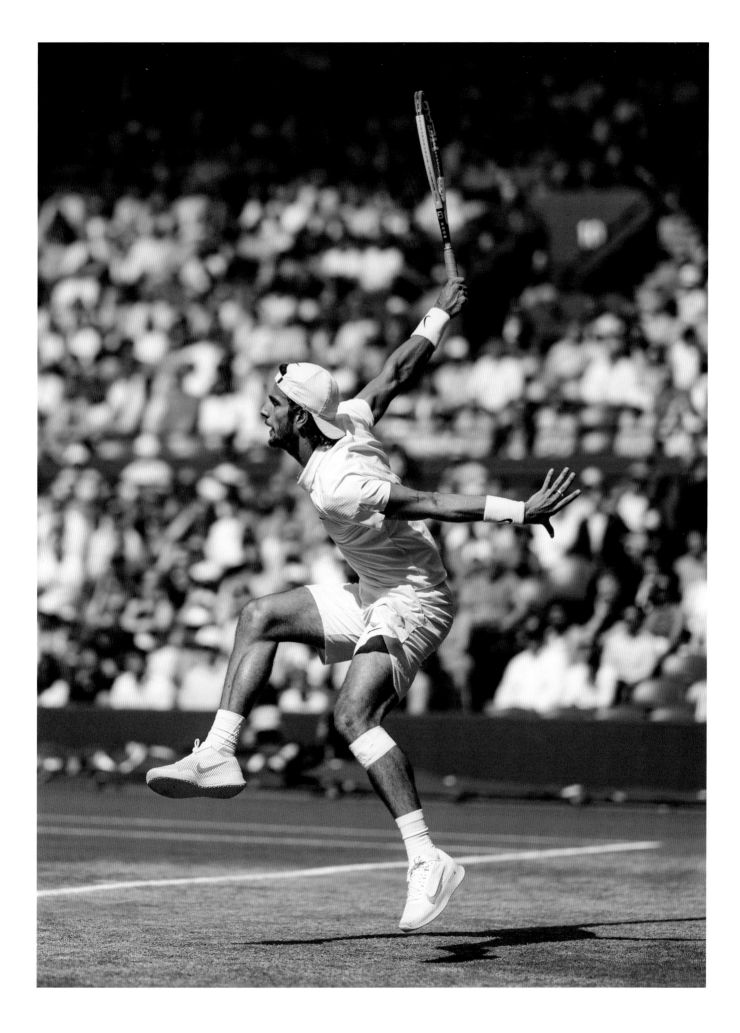

Lorenzo Musetti said reaching the semi-final was the second best day of his life, beaten only by the birth of his son four months ago

the 6ft 5in American seemed to be on course to make a Grand Slam semi-final for the first time in his career. In his 81 service games until that point in these Championships he had been broken only twice.

Before the match was over, however, Fritz's serve would be broken six times as Musetti became increasingly confident on his returns. In the third set, remarkably, Fritz won just three of the 12 points played on his first serve. The No.13 seed rallied briefly to take the match into a fifth set, but Musetti was the player dictating most of the play with a dazzling array of precision drop shots and lobs, wicked slices and firecracker ground strokes. Having raced into a 5-0 lead in the decider, Musetti completed his victory after three hours and 27 minutes.

"I found a way to develop my game set after set," Musetti said afterwards. "It was really a big reaction from me in the fifth. I probably played my best tennis of the week." The Italian said it was the second best day of his life following the birth of his son, Ludovico, in March.

In his first Grand Slam semi-final in two days' time Musetti would be taking on Novak Djokovic, who was given a free passage by the withdrawal of Alex de Minaur, who had suffered a hip injury on the very last point of his previous match. It was the 11th time in these Championships that a player had pulled out injured before their match in the gentlemen's or ladies' singles. With eight players also having had to retire mid-match, it was a demonstration of how physically demanding the modern game had become.

De Minaur said he was devastated at having to pull out before what would have been the biggest match of his career. "I'm playing these tournaments and I'm in the deep end of them," the Australian said. "That's why it hurts. I feel close. I feel closer than ever before."

The first match of the day on No.1 Court brought together two former champions at Roland-Garros. Jelena Ostapenko, who had won in Paris in 2017, had frequently proved that she could also be a formidable player on grass. A former champion at Birmingham and Eastbourne, she was through to her third quarter-final at The Championships. Barbora Krejcikova, the 2021 champion at Roland-Garros, who had lost five of her previous seven matches against Ostapenko, had a less impressive record on grass in singles, having never previously gone beyond the fourth round at Wimbledon.

Ostapenko had not conceded more than three games in any of the eight sets she had played so far. The 27-year-old Latvian tends to play in one of only two styles – attack or all-out attack – but in Krejcikova she was facing a canny player who hits the ball with clever variations of pace and spin and is a master at drawing mistakes out of her opponents. Ostapenko never found her rhythm and lost 4-6, 6-7(4) after making 35 unforced errors and hitting only 16 winners.

Both players still had work to do in the quarter-finals of the ladies' doubles, but both lost. Krejcikova and Laura Siegemund were beaten 4-6, 7-6(5), 4-6 by Gabriela Dabrowski and Erin Routliffe after nearly three hours on No.3 Court. Ostapenko and Lyudmyla Kichenok lasted only 68 minutes on No.2 Court, where they were beaten 1-6, 3-6 by Katerina Siniakova, Krejcikova's long-time doubles partner, and Taylor Townsend.

Because of de Minaur's withdrawal, the only singles match of the day on Centre Court was Elena Rybakina's quarter-final against Elina Svitolina. It lasted just 61 minutes as Rybakina, the No.4 seed and the highest-ranked player left in the draw, won 6-3, 6-2. She had lost only nine games in her last three matches. The 2022 Ladies' Singles Champion was broken in the opening game, but soon found

Two men, one goal and five sets – there was huge respect between Taylor Fritz and Lorenzo Musetti at the end of their enthralling battle

A ROYAL OCCASION

Her Majesty The Queen is known to be a keen tennis fan, as her smile proved when she visited The Championships 2024. Greeted at the Clubhouse entrance by Deborah Jevans, Chair of the AELTC (*left*), Her Majesty joined in with the fun and the Mexican Wave on Centre Court (*below*). But it was her namesake who caught her eye. The daughter of Santiago Gonzalez, the doubles world No.14 from Mexico, young Camila proudly showed off her official pass before shaking The Queen's hand. And when Her Majesty asked if Camila would like a photo of them together, she beamed for the cameras (*above*).

an excellent rhythm on her serve, losing only four points in the whole match when her first serve found the court. In taking her record at Wimbledon to 19 victories from 21 matches, Rybakina – albeit at a very early stage in her career – now had a win percentage at The Championships above 90 per cent, better than Martina Navratilova or Serena Williams achieved.

"I was really pleased with the way I played today," Rybakina said afterwards. "I want to win again. I have such amazing memories from 2022 and I'm just enjoying every time I step on the court."

It was Svitolina's eighth defeat in a Grand Slam quarter-final. The 29-year-old Ukrainian, who has also lost all three of the Grand Slam semi-finals she has reached, said she had tried "everything that was in my power" and added: "She didn't really let me into the match. When the opponent is striking the ball that big, everything goes in. Serve goes really quick. Lots of aces. It's tough to do anything."

The day's Centre Court programme ended with the welcome return of Ashleigh Barty, the 2021 Ladies' Singles Champion. Barty, who retired at the age of just 25 after winning her third Grand Slam title at the Australian Open in 2022, had been combining her time in the TV commentary box at The Championships with playing in the Ladies' Invitation Doubles alongside Casey Dellacqua. After beating Andrea Petkovic and Magdalena Rybarikova, Barty was asked at a press conference, no doubt

Barbora Krejcikova (below, left) could not contain her delight; Jelena Ostapenko (below) could not hide her disappointment

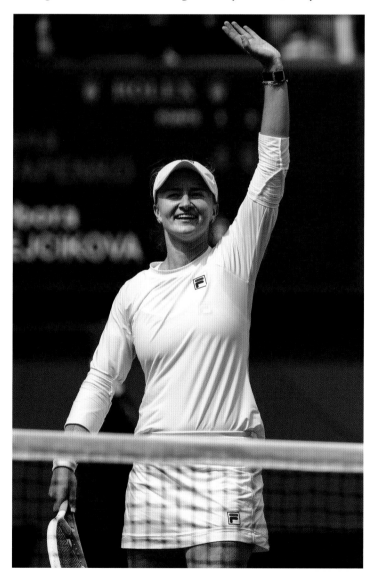

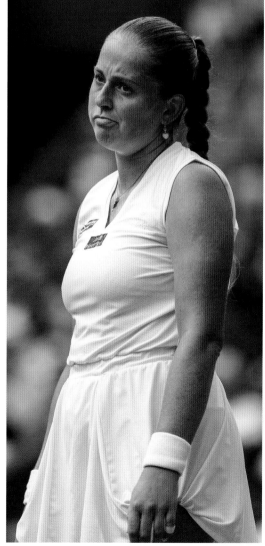

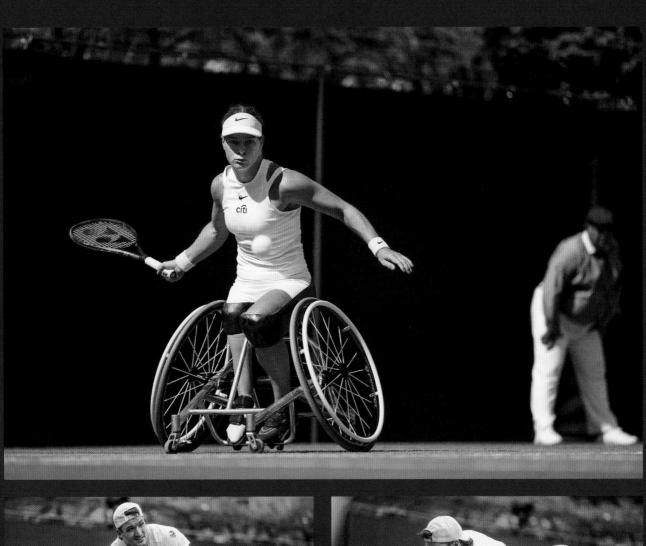
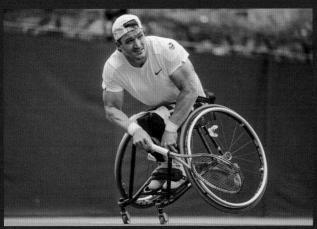
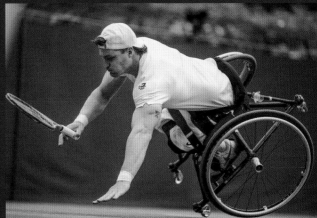
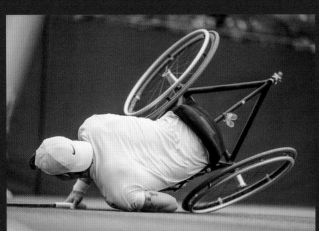
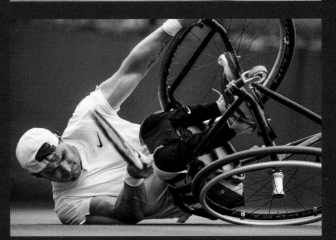

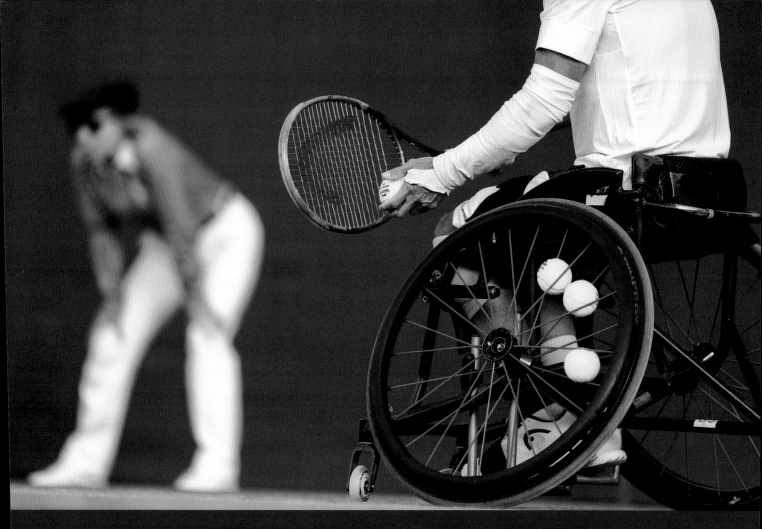

WHEELCHAIRS ON THE RISE

—

The plan had sounded so promising: the Wheelchair and Quad Wheelchair events would start on Day 9, a day earlier than in past years. That would allow for expanded draws – singles now featured 16 players while doubles had eight pairs – so that the Wheelchair events would be a major focus of attention for the second week of The Championships. And then it rained all day on Tuesday.

On Day 10, then, it was action stations as Courts 9, 14, 15 and 17 were dominated by the first round singles matches in every discipline. Nothing was going to stop Gustavo Fernandez, not even a dramatic fall *(pictured opposite)*. He simply got back on track and continued beating Gordon Reid 6-4, 6-4.

There were storylines to follow wherever you looked. Alfie Hewett was attempting to complete his career Grand Slam by winning his first Gentlemen's Wheelchair Singles title (he had finished as runner-up for the past two years). Diede de Groot *(opposite, top)*, the great champion from the Netherlands, was beginning her campaign for a 15th consecutive Grand Slam title. Unbeaten for 145 matches between February 2021 and May this year, that one defeat had sent a ripple of excitement through the locker room: was she vulnerable? Could she be beaten here? We would see in the coming days.

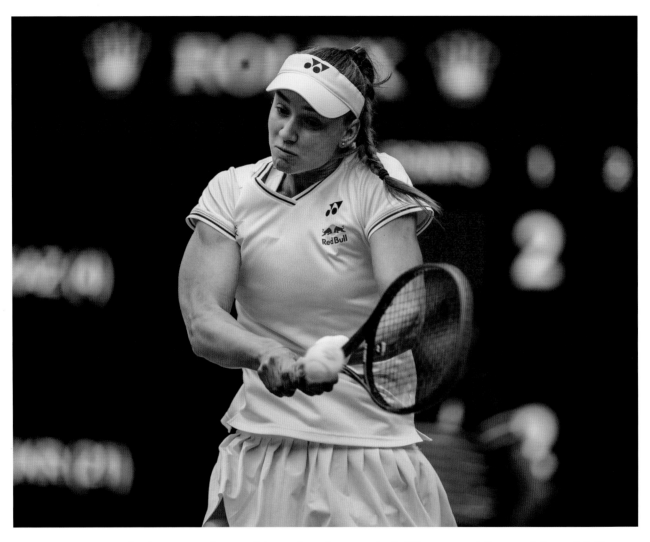

With only nine games dropped in the first three rounds, Elena Rybakina – the champion two years ago – was moving into top gear

for the umpteenth time, if she might make a comeback. "You guys are killing me," she smiled. "Anyone have a thesaurus for a word that I can use for 'no'?"

On the day when England's footballers beat the Netherlands to reach the European Championship final, there was plenty of British success in doubles. Neal Skupski and the New Zealander Michael Venus, Jamie Murray's usual partner, beat the Germans Constantin Frantzen and Hendrik Jebens 7-6(1), 7-6(1). Henry Patten and Finland's Harri Heliovaara knocked out the No.4 seeds, Marcelo Arevalo and Mate Pavic, winning 4-6, 7-6(5), 7-6(7) after coming back from 4-6 down in the first-to-10-points tie-break at the end of the third set. With Skupski and Venus taking on Patten and Heliovaara next, Britain was guaranteed a presence in the final.

Three of the forthcoming four mixed doubles quarter-finals would also feature home players. Marcus Willis, back at the All England Club eight years after famously facing Roger Federer on Centre Court in a match contested by players separated by 769 places in the world rankings, joined forces with his fellow Briton Alicia Barnett to beat Rajeev Ram and Katie Volynets. Jamie Murray and Skupski, both partnering Americans, also won. Murray and Taylor Townsend beat Kevin Krawietz and Alexandra Panova, while Skupski and Desirae Krawczyk knocked out Fabrice Martin and Cristina Bucsa.

With the Wheelchair events finally under way, one day late, Britain's Alfie Hewett began his quest to win the only Grand Slam singles title that had so far eluded him. The No.2 seed got off to a confident start, beating his fellow countryman Ben Bartram 6-1, 6-4 on Court 14.

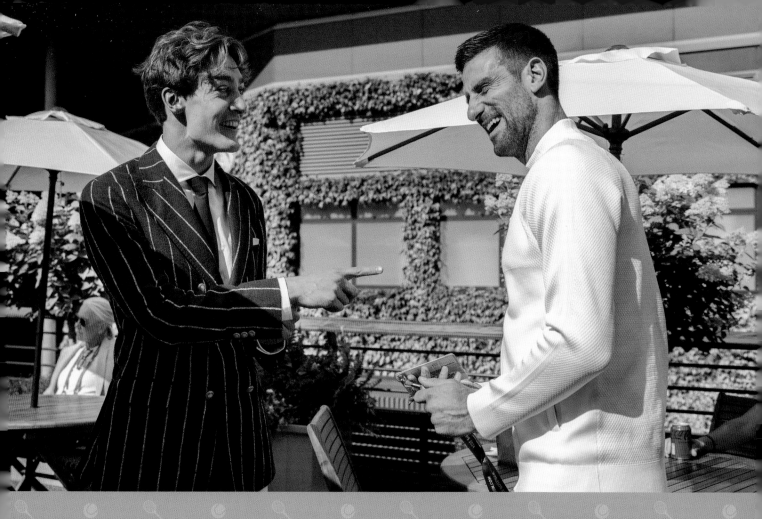

DAILY DIARY **DAY 10**

To see Novak Djokovic when he met the F1 star George Russell *(above, left)*, you would never have guessed what he had just been doing – unflustered, not a hair out of place, he was his usual debonaire self, which is remarkable considering what he had just put himself through. Having found himself with some spare time on his hands after Alex de Minaur was forced to withdraw before their quarter-final due to injury, Novak and his fragile knee headed for the hill in Car Park 4 and started some sprint training – and that hill is steep. We speak from experience: some members of the media are allowed to park there and hauling your heavy work bag up to the entry gate can feel like climbing the north face of the Eiger on roller skates. But there was the former champion, running up that hill at full pelt and trotting down again for another go. No wonder Carlos Alcaraz calls him "Superman".

• Elsewhere, Jelena Ostapenko's run was ended by Barbora Krejcikova in straight, if tight, sets. Obviously disappointed with the loss, she did have one happy memory to take away: her newfound friendship with hip-hop legend Lil Wayne. He posted on social media that she was "a joy to watch". "It's really cool, of course; it's really cool," Jelena said. "He has been messaging me, as well. He told me he's my huge fan, so that's really nice."

• It was the day to see and be seen as the Royal Box hosted actors Richard E. Grant, Keira Knightley *(below, left)* and Sir David Suchet, as well as musicians Bjorn Ulvaeus and Feargal Sharkey. Steve Carrell was not part of that particular gathering, but he was still at Wimbledon as an avid fan. Currently to be heard as the voice of Gru in *Despicable Me 4*, he arrived without Minions (much to the relief of the groundstaff) to tell Laura Robson about his first visit to The Championships back in 2019 ("It was magical," he recalled). Back again in the greatest of tennis theatres, it was clear what he thought about the experience. "You can feel the depth

of the tradition here," he said. "The energy here is so different to anywhere else. You can feel the energy of the players; you can feel the energy of the crowd – everyone is so excited to be here, but they feel like they are part of something. It's not just watching tennis; I think it's more encompassing than that."

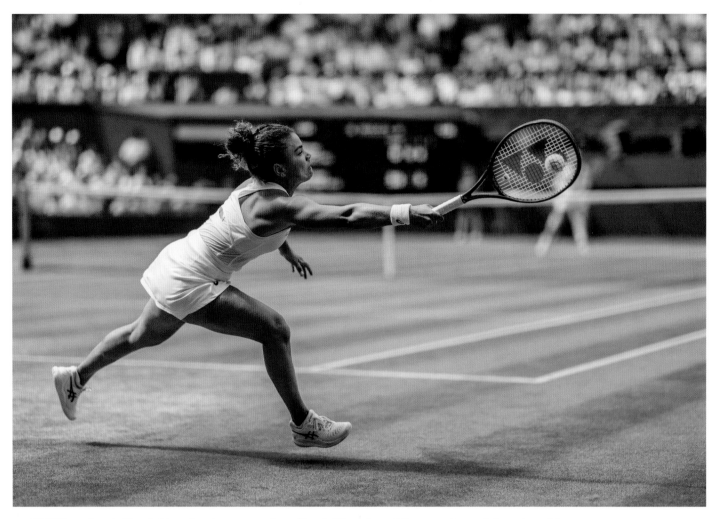

The fact that the last seven Ladies' Singles Championships had been won by seven different players told us that we should continue to expect the unexpected, but who would have predicted this semi-final line-up? While Elena Rybakina, the 2022 champion, had always been among the favourites to win the title, the other semi-finalists had barely been mentioned as contenders.

Above: Jasmine Paolini had never won a tour-level main draw match in singles on grass before this summer but was now inches away from a Wimbledon final

Previous pages: The roof was open and the sky was blue. Centre Court was back to its best

Barbora Krejcikova, Rybakina's opponent, had been troubled by repeated bouts of illness and had won only three matches since January. Jasmine Paolini had just finished as the runner-up at Roland-Garros but had gone into the grass court season having never won a main draw match on the surface. Her opponent, Donna Vekic, had never gone beyond the quarter-finals in any of her previous 42 appearances in Grand Slam tournaments.

Sport, however, can be glorious in its unpredictability and by the end of the day Centre Court had witnessed arguably the most dramatic pair of ladies' singles semi-finals in Wimbledon history. For the first time in 20 years both went to three sets, while the Paolini-Vekic match, which lasted two hours and 51 minutes, was the longest ladies' singles semi-final ever played at the All England Club. Both matches featured tennis of the highest quality as well as regular shifts of momentum and both were won by the player who had lost the opening set. Paolini beat Vekic 2-6, 6-4, 7-6(8) and Krejcikova beat Rybakina 3-6, 6-3, 6-4, which meant that there would be a new name on the trophy come Saturday evening.

Under sunny skies, the afternoon began with Vekic winning five games in a row to take the opening set of the first semi-final as Paolini struggled to get a foothold. The 28-year-old Italian, who packs a

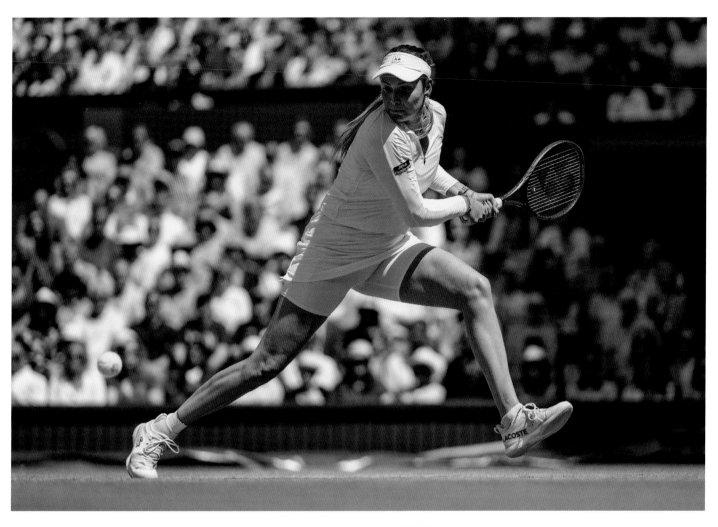

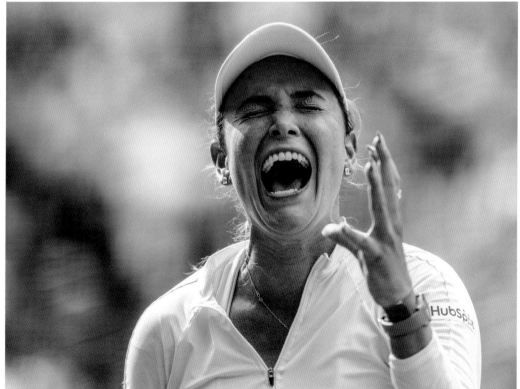

*It was the longest ladies' singles semi-final in Wimbledon history and for Donna Vekic (**above and left**) the tension was almost unbearable*

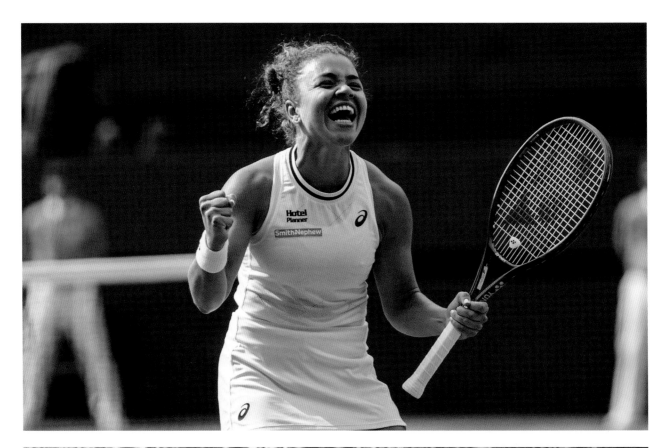

powerful punch for someone who stands just 5ft 4in tall, took a more aggressive approach in the second set, which went with serve until Vekic was broken for the first time when serving to stay in it at 4-5. However, the drama had only just begun.

The deciding set swung one way and then the other, with both players breaking serve twice. It was the fifth time in her six matches that Vekic had been taken to a deciding set and it became increasingly evident that she was struggling to last the pace. The Croatian's physical troubles, including pain in her right forearm, which she iced at the changeovers, were matched by her emotional torment. She was often in tears between points and at changeovers and looked despairingly towards the players' box, where her mother, Brankica, and her coach, Pam Shriver, offered what support they could. Shriver must have known exactly what her charge was going through, the American having lost on all three occasions when she had reached the singles semi-finals here in the 1980s.

Paolini, in contrast, looked in good shape physically throughout and was still energetically chasing down balls at the end. A majority of the crowd had seemed to be rooting for the Italian in the early stages, but there was growing support for Vekic as her pain became more apparent.

The tears flowed again after Vekic saved a first match point at 4-5 in the deciding set. She had break points which she failed to take at 5-5 and in the following game saved a second match point. From 3-3 in the match tie-break there was never more than a point between the two players until Vekic missed two forehands in a row from 8-8 as Paolini became the first Italian to reach the ladies' singles final. The match had lasted one minute more than the previous longest ladies' singles semi-final, between Serena Williams and Elena Dementieva in 2009.

Paolini also became the first woman to make the finals at both Roland-Garros and the All England Club in the same year since Williams in 2016. "This match, I will remember for ever," she said afterwards.

Opposite: The final beckons! A clearly delighted Paolini celebrates her semi-final triumph with her equally delighted team in the players' box

Below: Jasmine Paolini was now a finalist and her 'fight for every ball' philosophy – together with her almost permanent smile – enthralled the Centre Court crowd

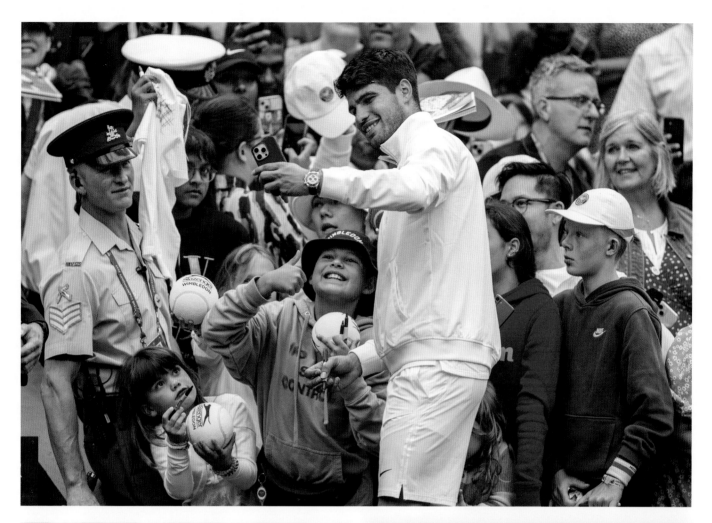

SELFIE HEAVEN

In the old days it was autographs; today it is selfies – everyone wants a record of their moment with the stars. And the players are more than willing to oblige. Some, like Carlos Alcaraz *(above)*, do the honours ("I'll click; you smile") while others - like Iga Swiatek *(left)* and Francisco Comesana *(below)* – lean into the throng and let the snap-happy photographers get their pictures. Jasmine Paolini *(opposite, top)* might have got a Service Steward involved with her photo, while Ons Jabeur *(opposite, bottom)* was much in demand as she made her way back to the locker room.

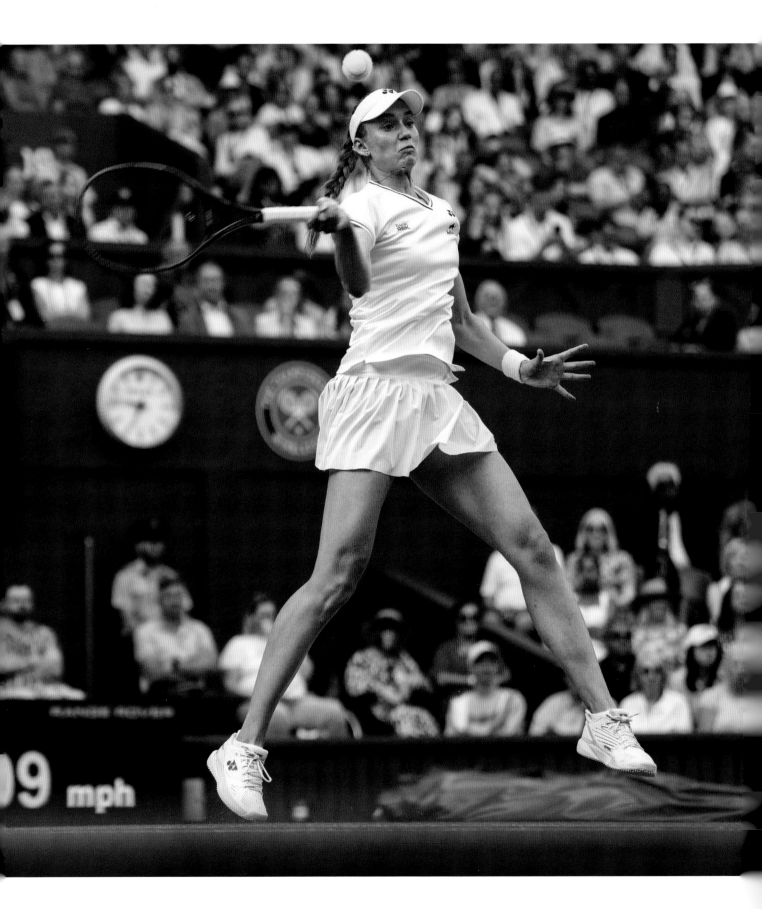

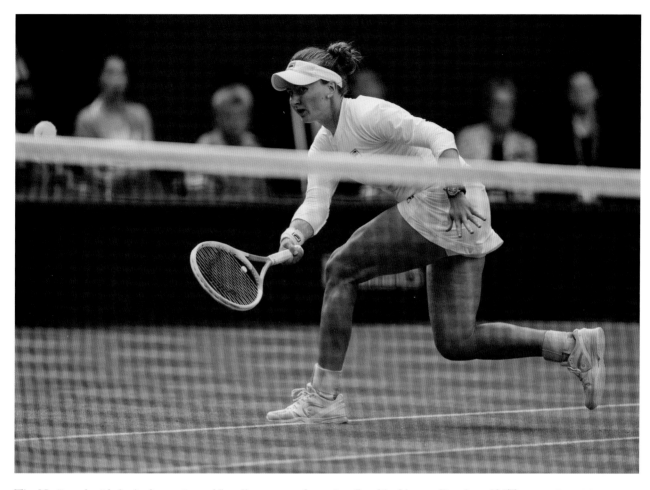

The No.7 seed said she had experienced "a rollercoaster of emotions" and had kept telling herself: "Try, point by point. Fight for every ball."

Although no Italian woman had ever reached the ladies' singles final at The Championships, Paolini said she had been inspired by the Grand Slam achievements elsewhere of some of her fellow countrywomen in recent years. Francesca Schiavone was Roland-Garros champion in 2010, Flavia Pennetta beat Roberta Vinci in the US Open final in 2015 and Sara Errani, Paolini's regular doubles partner, was runner-up at Roland-Garros in 2012. "Of course I'm grateful to them," Paolini said. "I remember the Grand Slam finals that they made. I think it's really important for the next generation to have people who can show you what is possible."

Vekic, who left Centre Court to a standing ovation, had won more points (118 to 111), hit more winners (42 to 26) and made more breaks of serve (four to three). The world No.37 struggled to find the words to convey her emotions at her post-match press conference. "It was a tough, tough match," she said eventually. "I believed that I could win until the end. She played some amazing tennis. All congrats to her. She definitely deserved it." Vekic added: "I thought I was going to die in the third set. I had so much pain in my arm and leg."

By the end of the match the crowd probably needed a rest as much as the players. When Krejcikova and Rybakina entered Centre Court for the second semi-final there were plenty of empty seats, though they soon filled up again, perhaps because of fears that the match might be over quickly. With Rybakina striking the ball with her customary power and Krejcikova struggling to cope with it, the 2022 champion raced into a 4-0 lead in just 19 minutes. However, Krejcikova retrieved one break before losing the first set and then broke again in the sixth game of the second.

Above: Three years ago Barbora Krejcikova won the Roland-Garros title. She knew what needed to be done to get to a Grand Slam singles final

Opposite: Elena Rybakina, the former champion and the favourite in this semi-final encounter, started well but Krejcikova was not to be denied

177

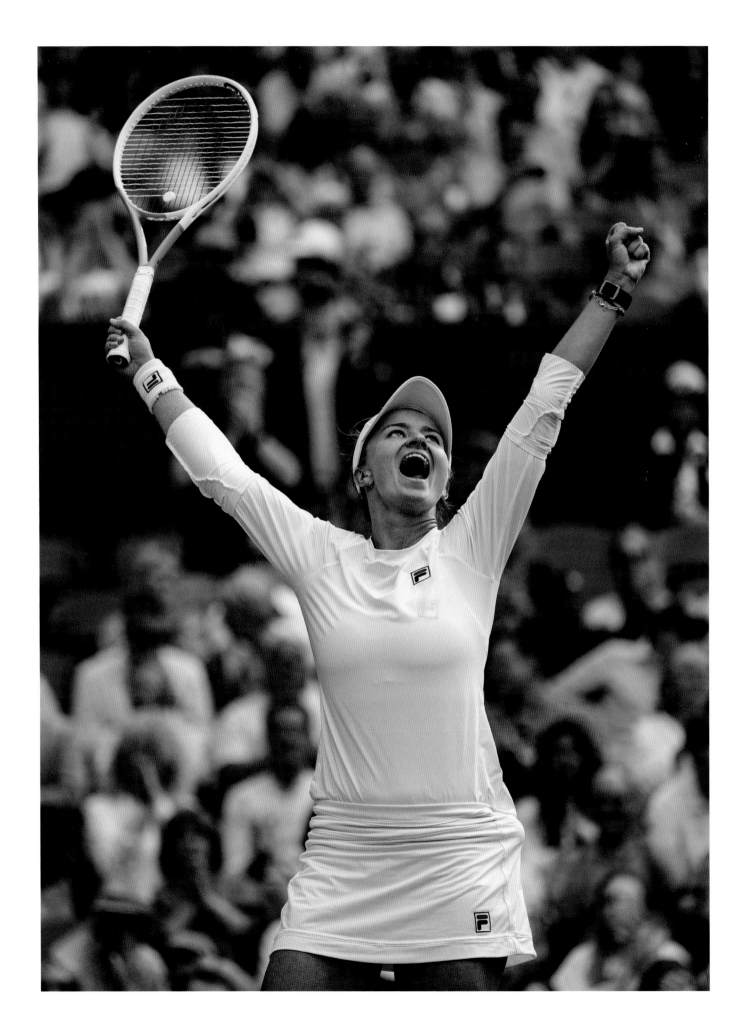

As the match progressed, Krejcikova's skilful manipulation of the ball was making life more difficult for Rybakina. After holding serve to take the second set and level the match, Krejcikova made a decisive move in the seventh game of the decider as Rybakina put an attempted drop shot into the net on what proved to be the last break point of the match. Three games later Krejcikova held serve to love to complete her victory in two hours and seven minutes.

"I'm so proud about my game and my fighting spirit today," Krejcikova said afterwards. "I was trying to fight for every single ball. During the second set I was getting my momentum and when I broke her I started to be in the zone – and I didn't want to leave the zone."

In reaching the final Krejcikova was following in the footsteps of her fellow Czech, Jana Novotna, who had been her coach and mentor but died of cancer in 2017 at the age of just 49. After losing the 1993 ladies' singles final, Novotna had famously cried on the shoulder of The Duchess of Kent at the presentation ceremony. She lost again in the 1997 final, to Martina Hingis, but returned one year later to win the title by beating Nathalie Tauziat.

In her post-match interview Krejcikova became emotional when talking about Novotna, saying she had been thinking a lot about her. "I have so many beautiful memories," the world No.32 said. "When I step on the court here I'm just fighting for every single ball because that's what I think she would want me to do. I hope she would be proud."

Rybakina, who had now lost all three of her meetings with Krejcikova, said it had been "a very close match". She added: "I think Barbora played really well. I had some chances but, anyway, I think it's a positive tournament for me. I've been playing pretty well the last four matches, so I'm happy with the level I am now and also how I felt physically on the court. In the last few months I was struggling a little bit."

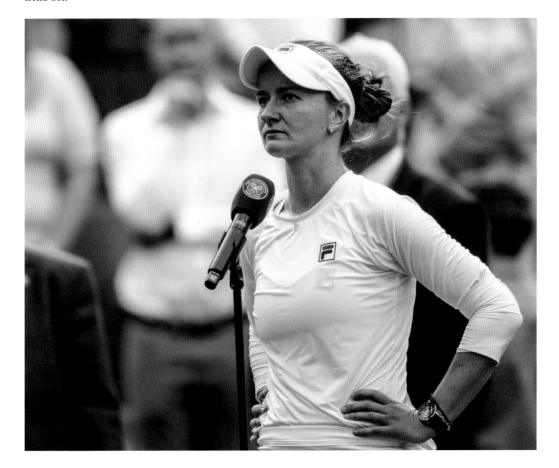

Opposite: Sheer joy – Barbora Krejcikova is just one match away from the title

Left: Krejcikova, once coached by the late Jana Novotna, the 1998 Ladies' Singles Champion, could not hide her emotions. "I hope she would be proud," she said

In the gentlemen's doubles Britain's Henry Patten and Finland's Harri Heliovaara, who were unseeded, continued their outstanding run with a 6-4, 7-6(1) victory over the No.9 seeds, Neal Skupski and Michael Venus, who had won the titles at The Queen's Club and Eastbourne in the build-up to The Championships. Skupski had also won the Wimbledon title in 2023 alongside Wesley Koolhof. In Saturday's final Patten and Heliovaara would take on the Australians Max Purcell and Jordan Thompson, who beat the top seeds, Marcel Granollers and Horacio Zeballos, 6-4, 6-4.

However, British interest in the mixed doubles ended in the quarter-finals. Marcus Willis and Alicia Barnett were beaten 3-6, 5-7 by the Mexicans Santiago Gonzalez and Giuliana Olmos, while Skupski, playing alongside the American Desirae Krawczyk, suffered his second defeat of the day when losing to Venus, his partner in the gentlemen's doubles, and Erin Routliffe. Jamie Murray and his American partner, Taylor Townsend, lost a tight contest with Jan Zielinski and Hsieh Su-Wei, who won the match tie-break 10-5.

Britain's Alfie Hewett continued to make progress in the Gentlemen's Wheelchair Singles but took his time to dispose of France's Stephane Houdet. The No.2 seed had 26 break points in the match, but Houdet saved 20 of them before Hewett won 6-1, 6-4 after an hour and 44 minutes. Tokito Oda, the No.1 seed, beat Joachim Gerard 6-3, 6-3. In the Gentlemen's Wheelchair Doubles Hewett and Gordon Reid maintained their quest to win the title for the sixth time with a 6-1, 7-5 victory in the quarter-finals over Gerard and Martin de la Puente. Diede de Groot, aiming to win her 15th successive Grand Slam singles title, beat the American Dana Mathewson 6-0, 7-5 and was in an even more ruthless mood in the doubles as she and Jiske Griffioen beat Maria Florencia Moreno and Momoko Ohtani 6-0, 6-0.

Marcus Willis and Alicia Barnett lost out to the Mexican team of Santiago Gonzalez and Giuliana Olmos in the mixed doubles quarter-finals

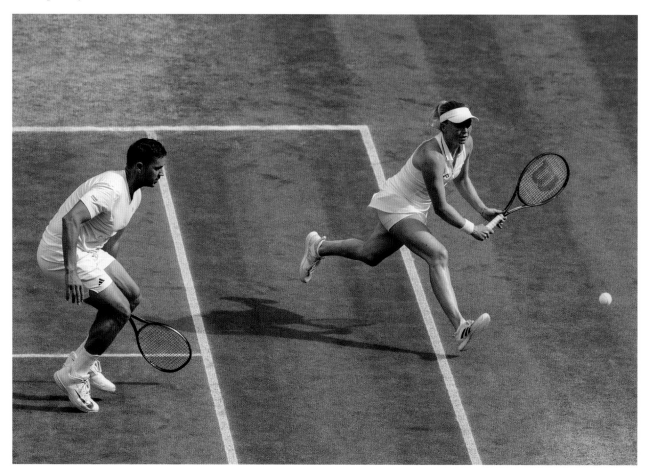

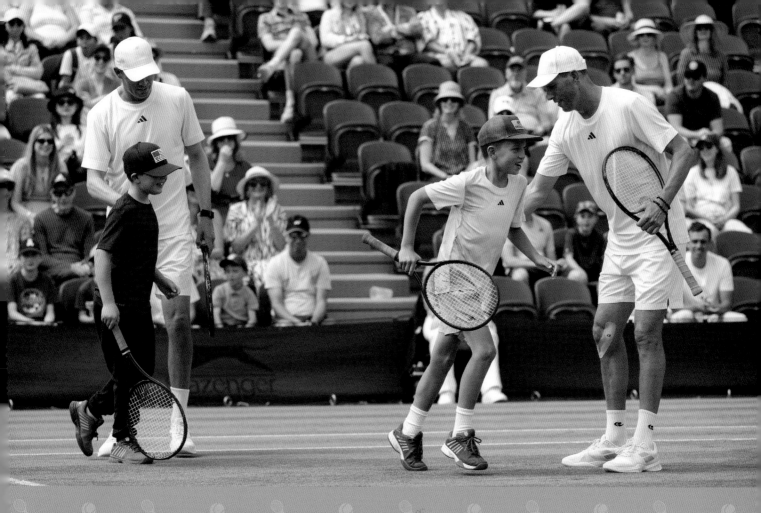

DAILY DIARY DAY 11

Out on No.2 Court, Americans Bob and Mike Bryan, the 46-year-old twins who together claimed 16 Grand Slam doubles titles between 2006 and 2014, were taking on Marcos Baghdatis and Xavier Malisse in the Gentlemen's Invitation Doubles. Bob had brought along his sons, Bobby Junior and Richie, and after a while handed them the rackets (*above*) so that Dad and Uncle could have a breather. The boys held their own for a couple of rallies, too, before Bob and Mike took over and went on to win.

• Barbora Krejcikova was going to the final. She had just beaten Elena Rybakina, the 2022 Ladies' Singles Champion, and was one match away from holding the Venus Rosewater Dish. How would she control her nerves before such an important match? Simple: build another Lego model. Before The Championships began she completed the 3,091-piece 'Milky Way' (a model of the galaxy, not the chocolate bar) and – as a great fan of Harry Potter – later took her mind off the pressures of work by building 'Dobby the House Elf' (with moveable head, ears, arms and fingers, and complete with Aunt Petunia's floating pudding cake, Tom Riddle's diary and Harry Potter's sock). Although, at only 403 pieces, Dobby was more of a rain delay distraction than a long-term project. She did fancy the idea of making a

Centre Court model but wasn't sure if such a thing existed. We bring good news: it does. It has 2,508 pieces and even has a moveable, retracting roof.

• In the first 10 days, the weather had been not so much inclement as utterly clement free. Everyone had scoured their various weather apps for information (one app, known in the press room as doom-dot-com, was forecasting everything bar a plague of locusts) but none could tell us when the clouds would stop leaking. Technology was useless. The best predictor of precipitation or play was the security guard stationed by Court 14. Always smiling and immaculately turned out, he was the key: if he brought his umbrella with him,

we had no rain; if he left it at home, it tipped it down. By Day 11 he had resolved to bring his brolly for the rest of The Championships. We were set fair for the next four days – doom-dot-com be damned.

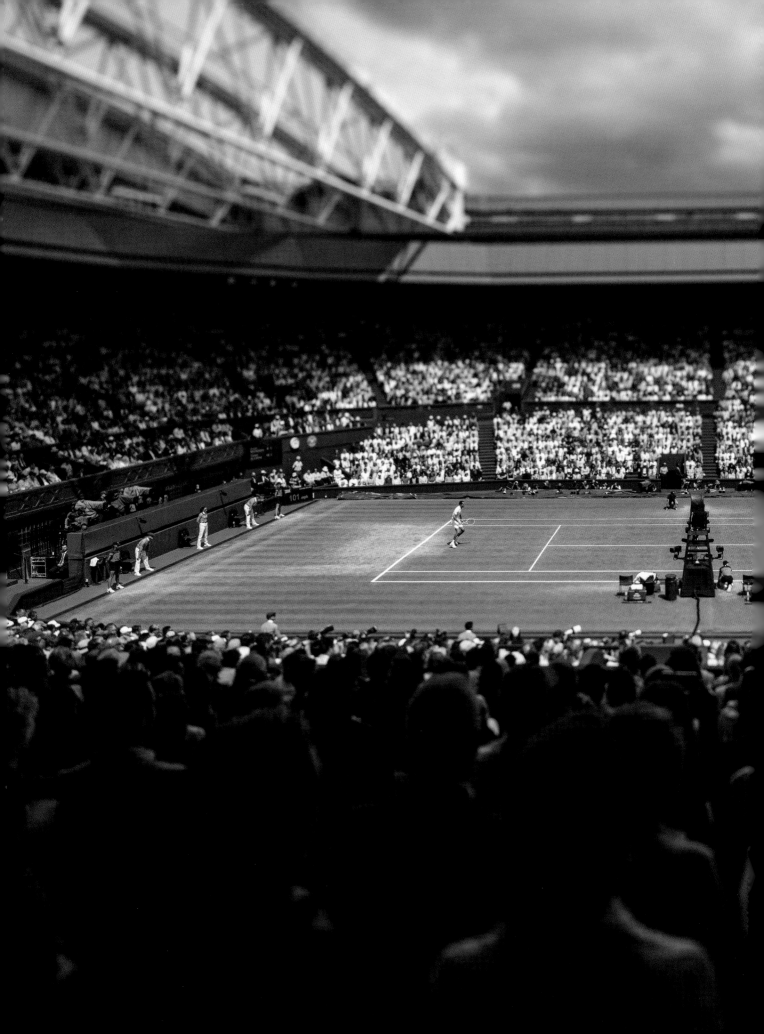

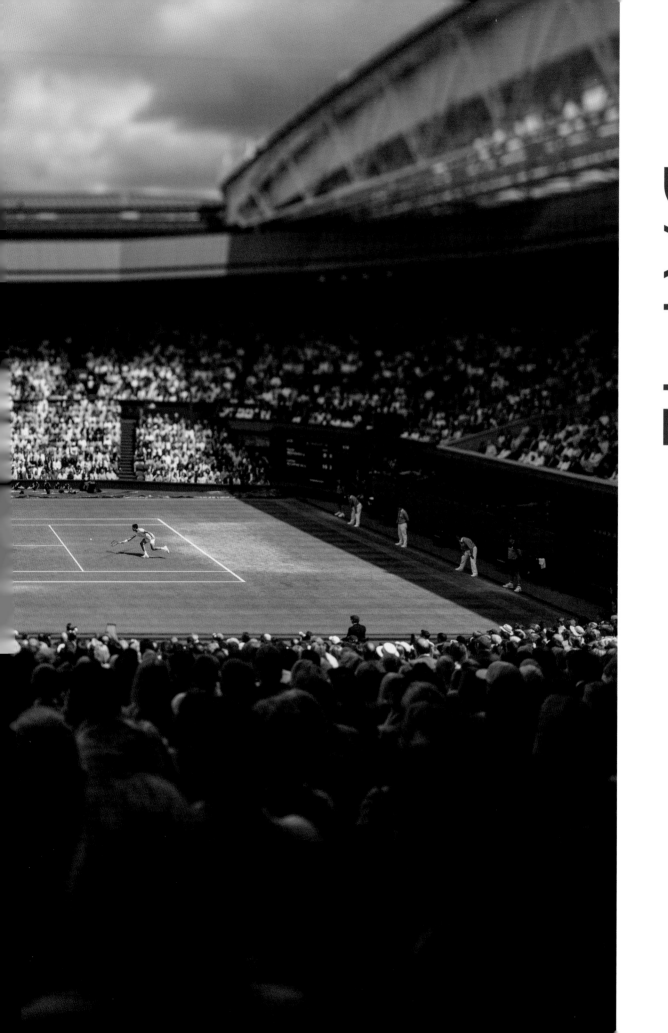

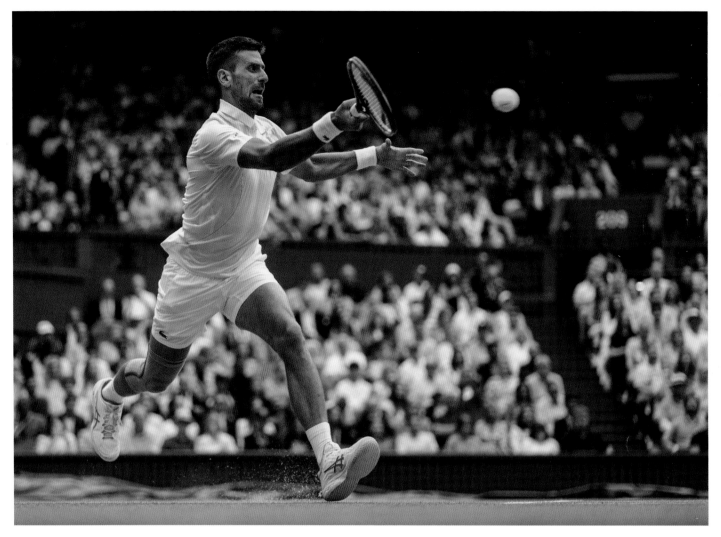

Since the turn of the year there had been times when we had started to think the unthinkable: that Novak Djokovic might indeed be a mere mortal and that age might actually be catching up with him. There had been no signs of that in 2023, when the Serb again went within one victory of winning all four Grand Slam titles and finished the season as world No.1 for a record eighth time. However, in 2024 he had started to appear vulnerable.

Above: Novak Djokovic was getting better with every round and now he felt close to his best – a 10th final was within touching distance

Previous pages: The defending champion dropped a set to Daniil Medvedev but refused to loosen his grip on his title

He looked well below his best at the Australian Open, a tournament he had dominated for years, and he described his semi-final defeat to Jannik Sinner in Melbourne as "one of the worst Grand Slam matches I've ever played". At Indian Wells he lost to Luca Nardi, the world No.123, who became the lowest-ranked player ever to beat him at Grand Slam or Masters 1000 level. Djokovic had not reached a final anywhere in 2024 by the time he arrived at Roland-Garros, where he was forced to withdraw before his quarter-final after tearing the medial meniscus in his right knee.

When the 24-time Grand Slam champion had surgery on the knee less than four weeks before the start of The Championships, the assumption in many quarters was that he would not make Wimbledon and would instead focus on being fit in time for the Olympic tennis tournament, which would be starting at the end of July. At 37 years of age, even someone with Djokovic's remarkable powers of recovery would surely struggle to make the start line at the All England Club. As The Championships approached, nevertheless, he sounded increasingly confident about his chances

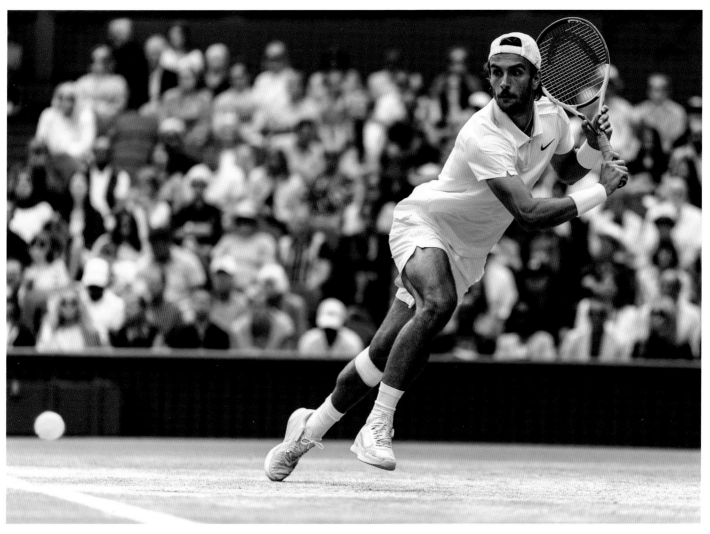

of playing and on the second day of the Fortnight he duly walked out onto Centre Court for his opening match.

As Djokovic's quest for a record-equalling eighth Wimbledon title progressed, just about the only sign that he had been dealing with a serious physical issue was the grey support he wore on his knee. His form was patchy at first, but he brushed aside Holger Rune in the fourth round with impressive ease, while Alex de Minaur's withdrawal before their quarter-final gave him more time to prepare for his semi-final against Lorenzo Musetti. Having beaten the Italian in five sets at Roland-Garros the previous month, Djokovic was looking in good shape to get the better of him again and win his ninth Wimbledon semi-final in a row. The age gap of 14 years and 285 days was the largest between two men's Wimbledon semi-finalists in the Open era, though the gulf in experience looked likely to be the more significant factor. Musetti had never gone this far at any Grand Slam tournament, though he had proved in his quarter-final victory over Taylor Fritz that he had a big-match temperament to go with his stylish game.

Musetti again demonstrated his shot-making ability as he matched Djokovic in terms of the number of winners struck – they hit 34 each – but the world No.25 came out second best in too many of the most important moments. Djokovic, who frequently put his faith in serve-and-volley and won 43 of the 56 points he played at the net, won 6-4, 7-6(2), 6-4.

Djokovic was the first to draw blood, breaking serve in the sixth game. Musetti broke back when the Serb served at 5-3, only to surrender the set with some loose play in the following game. In the second set it was Djokovic's turn to retrieve an early break of serve before going on to win the tie-break with something to spare. In the third a solitary break in a lengthy opening game was all he needed. Musetti said afterwards that Djokovic had seemed "in great shape – not only in his tennis but

Lorenzo Musetti said that Djokovic had never played so well against him and that the Serb's returning was "a joke". Not that Musetti had much to smile about…

THE CHAIR'S SPECIAL GUESTS

—

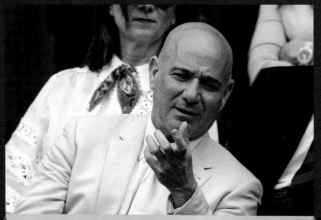

Everyone invited to The Championships is a special guest, but some are just a bit more special than others.

Every year the Chair of the All England Club invites their own Special Guests, always a select group of former players with anniversaries to celebrate. They attend during the Fortnight and take their place in the Royal Box. This year, Deborah Jevans invited Conchita Martinez, Chris Evert, Andre Agassi and Ken Rosewall.

Conchita *(above)* was marking the 30th anniversary of her triumph over Martina Navratilova when she became the first Spanish woman to lift the Venus Rosewater Dish – doing so in only her third appearance at The Championships and in what was to be Martina's last appearance in the final. For Chris *(above, left, with Rod Laver)*, it was 50 years since the first of her three Wimbledon singles wins. Beating Olga Morozova in 1974 was the start of a 12-year run that saw her collect 18 Grand Slam titles.

No one seemed more surprised than Andre *(left)* when he won the first of his eight Grand Slam titles at Wimbledon in 1992. That he should win a major trophy was never in doubt, but that the hard court specialist should do it first on the grass of SW19 was remarkable. Ken, on the other hand, never did get to lift the Gentlemen's Singles Trophy but the Australian never stopped trying, reaching his first final in 1954 and his fourth and last in 1974. He did, however, twice win the gentlemen's doubles, in 1953 and 1956, partnering compatriot Lew Hoad.

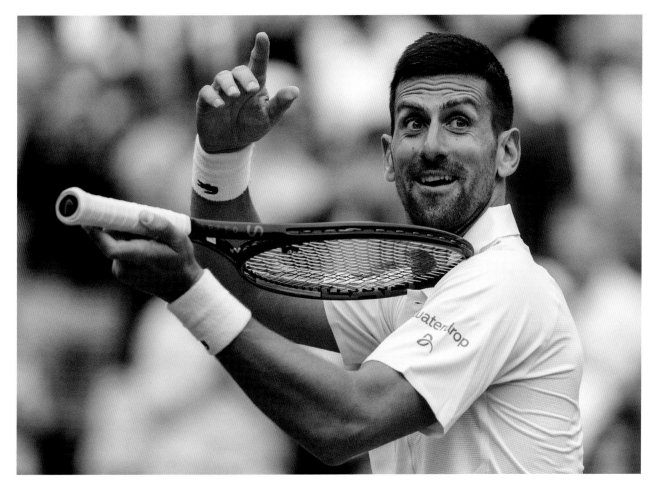

also physically." He added: "This was the seventh time that we were playing against each other and I've never faced a Nole like this. I was really impressed. I think his tennis really suits this surface well, especially with his returns. At the end it was really a joke how he was returning."

Djokovic said that in the early stages of the Fortnight he had not even thought about the possibility of reaching the final again. "I was just thinking about moving well, not injuring myself, to be honest, and feeling more free in my movement," he said. "But in the third and particularly the fourth round, I felt like: 'OK, I'm actually playing close to my best, and I can have a shot at the title'."

He was now one win away from reclaiming the trophy, but the man standing in his way would be Carlos Alcaraz, who had denied him in one of the great Wimbledon finals 12 months earlier. Alcaraz earned the chance to take on Djokovic again when he beat Daniil Medvedev 6-7(1), 6-3, 6-4, 6-4 in a semi-final that typified the 21-year-old Spaniard's performances so far at these Championships. He had played brilliantly at times, particularly in the latter stages of matches, but had also gone through lengthy periods when he appeared to lose focus. For a player whose thrilling tennis can exude self-confidence, he also looked surprisingly nervous on occasions.

Although Alcaraz went into the match leading Medvedev 4-2 in their head-to-head record, they were tied at 1-1 in their meetings both in Grand Slam semi-finals and at The Championships. Medvedev had won in straight sets when they met in the second round here in 2021, but Alcaraz had turned the tables in the semi-finals two years later.

Alcaraz mixed spectacular shot-making with glaring errors during a first set in which there were four breaks of serve. The last of them came in controversial fashion when Eva Asderaki-Moore ruled that the ball had bounced twice when Medvedev attempted to reach a drop shot. TV replays showed

His place in the final secured, Novak Djokovic once again turned to his six-year-old daughter, Tara, and pretended to play the violin (which she is learning to play)

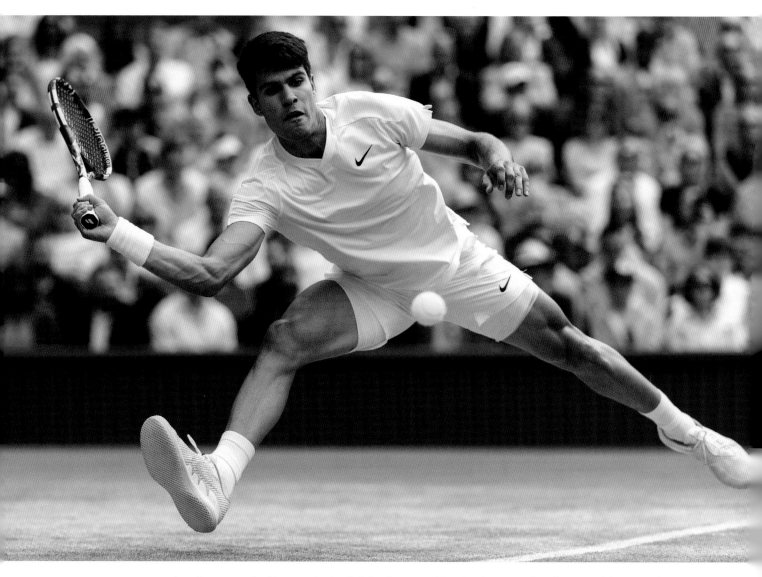

After a nervy, error-strewn first set, Carlos Alcaraz relaxed, went for his shots and started "to feel like I was going to have fun"

that the umpire had been right, but Medvedev voiced his displeasure at her decision. After consulting Denise Parnell, the Referee, Asderaki-Moore gave Medvedev a warning for unsportsmanlike conduct. "I said something in Russian," Medvedev explained later. "Not pleasant, but not over the line."

Medvedev recovered to dominate the tie-break, but the match turned when Alcaraz broke in the fourth game of the second set. Another early break put the Spaniard on the way in the third and by the time he had broken in the first game of the fourth with a huge forehand winner the world No.3 appeared to be back to his pulsating best. Medvedev, to his great credit, broke back immediately, but after he dropped his serve again in the seventh game Alcaraz closed out his victory.

"Every match, it's a war," Alcaraz said afterwards. "Obviously having nerves is normal, but you have to control them. When you're not controlling them it's difficult to play your best tennis or to deal with situations. That was what happened to me in the first set. I was struggling to play my service games calmly. I was in a rush. I was nervous. Daniil seemed like he was controlling the match. But after that first set I calmed myself and I started to play better, to feel like I was going to have fun. After that I was going to play my best tennis."

Medvedev took some consolation from the fact that the match had been closer than their semi-final 12 months earlier. "I felt the plan I had come up with wasn't working too badly," he said. "But he's tough

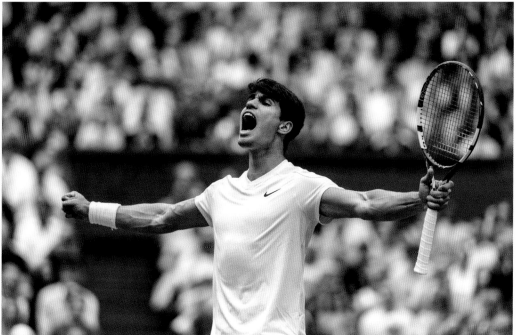

Above: Daniil Medvedev is a relentless competitor and a master of defence, but it was not enough to earn his ticket to the final

Left: Mission accomplished! Carlos Alcaraz celebrates his victory. One more match to go…

to play. I felt like I was serving well, definitely not any worse than in my other matches, but I had only five aces. He seemed to be running so well that he reached almost every ball."

Hsieh Su-Wei's remarkable run in the ladies' doubles ended with defeat in the semi-finals. Hsieh had won the title in each of her previous three appearances at The Championships, but the former world doubles No.1 and her partner, Elise Mertens, were beaten 6-3, 4-6, 4-6 by Katerina Siniakova and Taylor Townsend. In the other semi-final Erin Routliffe and Gabriela Dabrowski, the No.2 seeds and reigning US Open champions, beat Caroline Dolehide and Desirae Krawczyk 6-4, 6-3.

Tokito Oda, the No.1 seed and defending Gentlemen's Wheelchair Singles Champion, went down to a surprising defeat. The Japanese teenager made a flying start to his semi-final, but Martin de la Puente responded in positive fashion and went on to win 1-6, 6-3, 6-3. In the final the Spaniard would have to take on Britain's Alfie Hewett, who was made to work hard by Gustavo Fernandez. Hewett needed two hours and 41 minutes to complete a 4-6, 6-4, 7-5 victory on No.3 Court.

The continuing excellence of the Dutch in the Wheelchair events was emphasised when Diede de Groot and Aniek van Koot won their singles semi-finals. A 6-3, 6-2 victory over Wang Ziying kept De Groot on course to win her 15th consecutive Grand Slam singles trophy, while Van Koot was made to fight for more than two and a half hours for her 5-7, 6-4, 7-5 win over Yui Kamiji. It was the second match in a row in which Van Koot had been taken the distance. The Quad Wheelchair Singles final would also be an all-Dutch affair after Sam Schroder and Niels Vink, the top two seeds, beat Andy Lapthorne and Guy Sasson respectively.

"Did you hear the one about the pop star and the tennis player?" Sir Cliff Richard shares a joke with Vijay Amritraj

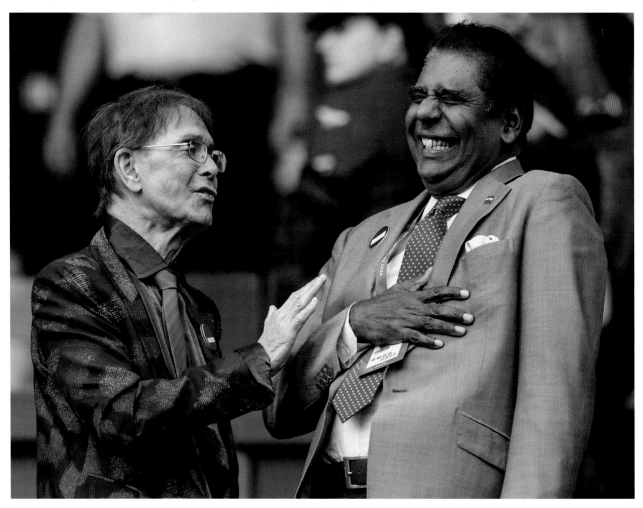

DAILY DIARY **DAY 12**

Was that booing we heard on Centre Court? Not again, surely? Oh, yes, it was. This time it was very definitely booing and this time it was very definitely all in good fun. Carlos Alcaraz (*above*) had reached his second consecutive final. He would play on Sunday afternoon before the Spanish football team would play England in the Euro 2024 final. "It's going to be a really good day for Spanish people," Carlos predicted as he spoke to Annabel Croft on court. The crowd booed. Carlos held up his hands: "I didn't say Spain's going to win. I just say it's going to be a really fun day." The crowd cheered. A small diplomatic incident had been averted. Smiles all round.

• If you want a simple explanation of how tennis works, ask Daniil Medvedev. Right, then Daniil, can you compare Carlos to the Big Three? Sure. Roger? "Plays on the line, hits beautiful technique shots." Novak? "Amazing defence, like a pinball player; the ball comes back faster to you." Rafa? "He can stay 10 metres behind [the baseline], but he is going to run to every ball and banana shot, lefty." And Carlos: "He can do all of it. That's what makes it tough. Probably in my career he's the toughest opponent I have faced." So now we know.

• The face looked familiar and the name rang a bell. Who was that on Court 4 in the boys' singles quarter-

finals? It was Jagger Leach, the son of Lindsay Davenport, the 1999 Ladies' Singles Champion (*below*), and the nephew of Rick Leach, a Gentlemen's Doubles and Mixed Doubles Champion in these parts. And, boy, was Jagger making his mum work overtime. Lindsay was back home in California providing commentary for the Tennis Channel, but as she was doing her prep for the ladies' final tomorrow, she was keeping an eagle-eye on the scores on Court 4. "She is just 'Mum' to me," 17-year-old Jagger told the ITF website. "It wasn't until I started playing myself that I realised and grasped what

she had done in her career. Then I would ask, 'Did you win that title?' and she would be embarrassed about it. I would be like, 'Wow'." Sadly, he lost in the singles but won his doubles quarter-final. Lindsay had another day, at least, of multi-tasking ahead.

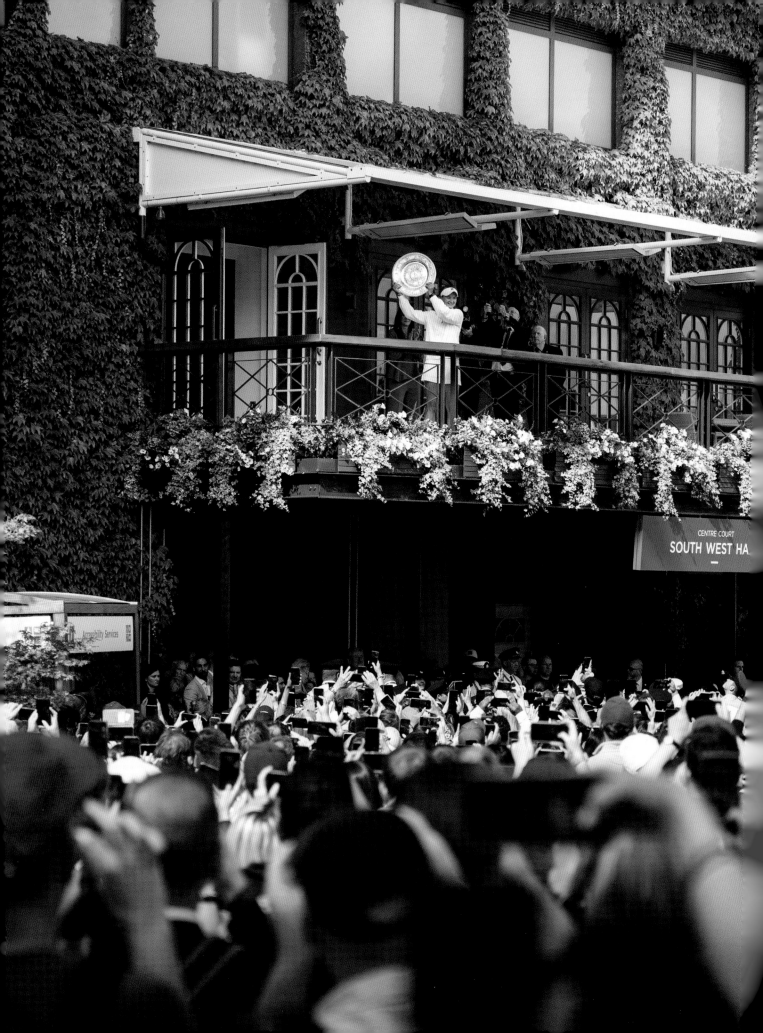

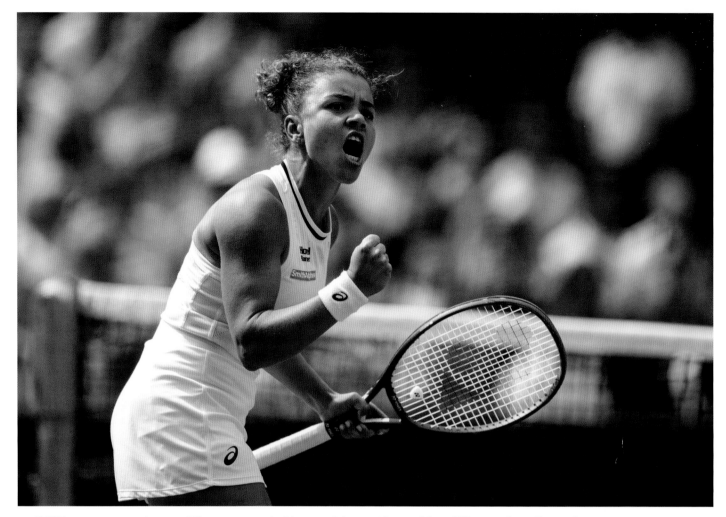

For a country with a population of less than 11 million, the Czech Republic has a remarkable record of success in ladies' singles at The Championships. Martina Navratilova, who took US citizenship after fleeing Czechoslovakia's communist regime in 1975, won a record nine Wimbledon singles titles, while Jana Novotna reached three finals and eventually triumphed in 1998. Petra Kvitova won the title twice, in 2011 and 2014, and Marketa Vondrousova flew the Czech flag again in 2023.

Above: The fightback begins – Jasmine Paolini regrouped at the start of the second set

Previous pages: Everyone wants to get their photo as Barbora Krejcikova proudly holds up the Venus Rosewater Dish

Would Barbora Krejcikova now extend that tradition or would she join Vera Sukova, Hana Mandlikova and Karolina Pliskova as Czechs who had made the final but not gone on to ultimate glory?

The last person standing in Krejcikova's way was a player from a country with a very modest record at The Championships. Italy, with a population more than five times bigger than the Czech Republic's, had never even had a semi-finalist in the ladies' singles until this year. Now, however, Jasmine Paolini, a 28-year-old from Tuscany who had just finished runner-up at Roland-Garros but had never won a main draw match on grass until this summer, was aiming to become Italy's first champion in either the ladies' or gentlemen's singles. At 5ft 4in tall she is six inches shorter than Krejcikova but strikes the ball with impressive power and is extremely quick across the court.

Both players had been comparatively late developers. Paolini, the younger of the two by just 17 days, had broken into the world's top 100 in singles for the first time at the age of 23, while Krejcikova had

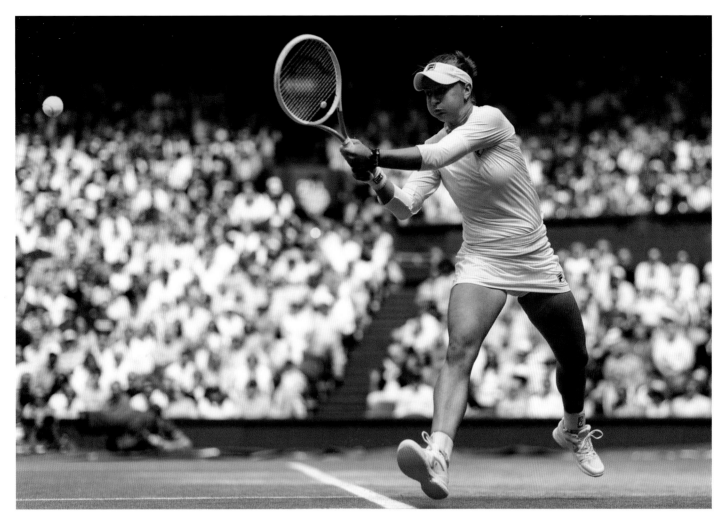

done so at 24. Krejcikova, nevertheless, had significantly greater Grand Slam experience, partly because she had been a successful doubles player before finding her way in singles as well. Although she had never previously gone beyond the fourth round at The Championships in singles, the 2021 Roland-Garros champion had already played in 12 Grand Slam finals across singles and doubles – and had only ever lost one of them. Moreover, one of those triumphs had been on Centre Court in the 2022 ladies' doubles (her victory in the same event in 2018 having come on No.1 Court).

On a warm and sunny afternoon Krejcikova was the quicker player into her stride, striking the ball with great power from the back of the court and winning 10 of the first 11 points. She served beautifully, with 19 of her 21 first serves in the opening set finding the court as Paolini was unable to create any break points. Within 35 minutes Krejcikova had the first set in the bag, after which Paolini left the court for a bathroom break.

When the world No.7 returned, the pendulum swung in her favour as she immediately found her range. Now it was the Italian on the front foot, racing into a 3-0 lead to the delight of all those in the crowd who had warmed to her endearing smile and positive outlook. When Krejcikova hit two consecutive double faults at the start of the next game it seemed that the tide had well and truly turned, though the Czech managed to hold for 3-1. Paolini, nevertheless, was not to be denied a second break of serve. When she levelled the match at one set apiece it was Krejcikova's turn to leave the court and find refuge in the bathroom.

The third set was tight from the start. Both players held serve comfortably until Paolini served at 3-3. The Italian saved one break point but on the second she double-faulted. At 4-3 Krejcikova held serve to love, but Paolini would not let the match slip without a fight. Serving for the title at 5-4, Krejcikova went 30-0 up, only for Paolini to win the next three points. The game went to four deuces, with Paolini saving two Championship points and Krejcikova saving two break points before securing

Krejcikova had dominated the opening set, but taken to a third she had to call on all her reserves of mental and physical strength

10 YEARS OF THE FOUNDATION
—

The Wimbledon Foundation – the official charity of the All England Club and The Championships – celebrated its 10th anniversary in 2024. Over the past decade it has donated £20 million and reached nine million people. It works on a local, national and international level to help communities, inspire young people and provide support in times of crisis and need.

Every year the Foundation asks two charities to nominate a young person to play a key role at The Championships. Satia Murray, 17 *(pictured above with Barbora Krejcikova and Jasmine Paolini)* was nominated by Ashdon Jazz Academy, a charity supporting the mental health and wellbeing of young women from minority communities in Merton, and performed the coin toss for the ladies' singles final. Cyprian Nelson, 19, representing Carney's Community in Wandsworth, would perform the coin toss for the gentlemen's singles final the following day.

This year, the tradition was also incorporated into the finals of the Wheelchair Singles events. Lucy Foyster, 11 *(left)*, representing Whizz Kidz, a charity supporting young wheelchair users, was selected for the Ladies' Wheelchair Singles final and enjoyed her meeting with Rufus the hawk. The Gentlemen's Wheelchair Singles final coin toss was performed by 10-year-old Alex Batt, who was nominated by the Dan Maskell Tennis Trust, which supports people with disabilities who play tennis.

Celebrating 10 years of the Wimbledon Foundation

—

£20m
expended on charitable activities

977
grants and donations awarded

9m
people reached

142,000
items donated to cha[...]

382
organisations supported

To celebrate the 10th anniversary of the Wimbledon Foundation, all those who had performed the coin toss since 2014 were invited to The Championships on Middle Sunday. *Left to right, **back row:*** Marni Johnson, Michael Ntim, Dylan Mulvey. ***Middle row:*** Lucas Schmetzer, Sean Seresinhe, Gabia Sakaviciute, Kaci Finch, Omar Popal. ***Front row:*** Philippa George, Rebecca Jones, Joshua Bills, Mu'awwiz Anwar, Uma Baker-Bahl

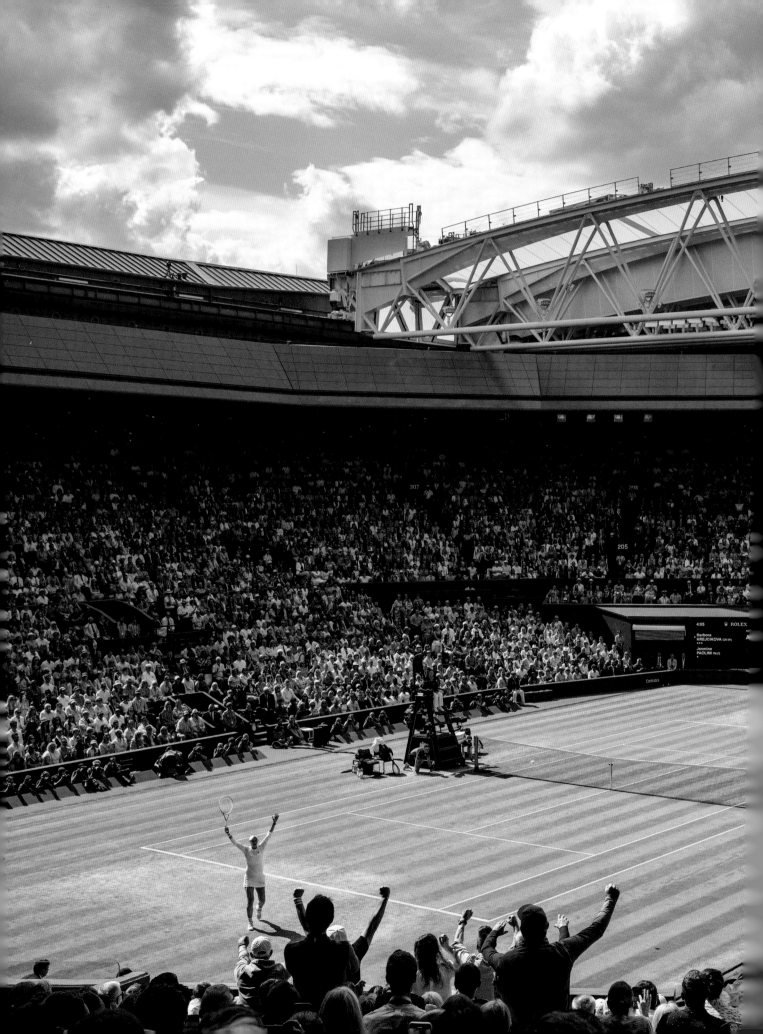

Previous pages and opposite: The moment of victory for Barbora Krejcikova. And no sooner had she walked back to her chair than her name was engraved on the trophy (above)

her 6-2, 2-6, 6-4 victory after an hour and 58 minutes. "I expected it was going to be difficult to serve it out, but I believed I could do it," Krejcikova said later. "I was just telling myself: 'Try to make the first serve, try to play your shot and be brave. If it's not going to work out it's going to be 5-5 and the match is not over.' I was quite prepared for both options."

In winning the title, Krejcikova played a total of 175 games across The Championships 2024, a record in the ladies' singles that surpassed the previous record of 173 set by Conchita Martinez in 1994.

At the request of Her Royal Highness The Princess of Wales, the Patron of the All England Club, the trophies were presented by Deborah Jevans, Chair of the Club. Paolini was still smiling, despite her disappointment, while Krejcikova talked emotionally in her post-match interview about her memories of Novotna, who had been her coach and mentor until her death in 2017.

Krejcikova, who is from Novotna's home city of Brno, said that when she was 18 and in need of some guidance about her future she had sought out the former Wimbledon champion. Knocking on Novotna's front door, Krejcikova handed her a letter asking for advice. "Knocking on her door changed my life," the new world No.10 said. "When I finished juniors I didn't know whether to continue or go the way of education. Jana was the one who told me I had the potential to go pro. Before she passed away she told me to go and win a Slam. I did, in Paris in 2021, and it was an unbelievable moment for me. I never believed I would then win the same trophy as Jana did in 1998."

As a child Krejcikova had dreamed of winning Roland-Garros. "Maybe things shifted a bit when I met Jana and when she was telling me stories about Wimbledon, grass, how difficult it was for her to win the title and how emotional she was when she actually made it," Krejcikova said. "After that I started to see Wimbledon as the biggest tournament in the world."

Krejcikova, who said she talks to Novotna in her dreams, was in tears when she was shown her name on the same honours board as her mentor. "The only thing that was going through my head was that I miss Jana a lot," Krejcikova said. "It was just very, very emotional. I think she would be proud.

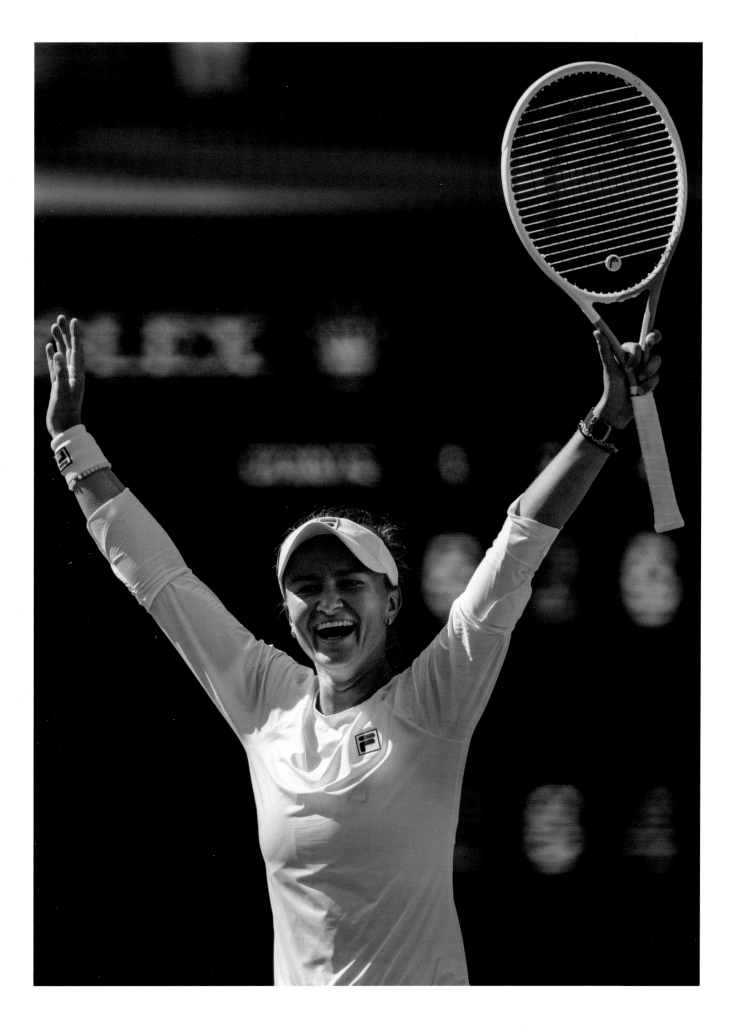

I think she would be really excited that I'm on the same board as she is, because Wimbledon was super special for her."

Meanwhile Paolini said she had to remember that "today is still a good day". She explained: "I played in a final of Wimbledon. As a kid I used to watch the finals on TV – cheering for Federer. But to be here right now, it's crazy. I enjoyed every moment here. It's been a beautiful two weeks."

The Italian, who would rise to a career-high position at No.5 in the world after The Championships, felt sure she would win a Grand Slam trophy one day but admitted: "Sometimes I'm a little bit scared to dream too much. I'm going back, trying to practise, to stay in the present. This is the goal for me and my team, to try to keep this level as much as possible. If I keep this level, I think I can have the chance to do great things."

Krejcikova became the eighth different Ladies' Singles Champion in the last eight Championships. In the last three years the champions have been Elena Rybakina, the world No.23, Marketa Vondrousova, the world No.42, and now Krejcikova, the world No.32. "It's exciting," Krejcikova said. "It's nice that everybody has that potential and can believe they can be the next Slam champion."

The gentlemen's doubles also produced surprise champions as 28-year-old Henry Patten and 35-year-old Harri Heliovaara won the title barely three months after joining forces for the first time. The Briton and the Finn, who were unseeded, had already knocked out three seeded pairs and now beat a fourth, the Australians Max Purcell and Jordan Thompson, winning the final 6-7(7), 7-6(8), 7-6(9).

Jasmine Paolini is presented with the runner-up salver by Deborah Jevans, Chair of the All England Club (below, left) and even manages to raise her trademark smile despite her disappointment (below, right)

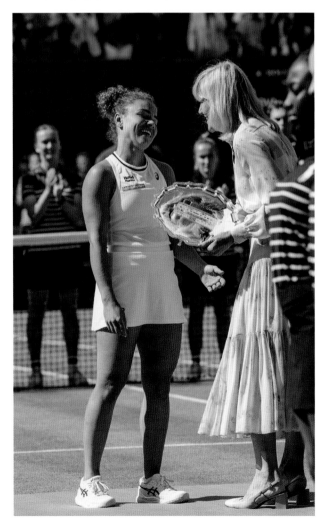

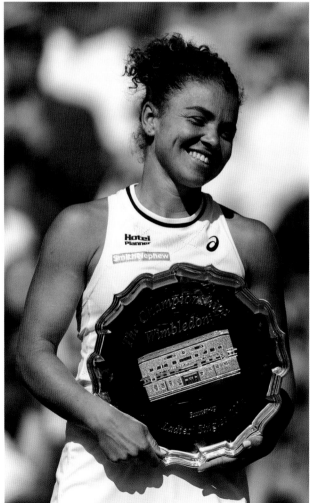

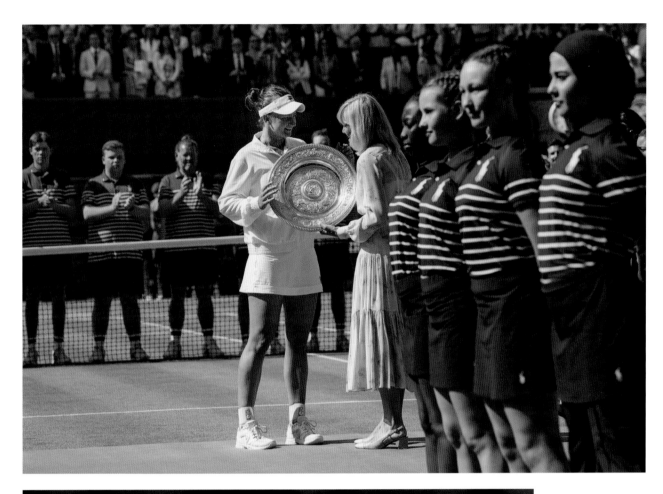

Above: Is it really mine? Barbora Krejcikova seems unsure whether to take the trophy from Deborah Jevans

Left: Yes, it is! Finally, the new champion can celebrate – the famous trophy is hers

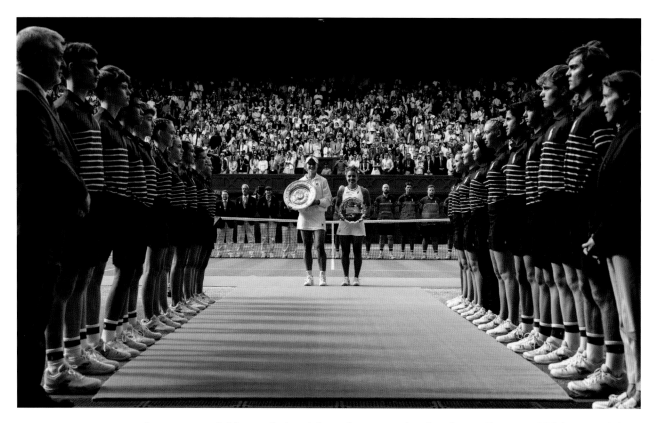

*Above: The Ball Boys
and Girls form a
guard of honour for
Barbora Krejcikova
and Jasmine Paolini*

*Following pages:
Krejcikova is enjoying
every second of her
success as she shows the
trophy to the crowd*

It was a remarkable match that did not feature any breaks of serve. Patten and Heliovaara did not create any break points at all, while Purcell and Thompson had one in the second set and two in the third but were unable to convert them. The Australians won the first tie-break on their sixth set point, having led 6-1 before losing six points in a row, and then failed to take three Championship points in the second set. The first came when Heliovaara served at 5-6 and two more followed in the tie-break, which Patten and Heliovaara eventually won 10-8. In the match tie-break at the end of the third set Purcell and Thompson led 8-6 before losing five of the last six points as their opponents closed out victory after two hours and 49 minutes.

Patten said afterwards: "My dad came up to me and said: 'That was like a bank robbery.' Which was harsh but fair. It seemed like we were always down. In the first set tie-break we were 6-1 down but clawed it back. In the second set tie-break we were 5-2 down, then a lucky net cord before a good return – but pretty lucky at the same time. Again we clawed it back. Then we were mini-breaks down in the third set tie-break. We didn't get near their serves all match. We basically blew open the doors and ran away with the trophy at the end of it."

Heliovaara, who worked at an airport during a five-year break from tennis between 2013 and 2017 while he studied for an engineering degree, had never previously gone beyond the quarter-finals in any Grand Slam men's doubles competition, though he won the mixed doubles at the US Open in 2023 alongside Anna Danilina.

Patten, who worked at The Championships in 2016 and 2017 collecting statistics for IBM, played college tennis at the University of North Carolina, Asheville, where he studied economics and management. He turned professional in 2020 and decided to focus on doubles two years later. Until these Championships he had never gone beyond the third round at any Grand Slam event. In his only previous appearance in the gentlemen's doubles at Wimbledon he had lost in the first round – now he was the third British player in the Open era to win the title. Jonny Marray won in 2012 alongside the Dane Freddie Nielsen, while Neal Skupski partnered the Dutchman Wesley Koolhof to victory in 2023.

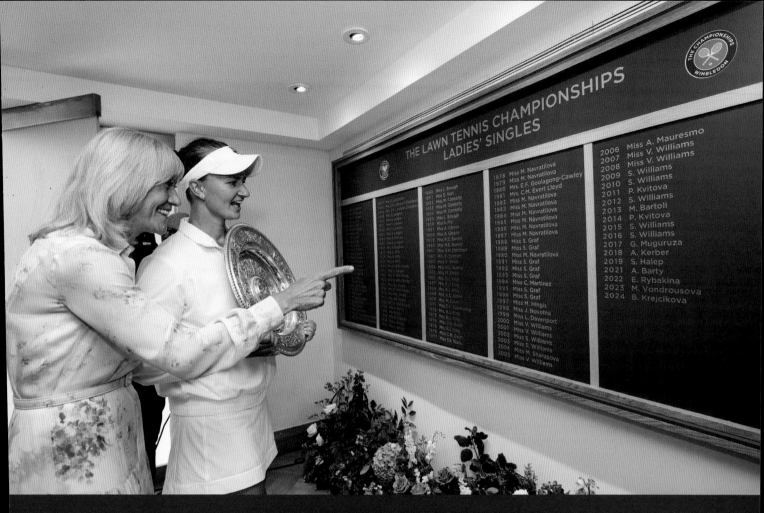

SHEDDING A TEAR FOR JANA

—

Ten years ago, an 18-year-old Barbora Krejcikova took her courage in both hands and knocked on Jana Novotna's door. Both of them had grown up in Brno in the Czech Republic; Jana was a Wimbledon champion, Barbora was not sure whether to turn professional or go to university. Would Jana help her? The answer was "Yes".

Jana's place in Wimbledon history was first cemented not by her 1998 victory but by her 1993 defeat. She had swept aside Gabriela Sabatini and Martina Navratilova to reach the final, and once there she had a point for a 5-1 lead in the third set against Steffi Graf. And then she double-faulted and did not win another game. At the presentation ceremony, she broke down and sobbed on The Duchess of Kent's shoulder. It was an image that went around the world.

She would have to wait another five years – and endure another final defeat – before she could finally lift the Venus Rosewater Dish, but at last Jana was the Ladies' Singles Champion.

Jana died from cancer in 2017 and her last words to Barbora were, "Go and win a Grand Slam". So when she saw her name alongside Jana's on the honours board, it was Barbora's turn to sob. "I think she would be proud," Barbora said, "because Wimbledon was super special for her".

Relief and tears
– Britain's Henry
Patten (**left**) and
Finland's Harri
Heliovaara cannot
believe that they are
now the Gentlemen's
Doubles Champions

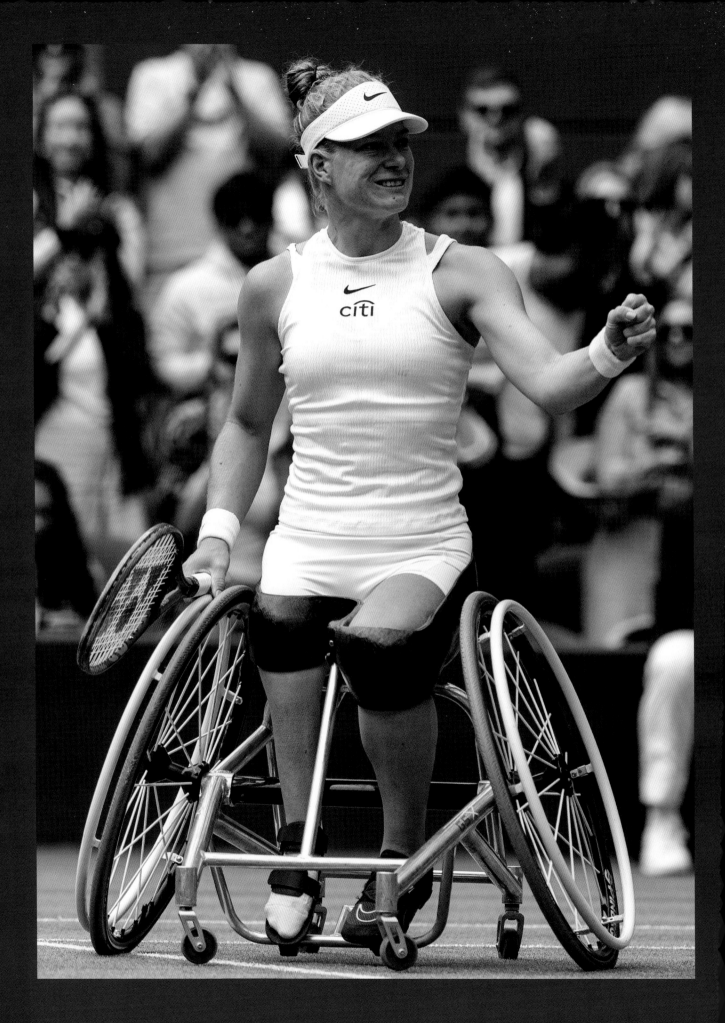

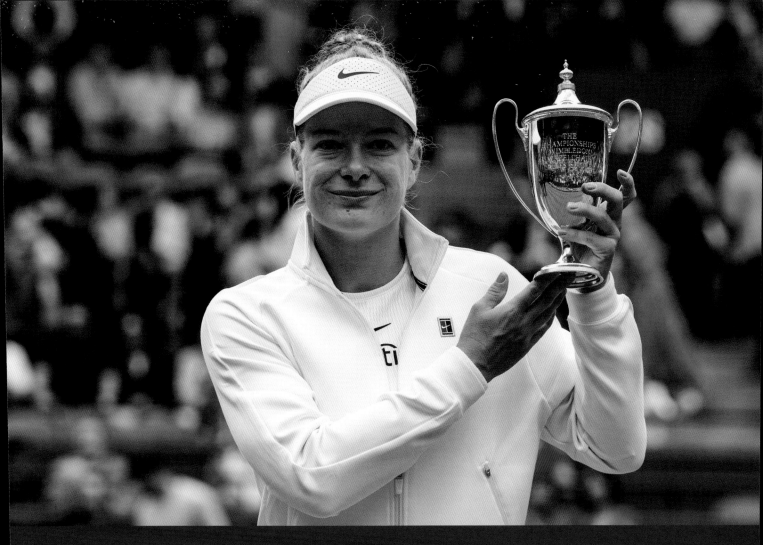

DE GROOT'S SWEET FIFTEEN

—

Pressure? What pressure? Diede de Groot had just won her 15th consecutive Grand Slam singles title, her sixth at Wimbledon and she had now extended her Grand Slam singles trophy collection to 23. Not only that, but she had done it in a year when she had lost two matches. This was the year when she was supposed to be a bit vulnerable. "I thought no one is going to expect anything from me anymore, but that's not the case," she said. "People still expect me to win. I expect me to win." And win she did, beating Aniek van Koot 6-4, 6-4.

Those two losses prior to The Championships were no more than minor blips (and her only defeats since February 2021); Diede at a Grand Slam, particularly Wimbledon, is an unstoppable force. She won her first major title at Wimbledon and for the 27-year-old Dutch player, this is where she loves to play. "It's the magical feeling of Wimbledon," she said, "the history, the way they do things, it's so original, it's so authentic. No other Grand Slam has that."

She also appreciates the emphasis The Championships place on the Wheelchair events (both singles finals were played on No.1 Court). "The crowd were into it," she said. "That's what's really special. I think it shows that Wheelchair tennis is ready for this."

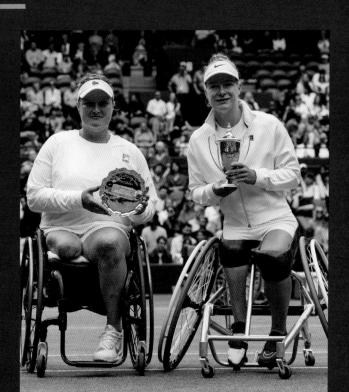

"I idolised Jonny Marray and Neal Skupski," Patten said. "They are big heroes of mine. To be joining them as Wimbledon champions is phenomenal."

Katerina Siniakova, who won the ladies' doubles title alongside Krejcikova in 2018 and 2022, lifted the trophy for the third time after partnering Taylor Townsend to victory in the last match of the day on Centre Court. The Czech and the American beat Canada's Gabriela Dabrowski and New Zealand's Erin Routliffe 7-6(5), 7-6(1). It was Siniakova's ninth Grand Slam doubles title, the Czech having won her eighth the previous month at Roland-Garros alongside Coco Gauff, and Townsend's first. "I've been close a couple of times so it really means a lot to be able to get over the finish line here," Townsend said afterwards. "To do it at Wimbledon is so special."

Siniakova and Townsend were playing only their 10th match together, having joined forces after the Czech contacted the American through social media. "We had played against each other a couple of times," Siniakova said. "I found playing against her really tough and tricky so I was curious to see how it would be playing on the same side."

Diede de Groot extended her remarkable winning streak as the 27-year-old Dutchwoman claimed the Ladies' Wheelchair Singles title for the sixth time by beating her compatriot, Aniek van Koot, 6-4, 6-4 on No.1 Court. It was De Groot's 15th consecutive Grand Slam singles title in a run that goes back to the US Open in 2020, her 23rd in total and her 42nd inclusive of doubles. "Wimbledon will always be my favourite," she said afterwards. "I won my first Grand Slam title here."

Sam Schroder and Niels Vink claimed another victory for the Dutch when they won the Quad Wheelchair Doubles for the third year in a row. They beat Britain's Andy Lapthorne and Israel's Guy Sasson 3-6, 7-6(3), 6-3 after two hours and 44 minutes on No.3 Court.

Smile, we are the new Ladies' Doubles Champions! Katerina Siniakova takes a selfie with her partner Taylor Townsend

DAILY DIARY DAY 13

At last it was time to celebrate. Barbora was the new Ladies' Singles Champion; she had won the title that she had never even dared to dream of when growing up. Better still: she was now a Member of the All England Club. And after the long round of trophy presentations, photo calls, press conferences and television interviews, it was finally time to celebrate with a few glasses of fizz on the players' lawn. That was when Pink *(above, left)* made her grand entrance to engulf Barbora in a massive hug (the two have known each other for years) and toast her victory with some of that champagne. The Czech invited the pop superstar to sit in her box at her next big final. "Listen, don't threaten me with a good time," the 44-year-old singer replied before announcing Krejcikova as her tennis coach, joking: "I'll be the oldest, slowest tennis pro in history."

• Just to make Barbora's weekend complete, it turned out that the people at Lego had been watching her progress intently. She is not the only enthusiast in the ladies' locker room – Iga Swiatek and Leylah Fernandez are both big builders – but she is the company's first Ladies' Singles Champion. To mark the occasion, the Czech division of Lego created their own replica of the Venus Rosewater Dish together with her own Lego figure and a tennis racket made from the plastic bricks which was presented to her when she got back home. Days don't get better than this.

• They were the 'Magnificent Seven': the seven former Wimbledon champions gathered in the Royal Box to witness a new Member being inducted into their club. From Angela Mortimer, the oldest surviving Ladies' Singles Champion, through to Billie Jean King, Ann Jones, Martina Navratilova and Conchita Martinez, and on to Maria Sharapova *(below)* and Marion Bartoli, they all knew exactly how Barbora Krejcikova felt as she held that famous trophy in her hands. Jasmine Paolini

could draw some emotional support from the Royal Box, too: Christine Janes, who was also watching as the Italian accepted the runner-up's silver salver, had lost her only Wimbledon final to Angela Mortimer 63 years before.

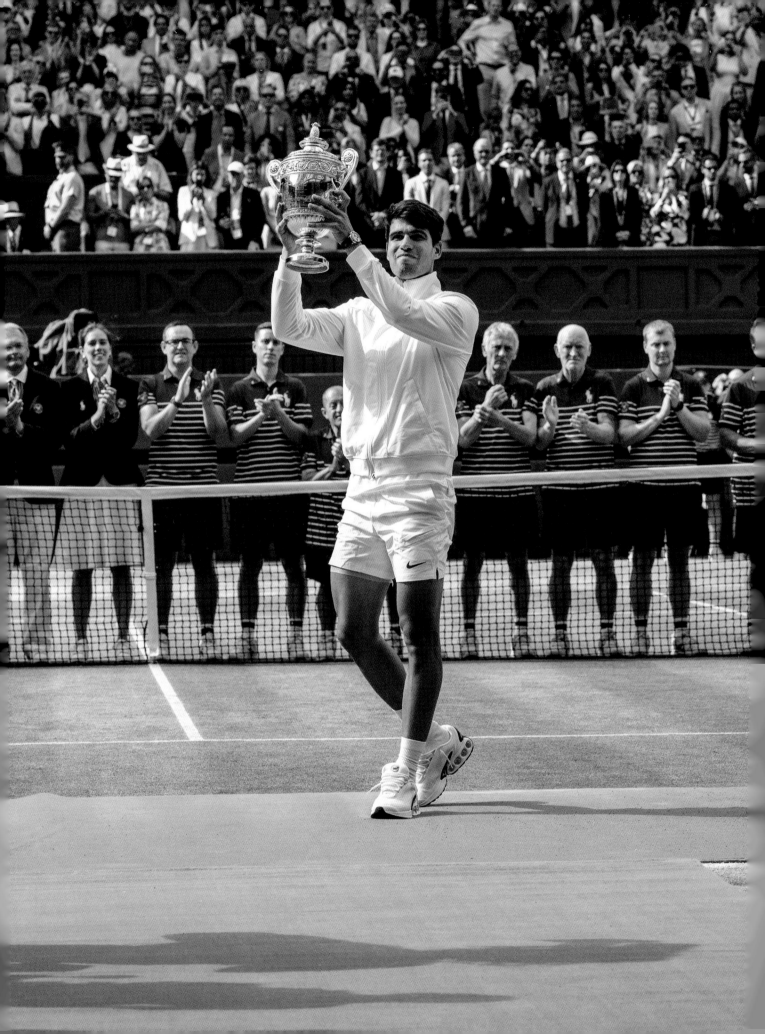

W

hen you consider that 128 players set out to contest the gentlemen's singles at The Championships every year, it is remarkable how many times the same two men emerge from the pack to meet in the final. Since tennis turned professional in 1968, eight pairs of players had contested two or more finals against one another, ranging from Bjorn Borg and Jimmy Connors, who met in the 1977 and 1978 finals, through to Novak Djokovic and Roger Federer, who contested the finals in 2014, 2015 and 2019.

Above: HRH The Princess of Wales, Patron of the All England Club, receives a standing ovation from the Centre Court crowd

Previous pages: All hail the king of Centre Court – Carlos Alcaraz had kept his grip on the trophy

Now another pair would be joining them, with Djokovic taking on Carlos Alcaraz 12 months after their electrifying final at The Championships 2023. The age difference between the two men was 15 years and 348 days. Only the 1974 finalists, Connors and Ken Rosewall, had been separated by a wider gap (17 years and 304 days).

When two exceptional players meet in a final there is always a huge amount at stake. Victory here would earn 37-year-old Djokovic a place alongside Federer, who held the all-time record of eight gentlemen's singles titles at Wimbledon, and a place on his own at the top of the tree in terms of the number of Grand Slam singles titles won. Djokovic matched Margaret Court's all-time record of 24 with his triumph at the US Open in 2023. Having already won 10 Australian Opens, he would also become the first player ever to win eight or more titles at two Grand Slam events, while victory would see him become the oldest Wimbledon Gentlemen's Singles Champion in the Open era.

Alcaraz had a long way to go before he could even contemplate matching some of Djokovic's records, but the 21-year-old Spaniard was already on his own history-making path. He was aiming to become only the second man in the Open era to win his first four Grand Slam singles finals, Federer having

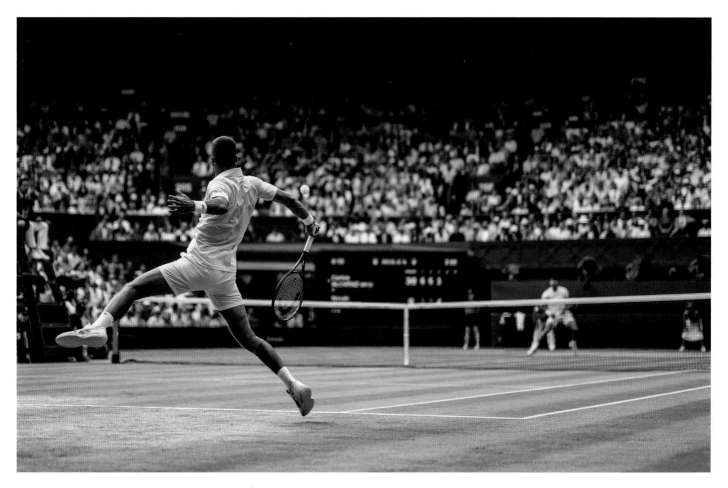

won the first seven finals he had contested. In terms of men's Open-era records, Alcaraz could become just the third player (after Bjorn Borg and Boris Becker) to win multiple Wimbledon titles aged 21 or under, the sixth to win Roland-Garros and Wimbledon in the same year (and the youngest to do so) and the ninth to retain his Wimbledon crown.

After one of the wettest and coolest Championships of recent times, the final was played in welcome warmth. Having the sun on his back seemed to inspire Alcaraz as the defending champion hit huge forehand winners from the start, repeatedly unsettled Djokovic with beautifully disguised drop shots and successfully chased down anything short.

For two sets Djokovic was curiously lacklustre. He was attacking the net regularly, but his approaches were simply not good enough and gave Alcaraz time to drill passing shots past him. When the Serb did have the chance to volley he frequently mistimed his strokes, either by putting the ball into the net or by attempting cushioned shots that Alcaraz reached with comparative ease.

When Alcaraz won the title the previous year he had done so despite losing the first set 6-1 in just 34 minutes. This time it was the Spaniard who was the faster man out of the blocks. In a 14-minute opening game he forced five break points, on the last of which Djokovic missed a forehand. On the fourth point of Alcaraz's first service game the Spaniard hit a 136mph serve, his fastest of the Fortnight. Djokovic then hit a double fault at the end of the fifth game to give Alcaraz his second break of serve.

Having served out for the opening set, Alcaraz broke in the first game of the second as Djokovic missed three forehands and then put what should have been a routine volley into the net. At 2-4 and 30-15 Djokovic played three shots that cost him his serve again and typified his struggles. A poor approach shot enabled Alcaraz to hit a forehand pass winner before Djokovic put another weak volley into the net and then double-faulted on break point.

There had barely been a flicker of emotion from Djokovic all match, but in the third game of the third set he finally burst into life, letting out a huge roar after saving four break points. When Alcaraz served at 2-3 in the best game of the match Djokovic orchestrated the crowd's cheers after hitting a

Above: Novak Djokovic later admitted he was powerless to stop Alcaraz. "He was the better player from the beginning till the end," he said

Following pages: Save for a slight wobble as he went to serve for the title, Carlos Alcaraz was in complete control during the final

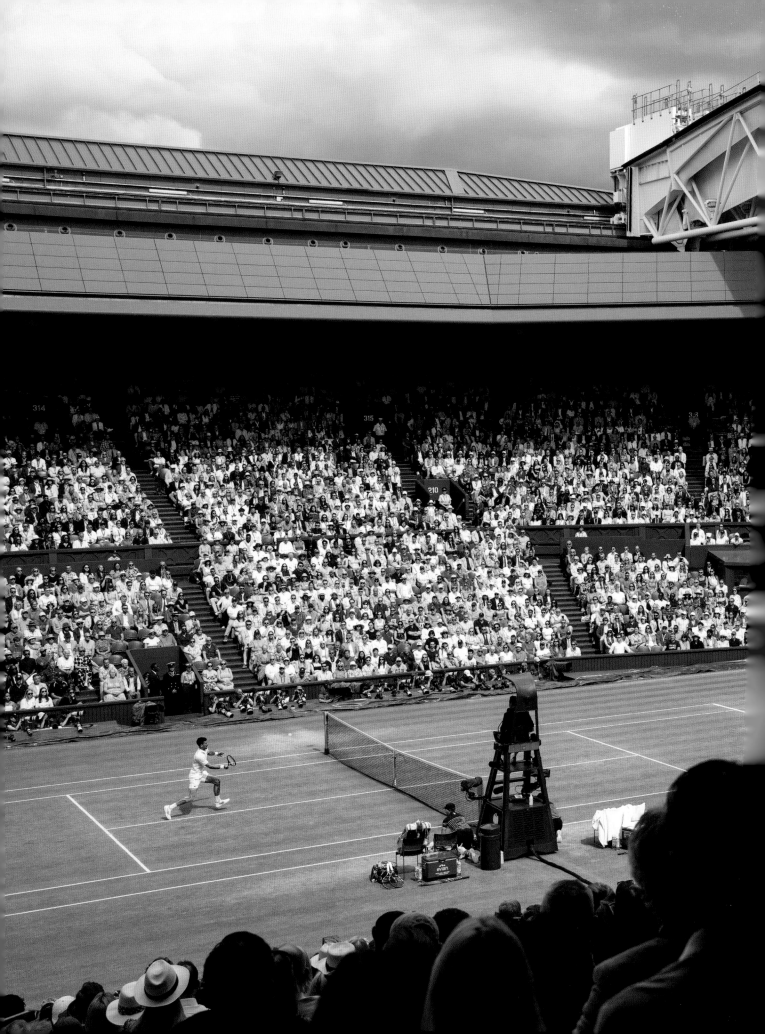

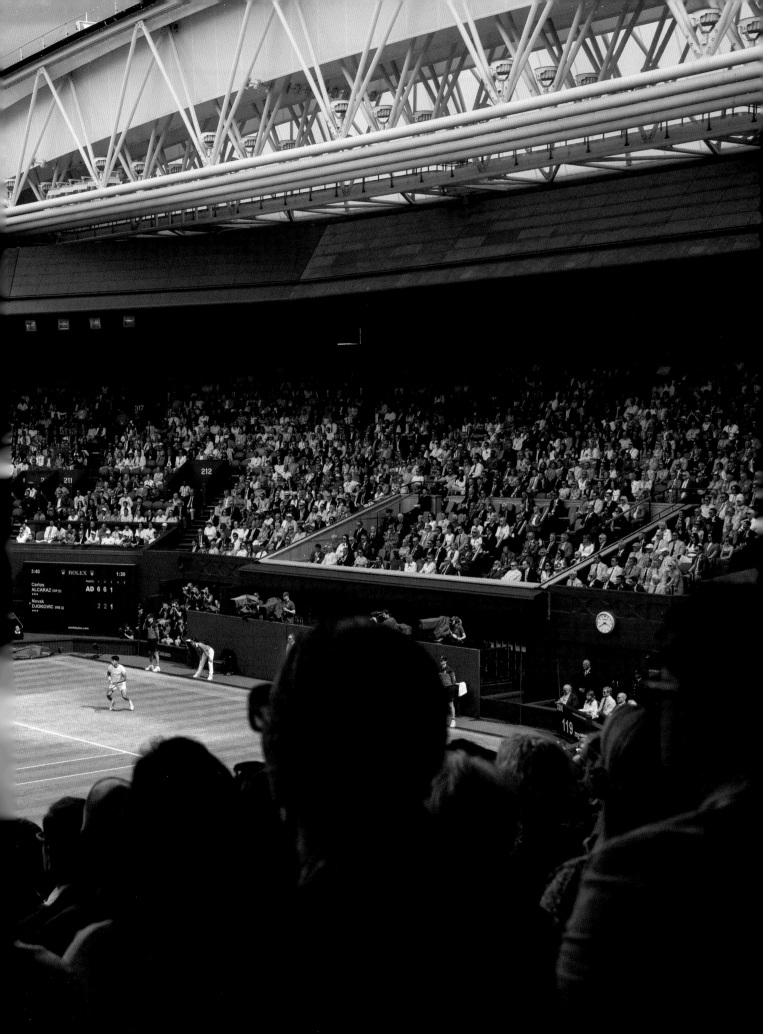

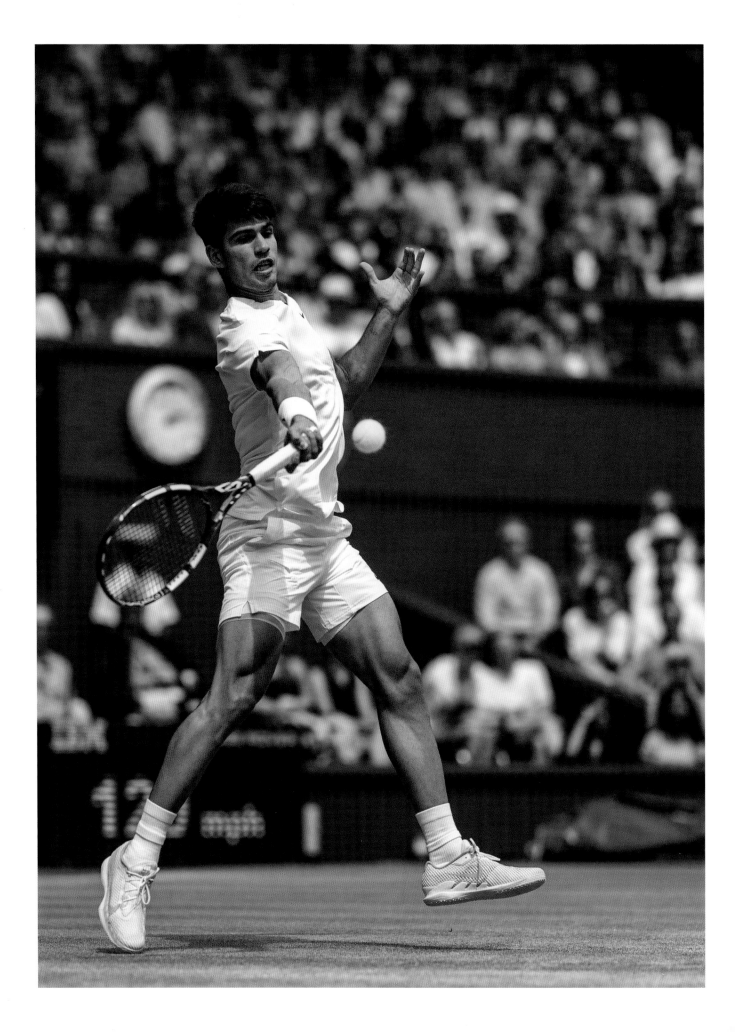

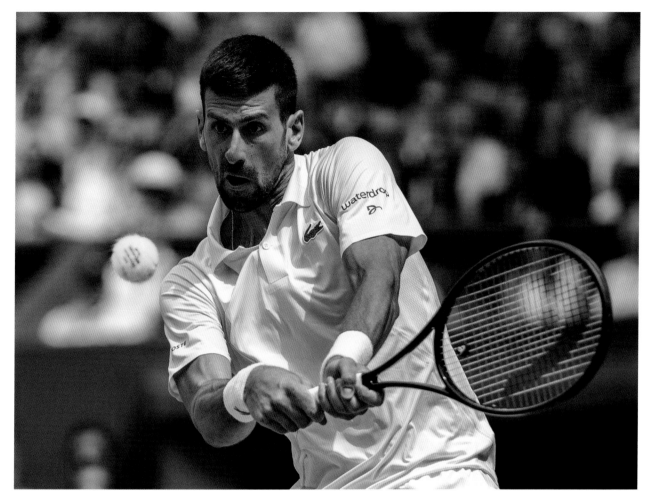

winning volley, only for the Spaniard's serve to get him out of trouble. A service winner saved a break point before two successive aces closed out a game that lasted 11 minutes.

Djokovic was now in a significantly more combative mood, but at 4-4 he went 0-40 down when Alcaraz hit an audacious drive-volley winner. Djokovic saved the first break point, but on the second he again found himself stranded at the net as Alcaraz pounced on another inadequate approach shot. The only time in the match that Alcaraz faltered was when he served for the title at 5-4 and 40-0. He double-faulted on his first Championship point, could not handle a ferocious forehand return on the second and then, with Djokovic apparently at his mercy, blazed a drive-volley wide. Two more missed forehands handed the Serb his only break of the match.

In his 37th Grand Slam final, were we about to witness a trademark Djokovic comeback from two sets down? The set went to a tie-break, but now Alcaraz held firm. Serving at 5-4, he showed great composure to hit a brilliant drop shot winner before securing his 6-2, 6-2, 7-6(4) victory after two hours and 27 minutes with an unreturned serve. The statistics from the match told their own story. Djokovic had played 53 points at the net but won only 27 of them, while Alcaraz won 16 of his 22. Alcaraz also hit 42 winners compared to his opponent's 26.

On a day when Rod Laver, Ken Rosewall, Stan Smith, Jan Kodes, Stefan Edberg, Andre Agassi and Lleyton Hewitt were among those in the Royal Box, the trophies were presented by the Patron of the All England Club, Her Royal Highness The Princess of Wales, who was making her first public appearance for nearly a month following the news earlier in the year that she had been having treatment for cancer.

Above: Novak Djokovic was on the back foot for most of the match, a testimony to Carlos Alcaraz's performance

Opposite: The Alcaraz forehand was at its ferocious best across all three sets

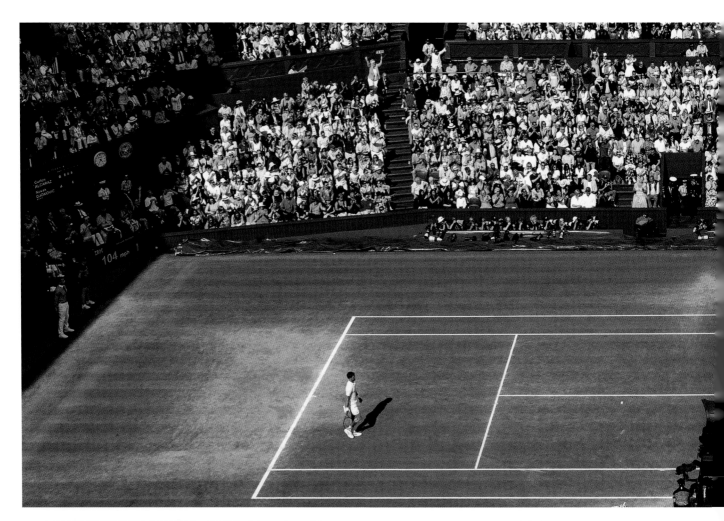

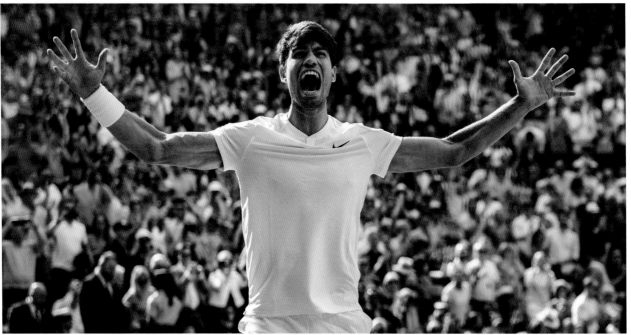

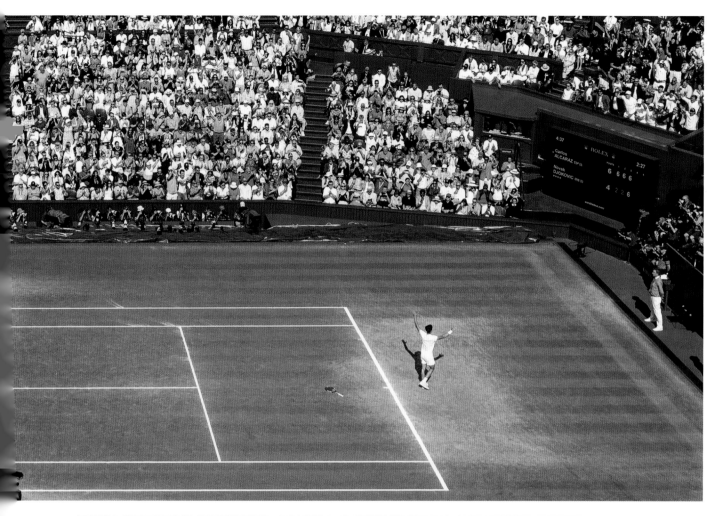

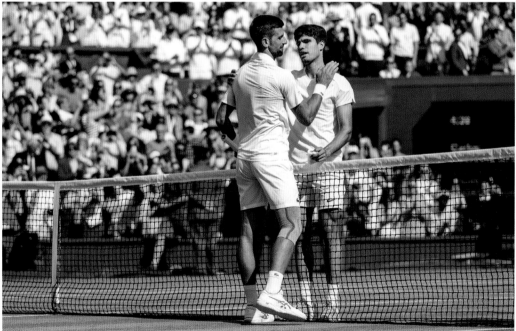

Above: Centre Court rises to acclaim a second Carlos Alcaraz gentlemen's singles triumph

Opposite: Alcaraz turns to his players' box in delight – he had been almost flawless in the defence of his title

Left: Seven-time champion Novak Djokovic congratulates his worthy successor

Right: For the second year running, Carlos Alcaraz's name is engraved on the Gentlemen's Singles Trophy

Opposite: The view from the top of the stand as the Centre Court crowd rises to salute the champion

Below: Her Royal Highness The Princess of Wales presents Carlos Alcaraz with the trophy and chats to the champion

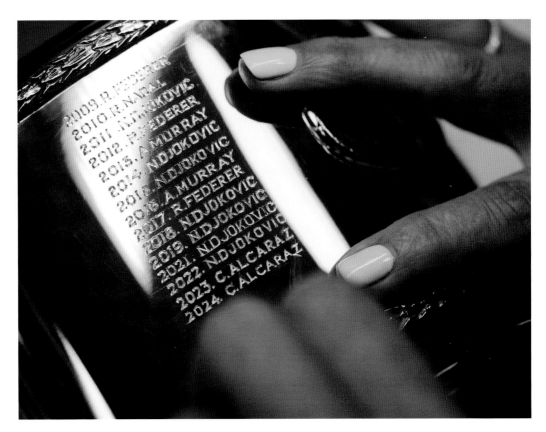

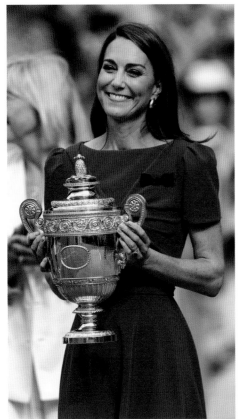

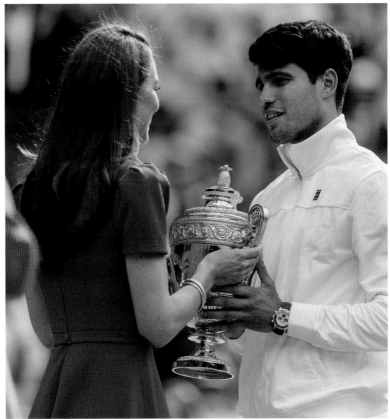

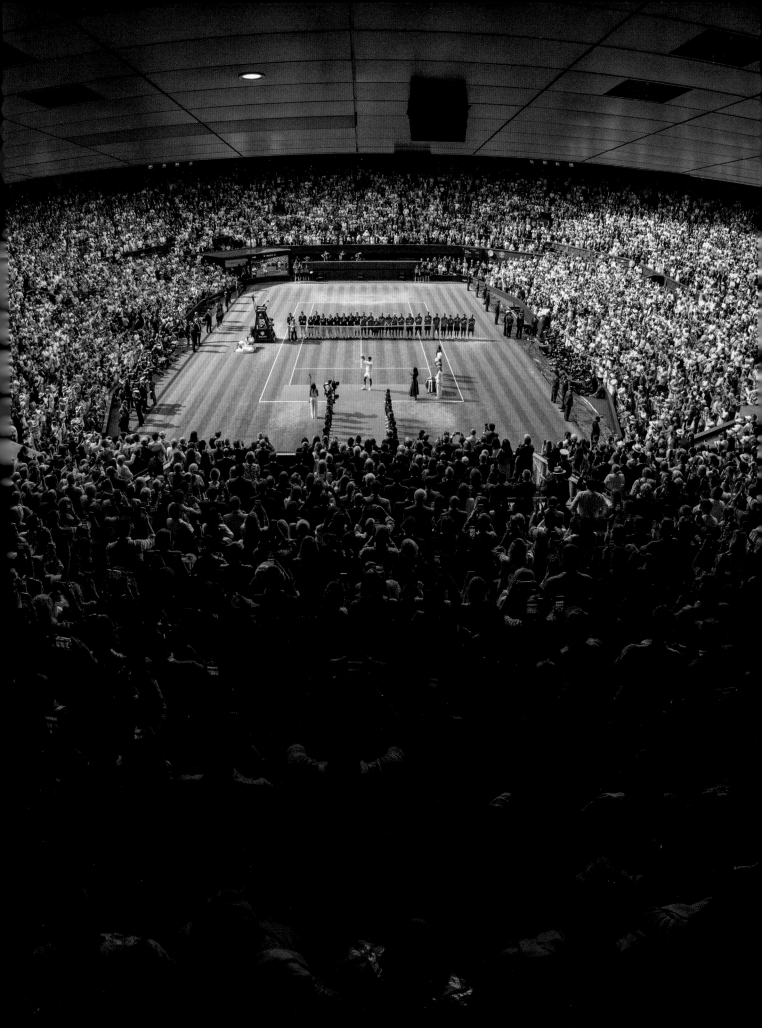

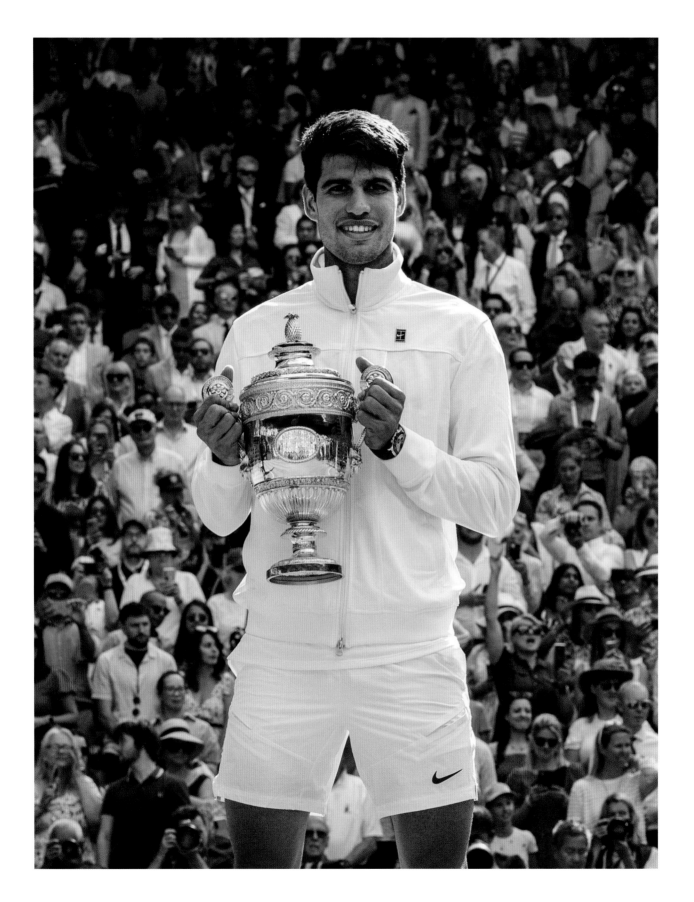

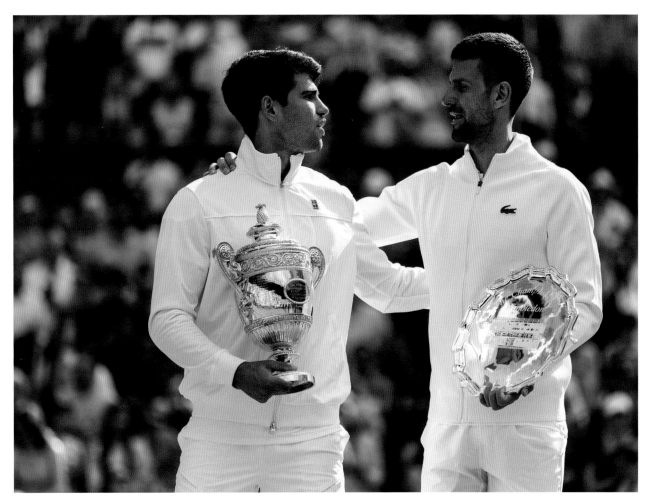

Above: Champions past and present – the respect between the two finalists was plain to see

Opposite: Carlos Alcaraz holds the Gentlemen's Singles Trophy as if he never wants to let it go

Alcaraz, interviewed on court after the match, said it was a dream to win the trophy again. "For me this is the most beautiful tournament, the most beautiful court and the most beautiful trophy," he said. Djokovic, whose only two losses in his last 41 matches at The Championships had been in his two finals against Alcaraz, was gracious in defeat. Despite his disappointment at the result, he underlined his joy at appearing in another Wimbledon final. "I'm a child living my childhood dream once again," he said.

By winning his first four Grand Slam titles before turning 22, Alcaraz had matched Borg, Becker and Mats Wilander. He had also won his first four at a younger age than Djokovic, Federer and Rafael Nadal had. "I've seen and I've heard all the stats," Alcaraz told reporters later. "I honestly try not to think about it too much. Obviously it's a really great start of my career, but I have to keep going. I have to keep building my path. At the end of my career, I want to sit at the same table as the big guys. That's my main goal. That's my dream right now."

Djokovic acknowledged Alcaraz's superiority on the day – "He was the better player and played every single shot better than I did" – but was pleased with his own achievements over the Fortnight given that he had had knee surgery less than a month before the start of The Championships. "I did all I could to prepare myself," he said. "If someone had told me three or four weeks ago that I would play in the Wimbledon final I would have taken it for sure."

Hsieh Su-Wei and Jan Zielinski, who had won their first mixed doubles title together at the Australian Open at the start of the year, claimed their second in the final match of The Championships on Centre Court. The 38-year-old Taiwanese and the 27-year-old Pole needed just 76 minutes to beat

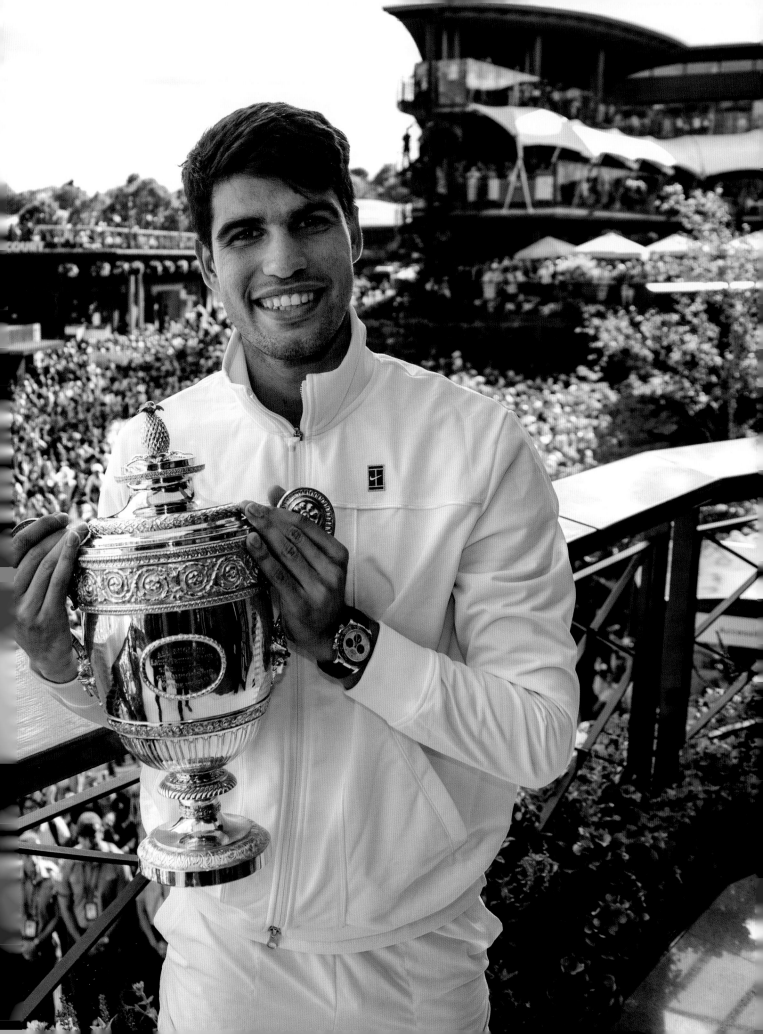

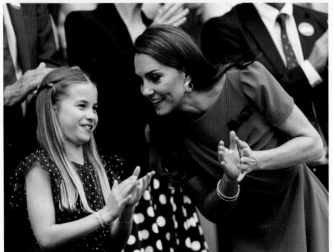

FIT FOR A PRINCESS

Her Royal Highness The Princess of Wales, Patron of the All England Club, made only her second public appearance since her cancer diagnosis earlier in the year to watch the gentlemen's singles final and present the trophies. The Princess plays tennis, follows tennis and always tries to attend The Championships when she can – and it would seem that her daughter, Princess Charlotte, is following in the family tradition. They were clearly enjoying the final (above and left) and Princess Charlotte seemed thrilled to meet the newly crowned champion, Carlos Alcaraz (below).

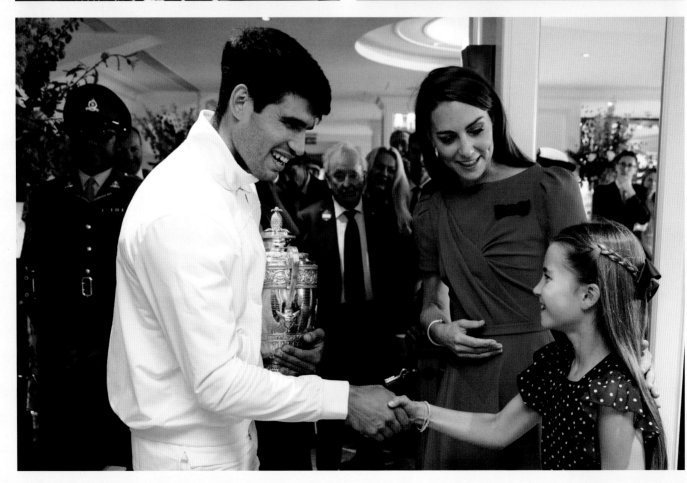

the Mexicans Santiago Gonzalez and Giuliana Olmos 6-4, 6-2. Hsieh, a prolific champion in ladies' doubles, had never previously gone beyond the semi-finals in mixed doubles, while Zielinski had never even won a mixed doubles match at Grand Slam level before he teamed up with Hsieh.

Meanwhile No.1 Court was the scene of emotional celebrations as Alfie Hewett won the Gentlemen's Wheelchair Singles title for the first time. The 26-year-old Briton, who had lost in the final in 2022 and 2023, completed his collection of Grand Slam singles trophies by beating Spain's Martin de la Puente 6-2, 6-3. The fifth game of the match proved a turning point as Hewett broke to love and then added the next five games.

Winning his ninth Grand Slam singles title, Hewett was cheered on by a large contingent of friends and family and was particularly pleased to have his grandfather in the crowd. "We did a lot together when we were younger," Hewett explained. "He was pretty much my chauffeur, the guy that would take care of me and take me to training. He's been ill recently. It was really special for him to be there. He hasn't seen me play live for over three years now. It meant a lot for him to be in the stands, and obviously to see the rest of my family."

To complete a memorable day, Hewett and Gordon Reid won the Gentlemen's Wheelchair Doubles for the sixth time when they beat Japan's Tokito Oda and Takuya Miki 6-4, 7-6(2) on No.3 Court. It was the 21st Grand Slam doubles title the Britons had won together. Hewett also became only the second man in Wheelchair tennis history, after Shingo Kunieda, to win the singles and doubles at every Grand Slam event.

Japan's Yui Kamiji and South Africa's Kgothatso Montjane won the Ladies' Wheelchair Doubles when they beat the Dutch pair of Diede de Groot and Jiske Griffioen 6-4, 6-4 to claim their first

Previous pages: "I'm not new anymore!" said Carlos Alcaraz, looking perfectly at home with the trophy on the Members' Balcony

Below: Could anyone look happier? Kgothatso Montjane (left) and Yui Kamiji celebrate winning the Ladies' Wheelchair Doubles title

Following page: Out for the count – Jan Zielinski falls flat on his back in delight as he and Hsieh Su-Wei win the mixed doubles final

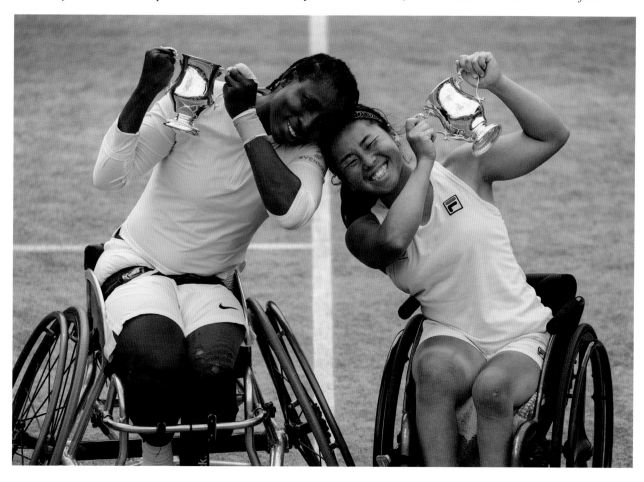

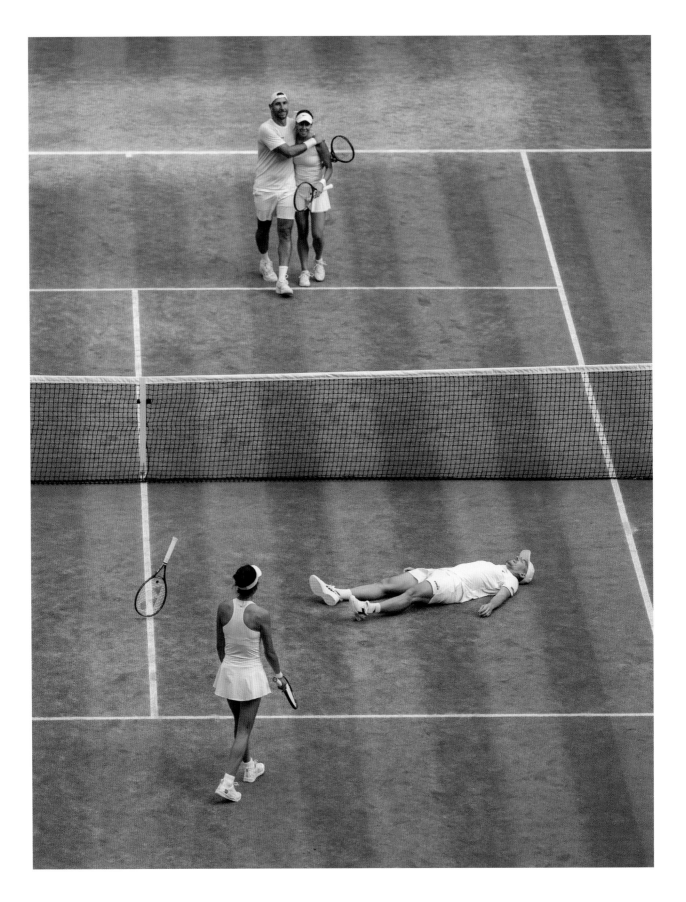

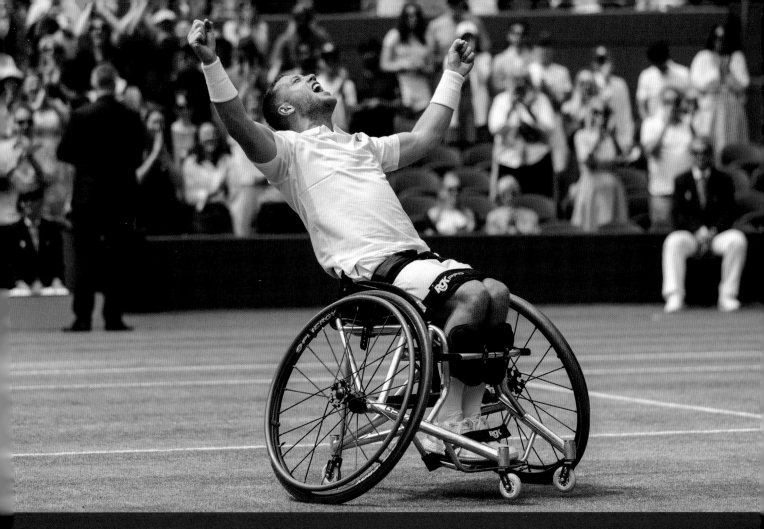

ALFIE'S LONG WAIT IS OVER

—

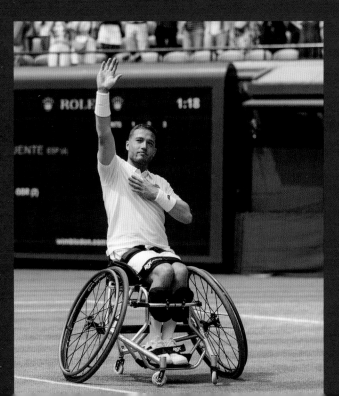

All good things come to those who wait, but Alfie Hewett *(above and left)* felt he had waited long enough – after finishing as runner-up in the two previous finals he got his wish at long last, and with his first Gentlemen's Wheelchair Singles title he completed his career Grand Slam. He beat Martin de la Puente 6-2, 6-3. It was his ninth Grand Slam singles title, but none tasted sweeter than this.

"For a British player to win Wimbledon, it's a huge thing," he said. "I'm not a massively spiritual person or anything like that, I just felt like something was holding me back over these last few years. It was making me wait for a reason. Today was that reason. To be out there in front of 10,000 people, No.1 Court, literally everyone there, apart from my brother, who I would want to be there, it just felt like it had a meant-to-be feeling today. This was weighing heavy on my shoulders for a long time. If I'm being honest, the minute I lost last year, I don't think there was a single day that I didn't think about being back here and changing the narrative."

Alfie, 26, is only the fourth Wheelchair athlete to complete a singles career Grand Slam after Dylan Alcott, Diede de Groot and Shingo Kunieda. It had definitely been worth the wait.

Wimbledon title as a team. Niels Vink beat his fellow Dutchman, Sam Schroder, 7-6(4), 6-4 to take the Quad Wheelchair Singles title for the second year in a row.

Norway's Nicolai Budkov Kjaer and Slovakia's Renata Jamrichova, both aged 17, became the first players from their respective countries to win Wimbledon junior titles. Budkov Kjaer beat Mees Rottgering, of the Netherlands, 6-3, 6-3 to win the boys' final in just 68 minutes. Both players had six break points in the match, but whereas Budkov Kjaer converted five of his, Rottgering took only two. Jamrichova claimed her second junior Grand Slam singles title of the year when she beat Australia's Emerson Jones 6-3, 6-4 in an hour and six minutes. Jamrichova played almost faultless tennis to win the first set in just 25 minutes but was made to work hard for the second after Jones went into a 3-1 lead. Jamrichova described it as "one of the greatest junior matches I've ever played".

Alexander Razeghi, of the United States, and Germany's Max Schoenhaus won the boys' doubles, while the Americans Tyra Caterina Grant and Iva Jovic took the girls' doubles title. In the 14-and-under singles events Japan's Takahiro Kawaguchi won the boys' title while the Czech Republic's Jana Kovackova claimed the girls' trophy.

For Alcaraz, winning the gentlemen's singles title was just the start of a busy day. After his post-match press conference and media interviews, he headed into London for the Champions' Dinner at The Old War Office at Raffles London. En route he watched on his phone and an iPad as Spain's footballers beat England in the European Championship final. Interviewed on stage at the dinner, Alcaraz said that one of the keys to playing "a complete match" in the final had been controlling his nerves and staying calm. Barbora Krejcikova, the Ladies' Singles Champion, was asked what winning the title had meant to her. She smiled and said she was looking forward to returning to the All England Club "every single year for the rest of my life".

Barbora Krejcikova has one more chance to hold the Venus Rosewater Dish before it goes back into the trophy cabinet in the Clubhouse

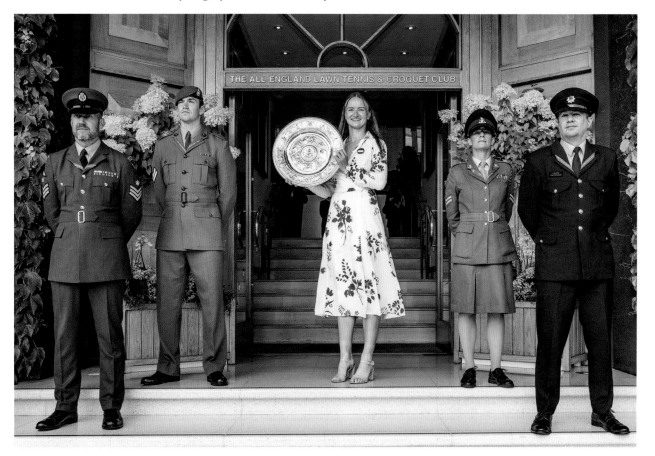

DAILY DIARY **DAY 14**

For a couple of days, The Championships – that most traditional of English sporting events – becomes the centre of attention in New York, the most iconic of American cities. Now in its third year, The Hill in New York brings strawberries and cream, Pimm's and rain (yes, it even rained...) to the Big Apple. Moved to a new and bigger venue under Brooklyn Bridge for this year's Championships *(above)*, the nine-acre site played host to 3,500 visitors each day. It all began on Friday evening with a concert by Nicole Scherzinger, and from Saturday morning – New York time – the spectators could watch the singles and doubles finals on the big screen. The whole area was decorated in Wimbledon colours and signage, making it as close to the experience of being in SW19 as can be.

• Carlos had done his bit, now it was over to the Spanish team in Berlin to try and do theirs against England in the Euro 2024 final. Throughout The Championships, Carlitos had been in touch with the Spain captain, Alvaro Morata. "I wished them the best of luck," he said. "When I finish [my match], he sends me some photos [showing] that he was watching before their match. It was kind of a lucky [charm] because he told me, 'OK, I'm going to talk to you because every time that we spoke, we won.'" Before winning his second Wimbledon

title, Carlitos sent the message to the boys in Berlin: "Sending a big hug, let's do this. Vamos!" And the rest is history.

• As the saying goes, behind every good man is a great woman – and Jan Zielinski is living proof of that. The Pole is the world No.27 in men's doubles and has five titles to his name, but in mixed doubles he had never won a match until this year. That is when he joined forces with Hsieh Su-Wei, the four-time Ladies' Doubles Champion at Wimbledon, and life would never be the same again. Already the Australian Open champions, the pair *(below)* beat Giuliana Olmos and Santiago Gonzalez in the final,

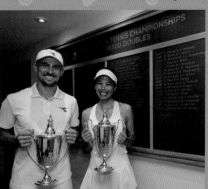

leaving Jan delighted. "I can't even put it into words," he said. "I was dreaming about this moment for so long and today we're Wimbledon champions. It's an unbelievable feeling and a great privilege."

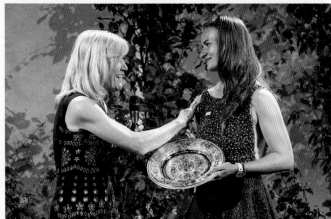

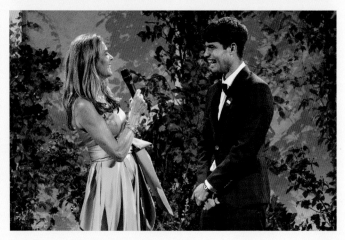

A MOMENT OF REFLECTION

Carlos Alcaraz finally had a few moments to himself – just him and the Gentlemen's Singles Trophy on Centre Court. The evening before had been a rush as he prepared for the Champions' Dinner while watching the European Championship final, but now all was quiet. *Opposite page, clockwise from right:* Club Chair Deborah Jevans presents Barbora Krejcikova with her replica trophy; Annabel Croft interviews Carlos Alcaraz; the two champions dance together; Service Stewards outside the Old War Office at Raffles London, venue of the 2024 Champions' Dinner.

WIMBLEDON 2024

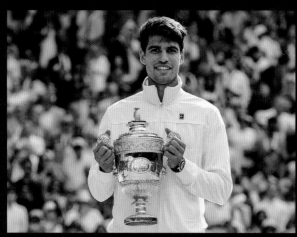

THE GENTLEMEN'S SINGLES
Carlos ALCARAZ

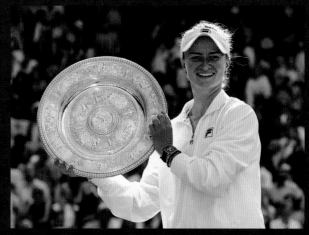

THE LADIES' SINGLES
Barbora KREJCIKOVA

THE GENTLEMEN'S DOUBLES
Harri HELIOVAARA
Henry PATTEN

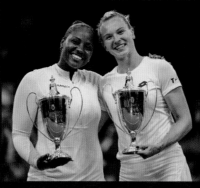

THE LADIES' DOUBLES
Taylor TOWNSEND
Katerina SINIAKOVA

THE MIXED DOUBLES
HSIEH Su-wei
Jan ZIELINSKI

THE GENTLEMEN'S
WHEELCHAIR SINGLES
Alfie HEWETT

THE LADIES'
WHEELCHAIR SINGLES
Diede DE GROOT

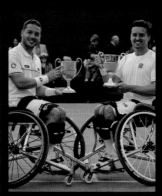

THE GENTLEMEN'S
WHEELCHAIR DOUBLES
Alfie HEWETT
Gordon REID

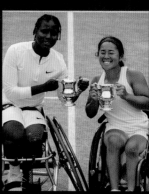

THE LADIES'
WHEELCHAIR DOUBLES
Kgothatso MONTJANE
Yui KAMIJI

THE CHAMPIONS

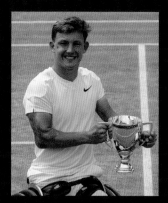

THE QUAD
WHEELCHAIR SINGLES

Niels VINK

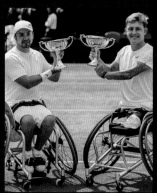

THE QUAD
WHEELCHAIR DOUBLES

**Sam SCHRODER
Niels VINK**

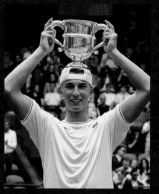

THE 18&U BOYS'
SINGLES

**Nicolai
BUDKOV KJAER**

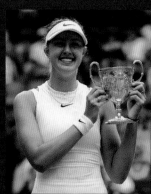

THE 18&U GIRLS'
SINGLES

Renata JAMRICHOVA

THE 18&U BOYS' DOUBLES

**Alexander RAZEGHI
Max SCHOENHAUS**

THE 18&U GIRLS' DOUBLES

**Tyra Caterina GRANT
Iva JOVIC**

THE 14&U BOYS'
SINGLES

Takahiro KAWAGUCHI

THE 14&U GIRLS'
SINGLES

Jana KOVACKOVA

THE GENTLEMEN'S
INVITATION DOUBLES

**Bob BRYAN
Mike BRYAN**

THE LADIES'
INVITATION DOUBLES

**Martina HINGIS
Kim CLIJSTERS**

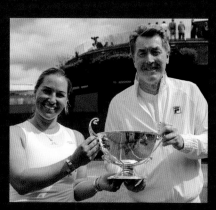

THE MIXED
INVITATION DOUBLES

**Dominika CIBULKOVA
Mark WOODFORDE**

THE GENTLEMEN'S SINGLES CHAMPIONSHIP 2024
Holder: CARLOS ALCARAZ (ESP)

The Champion will become the holder, for the year only, of the CHALLENGE CUP. The Champion will receive a silver three-quarter size replica of the Challenge Cup. A Silver Salver will be presented to the Runner-up and a Bronze Medal to each defeated semi-finalist.
The matches will be the best of five sets. If the score should reach 6-6 in the final set, the match will be decided by a first-to-ten tie-break.

First Round

1. Jannik Sinner [1] (1) (ITA)
2. Yannick Hanfmann (110) (GER)
3. Matteo Berrettini (59) (ITA)
4. Marton Fucsovics (70) (HUN)
5. Sumit Nagal (73) (IND)
6. Miomir Kecmanovic (52) (SRB)
7. (LL) Daniel Elahi Galan (103) (COL)
8. Tallon Griekspoor [27] (27) (NED)
9. Nicolas Jarry [19] (20) (CHI)
10. Denis Shapovalov (27) (CAN)
11. Daniel Altmaier (80) (GER)
12. (WC) Arthur Fery (247) (GBR)
13. (Q) Lloyd Harris (118) (RSA)
14. Alex Michelsen (55) (USA)
15. (Q) Mattia Bellucci (148) (ITA)
16. Ben Shelton [14] (14) (USA)
17. Grigor Dimitrov [10] (10) (BUL)
18. Dusan Lajovic (56) (SRB)
19. (Q) Cristian Garin (106) (CHI)
20. Juncheng Shang (91) (CHN)
21. Stan Wawrinka (95) (SUI)
22. (WC) Charles Broom (248) (GBR)
23. Gael Monfils (33) (FRA)
24. Adrian Mannarino [22] (24) (FRA)
25. Zhizhen Zhang [32] (38) (CHN)
26. Maxime Janvier (225) (FRA)
27. (Q) Jan-Lennard Struff (41) (GER)
28. Fabian Marozsan (43) (HUN)
29. Alexandre Muller (102) (FRA)
30. (Q) Hugo Gaston (71) (FRA)
31. Aleksandar Kovacevic (88) (USA)
32. Daniil Medvedev [5] (5)
33. Carlos Alcaraz [3] (3) (ESP)
34. Mark Lajal (269) (EST)
35. Aleksandar Vukic (69) (AUS)
36. Sebastian Ofner (45) (AUT)
37. Borna Coric (89) (CRO)
38. Felipe Meligeni Alves (145) (BRA)
39. Matteo Arnaldi (35) (ITA)
40. Frances Tiafoe [29] (29) (USA)
41. Sebastian Baez [18] (ARG)
42. Brandon Nakashima (65) (USA)
43. Pavel Kotov (53)
44. Jordan Thompson (40) (AUS)
45. Botic van de Zandschulp (97) (NED)
46. (WC) Liam Broady (156) (GBR)
47. Alexander Shevchenko (57) (KAZ)
48. Ugo Humbert [16] (16) (FRA)
49. Tommy Paul [12] (13) (USA)
50. Pedro Martinez (49) (ESP)
51. (Q) Otto Virtanen (147) (FIN)
52. Max Purcell (68) (AUS)
53. (Q) Zizou Bergs (82) (BEL)
54. Arthur Cazaux (98) (FRA)
55. Jakub Mensik (78) (CZE)
56. Alexander Bublik [23] (23) (KAZ)
57. Mariano Navone [31] (32) (ARG)
58. Lorenzo Sonego (54) (ITA)
59. Roberto Bautista Agut (112) (ESP)
60. Maximilian Marterer (85) (GER)
61. (LL) Luca Van Assche (104) (FRA)
62. Fabio Fognini (94) (ITA)
63. (Q) Alex Bolt (234) (AUS)
64. Casper Ruud [8] (8) (NOR)
65. Andrey Rublev [6] (6)
66. Francisco Comesana (122) (ARG)
67. Federico Coria (72) (ARG)
68. Adam Walton (101) (AUS)
69. Luciano Darderi (37) (ITA)
70. (WC) Jan Choinski (174) (GBR)
71. Constant Lestienne (92) (FRA)
72. Lorenzo Musetti [25] (25) (ITA)
73. Sebastian Korda [20] (21) (USA)
74. (LL) Giovanni Mpetshi Perricard (58) (FRA)
75. Yoshihito Nishioka (90) (JPN)
76. Nuno Borges (50) (POR)
77. Emil Ruusuvuori (87) (FIN)
78. Mackenzie McDonald (96) (USA)
79. Taro Daniel (84) (JPN)
80. Stefanos Tsitsipas [11] (11) (GRE)
81. Taylor Fritz [13] (12) (USA)
82. Christopher O'Connell (79) (AUS)
83. Kei Nishikori (48) (JPN)
84. Arthur Rinderknech (76) (FRA)
85. Flavio Cobolli (48) (ITA)
86. Rinky Hijikata (77) (AUS)
87. Daniel Evans (60) (GBR)
88. Alejandro Tabilo [24] (19) (CHI)
89. Jack Draper [28] (28) (GBR)
90. Elias Ymer (205) (SWE)
91. (Q) Cameron Norrie (42) (GBR)
92. Facundo Diaz Acosta (67) (ARG)
93. (WC) Henry Searle (539) (GBR)
94. Marcos Giron (46) (USA)
95. Roberto Carballes Baena (64) (ESP)
96. Alexander Zverev [4] (4) (GER)
97. Hubert Hurkacz [7] (7) (POL)
98. Radu Albot (144) (MDA)
99. Arthur Fils (34) (FRA)
100. Dominic Stricker (94) (SUI)
101. (LL) David Goffin (83) (BEL)
102. Tomas Machac (39) (CZE)
103. Roman Safiullin (44)
104. Francisco Cerundolo [26] (30) (ARG)
105. Felix Auger-Aliassime [17] (17) (CAN)
106. Thanasi Kokkinakis (93) (AUS)
107. (Q) Lucas Pouille (212) (FRA)
108. Laslo Djere (51) (SRB)
109. Jaume Munar (63) (ESP)
110. (WC) Billy Harris (176) (GBR)
111. (LL) James Duckworth (81) (AUS)
112. Alex de Minaur [9] (9) (AUS)
113. Holger Rune [15] (15) (DEN)
114. Soonwoo Kwon (80) (KOR)
115. (WC) Paul Jubb (201) (GBR)
116. Thiago Seyboth Wild (74) (BRA)
117. (Q) Quentin Halys (220) (FRA)
118. Christopher Eubanks (62) (USA)
119. Aslan Karatsev (99)
120. Karen Khachanov [21] (22)
121. Tomas Martin Etcheverry [30] (31) (ARG)
122. Luca Nardi (75) (ITA)
123. Alexei Popyrin (47) (AUS)
124. Thiago Monteiro (86) (BRA)
125. (WC) Jacob Fearnley (277) (GBR)
126. (Q) Alejandro Moro Canas (188) (ESP)
127. (Q) Vit Kopriva (123) (CZE)
128. Novak Djokovic [2] (2) (SRB)

Second Round

- Jannik Sinner [1] — 6/3 6/4 3/6 6/3
- Matteo Berrettini — 7/6(3) 6/2 3/6 6/1
- Miomir Kecmanovic — 6/2 3/6 6/3 6/4
- Tallon Griekspoor [27] — 7/6(3) 6/3 6/4
- Denis Shapovalov — 6/1 7/5 6/4
- Daniel Altmaier — 4/6 7/6(6) 1/6 6/3 6/1
- Lloyd Harris — 3/6 4/6 7/6(5) 6/2 7/6(9)
- Ben Shelton [14] — 4/6 6/3 3/6 6/3 6/4
- Grigor Dimitrov [10] — 6/3 6/4 7/6
- Juncheng Shang — 7/5 6/4 6/4
- Stan Wawrinka
- Gael Monfils — 6/4 3/6 7/5 6/4
- Zhizhen Zhang [32] — 7/6(4) 6/3 6/2
- Jan-Lennard Struff — 6/4 6/7(4) 6/2 6/3
- Alexandre Muller — 6/4 7/6(2) 7/6(5)
- Daniil Medvedev [5] — 6/3 6/4 6/2
- Carlos Alcaraz [3] — 7/6(3) 7/5 6/2
- Aleksandar Vukic — 6/7(9) 6/4 6/4 3/6 7/6(8)
- Borna Coric — 6/3 7/6(2) 6/3
- Frances Tiafoe [29] — 6/7(5) 2/6 6/1 6/3 6/3
- Brandon Nakashima
- Jordan Thompson — 5/7 5/7 6/4 6/4 6/4
- Botic van de Zandschulp — 6/2 4/6 6/3 6/2
- Ugo Humbert [16] — 6/1 4/6 7/6(2) 6/7(3) 6/1
- Tommy Paul [12] — 6/2 6/1 4/6 6/3
- Otto Virtanen — 6/3 6/2 6/4
- Arthur Cazaux — 6/1 6/4 6/7(2) 6/7(4) 7/6(8)
- Alexander Bublik [23] — 4/6 6/7(2) 6/4 6/4 6/2
- Lorenzo Sonego — 6/4 7/6(2) 6/4
- Roberto Bautista Agut — 6/3 6/1 6/4
- Fabio Fognini — 6/1 6/3 7/5
- Casper Ruud [8] — 7/6(2) 6/4 6/4
- Francisco Comesana — 6/4 5/7 6/2 7/6(5)
- Adam Walton
- Luciano Darderi — 7/5 4/6 2/6 7/5 6/2
- Lorenzo Musetti [25] — 4/6 7/6(4) 6/2 6/3
- Giovanni Mpetshi Perricard — 7/6(5) 6/7(4) 7/6(6) 6/7(4) 6/3
- Yoshihito Nishioka — 6/2 7/6(6) 2/6 6/3
- Emil Ruusuvuori — 7/6(6) 4/6 5/7 7/6(6) 6/3
- Stefanos Tsitsipas [11] — 7/6(5) 6/4 7/5
- Taylor Fritz [13] — 6/1 6/2 6/4
- Arthur Rinderknech — 5/7 6/4 6/7(2) 6/3 6/2
- Flavio Cobolli — 7/5 4/6 6/4 6/4
- Alejandro Tabilo [24] — 6/2 7/5 6/3
- Jack Draper [28] — 3/6 6/3 6/3 4/6 6/3
- Cameron Norrie — 7/5 7/5 6/3
- Marcos Giron — 3/6 6/3 6/4
- Alexander Zverev [4] — 6/2 6/4 6/3
- Hubert Hurkacz [7] — 5/7 6/4 6/4 6/4
- Arthur Fils — 6/3 6/2 3/6 6/4
- Tomas Machac — 3/6 3/6 6/4 6/1 7/6(5)
- Roman Safiullin — 6/7(5) 3/6 7/5 6/3 6/4
- Thanasi Kokkinakis — 4/6 5/7 7/6(9) 6/4 6/4
- Lucas Pouille — 3/6 7/6(4) 3/6 6/3 6/1
- Jaume Munar — 6/4 3/6 6/3 6/3
- Alex de Minaur [9] — 7/6(1) 7/6(3) 6/4
- Holger Rune [15] — 6/1 6/4 6/4
- Thiago Seyboth Wild — 1/6 3/6 7/6(6) 6/4 7/6
- Quentin Halys — 6/4 6/4 6/2
- Karen Khachanov [21] — 6/3 6/7(4) 7/6(11) 2/0 Ret'd
- Tomas Martin Etcheverry [30] — 6/1 6/4 6/4
- Alexei Popyrin — 6/4 6/7(8) 6/3 6/4
- Jacob Fearnley — 7/5 6/4 7/6(12)
- Novak Djokovic [2] — 6/1 6/2 6/2

Third Round

- Jannik Sinner [1] — 7/6(3) 6/4 7/6(4)
- Miomir Kecmanovic — 4/6 7/6(7) 1/6 6/2 6/4
- Denis Shapovalov — 7/6(3) 6/3 1/6 6/7(5) 6/4
- Ben Shelton [14] — 4/6 7/6(5) 6/7(5) 6/3 7/6(7)
- Grigor Dimitrov [10] — 5/7 6/4 7/6(4) 6/4
- Gael Monfils — 7/6(5) 6/4 7/6(3)
- Jan-Lennard Struff — 5/7 6/3 7/6(1) 7/6(8)
- Daniil Medvedev [5] — 6/7(3) 7/6(4) 6/4 7/5
- Carlos Alcaraz [3] — 7/6(5) 6/2 6/2
- Frances Tiafoe [29] — 7/6(5) 6/1 6/3
- Brandon Nakashima — 6/3 6/2 6/2
- Ugo Humbert [16] — 7/6(9) 3/6 7/6(5) 7/6(6)
- Tommy Paul [12] — 4/6 6/3 5/7 7/5 6/4
- Alexander Bublik [23] — 6/4 7/6(1) 6/2
- Roberto Bautista Agut — 6/3 3/6 6/3 6/4
- Fabio Fognini — 6/4 7/5 6/7(1) 6/3
- Francisco Comesana — 7/5 1/6 6/7(12) 6/1 7/6(8)
- Lorenzo Musetti [25] — 6/2 6/7(4) 7/6(3) 6/3
- Giovanni Mpetshi Perricard — 6/4 6/1 6/4
- Emil Ruusuvuori — 7/6(6) 7/6(10) 3/6 6/2
- Taylor Fritz [13] — 6/3 6/4 3/6 6/4
- Alejandro Tabilo [24] — 7/6(4) 7/6(4) 4/6 4/6 6/4
- Cameron Norrie — 7/6(3) 6/4 7/6(6)
- Alexander Zverev [4] — 6/2 6/1 6/4
- Arthur Fils — 7/6(2) 6/4 2/6 6/6 Ret'd
- Roman Safiullin — 6/2 6/4 5/7 6/3
- Lucas Pouille — 2/6 7/5 5/2 Ret'd
- Alex de Minaur [9] — 6/2 6/2 7/5
- Holger Rune [15] — 3/6 6/3 6/2 6/2
- Quentin Halys — 4/6 6/3 3/6 6/3 6/3
- Alexei Popyrin — 3/6 6/4 4/6 6/4 6/3
- Novak Djokovic [2] — 6/3 6/4 5/7 7/5

Fourth Round

- Jannik Sinner [1] — 6/1 6/4 6/2
- Ben Shelton [14] — 6/7(4) 6/2 6/4 4/6 6/2
- Grigor Dimitrov [10] — 6/3 6/4 6/3
- Daniil Medvedev [5] — 6/1 6/3 4/6 7/6(3)
- Carlos Alcaraz [3] — 5/7 6/2 4/6 7/6(2) 6/2
- Ugo Humbert [16] — 7/6(9) 3/6 7/6(5) 7/6(6)
- Tommy Paul [12] — 6/3 6/4 6/2
- Roberto Bautista Agut — 7/6(6) 3/6 5/7 7/6(1) 6/3
- Lorenzo Musetti [25] — 6/2 6/7(4) 7/6(3) 6/3
- Giovanni Mpetshi Perricard — 4/6 6/2 7/6(5) 6/4
- Taylor Fritz [13] — 7/6(3) 6/3 7/5
- Alexander Zverev [4] — 6/4 6/4 7/6(15)
- Arthur Fils — 4/6 6/3 1/6 6/4 6/3
- Alex de Minaur [9] — 6/2 6/2 7/5
- Holger Rune [15] — 1/6 6/7(4) 6/4 7/6(4) 6/1
- Novak Djokovic [2] — 4/6 6/3 6/4 7/6(3)

Quarter-Finals

- Jannik Sinner [1] — 6/2 6/4 7/6(9)
- Daniil Medvedev [5] — 5/3 Ret'd
- Carlos Alcaraz [3] — 6/3 6/4 1/6 7/5
- Tommy Paul [12] — 6/2 7/6(3) 6/2
- Lorenzo Musetti [25] — 4/6 6/3 6/3 6/1
- Taylor Fritz [13] — 4/6 6/7(4) 6/4 7/6(3) 6/3
- Alex de Minaur [9] — 6/2 6/4 4/6 6/3
- Novak Djokovic [2] — 6/3 6/4 6/4

Semi-Finals

- Daniil Medvedev [5] — 6/7(7) 6/4 7/6(4) 2/6 6/3
- Carlos Alcaraz [3] — 5/7 6/4 6/2
- Lorenzo Musetti [25] — 3/6 7/6(5) 6/2 3/6 6/1
- Novak Djokovic [2] — w/o

Final

- Carlos Alcaraz [3] — 6/7(1) 6/3 6/4 6/4
- Novak Djokovic [2] — 6/4 7/6(2) 6/4

Champion

- Carlos Alcaraz [3] — 6/2 6/2 7/6(4)

Heavy type denotes seeded players. The figure in brackets against names denotes the order in which they have been seeded. The figure in italics denotes ATP World Tour Ranking – 01.07.2024
(WC)=Wild card. (Q)=Qualifier. (LL)=Lucky loser.

THE GENTLEMEN'S DOUBLES CHAMPIONSHIP 2024
Holders: WESLEY KOOLHOF (NED) & NEAL SKUPSKI (GBR)

The Champions will become the holders, for the year only, of the CHALLENGE CUPS presented by the OXFORD UNIVERSITY LAWN TENNIS CLUB in 1884 and the late SIR HERBERT WILBERFORCE in 1937. The Champions will each receive a silver three-quarter size replica of the Challenge Cup. A Silver Salver will be presented to each of the Runners-up, and a Bronze Medal to each defeated semi-finalist. The matches will be the best of three sets. If the score should reach 6-6 in the final set, the match will be decided by a first-to-ten tie-break.

First Round	Second Round	Third Round	Quarter-Finals	Semi-Finals	Final
1. **Marcel Granollers** (ESP) & **Horacio Zeballos** (ARG).... [1]	Marcel Granollers & Horacio Zeballos [1]				
(A) 2. Thiago Monteiro (BRA) & Thiago Seyboth Wild (BRA)	6/2 6/3	Marcel Granollers & Horacio Zeballos [1]			
3. Nicolas Mahut (FRA) & Skander Mansouri (TUN)	Nicolas Mahut & Skander Mansouri	w/o	Marcel Granollers & Horacio Zeballos [1]		
(A) 4. Reese Stalder (USA) & Aleksandar Vucik (AUS)	6/4 7/6(3)		6/3 6/3		
5. Sebastian Ofner (AUT) & Sam Weissborn (AUT)	Sebastian Ofner & Sam Weissborn	Sebastian Baez & Dustin Brown			
6. Diego Hidalgo (ECU) & Alejandro Tabilo (CHI)	7/5 6/4	3/4 Ret'd			
7. Sebastian Baez (ARG) & Dustin Brown (JAM)	Sebastian Baez & Dustin Brown				Marcel Granollers & Horacio Zeballos [1]
8. **Hugo Nys** (MON) & **Jan Zielinski** (POL) [13]	3/6 6/3 7/6(5)				6/4 7/6(3)
9. **Nathaniel Lammons** (USA) & **Jackson Withrow** (USA) [12]	Nathaniel Lammons & Jackson Withrow [12]				
10. Marcos Giron (USA) & Alex Michelsen (USA)	6/3 6/2	Nathaniel Lammons & Jackson Withrow [12]			
11. Mackenzie McDonald (USA) & Ben Shelton (USA)	Mackenzie McDonald & Ben Shelton	6/4 6/4	Kevin Krawietz & Tim Puetz [8]		
12. Flavio Cobolli (ITA) & Lorenzo Sonego (ITA)	6/2 6/7(3) 6/4		6/3 6/4		
13. Alexander Bublik (KAZ) & Alexander Shevchenko (KAZ)	Yuki Bhambri & Albano Olivetti	Kevin Krawietz & Tim Puetz [8]			
14. Yuki Bhambri (IND) & Albano Olivetti (FRA)	6/4 6/4	4/6 6/4 6/3			
15. Luciano Darderi (ITA) & Fernando Romboli (BRA)	Kevin Krawietz & Tim Puetz [8]				Marcel Granollers & Horacio Zeballos [15]
16. **Kevin Krawietz** (GER) & **Tim Puetz** (GER) [8]	6/4 6/2				6/4 6/4
17. **Rajeev Ram** (USA) & **Joe Salisbury** (GBR) [3]	Rajeev Ram & Joe Salisbury [3]				
18. William Blumberg (USA) & Casper Ruud (NOR)	7/5 6/4	Andreas Mies & John-Patrick Smith			
19. Victor Cornea (ROU) & Fabian Marozsan (HUN)	Andreas Mies & John-Patrick Smith	4/6 6/3 6/2	Max Purcell & Jordan Thompson [15]		
20. Andreas Mies (GER) & John-Patrick Smith (AUS)	6/2 6/2		6/4 6/3		
21. Fabrice Martin (FRA) & Matwe Middelkoop (NED)	Fabrice Martin & Matwe Middelkoop	Max Purcell & Jordan Thompson [15]			
22. Tallon Griekspoor (NED) & Bart Stevens (NED)	6/4 6/3	6/4 7/5			
(WC) 23. Jay Clarke (GBR) & Marcus Willis (GBR)	Max Purcell & Jordan Thompson [15]				Max Purcell & Jordan Thompson [15]
24. **Max Purcell** (AUS) & **Jordan Thompson** (AUS) [15]	6/4 6/2				6/4 6/7(8) 6/3
25. **Maximo Gonzalez** (ARG) & **Andres Molteni** (ARG) [11]	Maximo Gonzalez & Andres Molteni [11]				
26. Petros Tsitsipas (GRE) & Stefanos Tsitsipas (GRE)	7/6(3) 6/3	Maximo Gonzalez & Andres Molteni [11]			
27. Tomas Machac (CZE) & Zhizhen Zhang (CHN)	Tomas Machac & Zhizhen Zhang	7/6(4) 6/4	Maximo Gonzalez & Andres Molteni [11]		
28. Ariel Behar (URU) & Adam Pavlasek (CZE)	2/6 6/3 6/4		6/2 6/7(4) 7/5		
29. Nuno Borges (POR) & Arthur Rinderknech (FRA)	Charles Broom & Arthur Fery	Charles Broom & Arthur Fery			
(WC) 30. Charles Broom (GBR) & Arthur Fery (GBR)	6/4 6/4	7/6(4) 7/6(5)			
31. Federico Coria (ARG) & Mariano Navone (ARG)	Wesley Koolhof & Nikola Mektic [7]				Harri Heliovaara & Henry Patten
32. **Wesley Koolhof** (NED) & **Nikola Mektic** (CRO) [7]	6/2 6/1				6/7(7) 7/6(8) 7/6(9)
33. **Simone Bolelli** (ITA) & **Andrea Vavassori** (ITA) [5]	Harri Heliovaara & Henry Patten				
34. Harri Heliovaara (FIN) & Henry Patten (GBR)	6/3 6/4	Harri Heliovaara & Henry Patten			
35. Pedro Martinez (ESP) & Jaume Munar (ESP)	Pedro Martinez & Jaume Munar	7/6(5) 6/3	Harri Heliovaara & Henry Patten		
36. Dusan Lajovic (SRB) & Sumit Nagal (IND)	6/2 6/2		7/6(1) 6/2		
(WC) 37. Jacob Fearnley (GBR) & Jack Pinnington Jones (GBR)	Rafael Matos & Marcelo Melo	Rafael Matos & Marcelo Melo			
38. Rafael Matos (BRA) & Marcelo Melo (BRA)	6/4 7/6(5)	6/7(1) 7/6(5) 7/6(3)			
39. Nicolas Barrientos (COL) & Francisco Cabral (POR)	Nicolas Barrientos & Francisco Cabral				Harri Heliovaara & Henry Patten
40. **Ivan Dodig** (CRO) & **Austin Krajicek** (USA) [10]	7/6(4) 7/6(6)				4/6 7/6(5) 7/6(7)
41. **Sadio Doumbia** (FRA) & **Fabien Reboul** (FRA) [16]	Sadio Doumbia & Fabien Reboul [16]				
(WC) 42. Oliver Crawford (GBR) & Kyle Edmund (GBR)	7/5 7/6(3)	Sadio Doumbia & Fabien Reboul [16]			
43. Julian Cash (GBR) & Robert Galloway (USA)	Julian Cash & Robert Galloway	6/7(5) 6/4 7/6(4)	Marcelo Arevalo & Mate Pavic [4]		
44. Theo Arribage (FRA) & Marcus Daniell (NZL)	7/6(6) 6/3		6/4 7/6(1)		
(A) 45. Romain Arneodo (MON) & Sem Verbeek (NED)	Romain Arneodo & Sem Verbeek	Marcelo Arevalo & Mate Pavic [4]			
46. Gonzalo Escobar (ECU) & Aleksandr Nedovyesov (KAZ)	2/6 6/2 7/5	6/4 6/4			
47. N.Sriram Balaji (IND) & Luke Johnson (GBR)	Marcelo Arevalo & Mate Pavic [4]				Harri Heliovaara & Henry Patten
48. **Marcelo Arevalo** (ESA) & **Mate Pavic** (CRO) [4]	6/4 7/5				6/4 7/6(1)
49. **Santiago Gonzalez** (MEX) & **Edouard Roger-Vasselin** (FRA) [6]	Santiago Gonzalez & Edouard Roger-Vasselin [6]				
(WC) 50. Daniel Evans (GBR) & Henry Searle (GBR)	6/3 3/6 6/3	Christopher Eubanks & Evan King			
(A) 51. Christopher Eubanks (USA) & Evan King (USA)	Christopher Eubanks & Evan King	6/3 7/6(3)	Neal Skupski & Michael Venus [9]		
(WC) 52. Liam Broady (GBR) & Billy Harris (GBR)	7/5 7/5		7/5 6/3		
53. Rinky Hijikata (AUS) & John Peers (AUS)	Rinky Hijikata & John Peers	Neal Skupski & Michael Venus [9]			
(WC) 54. Andy Murray (GBR) & Jamie Murray (GBR)	7/6(6) 6/4	6/4 6/7(5) 6/4			
55. Alexander Erler (AUT) & Lucas Miedler (AUT)	Neal Skupski & Michael Venus [9]				Neal Skupski & Michael Venus [9]
56. **Neal Skupski** (GBR) & **Michael Venus** (NZL) [9]	6/7(5) 6/3 7/6(5)				7/6(1) 7/6(1)
57. **Sander Gille** (BEL) & **Joran Vliegen** (BEL) [14]	Sander Gille & Joran Vliegen [14]				
(A) 58. Facundo Diaz Acosta (ARG) & Alexandre Muller (FRA)	6/2 6/3	Lloyd Glasspool & Jean-Julien Rojer			
59. Guido Andreozzi (ARG) & Miguel Reyes-Varela (MEX)	Lloyd Glasspool & Jean-Julien Rojer	7/6(5) 7/6(4)	Constantin Frantzen & Hendrik Jebens		
60. Lloyd Glasspool (GBR) & Jean-Julien Rojer (NED)	6/0 6/3		7/6(5) 7/6(3)		
61. Constantin Frantzen (GER) & Hendrik Jebens (GER)	Constantin Frantzen & Hendrik Jebens	Constantin Frantzen & Hendrik Jebens			
62. Pavel Kotov & Cristian Rodriguez (COL)	7/6(3) 7/6(3)	6/3 7/6(4)			
(A) 63. Sander Arends (NED) & Robin Haase (NED)	Rohan Bopanna & Matthew Ebden [2]				
64. **Rohan Bopanna** (IND) & **Matthew Ebden** (AUS) [2]	7/5 6/4				

Heavy type denotes seeded players. The figure in brackets against names denotes the order in which they have been seeded.
(WC)=Wild cards. (Q)=Qualifiers. (LL)=Lucky losers.

THE LADIES' SINGLES CHAMPIONSHIP 2024
Holder: MARKETA VONDROUSOVA (CZE)

The Champion will become the holder, for the year only, of the CHALLENGE TROPHY presented by The All England Lawn Tennis and Croquet Club in 1886. The Champion will receive a silver three-quarter size replica of the Challenge Trophy.
A Silver Salver will be presented to the Runner-up and a Bronze Medal to each defeated semi-finalist. The matches will be the best of three sets. If the score should reach 6-6 in the final set, the match will be decided by a first-to-ten tie-break.

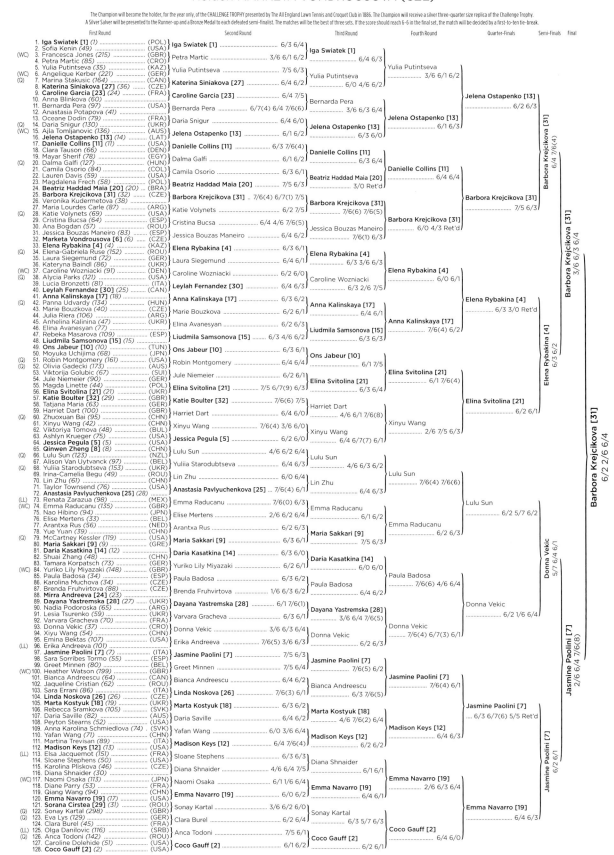

Heavy type denotes seeded players. The figure in brackets against names denotes the order in which they have been seeded. The figure in italics denotes WTA Ranking – 01.03.2024.
(WC)=Wild card. (Q)=Qualifier. (LL)=Lucky loser.

THE LADIES' DOUBLES CHAMPIONSHIP 2024
Holders: SU-WEI HSIEH (TPE) & BARBORA STRYCOVA (CZE)

The Champions will become the holders, for the year only, of the CHALLENGE CUPS presented by H.R.H. PRINCESS MARINA, DUCHESS OF KENT, the late President of The All England Lawn Tennis and Croquet Club in 1949 and The All England Lawn Tennis and Croquet Club in 2001. The Champions will each receive a silver three-quarter size replica of the Challenge Cup. A Silver Salver will be presented to each of the Runners-up and a Bronze Medal to each defeated semi-finalist. The matches will be the best of three sets. If the score should reach 6-6 in the final set, the match will be decided by a first-to-ten tie-break.

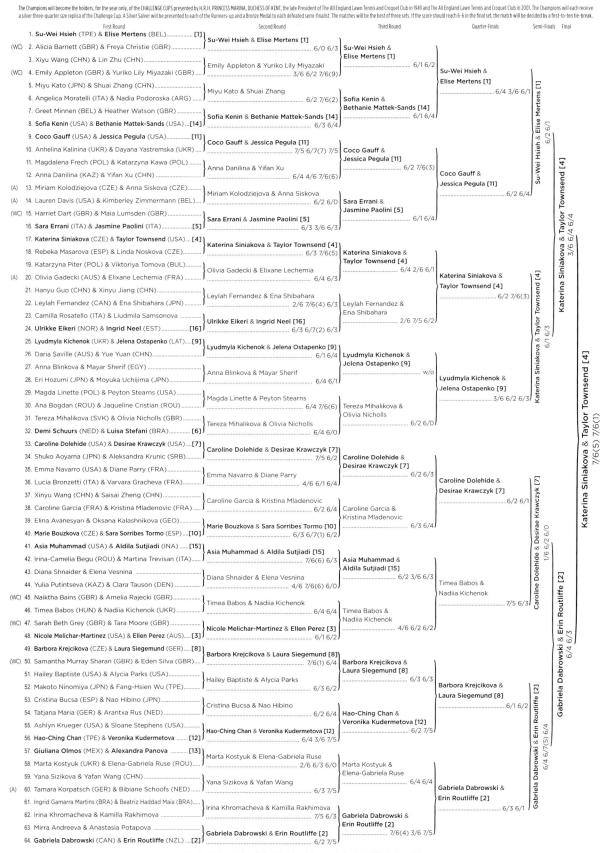

Heavy type denotes seeded players. The figure in brackets against names denotes the order in which they have been seeded.
(WC)=Wild cards. (Q)=Qualifiers. (LL)=Lucky Losers.

THE MIXED DOUBLES CHAMPIONSHIP 2024
Holders: MATE PAVIC (CRO) & LYUDMYLA KICHENOK (UKR)

The Champions will become the holders, for the year only, of the CHALLENGE CUPS presented by members of the family of the late Mr S. H. SMITH in 1949 and The All England Lawn Tennis and Croquet Club in 2001. The Champions will each receive a silver three-quarter size replica of the Challenge Cup. A Silver Salver will be presented to each of the Runners-up and a Bronze Medal to each defeated semi-finalist. The matches will be the best of three sets. If the score should reach 6-6 in the final set, the match will be decided by a first-to-ten tie-break.

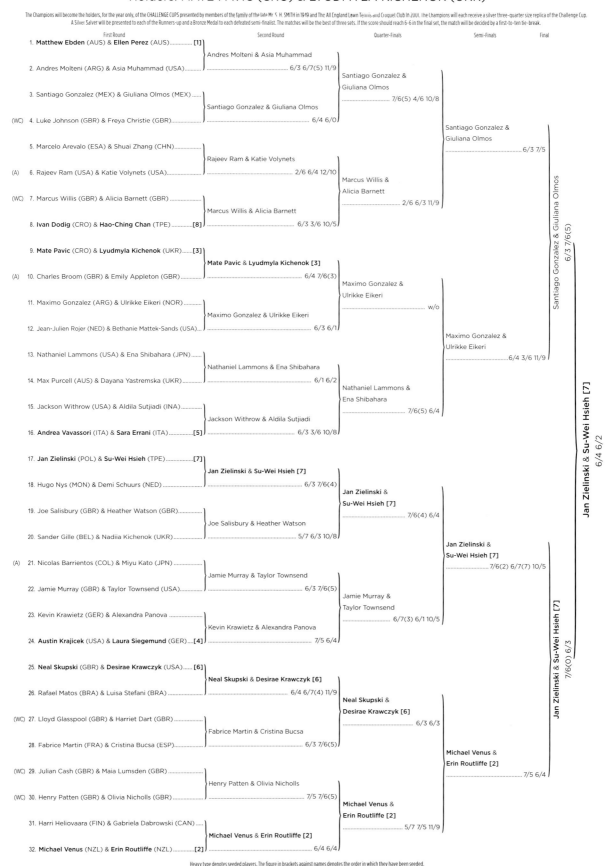

First Round	Second Round	Quarter-Finals	Semi-Finals	Final

1. **Matthew Ebden** (AUS) & **Ellen Perez** (AUS).............. **[1]**
 Andres Molteni & Asia Muhammad
2. Andres Molteni (ARG) & Asia Muhammad (USA).......... 6/3 6/7(5) 11/9
 Santiago Gonzalez & Giuliana Olmos
3. Santiago Gonzalez (MEX) & Giuliana Olmos (MEX)
 Santiago Gonzalez & Giuliana Olmos
 7/6(5) 4/6 10/8
(WC) 4. Luke Johnson (GBR) & Freya Christie (GBR)................. 6/4 6/0
 Santiago Gonzalez & Giuliana Olmos
 6/3 7/5
5. Marcelo Arevalo (ESA) & Shuai Zhang (CHN)..................
 Rajeev Ram & Katie Volynets
(A) 6. Rajeev Ram (USA) & Katie Volynets (USA)...................... 2/6 6/4 12/10
 Marcus Willis & Alicia Barnett
 2/6 6/3 11/9
(WC) 7. Marcus Willis (GBR) & Alicia Barnett (GBR)
 Marcus Willis & Alicia Barnett
8. Ivan Dodig (CRO) & **Hao-Ching Chan** (TPE)**[8]** 6/3 3/6 10/5

9. **Mate Pavic** (CRO) & **Lyudmyla Kichenok** (UKR).......**[3]**
 Mate Pavic & **Lyudmyla Kichenok [3]**
(A) 10. Charles Broom (GBR) & Emily Appleton (GBR)............. 6/4 7/6(3)
 Maximo Gonzalez & Ulrikke Eikeri
 w/o
11. Maximo Gonzalez (ARG) & Ulrikke Eikeri (NOR)
 Maximo Gonzalez & Ulrikke Eikeri
12. Jean-Julien Rojer (NED) & Bethanie Mattek-Sands (USA)... 6/3 6/1
 Maximo Gonzalez & Ulrikke Eikeri
 6/4 3/6 11/9
13. Nathaniel Lammons (USA) & Ena Shibahara (JPN)
 Nathaniel Lammons & Ena Shibahara
14. Max Purcell (AUS) & Dayana Yastremska (UKR)............. 6/1 6/2
 Nathaniel Lammons & Ena Shibahara
 7/6(5) 6/4
15. Jackson Withrow (USA) & Aldila Sutjiadi (INA)..............
 Jackson Withrow & Aldila Sutjiadi
16. **Andrea Vavassori** (ITA) & **Sara Errani** (ITA)**[5]** 6/3 3/6 10/8

17. **Jan Zielinski** (POL) & **Su-Wei Hsieh** (TPE)..................**[7]**
 Jan Zielinski & **Su-Wei Hsieh [7]**
18. Hugo Nys (MON) & Demi Schuurs (NED) 6/3 7/6(4)
 Jan Zielinski & **Su-Wei Hsieh [7]**
 7/6(4) 6/4
19. Joe Salisbury (GBR) & Heather Watson (GBR)...............
 Joe Salisbury & Heather Watson
20. Sander Gille (BEL) & Nadiia Kichenok (UKR) 5/7 6/3 10/8
 Jan Zielinski & **Su-Wei Hsieh [7]**
 7/6(2) 6/7(7) 10/5
(A) 21. Nicolas Barrientos (COL) & Miyu Kato (JPN)
 Jamie Murray & Taylor Townsend
22. Jamie Murray (GBR) & Taylor Townsend (USA)............. 6/3 7/6(5)
 Jamie Murray & Taylor Townsend
 6/7(3) 6/1 10/5
23. Kevin Krawietz (GER) & Alexandra Panova
 Kevin Krawietz & Alexandra Panova
24. **Austin Krajicek** (USA) & **Laura Siegemund** (GER)...**[4]** 7/5 6/4

25. **Neal Skupski** (GBR) & **Desirae Krawczyk** (USA)**[6]**
 Neal Skupski & **Desirae Krawczyk [6]**
26. Rafael Matos (BRA) & Luisa Stefani (BRA) 6/4 6/7(4) 11/9
 Neal Skupski & **Desirae Krawczyk [6]**
 6/3 6/3
(WC) 27. Lloyd Glasspool (GBR) & Harriet Dart (GBR)
 Fabrice Martin & Cristina Bucsa
28. Fabrice Martin (FRA) & Cristina Bucsa (ESP)................. 6/3 7/6(5)
 Michael Venus & **Erin Routliffe [2]**
 7/5 6/4
(WC) 29. Julian Cash (GBR) & Maia Lumsden (GBR)
 Henry Patten & Olivia Nicholls
(WC) 30. Henry Patten (GBR) & Olivia Nicholls (GBR)................. 7/5 7/6(5)
 Michael Venus & **Erin Routliffe [2]**
 5/7 7/5 11/9
31. Harri Heliovaara (FIN) & Gabriela Dabrowski (CAN)
 Michael Venus & **Erin Routliffe [2]**
32. **Michael Venus** (NZL) & **Erin Routliffe** (NZL)..............**[2]** 6/4 6/4

Semi-Finals / Final:

Santiago Gonzalez & Giuliana Olmos
........ 6/3 7/6(5)

Jan Zielinski & Su-Wei Hsieh [7]
6/4 6/2

Jan Zielinski & Su-Wei Hsieh [7]
7/6(0) 6/3

Heavy type denotes seeded players. The figure in brackets against names denotes the order in which they have been seeded.
(A)=Alternates. (WC)=Wild cards.

THE GENTLEMEN'S WHEELCHAIR SINGLES 2024
Holder: TOKITO ODA (JPN)

The Champion will become the holder, for the year only, of a Cup presented by The All England Lawn Tennis and Croquet Club. The Champion will receive a three-quarter size replica of the Cup. A Silver Salver will be presented to the Runner-up.
The matches will be the best of three tie-break sets.

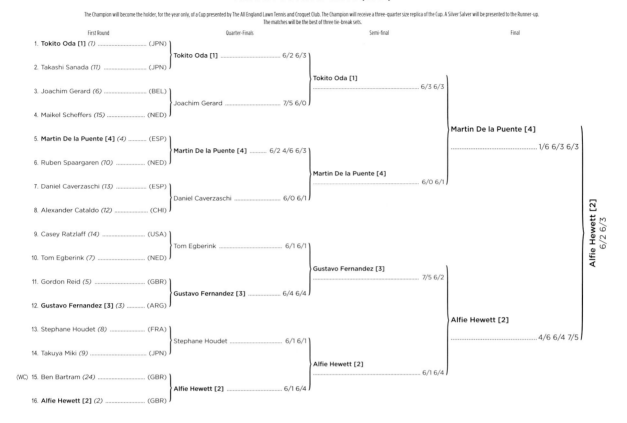

First Round	Quarter-Finals	Semi-final	Final
1. **Tokito Oda [1]** *(1)* (JPN)	**Tokito Oda [1]** 6/2 6/3		
2. Takashi Sanada *(11)* (JPN)		Tokito Oda [1] 6/3 6/3	
3. Joachim Gerard *(6)* (BEL)	Joachim Gerard 7/5 6/0		
4. Maikel Scheffers *(15)* (NED)			Martin De la Puente [4] 1/6 6/3 6/3
5. **Martin De la Puente [4]** *(4)* (ESP)	**Martin De la Puente [4]** 6/2 4/6 6/3		
6. Ruben Spaargaren *(10)* (NED)		Martin De la Puente [4] 6/0 6/1	
7. Daniel Caverzaschi *(13)* (ESP)	Daniel Caverzaschi 6/0 6/1		
8. Alexander Cataldo *(12)* (CHI)			
9. Casey Ratzlaff *(14)* (USA)	Tom Egbrink 6/1 6/1		Alfie Hewett [2] 6/2 6/3
10. Tom Egbrink *(7)* (NED)		Gustavo Fernandez [3] 7/5 6/2	
11. Gordon Reid *(5)* (GBR)	**Gustavo Fernandez [3]** 6/4 6/4		
12. **Gustavo Fernandez [3]** *(3)* (ARG)			Alfie Hewett [2] 4/6 6/4 7/5
13. Stephane Houdet *(8)* (FRA)	Stephane Houdet 6/1 6/1		
14. Takuya Miki *(9)* (JPN)		Alfie Hewett [2] 6/1 6/4	
(WC) 15. Ben Bartram *(24)* (GBR)	**Alfie Hewett [2]** 6/1 6/4		
16. **Alfie Hewett [2]** *(2)* (GBR)			

THE GENTLEMEN'S WHEELCHAIR DOUBLES 2024
Holders: ALFIE HEWETT (GBR) & GORDON REID (GBR)

The Champions will become the holders, for the year only, of Cups presented by The All England Lawn Tennis and Croquet Club. The Champions will receive a three-quarter size replica of the Cup. A Silver Salver will be presented to each of the Runners-up.
The matches will be the best of three tie-break sets.

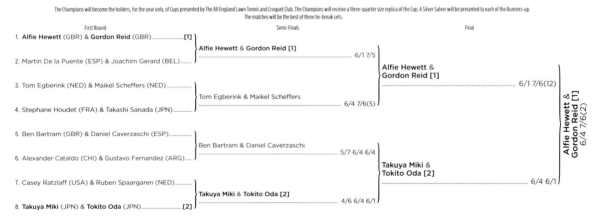

First Round	Semi-Finals	Final
1. **Alfie Hewett** (GBR) & **Gordon Reid** (GBR) [1]	**Alfie Hewett & Gordon Reid [1]** 6/1 7/5	
2. Martin De la Puente (ESP) & Joachim Gerard (BEL)		Alfie Hewett & Gordon Reid [1] 6/1 7/6(12)
3. Tom Egbrink (NED) & Maikel Scheffers (NED)	Tom Egbrink & Maikel Scheffers 6/4 7/6(5)	
4. Stephane Houdet (FRA) & Takashi Sanada (JPN)		
5. Ben Bartram (GBR) & Daniel Caverzaschi (ESP)	Ben Bartram & Daniel Caverzaschi 5/7 6/4 6/4	Alfie Hewett & Gordon Reid [1] 6/4 7/6(2)
6. Alexander Cataldo (CHI) & Gustavo Fernandez (ARG)		
7. Casey Ratzlaff (USA) & Ruben Spaargaren (NED)	**Takuya Miki & Tokito Oda [2]** 4/6 6/4 6/1	Takuya Miki & Tokito Oda [2] 6/4 6/1
8. **Takuya Miki** (JPN) & **Tokito Oda** (JPN) [2]		

Heavy type denotes seeded players. The figure in brackets against names denotes the order in which they have been seeded.
(A)=Alternates. (WC)=Wild cards.

THE LADIES' WHEELCHAIR SINGLES 2024
Holder: DIEDE DE GROOT (NED)

The Champions will become the holders, for the year only, of a Cup presented by The All England Lawn Tennis and Croquet Club. The Champions receive a three quarter size replica of the Cup. A Silver Salver will be presented to each of the Runners up. The matches will be the best of three tie-break sets.

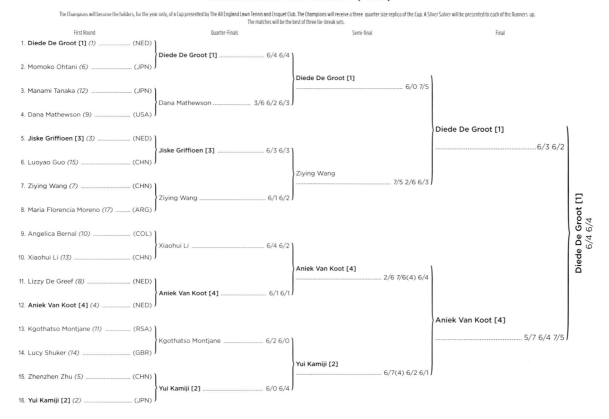

First Round	Quarter-Finals	Semi-final	Final
1. Diede De Groot [1] (1) (NED)	Diede De Groot [1] 6/4 6/4	Diede De Groot [1] 6/0 7/5	Diede De Groot [1] 6/3 6/2
2. Momoko Ohtani (6) (JPN)			
3. Manami Tanaka (12) (JPN)	Dana Mathewson 3/6 6/2 6/3		
4. Dana Mathewson (9) (USA)			
5. Jiske Griffioen [3] (3) (NED)	Jiske Griffioen [3] 6/3 6/3	Ziying Wang 7/5 2/6 6/3	
6. Luoyao Guo (15) (CHN)			
7. Ziying Wang (7) (CHN)	Ziying Wang 6/1 6/2		
8. Maria Florencia Moreno (17) (ARG)			
9. Angelica Bernal (10) (COL)	Xiaohui Li 6/4 6/2	Aniek Van Koot [4] 2/6 7/6(4) 6/4	
10. Xiaohui Li (13) (CHN)			
11. Lizzy De Greef (8) (NED)	Aniek Van Koot [4] 6/1 6/1		
12. Aniek Van Koot [4] (4) (NED)			Aniek Van Koot [4] 5/7 6/4 7/5
13. Kgothatso Montjane (11) (RSA)	Kgothatso Montjane 6/2 6/0	Yui Kamiji [2] 6/7(4) 6/2 6/1	
14. Lucy Shuker (14) (GBR)			
15. Zhenzhen Zhu (5) (CHN)	Yui Kamiji [2] 6/0 6/4		
16. Yui Kamiji [2] (2) (JPN)			

Diede De Groot [1]
6/4 6/4

THE LADIES' WHEELCHAIR DOUBLES 2024
Holders: DIEDE DE GROOT (NED) & JISKE GRIFFIOEN (NED)

The Champions will become the holders, for the year only, of Cups presented by The All England Lawn Tennis and Croquet Club. The Champions will receive a three-quarter size replica of the Cup. A Silver Salver will be presented to each of the Runners-up. The matches will be the best of three tie-break sets.

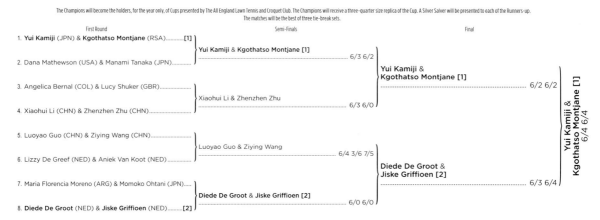

First Round	Semi-Finals	Final
1. Yui Kamiji (JPN) & Kgothatso Montjane (RSA) [1]	Yui Kamiji & Kgothatso Montjane [1] 6/3 6/2	Yui Kamiji & Kgothatso Montjane [1] 6/2 6/2
2. Dana Mathewson (USA) & Manami Tanaka (JPN)		
3. Angelica Bernal (COL) & Lucy Shuker (GBR)	Xiaohui Li & Zhenzhen Zhu 6/3 6/0	
4. Xiaohui Li (CHN) & Zhenzhen Zhu (CHN)		
5. Luoyao Guo (CHN) & Ziying Wang (CHN)	Luoyao Guo & Ziying Wang 6/4 3/6 7/5	Diede De Groot & Jiske Griffioen [2] 6/3 6/4
6. Lizzy De Greef (NED) & Aniek Van Koot (NED)		
7. Maria Florencia Moreno (ARG) & Momoko Ohtani (JPN)	Diede De Groot & Jiske Griffioen [2] 6/0 6/0	
8. Diede De Groot (NED) & Jiske Griffioen (NED) [2]		

Yui Kamiji & Kgothatso Montjane [1]
6/4 6/4

Heavy type denotes seeded players. The figure in brackets against names denotes the order in which they have been seeded.
(A)=Alternates. (WC)=Wild cards.

QUAD WHEELCHAIR SINGLES 2024
Holder: NIELS VINK (NED)

The Champion will become the holder, for the year only, of a Cup presented by The All England Lawn Tennis and Croquet Club. The Champion will receive a three-quarter size replica of the Cup. A Silver Salver will be presented to the Runner-up.
The matches will be the best of three sets. If the score should reach 6-6 in the final set, the match will be decided by a tie-break.

First Round	Semi-Finals	Final
1. **Sam Schroder [1]** *(1)* (NED)		
	Sam Schroder [1] 6/3 6/2	
2. Ahmet Kaplan *(6)* (TUR)		
		Sam Schroder [1] 6/1 6/0
3. David Wagner *(8)* (USA)		
	Andy Lapthorne 6/2 6/4	
4. Andy Lapthorne *(7)* (GBR)		
5. Guy Sasson *(3)* (ISR)		
	Guy Sasson 6/0 6/1	
6. Donald Ramphadi *(4)* (RSA)		
		Niels Vink [2] 7/5 7/5
7. Heath Davidson *(5)* (AUS)		
	Niels Vink [2] 6/3 6/3	
8. **Niels Vink [2]** *(2)* (NED)		

Niels Vink [2] 7/6(4) 6/4

QUAD WHEELCHAIR DOUBLES 2024
Holders: SAM SCHRODER (NED) & NIELS VINK (NED)

The Champions will become the holders, for the year only, of Cups presented by The All England Lawn Tennis and Croquet Club. The Champion will receive a three-quarter size replica of the Cup. A Silver Salver will be presented to the Runner-up.
The matches will be the best of three sets. If the score should reach 6-6 in the final set, the match will be decided by a tie-break.

First Round	Final
1. **Sam Schroder** (NED) & **Niels Vink** (NED) [1]	
	Sam Schroder & **Niels Vink** [1] 6/2 6/2
2. Heath Davidson (AUS) & Donald Ramphadi (RSA)	
3. Ahmet Kaplan (TUR) & David Wagner (USA)	
	Andy Lapthorne & Guy Sasson [2] 6/2 6/4
4. **Andy Lapthorne** (GBR) & **Guy Sasson** (ISR) [2]	

Sam Schroder & Niels Vink [1] 3/6 7/6(3) 6/3

Heavy type denotes seeded players. The figure in brackets against names denotes the order in which they have been seeded.
(A)=Alternates. (WC)=Wild cards.

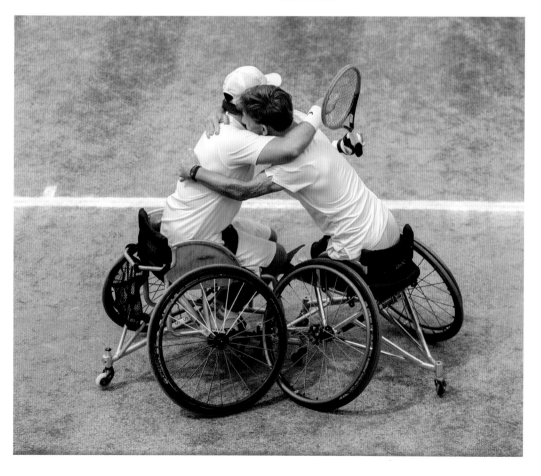

*Sam Schroder (**left**) and Niels Vink celebrate their victory in the final of the Quad Wheelchair Doubles on No.3 Court at The Championships 2024*

THE 18&U BOYS' SINGLES CHAMPIONSHIP 2024
Holder: HENRY SEARLE (GBR)

The Champion will become the holder, for the year only, of a Cup presented by The All England Lawn Tennis and Croquet Club.
The Champion will receive a three-quarter size Cup and the Runner-up will receive a Silver Salver. The matches will be the best of three sets. If the score should reach 6-6 in the final set, the match will be decided by a first-to-ten-break.

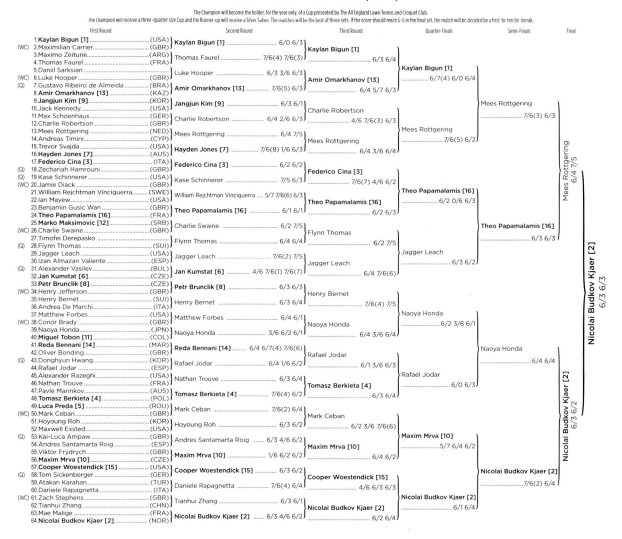

THE 18&U BOYS' DOUBLES CHAMPIONSHIP 2024
Holders: JAKUB FILIP (CZE) & GABRIELE VULPITTA (ITA)

The Champions will become the holders, for the year only, of a Cup presented by The All England Lawn Tennis and Croquet Club.
The Champions will receive a three-quarter size Cup and the Runners-up will receive Silver Salvers. The matches will be first to two sets. If the score is one set all, the match will be decided by a first-to-ten-break.

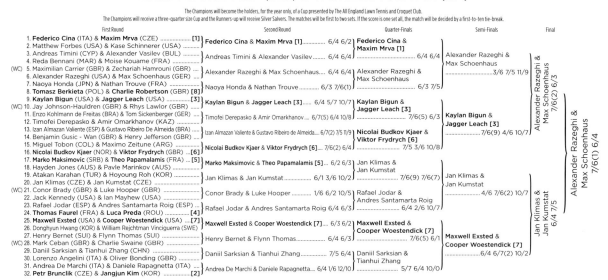

Heavy type denotes seeded players. The figure in brackets against names denotes the order in which they have been seeded. The Committee reserves the right to alter the seeding order in the event of withdrawals.
(WC)=Wild cards. (A)=Alternates.

THE 18&U GIRLS' SINGLES CHAMPIONSHIP 2024
Holder: CLERVIE NGOUNOUE (USA)

The Champion will become the holder, for the year only, of a Cup presented by The All England Lawn Tennis and Croquet Club.
The Champion will receive a three-quarter size Cup and the Runner-up will receive a Silver Salver. The matches will be the best of three sets. If the score should reach 6-6 in the final set, the match will be decided by a first-to-ten tie-break.

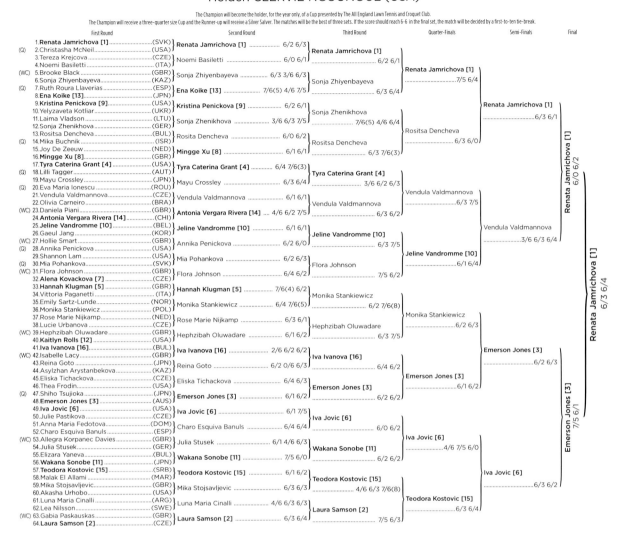

First Round	Second Round	Third Round	Quarter-Finals	Semi-Finals	Final
1. Renata Jamrichova [1] (SVK)	Renata Jamrichova [1] 6/2 6/3	Renata Jamrichova [1] 6/2 6/1	Renata Jamrichova [1] 7/5 6/4	Renata Jamrichova [1] 6/3 6/1	Renata Jamrichova [1] 6/0 6/2
(Q) 2. Christasha McNeil (USA)					
3. Tereza Krejcova (CZE)	Noemi Basiletti 6/0 6/1				
4. Noemi Basiletti (ITA)					
(WC) 5. Brooke Black (GBR)	Sonja Zhiyenbayeva 6/3 3/6 6/3	Sonja Zhiyenbayeva 6/3 6/4			
6. Sonja Zhiyenbayeva (KAZ)					
(Q) 7. Ruth Roura Llaverias (ESP)	Ena Koike [13] 7/6(5) 4/6 7/5				
8. Ena Koike [13] (JPN)					
9. Kristina Penickova [9] (USA)	Kristina Penickova [9] 6/2 6/1	Sonja Zhenikhova 7/6(5) 4/6 6/4	Rositsa Dencheva 6/3 6/0		
10. Yelyzaveta Kotliar (UKR)					
11. Laima Vladson (LTU)	Sonja Zhenikhova 3/6 6/3 7/5				
12. Sonja Zhenikhova (GER)					
13. Rositsa Dencheva (BUL)	Rosita Dencheva 6/0 6/2	Rositsa Dencheva 6/3 7/6(3)			
(Q) 14. Mika Buchnik (ISR)					
15. Joy De Zeeuw (NED)	Mingge Xu [8] 6/1 6/1				
16. Mingge Xu [8] (GBR)					
17. Tyra Caterina Grant [4] (USA)	Tyra Caterina Grant [4] 6/4 7/6(3)	Tyra Caterina Grant [4] 3/6 6/2 6/3	Vendula Valdmannova 6/3 7/5	Vendula Valdmannova 3/6 6/3 6/4	
(Q) 18. Lilli Tagger (AUT)					
19. Mayu Crossley (JPN)	Mayu Crossley 6/3 6/4				
(Q) 20. Eva Maria Ionescu (ROU)					
21. Vendula Valdmannova (CZE)	Vendula Valdmannova 6/1 6/1	Vendula Valdmannova 6/3 6/2			
22. Olivia Carneiro (BRA)					
(WC) 23. Daniela Piani (GBR)	Antonia Vergara Rivera [14] 4/6 6/2 7/5				
24. Antonia Vergara Rivera [14] (CHI)					
25. Jeline Vandromme [10] (BEL)	Jeline Vandromme [10] 6/1 6/1	Jeline Vandromme [10] 6/3 7/5	Jeline Vandromme [10] 6/1 6/4		
26. Gaeul Jang (KOR)					
(WC) 27. Hollie Smart (GBR)	Annika Penickova 6/2 6/0				
(Q) 28. Annika Penickova (USA)					
29. Shannon Lam (USA)	Mia Pohankova 6/2 6/3	Flora Johnson 7/5 6/2			
(Q) 30. Mia Pohankova (SVK)					
(WC) 31. Flora Johnson (GBR)	Flora Johnson 6/4 6/2				
32. Alena Kovackova [7] (CZE)					
33. Hannah Klugman [5] (GBR)	Hannah Klugman [5] 7/6(4) 6/2	Monika Stankiewicz 6/2 7/6(8)	Monika Stankiewicz 6/2 6/3	Emerson Jones [3] 6/2 6/3	Emerson Jones [3] 7/5 6/1
34. Vittoria Paganetti (ITA)					
35. Emily Sartz-Lunde (NOR)	Monika Stankiewicz 6/4 7/6(5)				
36. Monika Stankiewicz (POL)					
37. Rose Marie Nijkamp (NED)	Rose Marie Nijkamp 6/3 6/1	Hephzibah Oluwadare 6/3 7/5			
38. Lucie Urbanova (CZE)					
(WC) 39. Hephzibah Oluwadare (GBR)	Hephzibah Oluwadare 6/1 6/2				
40. Kaitlyn Rolls [12] (GBR)					
41. Iva Ivanova [16] (BUL)	Iva Ivanova [16] 2/6 6/2 6/2	Iva Ivanova [16] 6/4 6/2	Emerson Jones [3] 6/1 6/2		
(WC) 42. Isabelle Lacy (GBR)					
43. Reina Goto (JPN)	Reina Goto 6/2 0/6 6/3				
44. Asylzhan Arystanbekova (KAZ)					
45. Eliska Tichackova (CZE)	Eliska Tichackova 6/4 6/3	Emerson Jones [3] 6/2 6/2			
46. Thea Frodin (USA)					
(Q) 47. Shiho Tsujioka (JPN)	Emerson Jones [3] 6/1 6/2				
48. Emerson Jones [3] (AUS)					
49. Iva Jovic [6] (USA)	Iva Jovic [6] 6/1 7/5	Iva Jovic [6] 6/0 6/2	Iva Jovic [6] 4/6 7/5 6/0	Iva Jovic [6] 6/3 6/2	
50. Julie Pastikova (CZE)					
51. Anna Maria Fedotova (DOM)	Charo Esquiva Banuls 6/4 6/4				
52. Charo Esquiva Banuls (ESP)					
(WC) 53. Allegra Korpanec Davies (GBR)	Julia Stusek 6/1 4/6 6/3	Wakana Sonobe [11] 6/2 6/2			
54. Julia Stusek (GER)					
55. Elizara Yaneva (BUL)	Wakana Sonobe [11] 7/5 6/4				
56. Wakana Sonobe [11] (JPN)					
57. Teodora Kostovic [15] (SRB)	Teodora Kostovic [15] 6/1 6/2	Teodora Kostovic [15] 4/6 6/3 7/6(8)	Teodora Kostovic [15] 6/3 6/4		
58. Malak El Allami (MAR)					
59. Mika Stojsavljevic (GBR)	Mika Stojsavljevic 6/3 6/3				
60. Akasha Urhobo (USA)					
61. Luna Maria Cinalli (ARG)	Luna Maria Cinalli 4/6 6/3 6/3	Laura Samson [2] 7/5 6/3			
62. Lea Nilsson (SWE)					
(WC) 63. Gabia Paskauskas (GBR)	Laura Samson [2] 6/3 6/4				
64. Laura Samson [2] (CZE)					

THE 18&U GIRLS' DOUBLES CHAMPIONSHIP 2024
Holders: ALENA KOVACKOVA (CZE) & LAURA SAMSONOVA (CZE)

The Champions will become the holders, for the year only, of a Cup presented by The All England Lawn Tennis and Croquet Club. The Champions will receive a three-quarter size Cup and the Runners-up will receive Silver Salvers.
The matches will be first to two sets. If the score is one set all, the match will be decided by a first-to-ten tie-break.

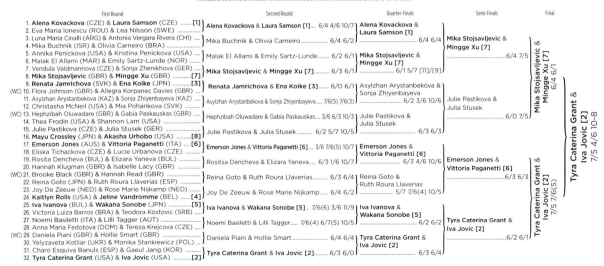

First Round	Second Round	Quarter-Finals	Semi-Finals	Final
1. Alena Kovackova (CZE) & Laura Samson (CZE) [1]	Alena Kovackova & Laura Samson [1] 6/4 4/6 10/7	Alena Kovackova & Laura Samson [1] 6/4 6/4	Mika Stojsavljevic & Mingge Xu [7] 6/4 7/5	Mika Stojsavljevic & Mingge Xu [7] 6/4 6/1
2. Eva Maria Ionescu (ROU) & Lea Nilsson (SWE)				
3. Luna Maria Cinalli (ARG) & Antonia Vergara Rivera (CHI)	Mika Buchnik & Olivia Carneiro 6/4 6/2			
4. Mika Buchnik (ISR) & Olivia Carneiro (BRA)				
5. Annika Penickova (USA) & Kristina Penickova (USA)	Malak El Allami & Emily Sartz-Lunde 6/2 6/1	Mika Stojsavljevic & Mingge Xu [7] 6/1 5/7 [11]/[9]		
6. Malak El Allami (MAR) & Emily Sartz-Lunde (NOR)				
7. Vendula Valdmannova (CZE) & Sonja Zhenikhova (GER)	Mika Stojsavljevic & Mingge Xu [7] 6/3 6/1			
8. Mika Stojsavljevic (GBR) & Mingge Xu (GBR) [7]				
9. Renata Jamrichova (SVK) & Ena Koike (JPN) [3]	Renata Jamrichova & Ena Koike [3] 6/0 6/1	Asylzhan Arystanbekova & Sonja Zhiyenbayeva 6/2 3/6 10/6	Julie Pastikova & Julia Stusek 6/0 7/5	
(WC) 10. Flora Johnson (GBR) & Allegra Korpanec Davies (GBR)				
11. Asylzhan Arystanbekova (KAZ) & Sonja Zhiyenbayeva (KAZ)	Asylzhan Arystanbekova & Sonja Zhiyenbayeva 7/6(5) 7/6(3)			
12. Christasha McNeil (USA) & Mia Pohankova (SVK)				
(WC) 13. Hephzibah Oluwadare (GBR) & Gabia Paskauskas (GBR)	Hephzibah Oluwadare & Gabia Paskauskas 3/6 6/3 10/3	Julie Pastikova & Julia Stusek 6/3 6/3		
14. Thea Frodin (USA) & Shannon Lam (USA)				
15. Julie Pastikova (CZE) & Julia Stusek (GER)	Julie Pastikova & Julia Stusek 6/2 5/7 10/5			
16. Mayu Crossley (JPN) & Akasha Urhobo (USA) [8]				
17. Emerson Jones (AUS) & Vittoria Paganetti (ITA) [6]	Emerson Jones & Vittoria Paganetti [6] 3/6 7/6(5) 10/7	Emerson Jones & Vittoria Paganetti [6] 6/3 4/6 10/6	Emerson Jones & Vittoria Paganetti [6] 6/3 6/3	Tyra Caterina Grant & Iva Jovic [2] 7/5 4/6 10-8
18. Eliska Tichackova (CZE) & Lucie Urbanova (CZE)				
19. Rosita Dencheva (BUL) & Elizara Yaneva (BUL)	Rositsa Dencheva & Elizara Yaneva 6/3 1/6 10/7			
20. Hannah Klugman (GBR) & Isabelle Lacy (GBR)				
(WC) 21. Brooke Black (GBR) & Hannah Read (GBR)	Reina Goto & Ruth Roura Llaverias 6/3 6/4	Reina Goto & Ruth Roura Llaverias 5/7 7/6(4) 10/5		
22. Reina Goto (JPN) & Ruth Roura Llaverias (ESP)				
23. Joy De Zeeuw (NED) & Rose Marie Nijkamp (NED)	Joy De Zeeuw & Rose Marie Nijkamp 6/4 6/2			
24. Kaitlyn Rolls (USA) & Jeline Vandromme (BEL) [4]				
25. Iva Ivanova (BUL) & Wakana Sonobe (JPN) [5]	Iva Ivanova & Wakana Sonobe [5] 7/6(6) 3/6 11/9	Iva Ivanova & Wakana Sonobe [5] 6/2 6/2	Tyra Caterina Grant & Iva Jovic [2] 6/2 6/1	
26. Victoria Luiza Barros (BRA) & Teodora Kostovic (SRB)				
27. Noemi Basiletti (ITA) & Lilli Tagger (AUT)	Noemi Basiletti & Lilli Tagger 7/6(4) 6/7(5) 10/5			
28. Anna Maria Fedotova (DOM) & Tereza Krejcova (CZE)				
(WC) 29. Daniela Piani (GBR) & Hollie Smart (GBR)	Daniela Piani & Hollie Smart 6/4 6/4	Tyra Caterina Grant & Iva Jovic [2] 6/3 6/4		
30. Yelyzaveta Kotliar (UKR) & Monika Stankiewicz (POL)				
31. Charo Esquiva Banuls (ESP) & Gaeul Jang (KOR)	Tyra Caterina Grant & Iva Jovic [2] 6/3 6/0			
32. Tyra Caterina Grant (USA) & Iva Jovic (USA) [2]				

Heavy type denotes seeded players. The figure in brackets against names denotes the order in which they have been seeded. The Committee reserves the right to alter the seeding order in the event of withdrawals.
(WC)=Wild cards. (A)=Alternates.

THE 14&U BOYS' SINGLES CHAMPIONSHIP 2024
Holder: MARK CEBAN (GBR)

The Champion will become the holder, for the year only, of a Cup presented by The All England Lawn Tennis and Croquet Club.
The Champion will receive a three-quarter size Cup and the Runner-up will receive a Silver Salver. The matches will be first to two sets. If the score is one set all, the match will be decided by a first-to-ten tie-break.

GROUP A	Michael Antonius (USA)	Niall Pickerd-Barua (GBR)	Livas Eduardo De Carvalho Damazio (BRA)	Takahiro Kawaguchi (JPN)	Wins	Losses	Group Winner
Michael Antonius (USA)		6/3 6/2 W	6/4 6/0 W	1/6 2/6 L	2	1	
Niall Pickerd-Barua (GBR)	3/6 2/6 L		3/6 3/6 L	2/6 2/6 L	0	3	Takahiro Kawaguchi (JPN)
Livas Eduardo De Carvalho Damazio (BRA)	4/6 06 L	6/3 6/3 W		2/6 6/7(7) L	1	2	
Takahiro Kawaguchi (JPN)	6/1 6/2 W	6/ 6/2 W	6/2 7/6(7) W		3	0	

GROUP B	Eric Lorimer (GBR)	Johann Nagel-Heyer (GER)	Dongjae Kim (KOR)	Hongjin Qi (CHN)	Wins	Losses	Group Winner
Eric Lorimer (GBR)		6/4 6/1 W	6/7(2) 7/5 8-10 L	6/7(5) 6/4 10-7 W	2	1	
Johann Nagel-Heyer (GER)	4/6 1/6 L		3/6 2/6 L	6/7(3) 4/6 L	0	3	Dongjae Kim (KOR)
Dongjae Kim (KOR)	7/6(2) 5/7 10-8 W	6/3 6/2 W		7/5 2/6 11-9 W	3	0	
Hongjin Qi (CHN)	7/6(5) 4/6 7-10 L	7/6(3) 6/4 W	5/7 6/2 9-11 L		1	2	

GROUP C	Jordan Lee (USA)	Rafalentino Ali Da Costa (INA)	Aran Selvaraasan (GBR)	Taiki Takizawa (AUS)	Wins	Losses	Group Winner
Jordan Lee (USA)		6/3 6/1 W	6/2 6/1 W	6/0 6/4 W	3	0	
Rafalentino Ali Da Costa (INA)	3/6 1/6 L		6/2 6/1 W	4/6 6/3 10-7 W	2	1	Jordan Lee (USA)
Aran Selvaraasan (GBR)	2/6 1/6 L	2/6 1/6 L		2/6 3/6 L	0	3	
Taiki Takizawa (AUS)	0/6 4/6 L	6/4 3/6 7-10 L	6/2 6/3 W		1	2	

GROUP D	Stan Put (NED)	Lucas Han (AUS)	Scott Watson (GBR)	Demian Agustin Luna (ARG)	Wins	Losses	Group Winner
Stan Put (NED)		6/1 7/5 W	7/5 6/4 W	6/2 6/0 W	3	0	
Lucas Han (AUS)	1/6 5/7 L		4/6 5/7 L	6/4 6/2 W	1	2	Stan Put (NED)
Scott Watson (GBR)	5/7 4/6 L	6/4 7/5 W		6/1 6/1 W	2	1	
Demian Agustin Luna (ARG)	2/6 0/6 L	4/6 2/6 L	1/6 1/6 L		0	3	

Semi-Finals — **Final** — **Champion**

Takahiro Kawaguchi (JPN)
Stan Put (NED)
→ Takahiro Kawaguchi 7/6(8) 6/4

Jordan Lee (USA)
Dongjae Kim (KOR)
→ Jordan Lee 6/3 6/1

Final: Takahiro Kawaguchi 6/2 6/2
Champion: Takahiro Kawaguchi

THE 14&U BOYS' SINGLES CONSOLATION PLAY-OFFS

Consolation Play-Off for 5th/6th Position (2nd placed players from round robin groups)

Eric Lorimer (GBR)
Michael Antonius (USA)
→ Michael Antonius 6/3 3/6 10-7

Scott Watson (GBR)
Rafalentino Ali Da Costa (INA)
→ Rafalentino Ali Da Costa 6/1 4/6 10-4

→ Michael Antonius 2/6 6/3 10-2

Consolation Play-Off for 9th/10th Position (3rd placed players from round robin groups)

Lucas Han (AUS)
Taiki Takizawa (AUS)
→ Taiki Takizawa 6/3 6/7(2) 10-8

Hongjin Qi (CHN)
Livas Eduardo De Carvalho Damazio (BRA)
→ Hongjin Qi 6/2 6/3

→ Taiki Takizawa 6/3 6/2

Consolation Play-Off for 13th/14th Position (4th placed players from round robin groups)

Niall Pickerd-Barua (GBR)
Johann Nagel-Heyer (GER)
→ Johann Nagel-Heyer 2/6 7/5 10-8

Aran Selvaraasan (GBR)
Demian Agustin Luna (ARG)
→ Aran Selvaraasan 7/5 6/1

→ Aran Selvaraasan 6/3 6/2

THE 14&U GIRLS' SINGLES CHAMPIONSHIP 2024
Holder: LUNA VUJOVIC (SRB)

The Champion will become the holder, for the year only, of a Cup presented by The All England Lawn Tennis and Croquet Club.
The Champion will receive a three-quarter size Cup and the Runner-up will receive a Silver Salver. The matches will be first to two sets. If the score is one set all, the match will be decided by a first-to-ten tie-break.

GROUP A	Jana Kovackova (CZE)	Margaret Sohns (USA)	Daniella Britton (GBR)	Zoe Doldan (PAR)	Wins	Losses	Group Winner
Jana Kovackova (CZE)		6/1 7/6(5) W	6/2 6/3 W	6/3 6/3 W	3	0	Jana Kovackova (CZE)
Margaret Sohns (USA)	1/6 6/7(5) L		2/6 6/4 6-10 L	6/4 6/0 W	1	2	
Daniella Britton (GBR)	2/6 3/6 L	6/2 4/6 10-6 W		6/3 6/4 W	2	1	
Zoe Doldan (PAR)	3/6 3/6 L	4/6 0/6 L	3/6 4/6 L		0	3	

GROUP B	Xinran Sun (CHN)	Raya Kotseva (USA)	Liv Zingg (GBR)	Tori Russell (AUS)	Wins	Losses	Group Winner
Xinran Sun (CHN)		6/3 6/3 W	6/2 6/0 W	6/0 6/0 W	3	0	Xinran Sun (CHN)
Raya Kotseva (USA)	3/6 3/6 L		6/3 6/2 W	6/2 6/2 W	2	1	
Liv Zingg (GBR)	2/6 0/6 L	3/6 2/6 L		6/1 6/3 W	1	2	
Tori Russell (AUS)	0/6 0/6 L	2/6 2/6 L	1/6 3/6 L		0	3	

GROUP C	Welles Newman (USA)	Megan Knight (GBR)	Claudia Chacon (VEN)	Sijia Zhang (CHN)	Wins	Losses	Group Winner
Welles Newman (USA)		6/3 3/6 5-10 L	6/0 6/0 W	6/2 6/4 W	2	1	Megan Knight (GBR)
Megan Knight (GBR)	3/6 6/3 10-5 W		6/1 6/0 W	6/2 6/0 W	3	0	
Claudia Chacon (VEN)	0/6 0/6 L	1/6 0/6 L		2/6 0/6 L	0	3	
Sijia Zhang (CHN)	2/6 4/6 L	2/6 0/6 L	6/2 6/0 W		1	2	

GROUP D	Keisija Berzina (LAT)	Yeri Hong (KOR)	Haniya Minhas (KSA)	Joyce Geng (CAN)	Wins	Losses	Group Winner
Keisija Berzina (LAT)		7/6(0) 6/1 W	6/4 6/2 W	0/6 6/3 10-6 W	3	0	Keisija Berzina (LAT)
Yeri Hong (KOR)	6/7(0) 1/6 L		6/4 6/1 W	6/7(3) 6/4 Ret'd W	2	1	
Haniya Minhas (KSA)	4/6 2/6 L	4/6 1/6 L		w/o W	1	2	
Joyce Geng (CAN)	6/0 3/6 6-10 L	7/6(3) 4/6 Ret'd L	w/o L		0	3	

Semi-Finals — **Final** — **Champion**

Jana Kovackova (CZE) ⎤
Megan Knight (GBR) ⎦ Jana Kovackova — 2/6 6/3 10-8

Keisija Berzina (LAT) ⎤
Xinran Sun (CHN) ⎦ Keisija Berzina — 6/2 6/4

Jana Kovackova 5/7 6/3 10-2

THE 14&U GIRLS' SINGLES CONSOLATION PLAY-OFFS

Consolation Play-Off for 5th/6th Position (2nd placed players from round robin groups)

Welles Newman (USA) ⎤
Raya Kotseva (USA) ⎦ Raya Kotseva — 7/5 6/3

Daniella Britton (GBR) ⎤
Yeri Hong (KOR) ⎦ Daniella Britton — 6/1 6/3

Daniella Britton 6/3 6/4

Consolation Play-Off for 9th/10th Position (3rd placed players from round robin groups)

Margaret Sohns (USA) ⎤
Sijia Zhang (CHN) ⎦ Sijia Zhang — 6/4 6/0

Haniya Minhas (KSA) ⎤
Liv Zingg (GBR) ⎦ Haniya Minhas — 6/7(3) 6/3 10-8

Sijia Zhang 6/2 7/6(1)

Consolation Play-Off for 13th/14th Position (4th placed players from round robin groups)

Joyce Geng (CAN) ⎤
Zoe Doldan (PAR) ⎦ Zoe Doldan — w/o

Claudia Chacon (VEN) ⎤
Tori Russell (AUS) ⎦ Tori Russell — 6/3 6/3

Tori Russell 6/4 3/6 10-4

THE GENTLEMEN'S INVITATION DOUBLES 2024
Holders: BOB BRYAN (USA) & MIKE BRYAN (USA)

The Champions will become the holders, for the year only, of a Cup presented by The All England Lawn Tennis and Croquet Club. The Champions will receive a silver three-quarter size Cup. A Silver Medal will be presented to each of the Runners-up. The matches will be the best of three sets. If a match should reach one set all a 10-point tie-break will replace the third set.

GROUP A	Juan Sebastian Cabal (COL) & Robert Farah (COL)	Jamie Delgado (GBR) & Sebastien Grosjean (FRA)	Tommy Haas (GER) & Mark Philippoussis (AUS)	Kevin Anderson (RSA) & Lleyton Hewitt (AUS)	Wins	Losses
Juan Sebastian Cabal (COL) & Robert Farah (COL)		7/5 6/3 W	2/6 6/3 11-9 W	6/4 5/7 3-10 L	2	1
Jamie Delgado (GBR) & Sebastien Grosjean (FRA)	5/7 3/6 L		3/3 Ret'd W	3/6 2/6 L	1	2
Tommy Haas (GER) & Mark Philippoussis (AUS)	6/2 3/6 9-11 L	3/3 Ret'd L		7/6(3) 4/6 10-12 L	0	3
Kevin Anderson (RSA) & Lleyton Hewitt (AUS)	4/6 7/5 10-3 W	6/3 6/2 W	6/7(3) 6/4 12-10 W		3	0

Final (Group A): Kevin Anderson (RSA) & Lleyton Hewitt (AUS)

GROUP B	Bob Bryan (USA) & Mike Bryan (USA)	Marcos Baghdatis (CYP) & Xavier Malisse (BEL)	James Blake (USA) & Bruno Soares (BRA)	Jeremy Chardy (FRA) & Feliciano Lopez (ESP)	Wins	Losses
Bob Bryan (USA) & Mike Bryan (USA)		6/3 6/3 W	7/5 6/3 W	6/4 6/4 W	3	0
Marcos Baghdatis (CYP) & Xavier Malisse (BEL)	3/6 3/6 L		6/7(5) 3/6 L	7/6(5) 6/3 W	1	2
James Blake (USA) & Bruno Soares (BRA)	5/7 3/6 L	7/6(5) 6/3 W		6/4 4/6 10-1 W	2	1
Jeremy Chardy (FRA) & Feliciano Lopez (ESP)	4/6 4/6 L	6/7(5) 3/6 L	4/6 6/4 1-10 L		0	3

Final (Group B): Bob Bryan (USA) & Mike Bryan (USA)

Final: Bob Bryan (USA) & Mike Bryan (USA) 6/1 6/4

THE LADIES' INVITATION DOUBLES 2024
Holders: KIM CLIJSTERS (BEL) & MARTINA HINGIS (SUI)

The Champions will become the holders, for the year only, of a Cup presented by The All England Lawn Tennis and Croquet Club. The Champions will receive a silver three-quarter size Cup. A Silver Medal will be presented to each of the Runners-up. The matches will be the best of three sets. If a match should reach one set all a 10-point tie-break will replace the third set.

GROUP A	Kim Clijsters (BEL) & Martina Hingis (SUI)	Daniela Hantuchova (SVK) & Laura Robson (GBR)	Agnieszka Radwanska (POL) & Francesca Schiavone (ITA)	Cara Black (ZIM) & Samantha Stosur (AUS)	Wins	Losses
Kim Clijsters (BEL) & Martina Hingis (SUI)		6/1 6/3 W	6/3 6/2 W	7/5 7/5 W	3	0
Daniela Hantuchova (SVK) & Laura Robson (GBR)	1/6 3/6 L		6/7(7) 2/6 L	5/7 5/7 L	0	3
Agnieszka Radwanska (POL) & Francesca Schiavone (ITA)	3/6 2/6 L	7/6(7) 6/2 W		6/7(5) 2/6 L	1	2
Cara Black (ZIM) & Samantha Stosur (AUS)	5/7 5/7 L	7/5 7/5 W	7/6(5) 6/2 W		2	1

Final (Group A): Kim Clijsters (BEL) & Martina Hingis (SUI)

GROUP B	Ashleigh Barty (AUS) & Casey Dellacqua (AUS)	Andrea Petkovic (GER) & Magdalena Rybarikova (SVK)	Johanna Konta (GBR) & CoCo Vandeweghe (USA)	Roberta Vinci (ITA) & Jie Zheng (CHN)	Wins	Losses
Ashleigh Barty (AUS) & Casey Dellacqua (AUS)		5/7 6/3 10-7 W	6/4 6/2 W	6/2 6/4 W	3	0
Andrea Petkovic (GER) & Magdalena Rybarikova (SVK)	7/5 3/6 7-10 L		6/3 6/4 W	7/6(3) 2/6 10-12 L	1	2
Johanna Konta (GBR) & CoCo Vandeweghe (USA)	4/6 2/6 L	3/6 4/6 L		4/6 4/6 L	0	3
Roberta Vinci (ITA) & Jie Zheng (CHN)	2/6 4/6 L	6/7(3) 6/2 12-10 W	6/4 6/4 W		2	1

Final (Group B): Ashleigh Barty (AUS) & Casey Dellacqua (AUS)

Final: Kim Clijsters (BEL) & Martina Hingis (SUI) 6/3 6/2

THE MIXED INVITATION DOUBLES 2024
Holders: NENAD ZIMONJIC (SRB) & RENNAE STUBBS (AUS)

The Champions will become the holders, for the year only, of a Cup presented by The All England Lawn Tennis and Croquet Club. The Champions will receive a silver three-quarter size Cup. A Silver Medal will be presented to each of the Runners-up. The matches will be the best of three sets. If a match should reach one set all a 10-point tie-break will replace the third set.

GROUP A	Greg Rusedski (GBR) & Iva Majoli (CRO)	Mark Woodforde (AUS) & Dominika Cibulkova (SVK)	Richard Krajicek (NED) & Conchita Martinez (ESP)	Mansour Bahrami (IRI) & Alicia Molik (AUS)	Wins	Losses
Greg Rusedski (GBR) & Iva Majoli (CRO)		3/6 4/6 L	2/6 5/7 L	3/6 6/4 10-7 W	1	2
Mark Woodforde (AUS) & Dominika Cibulkova (SVK)	6/3 6/4 W		7/5 2/6 10-6 W	7/6(2) 7/6(5) W	3	0
Richard Krajicek (NED) & Conchita Martinez (ESP)	6/2 7/5 W	5/7 6/2 6-10 L		6/3 7/5 W	2	1
Mansour Bahrami (IRI) & Alicia Molik (AUS)	6/3 4/6 7-10 L	6/7(2) 6/7(5) L	3/6 5/7 L		0	3

Final (Group A): Mark Woodforde (AUS) & Dominika Cibulkova (SVK)

GROUP B	Nenad Zimonjic (SRB) & Barbara Schett (AUT)	Todd Woodbridge (AUS) & Rennae Stubbs (AUS)	Thomas Enqvist (SWE) & Martina Navratilova (USA)	Jonas Bjorkman (SWE) & Anne Keothavong (GBR)	Wins	Losses
Nenad Zimonjic (SRB) & Barbara Schett (AUT)		6/3 6/4 W	7/5 6/3 W	6/4 3/6 10-5 W	3	0
Todd Woodbridge (AUS) & Rennae Stubbs (AUS)	3/6 4/6 L		6/4 7/5 W	3/6 2/6 L	1	2
Thomas Enqvist (SWE) & Martina Navratilova (USA)	5/7 3/6 L	4/6 5/7 L		6/7)5) 4/6 L	0	3
Jonas Bjorkman (SWE) & Anne Keothavong (GBR)	4/6 6/3 5-10 L	6/3 6/2 W	7/6(5) 6/4 W		2	1

Final (Group B): Nenad Zimonjic (SRB) & Barbara Schett (AUT)

Final: Mark Woodforde (AUS) & Dominika Cibulkova (SVK) 6/3 6/2

These events consists of eight invited pairs divided into two groups, playing each other within their group on a 'round robin' basis. The group winner is the pair with the highest number of wins.
In the case of a tie the winning pair may be determined by head to head results or a formula based on percentage of sets/games won to those played.

THE ROLLS OF HONOUR
GENTLEMEN'S SINGLES CHAMPIONS

1877	S.W. Gore	*1907	N. Brookes	1947	J. Kramer	1977	B. Borg	2007	R. Federer
1878	P.F. Hadow	*1908	A. Gore	*1948	R. Falkenburg	1978	B. Borg	2008	R. Nadal
*1879	J. Hartley	1909	A. Gore	1949	F. Schroeder	1979	B Borg	2009	R. Federer
1880	J. Hartley	1910	A. Wilding	*1950	E. Patty	1980	B Borg	2010	R. Nadal
1881	W. Renshaw	1911	A. Wilding	1951	R. Savitt	1981	J. McEnroe	2011	N. Djokovic
1882	W. Renshaw	1912	A. Wilding	1952	F. Sedgman	1982	J. Connors	2012	R. Federer
1883	W. Renshaw	1913	A. Wilding	*1953	E.V. Seixas	1983	J. McEnroe	2013	A. Murray
1884	W. Renshaw	1914	N. Brookes	1954	J. Drobny	1984	J. McEnroe	2014	N. Djokovic
1885	W. Renshaw	1919	G. Patterson	1955	M.A. Trabert	1985	B. Becker	2015	N. Djokovic
1886	W. Renshaw	1920	W. Tilden	*1956	L. Hoad	1986	B. Becker	2016	A. Murray
*1887	H. Lawford	1921	W. Tilden	1957	L. Hoad	1987	P. Cash	2017	R. Federer
1888	E. Renshaw	**†1922	G. Patterson	*1958	A. Cooper	1988	S. Edberg	2018	N. Djokovic
1889	W. Renshaw	*1923	W. Johnston	*1959	A. Olmedo	1989	B. Becker	2019	N. Djokovic
1890	W. Hamilton	*1924	J. Borotra	*1960	N. Fraser	1990	S. Edberg	2021	N. Djokovic
*1891	W. Baddeley	1925	J.R. Lacoste	1961	R. Laver	1991	M. Stich	2022	N. Djokovic
1892	W. Baddeley	*1926	J. Borotra	1962	R. Laver	1992	A. Agassi	2023	C. Alcaraz
1893	J. Pim	1927	H. Cochet	*1963	C. McKinley	1993	P. Sampras	2024	C. Alcaraz
1894	J. Pim	1928	J.R. Lacoste	1964	R. Emerson	1994	P. Sampras		
*1895	W. Baddeley	*1929	H. Cochet	1965	R. Emerson	1995	P. Sampras		
1896	H. Mahony	1930	W. Tilden	1966	M. Santana	1996	R. Krajicek		
1897	R. Doherty	*1931	S. Wood	1967	J. Newcombe	1997	P. Sampras		
1898	R. Doherty	1932	H.E. Vines	1968	R. Laver	1998	P. Sampras		
1899	R. Doherty	1933	J. Crawford	1969	R. Laver	1999	P. Sampras		
1900	R. Doherty	1934	F. Perry	1970	J. Newcombe	2000	P. Sampras		
1901	A. Gore	1935	F. Perry	1971	J. Newcombe	2001	G. Ivanisevic		
1902	H.L. Doherty	1936	F. Perry	*1972	S. Smith	2002	L. Hewitt		
1903	H.L. Doherty	*1937	J.D. Budge	*1973	J. Kodes	2003	R. Federer		
1904	H.L. Doherty	1938	J.D. Budge	1974	J. Connors	2004	R. Federer		
1905	H.L. Doherty	*1939	R. Riggs	1975	A. Ashe	2005	R. Federer		
1906	H.L. Doherty	*1946	Y. Petra	1976	B. Borg	2006	R. Federer		

For the years 1913, 1914 and 1919-1923 inclusive the above records include the "World's Championships on Grass" granted to The Lawn Tennis Association by The International Lawn Tennis Federation.

This title was then abolished and commencing in 1924 they became The Official Lawn Tennis Championships recognised by The International Lawn Tennis Federation.

Prior to 1922 the holders in the Singles Events and Gentlemen's Doubles did not compete in The Championships but met the winners of these events in the Challenge Rounds.

† Challenge Round abolished: holders subsequently played through.

* The holder did not defend the title.

LADIES' SINGLES CHAMPIONS

1884	M. Watson	1919	S. Lenglen	1956	S. Fry	1986	M. Navratilova	2017	G. Muguruza
1885	M. Watson	1920	S. Lenglen	*1957	A. Gibson	1987	M. Navratilova	2018	A. Kerber
1886	B. Bingley	1921	S. Lenglen	1958	A. Gibson	1988	S. Graf	2019	S. Halep
1887	L. Dod	†1922	S. Lenglen	*1959	M. Bueno	1989	S. Graf	*2021	A. Barty
1888	L. Dod	1923	S. Lenglen	1960	M. Bueno	1990	M. Navratilova	*2022	E. Rybakina
*1889	B. Hillyard	1924	K. McKane	*1961	F.A. Mortimer	1991	S. Graf	2023	M. Vondrousova
*1890	L. Rice	1925	S. Lenglen	1962	K. Susman	1992	S. Graf	2024	B. Krejcikova
*1891	L. Dod	1926	K. Godfree	*1963	M. Smith	1993	S. Graf		
1892	L. Dod	1927	H. Wills	1964	M.E. Bueno	1994	C. Martinez		
1893	L. Dod	1928	H. Wills	1965	M. Smith	1995	S. Graf		
*1894	B. Hillyard	1929	H. Wills	1966	B.J. King	1996	S. Graf		
*1895	C. Cooper	1930	H. Wills Moody	1967	B.J. King	*1997	M. Hingis		
1896	C. Cooper	*1931	C. Aussem	1968	B.J. King	1998	J. Novotna		
1897	B. Hillyard	*1932	H. Wills Moody	1969	A. Jones	1999	L. Davenport		
*1898	C. Cooper	1933	H. Wills Moody	1970	M. Court	2000	V. Williams		
1899	B. Hillyard	*1934	D. Round	1971	E. Goolagong	2001	V. Williams		
1900	B. Hillyard	1935	H. Wills Moody	1972	B.J. King	2002	S. Williams		
1901	C. Sterry	*1936	H. Jacobs	1973	B.J. King	2003	S. Williams		
1902	M.E. Robb	1937	D. Round	1974	C. Evert	2004	M. Sharapova		
*1903	D. Douglass	*1938	H. Wills Moody	1975	B.J. King	2005	V. Williams		
1904	D. Douglass	*1939	A. Marble	*1976	C. Evert	2006	A. Mauresmo		
1905	M. Sutton	*1946	P. Betz	1977	S.V. Wade	2007	V. Williams		
1906	D. Douglass	*1947	M. Osborne	1978	M. Navratilova	2008	V. Williams		
1907	M. Sutton	1948	L. Brough	1979	M. Navratilova	2009	S. Williams		
*1908	C. Sterry	1949	A.L. Brough	1980	E. Goolagong	2010	S. Williams		
*1909	P.D. Boothby	1950	A.L. Brough		Cawley	2011	P. Kvitova		
1910	D. Lambert Chambers	1951	D. Hart	*1981	C. Evert Lloyd	2012	S. Williams		
1911	D. Lambert Chambers	1952	M. Connolly	1982	M. Navratilova	2013	M. Bartoli		
*1912	E. Larcombe	1953	M. Connolly	1983	M. Navratilova	2014	P. Kvitova		
*1913	D. Lambert Chambers	1954	M. Connolly	1984	M. Navratilova	2015	S. Williams		
1914	D. Lambert Chambers	*1955	A.L. Brough	1985	M. Navratilova	2016	S. Williams		

GENTLEMEN'S DOUBLES CHAMPIONS

1884 E. Renshaw & W. Renshaw	1924 F. Hunter & V. Richards	1966 K. Fletcher & J. Newcombe	2002 J. Bjorkman & T. Woodbridge
1885 E. Renshaw & W. Renshaw	1925 J. Borotra & J.R. Lacoste	1967 R. Hewitt & F. McMillan	2003 J. Bjorkman & T. Woodbridge
1886 E. Renshaw & W. Renshaw	1926 J. Brugnon & H. Cochet	1968 J. Newcombe & A. Roche	2004 J. Bjorkman & T. Woodbridge
1887 P. Bowes-Lyon & H. Wilberforce	1927 F. Hunter & W. Tilden	1969 J. Newcombe & A. Roche	2005 S. Huss & W. Moodie
1888 E. Renshaw & W. Renshaw	1928 J. Brugnon & H. Cochet	1970 J. Newcombe & A. Roche	2006 B. Bryan & M. Bryan
1889 E. Renshaw & W. Renshaw	1929 W. Allison & J. Van Ryn	1971 R. Emerson & R. Laver	2007 A. Clement & M. Llodra
1890 J. Pim & F.O. Stoker	1930 W. Allison & J. Van Ryn	1972 R. Hewitt & F. McMillan	2008 D. Nestor & N. Zimonjic
1891 H. Baddeley & W. Baddeley	1931 G. Lott & J. Van Ryn	1973 J. Connors & I. Nastase	2009 D. Nestor & N. Zimonjic
1892 H.S. Barlow & E.W. Lewis	1932 J. Borotra & J. Brugnon	1974 J. Newcombe & A. Roche	2010 J. Melzer & P. Petzschner
1893 J. Pim & F. Stoker	1933 J. Borotra & J. Brugnon	1975 V. Gerulaitis & A. Mayer	2011 B. Bryan & M. Bryan
1894 H. Baddeley & W. Baddeley	1934 G. Lott & L. Stoefen	1976 B. Gottfried & R. Ramirez	2012 J. Marray & F. Nielsen
1895 H. Baddeley & W. Baddeley	1935 J. Crawford & A. Quist	1977 R. Case & G. Masters	2013 B. Bryan & M. Bryan
1896 H. Baddeley & W. Baddeley	1936 G.P. Hughes & C.R. Tuckey	1978 R. Hewitt & F. McMillan	2014 V. Pospisil & J. Sock
1897 H.L. Doherty & R. Doherty	1937 J.D. Budge & C.E. Mako	1979 P. Fleming & J. McEnroe	2015 J-J. Rojer & H. Tecau
1898 H.L. Doherty & R. Doherty	1938 J.D. Budge & C.E. Mako	1980 P. McNamara & P. McNamee	2016 P-H. Herbert & N. Mahut
1899 H.L. Doherty & R. Doherty	1939 E. Cooke & R. Riggs	1981 P. Fleming & J. McEnroe	2017 L. Kubot & M. Melo
1900 H.L. Doherty & R. Doherty	1946 T. Brown & J. Kramer	1982 P. McNamara & P. McNamee	2018 M. Bryan & J. Sock
1901 H.L. Doherty & R. Dohe rty	1947 R. Falkenburg & J. Kramer	1983 P. Fleming & J. McEnroe	2019 J.S. Cabal & R. Farah
1902 F. Riseley & S. Smith	1948 J. Bromwich & F. Sedgman	1984 P. Fleming & J. McEnroe	2021 N. Mektic & M. Pavic
1903 H.L. Doherty & R. Doherty	1949 R. Gonzales & F. Parker	1985 H. Guenthardt & B. Taroczy	2022 M. Ebden & M. Purcell
1904 H.L. Doherty & R. Doherty	1950 J. Bromwich & A. Quist	1986 J. Nystrom & M. Wilander	2023 W. Koolhof & N. Skupski
1905 H.L. Doherty & R. Doherty	1951 K. McGregor & F. Sedgman	1987 K. Flach & R. Seguso	2024 H. Heliovaara & H. Patten
1906 F. Riseley & S. Smith	1952 K. McGregor & F. Sedgman	1988 K. Flach & R. Seguso	
1907 N. Brookes & A. Wilding	1953 L. Hoad & K. Rosewall	1989 J. Fitzgerald & A. Jarryd	
1908 M. Ritchie & A. Wilding	1954 R. Hartwig & M. Rose	1990 R. Leach & J. Pugh	
1909 H.R. Barrett & A. Gore	1955 R. Hartwig & L. Hoad	1991 J. Fitzgerald & A. Jarryd	
1910 M. Ritchie & A. Wilding	1956 L. Hoad & K. Rosewall	1992 J. McEnroe & M. Stich	
1911 M. Decugis & A. Gobert	1957 G. Mulloy & E. Patty	1993 T. Woodbridge & M. Woodforde	
1912 H.R. Barrett & C. Dixon	1958 S. Davidson & U. Schmidt	1994 T. Woodbridge & M. Woodforde	
1913 H.R. Barrett & C. Dixon	1959 R. Emerson & N. Fraser	1995 T. Woodbridge & M. Woodforde	
1914 N. Brookes & A. Wilding	1960 R. Osuna & R. Ralston	1996 T. Woodbridge & M. Woodforde	
1919 R. Thomas & H. O'Hara Wood	1961 R. Emerson & N. Fraser	1997 T. Woodbridge & M. Woodforde	
1920 C. Garland & R. Williams	1962 R. Hewitt & F. Stolle	1998 J. Eltingh & P. Haarhuis	
1921 R. Lycett & M. Woosnam	1963 R. Osuna & A. Palafox	1999 M. Bhupathi & L. Paes	
1922 J. Anderson & R. Lycett	1964 R. Hewitt & F. Stolle	2000 T. Woodbridge & M. Woodforde	
1923 L. Godfree & R. Lycett	1965 J. Newcombe & A. Roche	2001 D. Johnson & J. Palmer	

LADIES' DOUBLES CHAMPIONS

1913 P.D. Boothby & W. McNair	1951 S. Fry & D. Hart	1984 M. Navratilova & P. Shriver	2016 S. Williams & V. Williams
1914 A. Morton & E. Ryan	1952 S. Fry & D. Hart	1985 K. Jordan & E. Smylie	2017 E. Makarova & E. Vesnina
1919 S. Lenglen & E. Ryan	1953 S. Fry & D. Hart	1986 M. Navratilova & P. Shriver	2018 B. Krejcikova & K. Siniakova
1920 S. Lenglen & E. Ryan	1954 A.L. Brough &	1987 C. Kohde-Kilsch & H. Sukova	2019 S-W. Hsieh & B. Strycova
1921 S. Lenglen & E. Ryan	M. Osborne duPont	1988 S. Graf & G. Sabatini	2021 S-W. Hsieh & E. Mertens
1922 S. Lenglen & E. Ryan	1955 F.A. Mortimer & J.A. Shilcock	1989 J. Novotna & H. Sukova	2022 B. Krejcikova & K. Siniakova
1923 S. Lenglen & E. Ryan	1956 A. Buxton & A. Gibson	1990 J. Novotna & H. Sukova	2023 S-W. Hsieh & B. Strycova
1924 H. Wightman & H. Wills	1957 A. Gibson & D. Hard	1991 L. Savchenko-Neiland &	2024 K. Siniakova & T. Townsend
1925 S. Lenglen & E. Ryan	1958 M. Bueno & A. Gibson	N. Zvereva	
1926 M. Browne & E. Ryan	1959 J. Arth & D. Hard	1992 G. Fernandez & N. Zvereva	
1927 E. Ryan & H. Wills	1960 M. Bueno & D. Hard	1993 G. Fernandez & N. Zvereva	
1928 P. Holcroft-Watson &	1961 K. Hantze & B.J. Moffitt	1994 G. Fernandez & N. Zvereva	
M. Saunders	1962 B.J. Moffitt & K. Susman	1995 J. Novotna &	
1929 P. Watson & M. Michell	1963 M. Bueno & D. Hard	A. Sanchez Vicario	
1930 H. Wills Moody & E. Ryan	1964 M. Smith & L. Turner	1996 M. Hingis & H. Sukova	
1931 P. Mudford &	1965 M. Bueno & B.J. Moffitt	1997 G. Fernandez & N. Zvereva	
D. Shepherd-Barron	1966 M. Bueno & N. Richey	1998 M. Hingis & J. Novotna	
1932 D. Metaxa & J. Sigart	1967 R. Casals & B.J. King	1999 L. Davenport & C. Morariu	
1933 S. Mathieu & E. Ryan	1968 R. Casals & B.J. King	2000 S. Williams & V. Williams	
1934 S. Mathieu & E. Ryan	1969 M. Court & J. Tegart	2001 L. Raymond & R. Stubbs	
1935 W. James & K. Stammers	1970 R. Casals & B.J. King	2002 S. Williams & V. Williams	
1936 W. James & K. Stammers	1971 R. Casals & B.J. King	2003 K. Clijsters & A. Sugiyama	
1937 S. Mathieu & A. Yorke	1972 B.J. King & B. Stove	2004 C. Black & R. Stubbs	
1938 S. Fabyan & A. Marble	1973 R. Casals & B.J. King	2005 C. Black & L. Huber	
1939 S. Fabyan & A. Marble	1974 E. Goolagong & M. Michel	2006 Z. Yan & J. Zheng	
1946 A.L. Brough &	1975 A. Kiyomura & K. Sawamatsu	2007 C. Black & L. Huber	
M. Osborne duPont	1976 C. Evert & M. Navratilova	2008 S. Williams & V. Williams	
1947 D. Hart & P. Todd	1977 H. Gourlay Cawley & J. Russell	2009 S. Williams & V. Williams	
1948 A.L. Brough &	1978 K. Melville Reid & W. Turnbull	2010 V. King & Y. Shvedova	
M. Osborne duPont	1979 B.J. King & M. Navratilova	2011 K. Peschke & K. Srebotnik	
1949 A.L. Brough &	1980 K. Jordan & A. Smith	2012 S. Williams & V. Williams	
M. Osborne duPont	1981 M. Navratilova & P. Shriver	2013 S-W. Hsieh & S. Peng	
1950 A.L. Brough &	1982 M. Navratilova & P. Shriver	2014 S. Errani & R. Vinci	
M. Osborne duPont	1983 M. Navratilova & P. Shriver	2015 M. Hingis & S. Mirza	

MIXED DOUBLES CHAMPIONS

1913	H. Crisp & A. Tuckey	1949	E. Sturgess & S. Summers	1975	M. Riessen & M. Court	2000	D. Johnson & K. Po
1914	J.C. Parke & E. Larcombe	1950	E. Sturgess & A.L. Brough	1976	A. Roche & F. Durr	2001	L. Friedl & D. Hantuchova
1919	R. Lycett & E. Ryan	1951	F. Sedgman & D. Hart	1977	R. Hewitt & G. Stevens	2002	M. Bhupathi & E. Likhovtseva
1920	G. Patterson & S. Lenglen	1952	F. Sedgman & D. Hart	1978	F. McMillan & B. Stove	2003	L. Paes & M. Navratilova
1921	R. Lycett & E. Ryan	1953	E.V. Seixas & D. Hart	1979	R. Hewitt & G. Stevens	2004	W. Black & C. Black
1922	H. O'Hara-Wood & S. Lenglen	1954	E.V. Seixas & D. Hart	1980	J. Austin & T. Austin	2005	M. Bhupathi & M. Pierce
1923	R. Lycett & E. Ryan	1955	E.V. Seixas & D. Hart	1981	F. McMillan & B. Stove	2006	A. Ram & V. Zvonareva
1924	J.B. Gilbert & K. McKane	1956	E.V. Seixas & S. Fry	1982	K. Curren & A. Smith	2007	J. Murray & J. Jankovic
1925	J. Borotra & S. Lenglen	1957	M. Rose & D. Hard	1983	J. Lloyd & W. Turnbull	2008	B. Bryan & S. Stosur
1926	L. Godfree & K. Godfree	1958	R. Howe & L. Coghlan	1984	J. Lloyd & W. Turnbull	2009	M. Knowles & A-L. Groenefeld
1927	F. Hunter & E. Ryan	1959	R. Laver & D. Hard	1985	P. McNamee & M. Navratilova	2010	L. Paes & C. Black
1928	P. Spence & E. Ryan	1960	R. Laver & D. Hard	1986	K. Flach & K. Jordan	2011	J. Melzer & I. Benesova
1929	F. Hunter & H. Wills	1961	F. Stolle & L. Turner	1987	M.J. Bates & J. Durie	2012	M. Bryan & L. Raymond
1930	J. Crawford & E. Ryan	1962	N. Fraser &	1988	S. Stewart & Z. Garrison	2013	D. Nestor & K. Mladenovic
1931	G. Lott & A. Harper		M. Osborne du Pont	1989	J. Pugh & J. Novotna	2014	N. Zimonjic & S. Stosur
1932	E. Maier & E. Ryan	1963	K. Fletcher & M. Smith	1990	R. Leach & Z.L. Garrison	2015	L. Paes & M. Hingis
1933	G. von Cramm &	1964	F. Stolle & L. Turner	1991	J. Fitzgerald & E. Smylie	2016	H. Kontinen & H. Watson
	H. Krahwinkel	1965	K. Fletcher & M. Smith	1992	C. Suk &	2017	J. Murray & M. Hingis
1934	R. Miki & D.E. Round	1966	K. Fletcher & M. Smith		L. Savchenko-Neiland	2018	A. Peya & N. Melichar
1935	F.J. Perry & D. Round	1967	O. Davidson & B.J. King	1993	M. Woodforde &	2019	I. Dodig & L. Chan
1936	F.J. Perry & D. Round	1968	K. Fletcher & M. Court		M. Navratilova	2021	N. Skupski & D. Krawczyk
1937	J.D. Budge & A. Marble	1969	F. Stolle & A. Jones	1994	T. Woodbridge & H. Sukova	2022	N. Skupski & D. Krawczyk
1938	J.D. Budge & A. Marble	1970	I. Nastase & R. Casals	1995	J. Stark & M. Navratilova	2023	M. Pavic & L. Kichenok
1939	R. Riggs & A. Marble	1971	O. Davidson & B.J. King	1996	C. Suk & H. Sukova	2024	J. Zielinski & S-W. Hsieh
1946	T. Brown & A.L. Brough	1972	I. Nastase & R. Casals	1997	C. Suk & H. Sukova		
1947	J. Bromwich & A.L. Brough	1973	O. Davidson & B.J. King	1998	M. Mirnyi & S. Williams		
1948	J. Bromwich & A.L. Brough	1974	O. Davidson & B.J. King	1999	L. Paes & L. Raymond		

GENTLEMEN'S WHEELCHAIR SINGLES CHAMPIONS

2016	G. Reid	2018	S. Olsson	2021	J. Gerard	2023	T. Oda
2017	S. Olsson	2019	G. Fernandez	2022	S. Kunieda	2024	A. Hewett

GENTLEMEN'S WHEELCHAIR DOUBLES CHAMPIONS

2005	M. Jeremiasz & J. Mistry	2010	R. Ammerlaan & S. Olsson	2015	G. Fernandez & N. Peifer	2021	A. Hewett & G. Reid
2006	S. Kunieda & S. Saida	2011	M. Scheffers & R. Vink	2016	A. Hewett & G. Reid	2022	G. Fernandez & S. Kunieda
2007	R. Ammerlaan & R. Vink	2012	T. Egberink & M. Jeremiasz	2017	A. Hewett & G. Reid	2023	A. Hewett & G. Reid
2008	R. Ammerlaan & R. Vink	2013	S. Houdet & S. Kunieda	2018	A. Hewett & G. Reid	2024	A. Hewett & G. Reid
2009	S. Houdet & M. Jeremiasz	2014	S. Houdet & S. Kunieda	2019	J. Gerard & S. Olsson		

LADIES' WHEELCHAIR SINGLES CHAMPIONS

2016	J. Griffioen	2018	D. de Groot	2021	D. de Groot	2023	D. de Groot
2017	D. de Groot	2019	A. van Koot	2022	D. de Groot	2024	D. de Groot

LADIES' WHEELCHAIR DOUBLES CHAMPIONS

2009	K. Homan & E. Vergeer	2013	J. Griffioen & A. van Koot	2017	Y. Kamiji & J. Whiley	2022	Y. Kamiji & D. Mathewson
2010	E. Vergeer & S. Walraven	2014	Y. Kamiji & J. Whiley	2018	D. de Groot & Y. Kamiji	2023	D. de Groot & J. Griffioen
2011	E. Vergeer & S. Walraven	2015	Y. Kamiji & J. Whiley	2019	D. de Groot & A. van Koot	2024	Y. Kamiji & K. Montjane
2012	J. Griffioen & A. van Koot	2016	Y. Kamiji & J. Whiley	2021	Y. Kamiji & J. Whiley		

QUAD WHEELCHAIR SINGLES CHAMPIONS

2019	D. Alcott	2022	S. Schroder	2023	N. Vink	2024	N. Vink
2021	D. Alcott						

QUAD WHEELCHAIR DOUBLES CHAMPIONS

2019	D. Alcott & A. Lapthorne	2022	S. Schroder & N. Vink	2023	S. Schroder & N. Vink	2024	S. Schroder & N. Vink
2021	A. Lapthorne & D. Wagner						

18&U BOYS' SINGLES CHAMPIONS

1947	K. Nielsen	1963	N. Kalogeropoulos	1979	R. Krishnan	1995	O. Mutis	2011	L. Saville
1948	S. Stockenberg	1964	I. El Shafei	1980	T. Tulasne	1996	V. Voltchkov	2012	F. Peliwo
1949	S. Stockenberg	1965	V. Korotkov	1981	M. Anger	1997	W. Whitehouse	2013	G. Quinzi
1950	J. Horn	1966	V. Korotkov	1982	P. Cash	1998	R. Federer	2014	N. Rubin
1951	J. Kupferburger	1967	M. Orantes	1983	S. Edberg	1999	J. Melzer	2015	R. Opelka
1952	R. Wilson	1968	J. Alexander	1984	M. Kratzmann	2000	N. Mahut	2016	D. Shapovalov
1953	W. Knight	1969	B. Bertram	1985	L. Lavalle	2001	R. Valent	2017	A. Davidovich Fokina
1954	R. Krishnan	1970	B. Bertram	1986	E. Velez	2002	T. Reid	2018	C.H. Tseng
1955	M. Hann	1971	R. Kreiss	1987	D. Nargiso	2003	F. Mergea	2019	S. Mochizuki
1956	R. Holmberg	1972	B. Borg	1988	N. Pereira	2004	G. Monfils	2021	S. Banerjee
1957	J. Tattersall	1973	B. Martin	1989	N. Kulti	2005	J. Chardy	2022	M. Poljicak
1958	E. Buchholz	1974	B. Martin	1990	L. Paes	2006	T. De Bakker	2023	H. Searle
1959	T. Lejus	1975	C. Lewis	1991	T. Enqvist	2007	D. Young	2024	N. Budkov Kjaer
1960	A.R. Mandelstam	1976	H. Guenthardt	1992	D. Skoch	2008	G. Dimitrov		
1961	C. Graebner	1977	V. Winitsky	1993	R. Sabau	2009	A. Kuznetsov		
1962	S. Matthews	1978	I. Lendl	1994	S. Humphries	2010	M. Fucsovics		

18&U BOYS' DOUBLES CHAMPIONS

1982	P. Cash & J. Frawley	1992	S. Baldas & S. Draper	2004	B. Evans & S. Oudsema	2016	K. Raisma & S. Tsitsipas
1983	M. Kratzmann & S. Youl	1993	S. Downs & J. Greenhalgh	2005	J. Levine & M. Shabaz	2017	A. Geller & Y.H. Hsu
1984	R. Brown & R. Weiss	1994	B. Ellwood & M. Philippoussis	2006	K. Damico & N. Schnugg	2018	Y. Erel & O. Virtanen
1985	A. Moreno & J. Yzaga	1995	M. Lee & J. Trotman	2007	D. Lopez & M. Trevisan	2019	J. Forejtek & J. Lehecka
1986	T. Carbonell & P. Korda	1996	D. Bracciali & J. Robichaud	2008	C-P. Hsieh & T-H. Yang	2021	E. Butvilas & A. Manzanera Pertusa
1987	J. Stoltenberg & T. Woodbridge	1997	L. Horna & N. Massu	2009	P-H. Herbert & K. Krawietz	2022	S. Gorzny & A. Michelsen
1988	J. Stoltenberg & T. Woodbridge	1998	R. Federer & O. Rochus	2010	L. Broady & T. Farquharson	2023	J. Filip & G. Vulpitta
1989	J. Palmer & J. Stark	1999	G. Coria & D. Nalbandian	2011	G. Morgan & M. Pavic	2024	A. Razeghi & M. Schoenhaus
1990	S. Lareau & S. Leblanc	2000	D. Coene & K. Vliegen	2012	A. Harris & N. Kyrgios		
1991	K. Alami & G. Rusedski	2001	F. Dancevic & G. Lapentti	2013	T. Kokkinakis & N. Kyrgios		
		2002	F. Mergea & H. Tecau	2014	O. Luz & M. Zormann		
		2003	F. Mergea & H. Tecau	2015	N-H. Ly & S. Nagal		

18&U GIRLS' SINGLES CHAMPIONS

1947	G. Domken	1963	M. Salfati	1979	M-L. Piatek	1995	A. Olsza	2011	A. Barty
1948	O. Miskova	1964	J. Bartkowicz	1980	D. Freeman	1996	A. Mauresmo	2012	E. Bouchard
1949	C. Mercelis	1965	O. Morozova	1981	Z. Garrison	1997	C. Black	2013	B. Bencic
1950	L. Cornell	1966	B. Lindstrom	1982	C. Tanvier	1998	K. Srebotnik	2014	J. Ostapenko
1951	L. Cornell	1967	J. Salmone	1983	P. Paradis	1999	I. Tulyaganova	2015	S. Zhuk
1952	F. ten Bosch	1968	K. Pigeon	1984	A. Croft	2000	M.E. Salerni	2016	A. Potapova
1953	D. Kilian	1969	K. Sawamatsu	1985	A. Holikova	2001	A. Widjaja	2017	C. Liu
1954	V. Pitt	1970	S. Walsh	1986	N. Zvereva	2002	V. Douchevina	2018	I. Swiatek
1955	S. Armstrong	1971	M. Kroshina	1987	N. Zvereva	2003	K. Flipkens	2019	D. Snigur
1956	A. Haydon	1972	I. Kloss	1988	B. Schultz	2004	K. Bondarenko	2021	A. Mintegi Del Olmo
1957	M. Arnold	1973	A. Kiyomura	1989	A. Strnadova	2005	A. Radwanska	2022	L. Hovde
1958	S. Moore	1974	M. Jausovec	1990	A. Strnadova	2006	A. Wozniacki	2023	C. Ngounoue
1959	J. Cross	1975	N. Chmyreva	1991	B. Rittner	2007	U. Radwanska	2024	R. Jamrichova
1960	K. Hantze	1976	N. Chmyreva	1992	C. Rubin	2008	L. Robson		
1961	G. Baksheeva	1977	L. Antonoplis	1993	N. Feber	2009	N. Lertcheewakarn		
1962	G. Baksheeva	1978	T. Austin	1994	M. Hingis	2010	Kr. Pliskova		

18&U GIRLS' DOUBLES CHAMPIONS

1982	P. Barg & E. Herr	1994	E. De Villiers & E. Jelfs	2005	V. Azarenka & A. Szavay	2015	D. Galfi & F. Stollar
1983	P. Fendick & P. Hy	1995	C. Black & A. Olsza	2006	A. Kleybanova & A. Pavlyuchenkova	2016	U. Arconada & C. Liu
1984	C. Kuhlman & S. Rehe	1996	O. Barabanschikova & A. Mauresmo	2007	A. Pavlyuchenkova & U. Radwanska	2017	O. Danilovic & K. Juvan
1985	L. Field & J. Thompson	1997	C. Black & I. Selyutina	2008	P. Hercog & J. Moore	2018	X.Wang & X. Wang
1986	M. Jaggard & L. O'Neill	1998	E. Dyrberg & J. Kostanic	2009	N. Lertcheewakarn & S. Peers	2019	S. Broadus & A. Forbes
1987	N. Medvedeva & N. Zvereva	1999	D. Bedanova & M.E. Salerni	2010	T. Babos & S. Stephens	2021	K. Dmitruk & D. Shnaider
1988	J-A. Faull & R. McQuillan	2000	I. Gaspar & T. Perebiynis	2011	E. Bouchard & G. Min	2022	R. Nijkamp & A. Okutoyi
1989	J. Capriati & M. McGrath	2001	G. Dulko & A. Harkleroad	2012	E. Bouchard & T. Townsend	2023	A. Kovackova & L. Samsonova
1990	K. Habsudova & A. Strnadova	2002	E. Clijsters & B. Strycova	2013	B. Krejcikova & K. Siniakova	2024	T.C. Grant & I. Jovic
1991	C. Barclay & L. Zaltz	2003	A. Kleybanova & S. Mirza	2014	T. Grende and Q.Y. Ye		
1992	M. Avotins & L. McShea	2004	V. Azarenka & V. Havartsova				
1993	L. Courtois & N. Feber						

14&U BOYS' SINGLES CHAMPIONS

2022	S. Cho	2023	M. Ceban	2024	T. Kawaguchi

14&U GIRLS' SINGLES CHAMPIONS

2022	A. Tatu	2023	L. Vujovic	2024	J. Kovackova